未来影像　影响未来

——2017 ICEVE
北京国际先进
影像大会演讲集

侯光明　主编

版权专有 侵权必究

图书在版编目（CIP）数据

未来影像　影响未来：2017 ICEVE 北京国际先进影像大会演讲集/侯光明主编. —北京：北京理工大学出版社，2019.6
ISBN 978 - 7 - 5682 - 7157 - 8

Ⅰ. ①未… Ⅱ. ①侯… Ⅲ. ①电影事业 - 文集 Ⅳ. ①J99 - 53

中国版本图书馆 CIP 数据核字（2019）第 128393 号

出版发行 / 北京理工大学出版社有限责任公司
社　　址 / 北京市海淀区中关村南大街 5 号
邮　　编 / 100081
电　　话 / （010）68914775（总编室）
　　　　　（010）82562903（教材售后服务热线）
　　　　　（010）68948351（其他图书服务热线）
网　　址 / http：//www.bitpress.com.cn
经　　销 / 全国各地新华书店
印　　刷 / 雅迪云印（天津）科技有限公司
开　　本 / 787 毫米 × 1092 毫米　1/16
印　　张 / 19.25　　　　　　　　　　　　　　责任编辑 / 梁铜华
字　　数 / 375 千字　　　　　　　　　　　　　文案编辑 / 梁铜华
版　　次 / 2019 年 6 月第 1 版　2019 年 6 月第 1 次印刷　责任校对 / 杜　枝
定　　价 / 198.00 元　　　　　　　　　　　　　责任印制 / 施胜娟

图书出现印装质量问题，请拨打售后服务热线，本社负责调换

序

北京国际先进影像大会暨展览会（International Conference & Exhibition on Visual Entertainment，ICEVE）由国内权威的电影高校北京电影学院与国内顶尖的影像科学技术组织中国电影电视技术学会共同发起，是中国第一个关注影像技术领域的大型会展平台。

每年一度的 ICEVE 大会都将全球科技界、艺术界和影视产业界的专家和从业者齐聚在北京电影学院，共同对影视技术领域的国际前沿话题和发展前景进行探讨。随着近年来中国电影产业的不断发展，中国电影市场已经成为全球第二大电影市场，并且随着中国国际影响力的逐渐提升，在全球影视产业中正在起着越来越重要的作用。在此背景下，无论在电影的技术创新、艺术创作，还是在产业环境保障层面，中国电影人都应当构建具有国际视野和面向未来的专业素养，推动将中国建设成为文化强国与电影强国。

ICEVE 大会聚焦高质量影像、先进影像流程、VR/AR 内容制作和未来影像等前沿领域，致力于通过会议与展览会，搭建一个集前沿影像技术学术研讨与展示、影像制作内容合作洽谈、影像技术领域国际交流于一体的创新型交流平台，帮助更多专业人士启发思维，提升国内整体影视内容制作水准。自 2011 年发起至今，ICEVE 大会已发展成为国内先进影像内容制作行业的风向标，深刻影响着中国影像技术的发展趋势与迭代变革，为中国影视内容制作从业者提供着信息获取、技术交流、产品贸易的平台服务。

ICEVE 大会被媒体视为中国先进影像领域的风向标与嘉年华，被与会听众视为该行业领域中最不可缺席的活动。在这里，您得以聆听影像行业中最优秀的一批同行就务实的话题做无私的分享。

本书是 ICEVE 大会 2017 年的主题演讲发言汇总（由于版面所限，大部分演讲时用的 PPT 图片被省略）。

目 录

人工智能与影视制作主题论坛

陈宝权
未来影像前瞻：人工智能会主导影视内容制作吗？ ... 3
Future Visual Entertainment: Will AI Pervade in the Field of Film Making? 9

童欣
从交互图形到智能图形 .. 15
From Interactive Images to Smart Images ... 24

李文新
当人工智能遇上电影 .. 31
When AI Meets Film .. 36

虚拟现实影像内容主题论坛

周昆
计算机图形学 2.0: 由终端用户生成的 3D 内容 .. 43
Computer Graphics 2.0: 3D Contents Generated by End Users 52

Dominick Spina
Real-time Visualization, High Power Computing and Rendering for Content Creation ... 59
运用实时可视化与高性能渲染技术打造高品质影视内容 63

Sebastian Knorr
V-sense — Extending Visual Sensation Through Image-based Visual Computing 67
V-sense——基于图像可视计算的视觉感知增强 ... 73

王之纲
对虚拟现实艺术本体性的思考 ... 77
Reflection on the Noumenon of Virtual Reality Art 84

Gianluigi Perrone

The Leadership of China in the Virtual Worlds: the Social VR Project Which Is
Going to Change the Future of Virtual Economy ································ 91
 中国领军的虚拟世界：将会改变虚拟现实产业的社会化 VR 项目 ············ 97

曾智

更加"真实"的现实，探索下一代全景拍摄技术 ································ 101
 To Develop New Technology of Panoramic Shooting for
 Better Presentation of Reality ·· 107

钱晓勇

信息传播 ··· 113
 Information Communication ·· 119

高质量影像与先进制作流程主题论坛

Kurt Akeley

Lytro Immerge: Virtual Reality Cinema with Six-degree-of-freedom Viewing ········ 127
 Lytro Immerge 系列相机：用六自由度观看的 VR 电影 ······················ 137

Jim Chabin

The Next Generation of Consumers ··· 147
 新一代影视消费者的特征 ·· 151

Bill Collis

Empowering Content Creative Workflow ··· 155
 先进技术助力影视制作流程 ··· 161

Stephani Maxwell

A Unique Approach to Collaboration Across Artistic Disciplines for
Creating Works of Art ·· 165
 通过跨学科艺术家的合作来创新艺术作品 ···································· 170

王勇猛

《悟空传》《绣春刀 II》《羞羞的铁拳》等制作分享 ······························ 175
 Production of *Wu Kong*, *Brotherhood of Blades II*, and *Never Say Die* ········ 183

未来影像主题论坛

权龙
计算机视觉、视觉学习和 3D 重建：用无人机和智能手机捕捉三维的世界！ ……191
Computer Vision, Visual Learning and 3D Reconstruction:
Capture the 3D World with UAVs and Smartphones! ……198

虞晶怡
给予 VR/AR 双眼和大脑 ……205
Equipped VR/AR with Eyes and Brain ……214

杨睿刚
用 3D 视觉探索内容生成的新领域 ……223
Exploring New Area of Content Generation by 3D Vision ……229

Ludger Pfanz
Future Design ……235
未来设计 ……244

宋维涛
近眼显示技术的现状和展望 ……251
Present State and Perspectives of Near-eye Displays ……257

Kfir Aberman and Oren Katzir
Dip Transform for 3D Shape Reconstruction ……263
基于浸入变换的三维重建 ……268

Toyomi Hoshina
Attempts for Life and Visual Expression Devices ……273
对生命与视觉表现装置的尝试 ……280

Jake Black
Cutting Edge VR Content in Hollywood ……285
好莱坞 VR 内容的前沿探索 ……293

International Conference &
EXhibition on Visual Entertainment

2017 ICEVE 北京国际先进影像大会演讲集

人工智能与影视制作主题论坛

未来影像前瞻：人工智能会主导影视内容制作吗？

◎ 陈宝权

大家早上好！很高兴第二次参加 ICEVE 先进影像大会，借这个机会我先介绍一下北京电影学院未来影像高精尖创新中心近一年来科研方面的进展。高精尖创新中心定位国际前瞻技术研究与应用。成立一年来，中心已有一支由四位一级研究员带领的核心技术团队。

下面我对这四个方向做一个简单的介绍。第一个方向叫现实捕获，就是对现实存在的场景和人从表象到物理与生理现象进行数字化。因为数字化便于我们对它进行编辑、模拟与艺术再创作，这一方向的工作越来越成为未来的核心技术，它是所有数字创作与制作的基础。我们也进一步开展在内容制作上的研究，比如从一个物体或者场景生成新的场景，并且实现高度的智能化。这种智能化包括对数字化的物体进行自动化真实感纹理映射；对物理现象的捕获、反演与模拟编辑，以及对视频的深度理解，比如对从颜色到纹理，再到里面所涉及的几何形体，甚至物体的移动轨迹等进行深度分析，并在这种分析的基础上，对视频进行索引、编辑，或合成新的视频内容。

第二个方向是未来显示，目标是开发一个紧凑、轻便，同时高分辨率、高视场角，甚至具有深度感的头戴显示设备，让 VR 显示更加逼真且便捷。随着 3D 影视在未来更加普及，它会发挥更大的作用。我们也研究未来在这种头戴式的显示环境之下，怎样做到体验更加自然舒适、具有更高沉浸感，并通过多通道高效交互等。

第三个方向是智能影棚，也就是研究在电影拍摄阶段，如何采用机器人让电影的拍摄更精准高效。比如，如何智能化地定位摄像头的位置，让拍摄过程更加高效、准确；如何设置灯光，确定灯光的位置、照射方向，还有它的强度、色温等。传统电影拍摄中的灯光设置非常耗费时间和精力，我们努力让其过程变得更加高效。

陈宝权在 ICEVE 大会现场

陈宝权在 ICEVE 大会现场

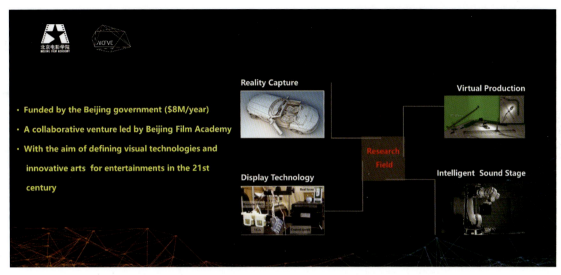

未来影像高精尖创新中心的研究方向：现实捕获、未来显示、智能影棚和虚拟制作

第四个方向是虚拟制作，主要是数字内容设计和预览技术（PreViz）平台的开发，为影视创作与制作提供新的模式，大幅度提高现场制作效率和效果。

高精尖创新中心作为一个创新的平台对电影的制作有非常密切的参与。这些技术已经通过和知名导演合作应用于最新的一些影片拍摄过程中，特别是在可视化预演方面进行了深度合作；也针对一些大型舞台场景的设计，比如对2022年北京冬奥会的表演场景的预览和仿真训练系统等，做出了贡献，得到了组委会的高度认可。

数字技术正在全方位改变影视创作与制作的过程，很多先锋电影导演通过与我们合作已经有了很好的体验，希望在未来的电影作品中，能更多地引入这样新的技术。新生代导演是数字时代的原住民，他们能很快地接受数字技术，并且引领未来。

我们应该把现在做的事情放到整个电影历史发展的过程当中。那么影视科技未来的发展趋势是什么？

影视制作尽管从发明到现在的时间并不长，但已经经历了好几代的演变，从最早期记录影像的年代到现在三维活动影像的时代，从叙事的方式到内容创作的方式，由于相关科技的发展，这些技术都发生了很大的变化。接下来我从影视制作流程的几个方面来进行简单的介绍。

我们知道传统的电影制作大概是这样的一个流程：创作、设计、拍摄与制作，最后是后期特效。这是现在比较标准、传统的流程。这个流程的每个方面现在的发展趋势都是智能化的程度越来越高。比如说创作，我们可以通过人工智能的方

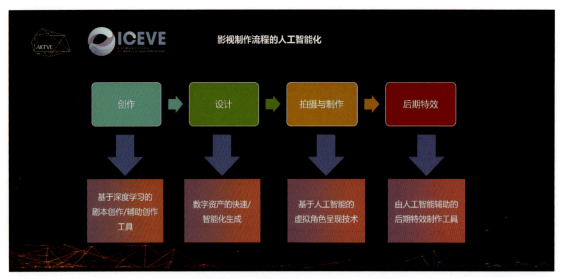

人工智能将会改变影视制作流程的每一个环节

式来进行创作，或是辅助创作。再比如设计，资产的生成不仅越来越多地采用数字化的技术，而且在这个技术里面，智能化程度进一步提高。在拍摄与制作的过程中，人工智能技术会发挥更多的作用，后期特效制作就更会如此了。而且，后期特效在未来会越来越多地融入拍摄与制作过程之中，而不是与之分离。

下面我从几个方面来做一个介绍。比如说在剧本创作方面有个比较前端的实验。有一个叫"Sunspring"的科幻片，它的剧本创作完全是以人工智能的方式来实现的。通过人工智能来阅读学习很多已有的科幻小说，找到写作科幻小说的一些基本的要素，然后创作自己的故事，这个故事里有谋杀、爱情等多个方面的元素；不仅是创作了这样的一个作品，还请真人来表演，电影最后还获了奖，这是一个非常独特的尝试。

当然，人工智能在实际的剧本创作中更多的是一个辅助的作用。比如对一些人物、形象上的设计。也许主体的一些特性需要人来设计，但接下来非常多的细节可以通过人工智能来丰富。在数字资产的快速生成方面就更加依赖人工智能技术来提高效率，因为传统的数字资产生成是会耗费大量的人力和物力的。现在，从一个形体几何的获取甚至一个动作的捕获到一个动态现象的模拟、仿真等都可以通过智能化的技术来进一步提高。

举个例子，比如说我们看到的这三个动画（下页图），最左边是一个真实的荷叶在被风吹了以后的动态过程，这个过程我们可以通过数字捕获技术把它数字化，并对其物理过程进行拟合，之后反演这个物体的一些物理特性，接下来再通过数字化技术进行新的模拟。也就是说，我们可以让这样一个物体重生，让它在一个

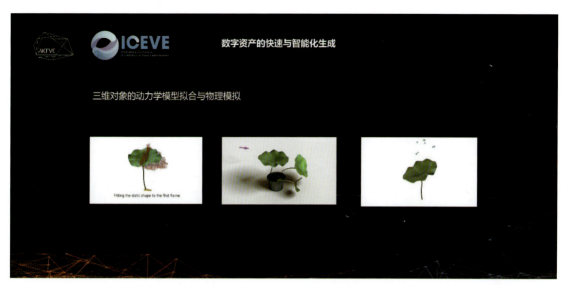

通过人工智能对三维物体的物理特性进行模拟

新的场景之下做新的动态表现。

比如说我们对这片荷叶吹某个方向的风，或者让水珠掉下来落在这片荷叶上，那这片荷叶就会依据它的物理特性做相应的反应。如此，这个从捕获到重生的过程，都是通过数字化智能技术来实现的。再比如一个人体，或其脸部、头部的设计与编辑，也可以通过智能化的技术变得非常快捷。这里展示的就像艺术家画草图一样，通过此草图，计算机马上就能得到一个相对应的三维几何。

有这样的技术支撑，艺术家可以非常自由、自如地草绘一个新形象，其精确的三维几何能快速生成，依据它可以动态地进行新的表情演示。还有一些自然现象比如流体，也可以采用智能化的技术进行设计。我们知道流体计算是由非常复杂的物理模型来主导的，这个计算量非常大。对一个比较大场景的运动进行模拟并实现细节所需的计算量非常大，对电影制作的高效需求是很大的挑战。如果采用人工智能技术，可以通过学习许多已经模拟计算了的一些现象，对新的物理模拟进行指导，比如，精确的物理模拟只在比较粗略的层面进行，细节的现象表现可以通过所学习到的东西来进行模拟，从而大大提高计算效率。

不仅是物理现象，对于人或者动物的动作也可以通过学习的方式进行训练、提高。比如说这个虚拟设计的生物，它在场景里面跳过不平的、有沟沟坎坎或者有坡度的一个地面。这样的动漫以前都是靠人工来进行控制，都是靠动漫师凭着经验一帧一帧去设计，这是一个很烦琐的过程。同样的道理，利用人工智能深度学习这样的技术，我们也可以通过对一些捕获的，或者人为动漫设计的运动数据的学习来实现在新环境里的自适应动作。

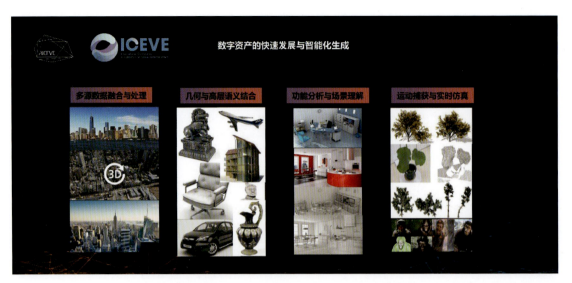

人工智能将极大提升电影制作的三维资产计算效率

当然，目前的技术还没有先进到代替人的表演。但是我们可以看到，人工智能技术在一步一步地逼近这种可能。在后期的制作方面，会有更多的人工智能技术来帮忙。比如说一个大型场景的渲染，如果要获得高度逼真的渲染，其计算量是非常大的；与此类似的是，深度学习技术现在已经帮助后期制作大大提高了效率。通过学习，不必对原始的光照模型做全分辨率的计算也可以达到细节逼真的效果。在后期制作中当然还包括其他各种各样的物理现象，比如火焰、烟雾等，它们都可以通过深度学习的方式来大大地提高模拟计算效率。这样的技术，可以实现对场景的快捷改变。对于一个场景的变化，整个物理模型的区域和边界条件等方面都发生了变化，按传统的计算方法，一切需要重新计算，而人工智能技术则实现了计算效率飞跃式的提高。

再回到我们高精尖创新中心，我们的科研团队已经在内容的生成、在线拍摄的过程中大量地探索了人工智能技术。从拍摄预览到在线拍摄，再到后期特效，中心的科技团队在这几个方面同时向前推动。我们还通过不断参与影视制作来寻找实际的问题，有针对性地进行科技攻关或者新技术的应用。

中心通过举办、赞助、参与科技或艺术类会议来促进技术和艺术的融合。中心在每个周五的下午都举办科技沙龙，邀请从技术到影视制作各方面的专家来讲座、交流，已经形成了一个比较常态的活动，形成了一个艺术与技术共生的社群。

欢迎各位未来给予更多关注，并踊跃参与中心的这些活动，积极加入我们这个社群中来，共同推进中国和世界的影像技术的发展。

谢谢各位！

Future Visual Entertainment: Will AI Pervade in the Field of Film Making?

▶▶ Chen Baoquan

Good morning! I am glad to attend the International Conference & Exhibition on Visual Entertainment (ICEVE) for the second time. I would like to brief you on the progress of scientific research made by the Beijing Film Academy's Advanced Innovation Center for Future Visual Entertainment (AICFVE) over the last year. The Center focuses on research and applications of globally advanced technologies. In the year since inception, AICFVE has set up a core technology team consisting of four first-tier principal investors.

I am going to introduce four key research fields: the first field is reality capture, which is the digitalization of presentation, the physical and physiological phenomena of scenes and people in the real world. Only after this can we edit, model and recreate the subjects. The work in this field is becoming the core technology of the future, the foundation of all digital creation and production. We have also been furthering our study of content production, for example, the generation of a new scene from a subject or a scene, with a high level of intelligence, which includes the automatic, lifelike projection of texture of a digital subject; the capture, inversion and simulate-editing of a physical phenomenon; deep understanding of a video, that is, deep analysis of its colors, its textures, geometrical objects and even the motion paths of them involved in the video and on the basis of that analysis, video indexing and editing our video composition.

The second field is intelligent display technology, with the aim of developing a compact, lightweight wearable display device with high definition, wide field of view and even depth perception, making VR displays more lifelike and convenient. As 3D films will gain further penetration in the future, the technology will play a bigger role. We have also been studying how to make experience more natural, comfortable, immersive, and enable efficient interaction through multiple channels, etc. when such a display device is used.

The third field is virtual production, where we study how to use robots for more accurate and efficient in film production. For example, how to intelligently place the cameras; how to

set lighting to confirm the location, direction, intensity and color temperature of the lights. In traditional filming, light setting can take a lot of time and effort, so we try to increase the efficiency.

The fourth field is digital content design and a PreViz (previsualization) platform development, which will provide new models for film creation and production and sharply improve film production efficiency and effect. AICFVE has frequently participated in film making as an innovation platform. Through cooperation with well-known directors, we have applied these technologies to the shooting of recent films, especially the previsualization process. The technologies have also been used in the design of large stage scenarios, such as the performance scenario preview and simulated training system used in the 2022 Beijing Winter Olympics, a project that was highly applauded by the Olympic Organizing Committee.

Digital technologies are comprehensively changing the process of creating and producing films. A host of avant-garde film directors, who had a good experience in working with us, hope to introduce more new technologies in their future films. Directors of the new generation are indigenous people in the digital era, who are ready to embrace digital technologies and will lead the future.

We should place what we do in the context of film history, and ask ourselves the question: where is film tech heading?

In its short history, film production has undergone several generations of evolution. From the image recording in the earliest days to the 3D imaging used in today's world, from the storytelling models to the content production, these techniques have changed significantly due to developments in relevant technologies. Next, I will give a brief introduction from several aspects of the film production process.

We know that the traditional film production process consists of creation, design, shooting and production, and post-production. Nowadays, every step in the process is becoming more intelligent. Take creation as an example, we can use artificial intelligence for creation or to help with creation. In terms of design, the generation of assets involves increasing application of digital technologies, with a higher degree of intelligence. AI application will increase in shooting and production, and even more so in post-production. Post-production will be increasingly integrated in the process of shooting and production, rather than being separated from it.

Next I am going to talk about the different steps in film making. In terms of play writing, there was an experimental science fiction film, Sunspring, whose screenplay was entirely completed by an AI bot. The bot read and learned a great many science fiction publications,

identified essential factors in writing a sci-fi novel, and created its own story, one that involves murder, love and other elements. The work is also played by human actors and won a prize. This is a unique attempt.

Of course, AI is more of an assistant in the actual process of play writing. Maybe some features of characters need to be designed by people, but the remaining details can be enriched by AI. The rapid generation of digital assets relies more on AI for high efficiency, since the traditional method can require a lot of human resources and materials. Today, the capture of a geometrical object and a movement, or the simulation of a dynamic phenomenon can all be enhanced using intelligent technologies.

For example, among the three animations we see, the left one shows the dynamic process of a real lotus leaf being moved by wind. We can digitalize the process through the digital capture technology, combined with the fitting of its physical process, invert some physical features of the object, and conduct a new simulation through the digitalization technology. That is to say, we can make such an object reborn, giving a new dynamic performance in a new scenario.

If we let wind blow on the lotus leaf from some direction, or let a water-drop fall on it, it will give a corresponding reaction according to its physical features. In this way, the whole process from capture to rebirth is completed by digital intelligence technologies. Designing and editing a human body, a face or a head can be quick thanks to intelligence technologies. What is displayed here resembles an artist's drawing (a draft) from which the computer immediately generates a corresponding three-dimensional geometry.

Endorsed by such technologies, artists may sketch a new image in a free and easy manner, and the three-dimensional geometry of the image can be generated accurately and quickly, allowing a new dynamic representation of facial expressions. Other natural phenomena, such as fluid, can be designed using intelligence technologies as well. Fluid computing involves highly complex physical models and a huge amount of computing. It is also the case with the simulation of movements in a large scenario along with the display of details, posing a great challenge to film making due to the need for high efficiency. AI can learn from phenomena that have already undergone analog computation, which will guide new physical simulation. For example, accurate physical simulation only takes place at a coarse level, but the display of the details can be simulated using what has been learned, so that the computing efficiency is increased.

Apart from physical phenomena, the movement of people or animals can also be trained and advanced through deep learning. An animation of a virtually designed animal hopping

over a ditch or a slope used to be controlled by humans, meaning a cartoonist had to design it frame by frame based on their personal experience, which was a tedious process. By utilizing AI's deep learning technology, we can learn from the movement data that is captured, or designed as animations, to realize adaptive movements.

Still, existing technologies are not advanced enough to replace human performance, but AI is making it increasingly possible. Post-production now needs more help from AI technologies. In the rendering of a large scenario, which requires a large amount of computing for a highly lifelike effect, the deep learning technology has sharply improved the efficiency. With deep learning, a true-to-life effect can be achieved without the need to compute the original shading model in full resolution. Post-production also deals with other physical phenomena, such as fireworks and fog, all of which can be simulated with a higher efficiency level thanks to deep learning. Such a technology is able to swiftly change a scenario, leading to changes in the whole area, boundary conditions and other elements of the physical model. When the traditional computing method is adopted, everything needs to be computed anew, but AI technologies have made great strides towards enhancing the computing efficiency.

Now let me go back to the AICFVE Our scientific research team has been exploring AI technologies in PreViz, content generation, online shooting and post-production. By searching for actual issues through continuous participation in film production, we will focus our efforts on achieving technological breakthrough or applying new technologies.

The AICFVE. promotes the integration between technology and art by organizing, sponsoring and attending technology or art meetings. The center holds a tech salon every Friday afternoon, where experts of technology and film production are invited to lecture and communicate. This salon has become a regular event that have given rise to a community where technology and art meet.

Your increased interest and involvement in these activities held by the center are highly welcome. I hope you will join our community in promoting the development of visual entertainment technologies in China and the rest of the world.

Thank you!

人工智能与影视制作主题论坛 | 未来影像 影响未来 | 13

童欣

从交互图形到智能图形

◎ 童欣

大家上午好！非常荣幸能有这个机会向大家展示一下我们在微软亚洲研究院最近所做的一些工作。在去年先进技术影像会议上，我给大家介绍了我们如何研发一些技术帮助大家更迅捷、更方便地来采集真实世界中的一些三维内容。那么今天我讲的是进一步的，即如何"从交互图形到智能图形"。

在过去的几年中，每个人都看到了VR、AR设备的普及。设备的普及也给我们大家带来了新的视觉享受和很多新的体验。比如说，我们可以让一个人坐在家里就能到另外一个地方去探索一个现实世界中很遥远的地方，有一个遥在的体验。

那么同样，我们可以用一些AR的三维内容来帮助大家做一些培训、学习，比如说做一个医学的培训；在工业制造设计中我们也可以通过AR技术让很多的人能够实时看到我们设计的内容，同时进行一些交互修改、多人协同。在一个复杂的工作环境中，我们通过一些AR的设备可以让不同的人协同工作，然后让在现场的人能够快速得到所需要的信息，并进行精细的和准确的操作。

为了使所有这些看起来非常激动人心的应用成为可能，我们需要一个非常高质量的三维内容。如果没有一个高质量的三维内容，所有这些应用都会大打折扣。但是就像去年我这张PPT所展示的，我们现有的这些三维内容的产生方式与过去的几十年相比其实并没有什么根本的改变，基本上是，我们的艺术家付出很辛苦的劳动以后，把这些三维内容传递给最终用户，让最终的用户享受这些三维内容。

童欣在ICEVE大会现场

Graphics Content Creation

Artist End user

三维内容的生产和传递方式在本质上和几十年前并没有差别

 我们再来看看他们所使用的工具。我们会发现，现在这些三维内容产生的工具对普通用户而言是非常难学的，比如造型软件可能需要我们的艺术家付出几年的辛劳，才能掌握这些工具，现有的捕捉设备基本上只能在一个专业的 studio 中得到使用，它们的造价也非常昂贵。

 在过去的几年中，我们也在探索如何通过一些智能技术开发一些算法来帮助大家快速地生成一些高质量的三维内容。我们想到的一个办法就是，通过智能算法加简单交互的方式代替一些用户烦琐的交互操作来做内容生成。经过几年的探索，我们觉得这是一条充满希望的道路。原因有以下三个：第一个是，因为我们现在有了一些非常便宜的设备，我们可以快速地获取部分三维可视内容，比如 RGB 相机和深度相机可以帮助我们获取一些深度信息，或者一些材质信息。第二个是，我们专业的艺术家和捕捉设备，在过去的这么多年中帮助我们产生了大量的数据，这些高质量的数据可以帮助我们从中学习到一些有关三维内容的模型。第三个是，最近几年机器学习方面技术的进步也会帮助我们更好地设计算法。

 基于这些已有的条件，我们提出一个解决方案，就是通过一些便宜的设备，加上一些比较聪明的算法，结合用户一些非常稀疏的输入，我们希望能够快速有效地生成一些高质量的内容。在下面的这个演讲中，我将展示一些我们在今年所做的三项研究工作。通过这三项研究工作，我们看看如何用这个解决方案帮助用户快速生成三维形状，产生材质和高质量的渲染结果，以及一些动画。

 第一项工作是 Bend Sketch。这项工作由我们组的刘洋、潘浩研究员带领我们的实习生完成。这项工作的目标是，假设我们的用户看到了一个非常漂亮的杯子，

Our Goal

- Help users to easily create free form 3D models from sketch/image

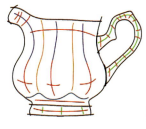
2D sketching
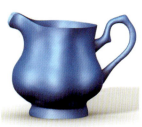
3D shape

用户可以很方便地将平面草图转化为三维模型

或者说他想设计一个这么漂亮的形状，那么他只需要在电脑上通过画一些非常稀疏的、我们叫 sketch 的线框、草图，我们的算法就会从这些草图出发，自动地帮他生成三维形状。

在这个草图中，大家会看到我们标记的一些线有一些不同的颜色，黑色的线代表了这个物体的轮廓，这些线我们是需要用户单独标出来的，里面的这些线代表了用户标记的形状的一些细节的起伏变化，这些线的颜色代表不同的形状，是我们的算法自己分析得到的。

我们的工作基于一个基础的概念，即我们非常擅于从一张两维的图片，或者一个草图中去识别一些三维的形状，特别是我们对一个曲面或一个表面的凸凹变化，尤其对它凸起了多少非常敏感，而且用几条线就能比较好地描述这个变化。

基于这个观察，我们的系统让用户画出这些曲线来告诉我们在这个局部的表面上这个形状到底凸起或凹下去有多厉害，这样的线我们叫作 Bend Line。那么大家看到，就像左边的（下页图），对一些变化比较大的地方、不连续的地方，我们也希望用户给我们画出一些线，画完线之后就形成大家看到的这个草图，即 sketch。有了这个 sketch 之后，我们的算法就开始工作了。

我们的算法要根据我们在这么多年中总结出来的几何的约束和一些几何的知识来自动地从这个草图中推断出三维形状。为此我们首先从这个草图中把这些曲线的类型识别出来，比如说，在用户画了这条曲线之后，我们要识别这条曲线中哪一段代表这个地方的形状是凸起的、哪一段代表这个形状我们觉得它应该是凹下去的。从这条线出发，我们进一步在这个二维图上形成一个方向场，根据这个方向场，我们把物体表面的法向恢复出来。最后根据法向，我们来恢复这个物体

Our Key Idea

- Human perception can easily recognize 3D shape from 2D image
- Human perception is sensitive to shape curvature variations

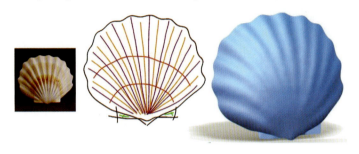

人类很擅长将平面图形认知成三维形状

的三维形状。

下面,我给大家演示的是一个我们实际系统的操作。假设你是一个普通的用户,在脑海中没有什么形象的时候,我们给你一张图,这个时候你通过笔,大家可以看到,先把轮廓描绘出来。我们就生成一个基本的平面并展示出来。这个时候你画了一条线,代表这个地方是不连续的。在这之后,大家看到你画了几条线,告诉系统说这个地方可能应该凸出来,我们的系统就会自动把这个表面变成凸出来的。当你觉得这个表面差不多了的时候,我们就可以利用一个对称性的原则很简单地把这个形状对称出来,然后这个鸟的形状就能很快地生成了(下页上图)。

我们可以再看一遍这个过程,大家可以看到,在这个过程中,其实用户的控制是非常便捷的,他所有的控制只要通过一些简单的草图就可以实现,而我们的系统会自动地帮助他快速地生成他所要的形状。这里我们展示了通过我们的系统帮助用户生成的一些各种各样的形状(下页下图)。大家可以看到,不论是靴子、贝壳,还是一个帽子,或者一个莲蓬,所有这些形状都可以通过一些草图自动生成,我们在完成我们的系统后,请了一些普通的用户,还有一些专业的用户,对其进行了评估。我们发现普通的用户经过大概20分钟的学习之后就可以快速地设计出一些比较好的三维形状。我们的专业用户使用之后也发现,这样的一个工具可以帮他们快速地做一些概念设计,生成一些比较理想的初始形状;然后,他们可以把这些初始形状导入专业的工具,进行一些细节的修饰之后,快速达到他们设计的目的。我们的系统对他们来说帮助非常大。

上面我们讲到了如何通过草图帮助用户生成三维的形状。下面来看一看,我

用户画一些简单的线条，就能帮助 AI 将图片生成三维模型

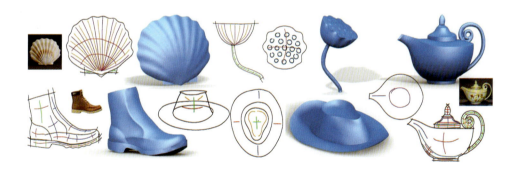

这个工具可以帮助用户快速进行三维的概念设计

们如何通过机器学习的技术帮助用户生成一些高质量的材质内容。这里面我们想做的工作是，假设用户给定一张图片，我们希望从这张图片出发，自动地生成一些物体材质的贴图。比如说，它的高光贴图、Diffuse 贴图和它的法向贴图。有了这些贴图之后，我们就可以把这些材质映射到任何一个新的虚拟的物体上进行绘制。传统中我们的艺术家每天都在做这个工作。但他们需要用各种各样的工具，比如说 Photoshop 什么的，再经过很多手工操作才能实现这个目标。那我们想做的工作是能不能用一些机器学习的技术代替用户这些烦琐的手工，自动地和快速地帮助用户实时地从输入图片生成材质贴图，同时我们希望这张材质贴图的质量至少能达到一定水平，用户或者直接使用，或者稍做修改就能够使用。为了达到这个目标，我们

希望我们能用一个现在大家非常流行的深度学习的技术来做这件事情。我们面临的挑战是什么呢？如果大家对深度学习稍微有所了解的话，大家会发现这里面一个巨大的挑战就是，为了让深度学习工作起来，我们需要大量的训练数据。

所谓的大量训练数据就是我们需要给用户提供的算法。我们需要提供成万对或者成十万对的输入图像和对应的真实的材质贴图。这件事情是非常难的，因为如果我们能够生成这么多的材质贴图，我们就不需要做这项工作了。我们的一个重要观察是，虽然我们没有很多这样的训练数据能生成，但是我们在真实世界中从网上能够下载大量的材质图像。假设我们在Internet网上搜索"wood"，我们就能获得大量的木头图片，这非常容易做到。

然后，我们发现另外一件很有意思的事情。假设我给了你一套材质贴图，而且现在的绘制算法已经足够好了，那么它们可以帮助你非常真实地生成一些高质量的图像。就是说，一个逆向的过程实际上对我们来说是现成的，那我们就研发了一个算法，希望能利用这些大量的从网上下载到的图片和我们的这个逆向的绘制过程一起来帮助我们做一个深度学习的训练过程（下页上图）。最后，帮助我们实现这个目标。这个工作是我们组的董悦研究员带领实习生完成的。这里我们展示了我们算法所生成的一些结果（下页下图）。大家看，最上面的一行是给定一张木头的图像之后，用我们的方法所生成的一个材质贴图，中间这行是假设我们不用我们的技术，只用一些少量的成对样本生成的结果。大家可以看到，高光的部分非常模糊，很多的细节都丢失了，木头很多地方的纹理也不太对。和下面的这个真实的材质贴图相比较，我们能看到我们生成的结果更加逼近于原始的、真实的材质贴图。

关于这个技术，我们现在也已经把它完全开源了，大家在网上就可以下载到我们所有的源代码，包括我们的工具，它们可以帮助大家做这项工作。关于这项工作，我们也非常感谢电影学院的叶风教授的帮助。这个另外的结果大家可以看到，针对不同的材质，不论是金属，还是塑料，还是木头，我们的方法都能生成比较真实的结果。

刚才我们讲到了材质建模的东西，最后我们来看一看动画。刚才陈宝权教授介绍了很多动画生成、物理模拟方面非常出色的工作，那我们想做更多的工作。我们不仅想生成虚拟内容，我们想，我们的计算机都这么发达了，大家做了很多虚拟的东西，我们想把虚拟的东西带到真实的世界中来。

在传统中这些制造和设计的过程是非常烦琐和艰难的。为什么呢？因为我们在真实的世界所做的所有真实的东西需要符合物理约束，这件事情需要很多计算和物理知识，一般人很难做到。我们最近所做的一个项目是希望能够帮助用户快速地设计软体机器人。这些软体机器人在真实世界中，大家可以看到，会有非常多的应用，这里展示了一些气动的软体机器人（第22页图），我们通过给这些软

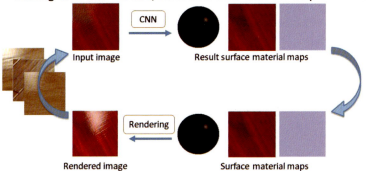

运用自主增强的神经网络来进行深度学习训练

体机器人充气，给定不同的气压之后，这些软体机器人就会做不同的变形，以便做各种各样的工作，比如说在管子中爬行、抓一些物体等。设计这些机器人需要丰富的经验和反复的尝试。我们所做的工作是希望用户只给定他想要的一个物体的变形，然后，我们的系统自动地帮助用户设计一个这样的软体机器人，我们把这个软体机器人打印出来，充了气之后，大家可以看到，它就可以自动地像左边的心脏一样做它的变形了，所有的过程我们希望是全自动的。这个项目是我们的张译中研究员和刘洋研究员带领我们的实习生一起完成的。

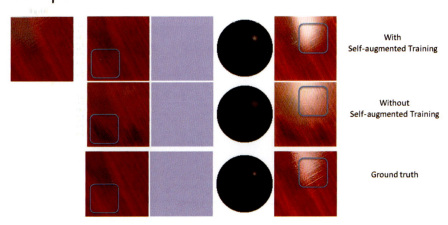

算法生成的结果更接近真实的材质贴图

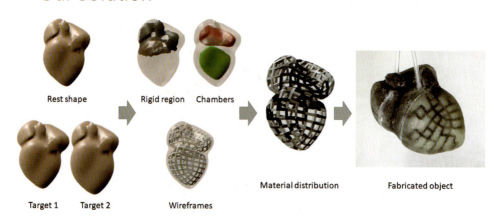

快速生成软体机器人的形状

这个逆向的设计过程实际上是非常困难的。在前段时间,我们做完了这项工作之后,和北航的做软体机器人的教授进行了交流。他对我们的工作非常感兴趣,因为在他的日常工作中,即使为了做一个最简单的,大家看到,像是抓物体的手臂这样的工作,也需要他的一个研究生反复尝试,尝试半年,甚至两年到三年来做这项工作。但在我们现在的过程中,我们只需要通过十几分钟的计算就可以自动地做这项工作了。

我们的方法很简单。用户提供一个形状,一个在自然状态下的形状,再提出一个目标形状。首先我们来算一算哪些部分不需要变形。那么这些部分我们就用最坚硬的材质填充起来。然后,我们的系统需要自动计算一下我们希望把气囊分布在什么地方,气囊应该长多大、什么形状。我们都把它们算好。

然后,在这个气囊外面,我们希望包裹一堆这样的线框,当我们的气囊充气之后,这些线框可以得到进一步控制,即朝哪个方向应该变形、什么方向不需要变形等。有了这个之后,我们下一步就需要对这些材质,即每个线框里面的材质,进行进一步的优化。在一些地方我们希望它们硬一点,这样充气的时候它们就不太容易变形;在另一些地方我们希望它们稍微软一点,这样在充气的时候它们的变形就会大一点。

通过这样的计算和优化之后,我们得到了每条线上的材质。最后,我们用三维打印机把这个东西打印出来,就得到了我们最后的形状。我给大家展示几个结果。首先,比如说我们想做一只青蛙。通过充气,它能做一个呼吸,即一鼓一鼓的动作。那么我们做了这样的一个模型出来。通过打印之后,大家可以看到,它可以在充气的时候自动地模拟这样一个变形的效果。同样地,我们也可以做一个

非常有趣的爬行小生物。我们希望在充气之后，它的四肢能够移动，能够做一个爬行的动作。

大家可以看到，这是我们做的一个结果，非常有意思。在充气之后，这个小动物的四肢和腹部就会自动变形。它可以在桌子上自动地爬行。然而，所有这些自动的过程在以前大家是不敢想象的。那么，现在我们有了三维打印机，有了强大的计算手段，用户只需要提供目标，告诉我们他想做什么，我们就能自动地帮助他实现目标。

通过算法设计出可以自动呼吸的青蛙

最后我总结一下今天讲的三项工作。我们看到通过一些我们设计的智能算法，我们可以帮助用户快速有效地生成一些高质量的三维内容。这里面的智能可能比大家现在喜欢讲的人工智能里面的算法定义更宽泛一些。我们讲的不仅是机器学习算法，也包含我们人类利用几十年、几百年所研发的这些几何、物理的知识，还包括我们研发的这些高端的、非常有效的物理模拟和物理计算的机制。当然，也包含我们最近所研发的一些机器学习的技术。

这些智能的算法有希望帮助我们，以及用户，快速地、方便地生成高质量的内容。这是好的方面。另一方面我们还看到，虽然我们有了这些工具，但我们要让一个普通用户生成高质量的三维内容，还有很多的工作需要做。我们也希望通过技术的发展，在五年或者十年后让大家像现在拍照一样容易地、快速地生成高质量的三维内容和图形内容，真正地享受这些内容给我们带来的好处。

我的报告就到这里，谢谢大家！

From Interactive Images to Smart Images
▶▶ Tong Xin

Good morning everyone! It is a great honor to have this opportunity to demonstrate to you what we have been doing recently. Last year, at the Advanced Technology Conference, I introduced how we researched and developed some technologies that facilitated the faster collection of three-dimensional images in the real world. Today, I'm going to give a talk titled From Interactive Images to Smart Images.

In the past several years, our VR and AR equipment has become more and more popular, which has brought new visual enjoyment to everyone who uses it. New visual enjoyment means new experiences. For example, with our help, someone who is sitting at home can experience another location, to explore a place far removed from reality, like a teleportation experience.

By the same token, we can use three-dimensional AR content to help people with training or studying. For example, we can use AR for medical training. At the same time, we can also use AR in industrial manufacturing. Many people can see our designed content in real time and carry out interactions, editing, and multi-person coordination. In a complex work environment, we can use some AR equipment to allow many different people to coordinate their work together and enable everyone present to collect information they need urgently, and carry out precise and accurate operations.

All these applications are scintillating. We have realized that to adopt these applications, we need high quality, three-dimensional content. Otherwise the applications will not be utilized to their full advantage. Just like what I demonstrated last year in the PPT, if we take a look at the method of producing three-dimensional content, we will see there hasn't really been any change. Basically, we require hard work from artists to produce three-dimensional content to be delivered to the end users, which enables end users to enjoy it.

Let's have a look at their tools. We will see that the tools used to generate three-dimensional content is quite difficult to learn for ordinary customers. Some of this modeling software may take several years of hard work for our artists to master, since they are complex tools. Current capture equipment can only be used in a professional studio, which can be very expensive.

In the past several years, we have been exploring some smart methods to develop tools to help everyone create high quality, three-dimensional content rapidly. We came up with

the idea of utilizing interactive smart methods instead of cumbersome operations. Now we realize these technologies are viable for the following three reasons: Firstly, we now have some very cheap equipment to facilitate our rapid, partial image capturing, for example, our RBG. camera and our depth camera can help us capture depth information or some other texture information. Furthermore, our professional artists, or our capture equipment, has helped us capture large amounts of data for many years. This high-quality data can help us learn certain laws of objects and models. Finally,in recent years, machine learning technology has also helped us work better in some areas.

Therefore, we hope to propose a solution that, by using some cheap equipment, on top of our smart algorithm, and some scattered input from users, will generate some high quality content. In the following speech, I'm going to demonstrate the three latest research projects. Let's have a look at how, through these research projects, we can take advantage of some intelligent methods to help users generate three-dimensional content texture and high quality rendering effects, and create some animated content.

The first project I would like to demonstrate is called *Bend Sketch*, which was conducted by our researchers Liu Yang, Pan Hao and some interns. The purpose of this project is clear. Imagine that our customer sees a beautiful cup, or maybe he would like to create a beautiful shape like this. However, we hope he will only need to draw some sporadic lines, or sketch and draft. Originating from this sketch, our algorithm can generate automatically a three-dimensional shape.

In this sketch, we can see different lines and different colors marked out by us. This black line represents the contour of this object. Our user needs to mark out this line individually. The lines inside represent the change of these shapes. These colors actually do not need to be marked out by users, our system will help users identify automatically the characteristics of these lines.

Our work is based on the fundamental idea that human beings are actually very good at identifying three-dimensional shapes from a two dimensional picture or a sketch. We humans are especially sensitive to a curved surface or concave-convex transformations of a surface, especially how prominent the curve is. The transformation can be described simply by using several lines.

Based on this observation, we hope to research and develop a system. In this system, users can use some of the lines drawn above to tell us how prominent the convex or the concave is on this topical surface by using these lines. We call this system Bend Line. Please have a look at the one on the left. With some sharp and discontinuous shapes, we also hope that our users can create by simply drawing some lines. Thus we have something here on the left. First we create a draft, a sketch, then our algorithm will start working.

Based on the geometric constraints that we have generalized from our years of work, the

algorithm will automatically identify the three-dimensional shape in this sketch using some geometric knowledge. What do we need first to achieve this? Firstly, we need to identify the types of the curves in this sketch. For example, after the user draws this curve, we need to identify which segments of this curve represent convex and which segments represent concave. We need to first do this identification. Starting from this line, we will further form on this two-dimensional surface a direction field. Based on this direction field, we will restore the surface to normal. Finally, based on the normal, we can restore the three-dimensional shape of the object.

Next, I'm going to show you a demonstration. Suppose you are an ordinary user and you don't have a clear idea of an image yet. We will give you a picture, then you can draw with a pen as a user. Once we have generated a basic flat area, here the user draws a line, representing a discrete segment. After this, our user draws several lines, which tell us this area should be convex. Then our system will automatically draw a convex line. When the user feels that the surface is ready, we can generate the symmetrical shape by mirroring the drawn shape using the principle of symmetry. Then the bird is generated aptly.

Let's have a look at this process again. As you can see, in this process, the user control is very easy. He only needs to draw some simple sketches as a matter of control and our system will automatically generate shapes for the users. Here we have demonstrated how to help our users to generate various shapes using sketches. Shapes such as a boot or a shell or a hat, or maybe a lotus pod, all can be generated using sketches. Since we developed the tool, we have taught some ordinary users to use it. Some expert users have also evaluated it and after about twenty minutes of learning how to use it, some ordinary users realized that they could rapidly and freely generate some really nice shapes. After using the tool, our expert users also realized that a tool like this could help them with speedy conceptual designs and generate some nice initial shapes. Then they could import these initial shapes to some professional tools for detailed modification in order to achieve their design purpose rapidly, which significantly helps them.

So we talked about how to help our users to generate three-dimensional shapes using sketches. Next, let's have a look at how we can utilize machine learning technology to help users to generate high quality texture. So what do we want to do here? What we would like to do is, say, imagine a user sends us a single image, we hope to be able to originate from this single picture some texture mapping automatically. For example, its specular mapping, diffuse mapping, and normal mapping. With these mappings, we can reflect these textures to any new virtual object for drawing. Our artists were doing the same traditionally, but they needed all kinds of tools for this, such as Photoshop etc., and they needed many manual operations to achieve this goal. What we would like to do is to find out whether we can replace all this

tedious work with machine learning technology, which will automatically and rapidly help users generate texture mapping in real time. At the same time, we hope that the quality of the texture mapping is up to a certain standard so that the user will say that the texture mapping is good enough to use directly. If it is not good enough, we hope the user will trust the quality enough that a bit of modification will suffice. We hope to reach this goal. So what kind of challenge are we facing in achieving it? We hope that we can use deep learning technology which is really popular right now to achieve this. If you know a bit about deep learning, you may know there is a huge challenge for deep learning to work, we need large amounts of training data.

The so-called large amount of training data is algorithms that we provide to our users. We need to provide tens of thousands, or hundreds of thousands of pairs of input images and real texture mappings, which is very difficult since if we were able to generate so many texture mappings, we would not need to do this at all, right? So, it is really difficult. We made an important observation though and that is we haven't such a large training data set, but we can download large amounts of texture mapping from the Internet in the real world, which is really easy. Suppose we search the word "wood" on the Internet, we will get large numbers of images of wood.

Then we discovered something else interesting. Say if we give you a set of texture mappings, our drawing algorithm is good enough that it can help us generate high quality realistic images. That means a reverse engineering process is at hand for us. So we have developed an algorithm and we hope our algorithm can utilize the large numbers of images downloaded from the Internet together with our reverse engineered drawing process to help us with our deep learning training process, and ultimately help us achieve our goal. This is done by our researcher Dong Yue and interns. Here I would like to showcase some of our end products: the top one row shows the texture mapping of given wood picture using our method; the middle row shows what it would look like if we only used a small client sample. You can see the quality in the highlighted area is very bad. The area is very blurred and many details are lost and the texture of these areas of the piece of wood are incorrect. Compared to the Ground Truth mapping below, we can see that our generated result is closer to the original, realistic texture.

Our technology is completely open. Everyone can download the source code on the Internet including our tools, to help people do this task. We are really grateful to Prof. Ye Feng of the Film Academy for his work. He helped us a lot in the process. This is another end product for different materials including metal, plastics and wood. Our method can help generate very realistic results in each case.

So we have talked about material modeling. Finally, let's have a look at animation. Prof. Chen Baoquan talked about his excellent work on animation and physical modeling, and we want to do more work in, but not limited to, virtual content generation. We thought

that our computers are so developed now, and people have developed so many new virtual technologies, that we would like to try and bring virtual objects into the real world.

Traditionally, manufacturing and designing processes could be tedious and difficult. Why? That's because real objects in the real world have to follow laws of physics. So it is very difficult, but what we are trying to do, we hope, is to make a soft robot in the project aptly named Soft Robotics. These soft robots have many applications in the real world (some pneumatic soft robots are demonstrated here). We fill these robots with air and set different air pressures, then these robots go through different transformations and do different kinds of jobs. For example, some will crawl in pipes and grasp various objects. But we hope to go even further. We hope that our users only need to define the transformation of one object, like the one on the left. After the transformation of this one object is defined, we hope our system will automatically help our users design a soft robot, and this soft robot will be printed using 3D printers and it will be filled with air. We hope the whole process can be automated. This project is conducted by our researchers Zhang Yizhong, Liu Yang and interns.

Then, as you can see, the reverse engineering process is very difficult actually. Earlier on, after we finished this job, we communicated with a professor on soft robots at Beihang University. He is very interested in our work, because in their daily work, even the simplest task, for example, like holding onto someone's arm, takes a graduate student half a year or maybe even two to three years with repeated attempts to achieve. However, our process only needs some calculations which takes a bit over ten minutes to automate.

Our method is very simple. First, we hope that our users will provide the shape in its normal state and then its desired shape to be transformed into. After we are given this shape, our algorithm will calculate which parts will not need to be transformed, which areas will be filled with the hardest materials. Then our system will automatically calculate where we need to place the balloons, how big these balloons need to grow and what shapes. We will calculate them all.

Then we hope to lace the balloons with wires. These wires will help us control our balloons after they are filled with air to determine their transformation directions. After this process, we will need to optimize the materials laced in these wires. Some areas need to be tougher so that they won't deform when being filled with air. Some areas need to be softer so that they will be larger in the transformation process when being filled with air.

After calculation and optimization processes, we can determine materials on each wire. Finally, we will print the object with 3D printers. We have our final shape. Let us show you some end products: if we want to make a frog, which will simulate inhaling and exhaling movements through an air pump after we have made the model, then you can see the simulation with the transformation automatically animated of it being filled with air. Similarly,

we can make a very interesting crawling organism, and we hope after pumping air into it, its limbs can move and make some crawling movements.

So this is the end product. Very interesting. After pumping air into it, the little animal's limbs and torso will go through automatic transformations and it can now crawl on the table. All these automation processes were beyond people's imagination in the past. Now we have 3D printers and through our powerful calculations of our computers, users will only need to give us their goals, and we will be able to help our users to achieve their goals automatically.

Now let's summarize the three projects we talked about today. We talked about a smart algorithm that can help our users generate high quality, three-dimensional content. The intelligence I'm talking about here has a wider meaning, it is more than just artificial intelligence. I think it also consists of accumulated knowledge of human beings for decades and hundreds of years, including knowledge on geometry and physics as well as these cutting edge and effective physical simulations and physical calculation mechanisms that we have developed. Of course, also included is the machine learning technology recently developed by us.

All these technologies and intelligent algorithms can help us and our users rapidly and conveniently generate high quality content. This is one side of the story, the good side. However, on the other side, we have realized that although we have developed these tools, we are still some distance away from enabling an ordinary user to generate high quality three-dimensional content easily. There is still so much work to be done. We hope that through our technological development, we will enable everyone to generate high quality, three-dimensional content and images in a method that, within five to ten years, is as easy as taking a picture. Users will truly enjoy the benefits brought by these images.

That's the end of my talk. Thank you.

李文新

当人工智能遇上电影

◎ 李文新

各位早上好。在我看来人工智能和影视这种跨界的合作、互动有两个基本的前提。第一个前提是要彼此看见，像今天一样，我们能面对面；另外一个前提就是对话有共同基础，彼此说话得互相听得懂。可是对我来说我基本上是不懂电影的，好在做科学研究的人最大的一个特点是喜欢挑战，尤其是挑战自己，所以我就定下心来在这一个月里面疯狂地看电影。因为我看的所有电影都是跟人工智能相关的，所以我就说几句我看的这些电影。

我们做研究一般总会有一个逻辑。我今天关键想说的就是三和四。未来电影，是关于不存在事情的，不存在就可以开脑洞，随便想随便说。我看了这么多电影就在想一个问题，关于未来，科技的发展我们的期待和恐惧是什么？

在说这两个话题之前，我想先介绍一下背景。我还是看过一些电影的。三十年前，就是八十年代，我在北大上学的时候周末没有事情，一年级、二年级看电影，三年级去舞会，四年级跳到了一个男朋友，然后就两个人去看电影、去舞会。我看了那么多场电影，其实三十年之后，我只记住了三个画面。一个是《魂断蓝桥》，在火车站，女主角看见男主角的画面。那整部电影我都忘了，我就记住这一个画面，因为那种喜欢的感觉还在。我记得当时男主人公说："你怎么知道我今天回来？"

第二个是《合法婚姻》，我记住的是其最后一个画面：一辆有轨电车定格在那里，字幕说，男主人公阵亡了。在那一刻，我觉得电影全篇都是铺垫，就为了等待这一张阵亡的通知书，所以给我留下了非常深刻的印象。第三个是《血洗乐园》，大家应该都看过，这个电影在美国叫《西部世界》，这是我迄今看到的最好的。包括我最近疯狂看的人工智能电影里面，没有一部电影能超越这部电影，在一个研究人工智能的 IT 女教授的眼里，没有一部现在的电影能超越这部电影。关于人工智能的想象、画面，还有感动，这个画面给了我深刻印象。我摆这几张就是想知道电影到底是什么、我为什么要花时间来看电影。

我想说无论现代科技怎么发展，一个动人的故事永远是最重要的。后两次特

电影《魂断蓝桥》

电影《她》

别密集地看电影其实都是为了我要做的工作。十年前我在开设"生物特征识别"课的时候，我本人正在研究生物特征识别，就是掌纹、指纹、人脸识别，尤其是做手指静脉、手指皮下血管的分布图，根据这个图来识别你就是你。现在人脸识别是很火的。我们也做耳朵等。再说，我开了"生物特征识别"这门课后，我觉得枯燥地讲这些内容可能很难吸引学生的注意力，所以我就拼命地看了很多科幻电影，从中去寻找跟生物特征识别相关的镜头，结果就是：《史密斯夫妇》的第26分钟20秒有个语音识别的画面，《碟中谍》的第11分钟有个虹膜识别的画面，《真实的谎言》的第20分钟38秒有个扫描身体和手掌融合的画面，《国家宝藏》的第37分钟有个指纹识别的画面，《极限特工2》的第2分59秒和第1小时17分的时候分别出现手掌和虹膜的画面，等等。所有这些电影都是外国的。我觉得没有看过特别好的中国科幻片。这次我也看了一些电影，包括《人工智能》《我，机器人》《机器姬》《她》，后面几个不一定是人工智能的，有点关系，但没有那么大关系。

《人工智能》这个电影，我自己的观感就是人对机器产生感情还是有可能的，因为你买了一个毛绒玩具都会爱不释手，但是从人工智能发展的现状和对它未来的预测来讲，我对这个电影的结局是不太满意的，我觉得这个结局太悲观了。

《我，机器人》，我对它的观感是，其实机器人没有那么可怕，但是科技的发展可能会产生这种生物和机械的结合体，这个倒是很可怕的，因为我们可能很难

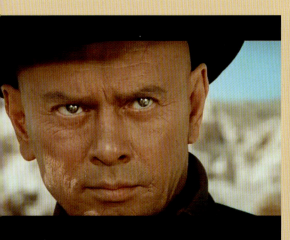
电影《血洗乐园》

电影《我，机器人》

判断一件事情该做还是不该做，这个人该杀还是不该杀则基于各种伦理道德考量，这还只是一个手臂是机械的，如果脑子有一半是机械的呢？如果有植入芯片呢？在我的眼里，这件事情比纯粹机械的机器人可怕得多。我要大大地吐槽一下这个导演，不论他是出于何种考虑，是他使发明机器人的科学家跳楼了，我看到好几部电影都在让人说研究机器人的科学家该死这件事，我非常想吐槽这一点。

总之，这个电影没什么情节。《机器姬》的导演再次让开发者和测试者统统都死掉，在我看来这是一个非常邪恶的结局，是一个不利于科学发展的结局。

《她》这个电影主要是说语音识别，还有自然语言理解技术的发展会导致一个什么样的未来。从技术上我个人感觉是可以做到的，不过未来的走向我可能想说这要看人类的选择，我想赞一下这个电影，我觉得含金量非常高，它虽然没有什么人工智能的画面，但是我觉得它的文化内涵比较丰富，我还是挺喜欢它的。

我想重点说说畅想。未来，肯定是现在不存在的，所以可以随便想一想、说一说，就是在我这两次特别密集地看电影的过程中，我非常强烈地感觉到视频或者是电影的搜索是一件非常困难的事情，至少是现在可以改进的一件事情。我想如果要动手做的话，我会特别需要一个自动的提取软件，看完电影之后可以把有故事情节转折的画面自动剪辑出来，配上一些简短的文字，这样的话我就不用每个电影都花两个小时看，我可能三五分钟看一部电影，也可以选择我在哪个电影

里投入更多的时间。这么多的电影，如果我想有个宏观认识的话，可以用人工智能的方法做一下自动的聚类、分类、情感上的分析、线索上的分析、科技含量的分析，这些都是可以用人工智能的方法自动做的，我觉得是值得做的。

关于电影院，我们现在都是肩并肩地坐在屋子里，现在去看三维电影会发给观众一个眼镜，大家也很自然地接受了这个眼镜，在我看来眼镜上还可以装更丰富的传感器，我们现在只是看到了三维的感觉，其他的或者说手镯、座位什么的，都是可以加一些人为的电信号的刺激或其他的刺激，让你看电影的时候扎一下自己就会感到痛，或者直接给一些脑电波的刺激，那么你就有更高维的电影可以看。还有就是我们电影院里如果通过眼镜加入一些无线传感器，就可以把影院里观众的体验收集到，你会知道这部电影在放映的时候有多少人心跳加剧，或者说在哪一分钟哪一个画面观众会感觉比较感动等，反正你都可以想象。这个其实从目前的基础上来讲并不难做，在眼镜上加一点功能，把它连起来就可以了，那样的话你就可以知道不同的人群不同的影院里观众的感受。

我们为什么看电影？在我眼里它更多的是一种社交方式，情侣可以一块儿去看电影，或几个朋友、同学聚会去看电影，很多情况下很多人看电影是为了跟亲近的人在一起，那么也许可以增加一些互动的方式。我们戴上一个眼镜，可不可

关于未来，人类有怎样的期待与恐惧？
纯属个人观点

- 非生命的机械机器人没有想象的可怕
- 可怕的是半生命半机械或者新生命物种的产生
- 计算机的发展正在加速其他基础学科的发展
- 民用的研究总是要治愈现实的痛苦，并且是有监督的，而军用的研究是不可预知的
- 科学家只是对未知领域进行探索，探索的核心目标是更好地认知世界并使事情变得可理解和可控制，商人和政客才是确定科技应用走向的关键
- 高科技只提供展示的手段，电影的核心依旧是动人的故事

关于未来，人类有怎样的期待与恐惧？

以有一个分角色的电影，不同的人看到的是不一样的，几个朋友或情侣看完后，再对一下，这个故事情节就完整了。我想这在技术上是可以做到的。

还有就是我看一部电影的时候，可能想演其中一个角色，但是这个电影已经拍好了，我可以把我的脸贴在某一个角色上，我不知道这在版权方面有没有问题，但是我也想当一个女主角，至少先当个女配角，那我想把我的脸贴到上面，这在技术上是不难实现的。我们每个人可以看一个自己版本的电影，或者说我不贴我的脸，也可以贴一些我喜欢的明星，这样我们每个人可以看不同版本的同一部电影，我想这应该是可以做的。

还有就是电影院现在都是一排一排坐的，不一定很舒服，也许未来可以有不同的场景设置，可以有一个桌子大家围坐，三维电影主角可能还可以走出来在你耳边说话，我想这个在技术上都是可以实现的，也就是说有个桌子或者有张床。总之电影院还可以舒适一些，不一定大家非得一排排地坐在那儿。而且也许你还可以成为电影里的一部分，坐到一个桌子上，这个影院桌子的场景可以到另外一个影院里面变成它的一部分，总之未来都是可以想象的。

刚才我已经说过，我觉得非机械的机器人其实没有多么可怕，我记得在看《血洗乐园》(《西部世界》)那部电影的时候，有个朋友是个中文系的妹子，因为我看完那个片子特别激动，觉得特别好，可是她说特别不好、特别假，说那么全能的机器人泼一下水就不行了。我当时特别愕然，觉得这是学科的分界线。一个简单的道理，一物降一物嘛。就像谈恋爱，A喜欢B，B喜欢C，C又喜欢A，这很正常。所以任何强大的个体，都有它的软肋、弱点。在我看来纯机械的没有那么可怕，但是半生命的或者是新物种就不一样了，因为计算机现在渗透到各行各业，包括生命科学、现代物理、材料、化学的研究，加速了这些基础学科的发展，很有可能会产生新物种，那么怎么看待这个新物种？我们人类会被这个新物种取代，那才是可怕的。纯粹的机械没有那么可怕。

还有，民用的研究目的主要是治愈现实的痛苦，并且它是有大众监督的，大家还都在公共的场合去说，因为你要兜售，而军用的研究才是不可预知的。我们不知道的东西才是可怕的。其实，科学家对未来的探索，他的核心目标是要认知世界，并且使世界变得可控，这是一个基本的目标。当这个技术被用来获取权力或者说进行利益的交换时，它才变得可怕。最后一句话，回到电影，我依然觉得电影的核心应该是动人的故事，而不是技术。

好，谢谢大家。

When AI Meets Film

▶▶ Li Wenxin

Good morning, everyone. When we're talking about the cooperation and interaction between AI and the film and television industry, there are two preconditions, from my point of view: firstly, we need to see each other, like we do today, where we can talk face to face. Secondly, a common ground is required for dialogue so that we could understand each other. Although I knew little about film, I, as a science researcher, love to take challenges, especially when the objective of the challenge is myself, therefore, I devoted myself crazily to watching films during the last thirty days. All these films were AI-related, and I'd like to talk a little bit about them in my speech.

Generally, there always was a logic through our research process and today my speech will concentrate on the third and fourth point. Future films are about things that are not existing, which means one can have an unbounded imagination and say whatever he thinks of the future and what it would be like. For me, there is one question that I have after watching so many films, which is, as far as the future is concerned, what is our expectation on the development of technology and our fear of it?

Before these two topics, I'd like to tell you some background stories. As a matter of fact, I did watch a few films, although that was thirty years ago. Back in the 80s, when I studied in Beijing University, we didn't have classes during the weekends, so I spent these days watching films, only during my freshman and sophomore year. I did this instead of going to dancing parties during my junior year. Until the senior year when I met my boyfriend at a dancing party, we two watched films and went dancing together. Thirty years have passed, and out of those many films that I'd seen, there are only three scenes I can remember. This is the one from *Waterloo Bridge* when the heroine met the hero at the train station. This is the only scene of the entire film that I can remember, because my deep fondness of it is still there in my heart. "How did you know I was coming?" asked the hero.

The second scene is the last scene of *Legal Marriage*. It ends with the trolley car disappearing into distance and the subtitle says that the hero died in battle. At that moment, I felt that the entire film was the groundwork set for this notification of his death. I was deeply impressed by this scene. I believe you have seen this one that was called *Westworld* in America, which is the best of all those AI films that I've seen, including these ones that I've seen recently. No film can surpass it. Yes, in a female AI professor's eye, not any of today's films can surpass

this one, which presented its rich imagination on AI, delivered excellent images and deeply moved the audience. This scene left a great impression on me. The reason why I showed these pictures here is that I am trying to figure out what film is and why I shall spend time watching a film.

From my point of view, no matter how the modern technology develops, a beautiful story is always of the most significance. My last two intensive film watching periods were for my job actually. Ten years ago, I set up a course named *Bio Metric Feature Recognition* because I was specializing in bio metric feature recognition, that is to recognize a person through his palm print, fingerprint, face and in particular, the distribution diagram of his finger vein and subcutaneous blood vessels of his fingers. Human face recognition is popular at present, but we also do research on recognition by ears and such. Although the course had been set up, it was hard to attract the students' attention on the content of them if you give lessons in a boring way. For this reason I watched a lot of scientific films with all my efforts to look for shots related to *Bio Metric Features Recognition*. Here is what I've found: at 26′20″ of *Mr. and Mrs. Smith*, there is a scene of phonetic recognition; at 11′ of *Mission Impossible*, there is a scene of iris recognition; at 20′38″ of *True Lies*, there is a scene of body screening and merge of palms; at 37′ of *National Treasure*, there is a fingerprint scene; at 2′59″ and 1h17′ of *XXX 2*, there is a palm and an iris recognition scene separately; and so on. All the films mentioned are foreign films and I don't think I've seen some Chinese scientific films that are fairly good. For this time, I've watched a few films too, including AI, *I Robot, Ex Machina, Her*, the last few of which might not be exactly about AI but could be related to it although not that much.

As for the film, AI, what came to my mind is that it would be possible for humans to develop feelings for machines, in the same way as you would be too fond of a stuffed toy to let go of it. However, if I'd say something from the perspective of current state of AI's development and prediction of its future, the ending of this film is too pessimistic to be satisfying.

Next is *I Robot*, from which I'd developed an idea that robots are not as terrifying as the combination of living creatures and machinery, which might be a product of the development of technology. The latter is terrifying because we could hardly make decisions on moral and ethical conundrums, like whether to do one thing or not, or whether the person should be killed or not. In this film, there is only one arm mechanized, but what if half of the brain becomes mechanized? What if the brain is implanted with a chip? To me, this is much more terrifying than completely mechanical robots and I have to complain of its director who, in consideration that they had the scientist that invented robots, jump off the building in the film. I've seen several films saying that robot scientists should die and I'd like to express my disagreement with this kind of idea.

Briefly, this film has a thin plot, but, the director of *Ex Machina* set the developers and test

engineers of robots to die in the film, which in my opinion is an evil end and not beneficial to scientific development.

Her is mainly about phonetic recognition and what the future would be like led by the development of natural language understanding technology. From my point of view, it's possible to realize that technically but where would the future go all depends on how humans choose. I'd give it a thumb up because despite of limited AI shots in it, the film has terrific content and rich cultural connotation, and I enjoy it very much.

Next, my speech is mainly about some of my thoughts on future films. Future, which has not existed yet, is open to unbounded imagination and discussion. During my last two intensive film watching times, I felt strongly that searching for a certain video or film is quite a complex process, which could be improved at this stage at least. I think an automatic extraction software is highly needed to edit all the turning points of the plot automatically and attach some brief words, if so, I can finish a film within three to five minutes instead of two hours, and I can decide in which film I should invest more time. If I'd like to have a macroscopic understanding on these films, AI technology can help us realize automatic analysis of cluster, classification, sentiment, clues and technological elements, all of which can be analyzed by using AI technology and are worthwhile in my opinion.

As for cinemas, we sit inside them side by side when watching films. They offer 3D glasses to the audience for 3D films and we accept these glasses as a matter of course. To me, more diversified sensors could be installed on these glasses. For now, we've only seen the 3D effect through our eyes, but films of higher dimensions could be realized by artificially applying simulations of electrical signals, or other kinds on bracelets or seats, through which you could feel prickled by triggered signals or brain wave stimulation during the film and we can add wireless sensors on these glasses so that we can collect their experiences and the statistics on how many of them had accelerated heartbeat, which scene at which minute had moved them most, or other factors that you could imagine. It's not hard to achieve this on the basis of what we've developed. Adding a few more functions to the glasses and getting them linked with certain facilities, we could know how the audience of different patterns feel in different cinemas.

Why do we watch films? In my opinion, to watch a film is more like a way of socializing. One can go to watch a film with his/her lover. Friends or classmates can watch a film when they are having a get-together. In many cases, people watch films for having an intimate time with those to whom they have been close, hence a few kinds of interaction could be added, for instance, if we make one film into several versions by separating the roles, so that one can see, with glasses on, a film that is different from what his/her lover or friends would see. Piecing together all these versions, they'll get a complete plot. I think this can be realized at the technological level.

Or, I might want to play a role in the film that I'm watching, but unfortunately, it has

already been produced. So, I wonder if the face of a certain role could be covered by mine. I am not sure if doing so would cause a copyright issue, but a supporting role will do if the leading role is difficult to get. From my point of view, covering the face of the role with mine is not that hard to achieve at the technological level. As thus, each of us can see a tailored film, with one's own face in it or that of some star that you like. I think this idea, that each person can see the same film but in different versions could be realized technically.

In cinemas, the seats are all set in row after row and the audience might find this uncomfortable when watching films. So, cinemas may have different seat arrangements in the future, for example, introducing a table where people could sit around. What's more, the roles of 3D films could even walk out of the screen and talk to your ears. I think this could be realized technically as well. With a table or a bed, cinemas could be more comfortable anyway, and there is no need to sit in the seats row after row. Maybe, you could be a part of a film or you could sit on a table, and the scene on this cinema's table could move to another cinema and become a part of it. All in all, everything about future could be envisioned.

As I've said earlier, I think non-living mechanical robots are not that terrifying. I remember when I'd finished watching *Westworld* and got very excited because I thought that film is terrific, a female friend, who studied in Department of Chinese Language, said it was terrible and fake. She asked, "Why not pour some water on those seemingly all-around robots?" I was astounded. Maybe this is the demarcation line of disciplines. Simple truth: everything has its vanquisher. It's like when people have feelings of romantic love. A likes B, B likes C but C likes A, which is common. Any strong individual has its Achilles' heel or its weakness. From my point of view, completely mechanical robots are not that terrifying, but it will be totally different if there appears a semi-synthetic body, or a new species, that is likely to evolve with the development of fundamental disciplines accelerated as computer technology has been widely applied in various areas of research, including bio-science, modern physics, material science, and chemistry. So, how should we treat this kind of new species? That we humans might be replaced by this new species is the most terrifying. Completely mechanical is not that terrifying.

Furthermore, the goal of civilian research is mainly to cure the pain of reality. The civilian research is supervised by the public because you have to speak in public places if you want to promote them, whereas military research is unpredictable. The unknown is terrifying. In fact, the core objective of scientists' exploration of future is to know the world, and to make it controllable. Technologies would be terrifying only when they are used for acquiring power or exchanges of interests. Lastly, back to film, I think the core of a film should be a beautiful story rather than techniques.

That's all. Thank you.

International Conference &
EXhibition on Visual Entertainment

2017 ICEVE 北京国际先进影像大会演讲集

虚拟现实影像内容主题论坛

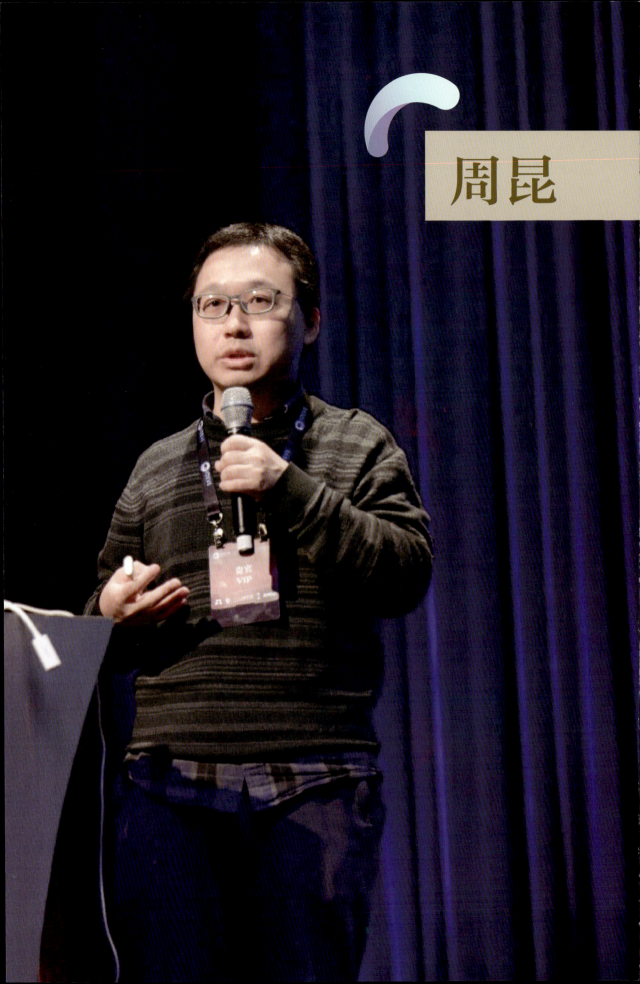

周昆

计算机图形学 2.0：由终端用户生成的 3D 内容

◎周昆

大家好！非常高兴有机会能到北影做交流。这是我第二次到北影。我今天报告的题目是"计算机图形学2.0"，副标题是说我们的目的是由终端用户生成的3D内容。

大家知道，计算机图形学狭义上说是用计算机来生成的一些视觉特效，包括图形、影像、电影这类东西。所以计算机图形学主要研究三部分内容：建模、动画和渲染。建模做的事情就是在电脑里构建一个3D场景、一个模型。然后除了静态的部分之外，我们还要做动态的部分，就是动画。最终用渲染生成这样的一些画面。

在计算机图形学的早期阶段，哪怕是在今天，绝大部分研究都是围绕这三个核心问题。我们会做出很多这样的工具和软件让艺术家、设计者去使用，用这些工具和软件制作电影、游戏，最后成为普通用户消费的内容。但是普通的用户和内容创造本身并没有直接的联系，所以我们把这个称为1.0阶段。这个1.0阶段是类比于以前在互联网早期阶段的Web 1.0。大家知道Web 1.0是指互联网早期的新闻网站、门户网站时代，普通人只是去观看、浏览由这些网站的专业编辑生成的一些内容。

我今天要讲的2.0同样也是类比于我们现在的Web 2.0阶段。在Web 2.0阶段，互联网上的绝大部分内容都是由普通人创作和分享

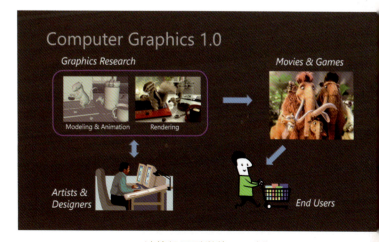

计算机图形学的 1.0 时代

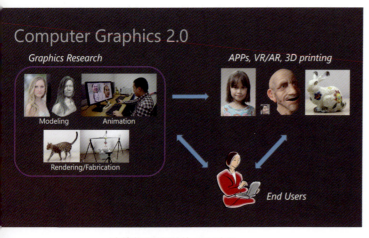

计算机图形学的 2.0 时代

出来的。在这个阶段，我们的图形学会继续做一些研究内容，包括建模、动画和渲染，等会儿还会讲到制造。这些研究会做出很多的软件、很多的工具，直接给终端用户，给普通人去用。普通人用这些工具和软件会创造很多内容。这些内容会在比如说移动APP、VR、3D 打印里直接得到运用。所以在这个时候，大家看到，内容创造中产生内容的主体变成了普通用户，而不再是专业用户。

如果说过去是 PGC，专业生产内容，今天就是 UGC，用户生产内容。目前已完成了这样的一个变化。

这件事情讲起来可能有点抽象。接下来，我会举三个例子。用三个例子来看一下在计算机图形学 2.0 这个阶段我们在做一些什么研究：第一个例子是数字化身；第二个我们讲室内场景的建模；最后我们讲一个与 3D 打印相关的工作。

第一个案例是数字化身。我们是想做这样的一件事情，就是在移动智能手机上创造逼真的数字化身，这些数字化身可以跟普通用户进行一些互动。大家知道数字化身在 CG 电影里已经非常普遍。我们在电影制作中用很多方法来捕获演员面部的表情，然后把这些捕获到的面部表情作用在虚拟角色上。

除了角色的面部表情，还有头发，这在 CG 电影里同样非常重要。但不幸的是，不论是面部还是头发的建模和动画，都依赖于一些专业设备和复杂的计算，这就使得我们在交互应用中很少看到真实的脸部动画和头发。比如说在很多 VR 社区或者游戏里面，我们看到的表情都是非常呆滞的，表现力是不够的。头发也只是用一些非常粗糙的多边形来表示。

我们在 2011 年、2012 年开始尝试做这件事情，先是解决脸部的问题。我们想做一件什么事呢？就是使用一个普通的 Web 相机，几百元钱就能买到，任何一个用户只要进入这个相机的视线范围，

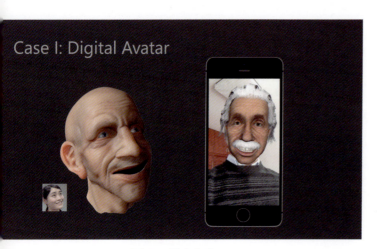

案例 1：数字化身

就会被捕捉到,而且不仅是二维的特征点,包括三维的几何形状,都可以被实时地捕捉到,还可以知道他的面部表情到底是什么。然后再把这些表情的参数和头部运动作用在任意的一个数字化身上,这样就能实时生成一个数字化身动画。这就是我们想做的事。

而且我们希望它应用的范围不止是在电影工作室、动画工作室,我们希望它能应用在任意的环境,特别是在移动手机上。比如说网吧的应用环境,房间里的灯全部关掉了,基本上脸只是被屏幕的光打亮。或者说在户外,太阳光可能直射,会有阴阳脸。不管是在什么样的极端条件下,我们希望这个算法都会做得很好。所以我们从 2013 年开始,2014 年、2015 年、2016 年,连续做了四年来解决这个问题。

那头发怎么办?大家知道头发的建模在 CG 里面是一件非常困难的事情。需要很熟练的或者非常有经验的一些建模师才能做好。我们怎么解决头发建模的问题呢?我们直接从图像,特别是单幅图像里面用机器学习的方法把 3D 头发,把每一根发丝计算出来。

这是我们 2016 年在 SIGGRAPH 上做的一个例子(下图)。左边是一张人像照片,右边是全自动计算出来的头发 3D 模型。在计算机上,我们只需要一分钟的时间就可以完成所有的计算。而且这个头发其实是 360°都可以旋转的,不只是有正面的部分。这是算法做的一些例子。不管是对长发,还是对这种非常具有挑战性的非常短的头发,我们都可以做出非常好的效果。

除了建模静态的头发之外,我们还需要做头发的动画,也就是头发的动力学仿真。头发的动力学仿真大家知道是非常难做的事情。因为一个正常人的头发超过十万根,十万根以上的三维曲线在空间中的碰撞、摩擦、相互作用是一个非常耗

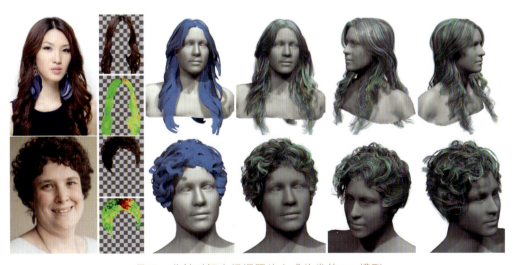

只用一分钟时间来根据照片生成头发的 3D 模型

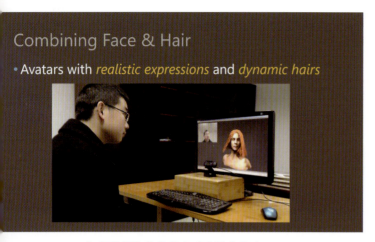

包含面部和头发的全动态数字化身

时的计算。所以我们在 Maya、3D Max 这些软件中所做的头发解算是一件非常耗时的事。为了解决这个问题,我们在 2014 年的时候设计了一个方法来实时地进行头发运动的解算。

最终我们把脸跟头发合在一起,就能做全动态的数字化身。在这样的例子里面,大家看到一个用户使用一个普通摄像头,数字化身头部的运动、脸部的表情都是跟随着用户,同时头发的动力学仿真也是在实时计算。这样一件集实时的脸部动画、头发的动力学仿真以及实时渲染于一体的、能在 PC 上做到实时互动的事情,也是我们第一次做到。

这就是我要介绍的第一个例子,数字化身,对人的建模。第二个例子是室内场景。我们希望做一件什么事情呢?大家知道我们现在已经有消费级的深度相机,可以扫描周围的环境得到一些点云。但在很多应用里光有点云是不够的,我们希望得到具有语义的三维模型。这样在 VR 等应用里面,才可以真正地把这些模型应用起来。

这个研究的背景就是消费级深度相机的普及,比如说微软的 Kinect,英特尔的 RealSense,以及 iPhone X 上的深度相机。2018 年第二季度可能大部分的安卓手机上都会有深度相机。有了这个相机之后,你可以去扫描周围的所有东西,把身边的东西都数字化。这样可以得到非常多的三维数据,但是所有这些三维数据都是原始数据,只是一些点云,是没有语义的。有一些研究方法用平面和距离场这样的方式来表达这样的几何形状。但这些没有语义的模型实际上是不适合图形学中很多应用的,比如说 VR 应用。

所以我们就在想,如果要根据扫描出的点云数据,生成一个语义模型的话,到底要做一个什

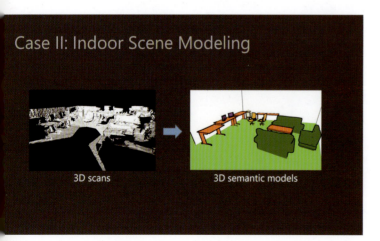

案例 2:室内场景建模

么样的算法。这就涉及图形学和视觉的结合，需要去做物体识别，做语义分割。我们在 2012 年的时候就开发了一个简单的方法，一个离线的方法。

它是一个什么样的流程呢？用户拍一张照片，我们会对拍到的深度图像结合颜色的信息去做语义分割，分割完成之后我们会到一个三维模型数据库里去找匹配，找到跟分割区域最匹配的模型，然后把这个匹配的模型做一

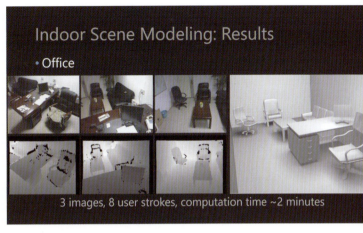

基于 3 张照片用两分钟计算时间完成的室内场景模型

个形变，使得它跟输入的深度数据最为匹配，最后就可以构造出一个三维模型出来。

那如果场景比较大怎么办呢？你就要拍好几张照片。前一张照片和后一张照片之间需要有一定的重合度，这样才能有一个全局的定位。你可以不停地拍，拍完之后就可以把场景构建出来。比如说这是我在浙大的教师办公室，十几平方米大小。我们拍三张图像，用户做一些简单的交互，整个计算、交互时间大概 2 分钟就能构建出上面这样一个三维场景。

这样离线的方法存在一个问题，就是说，你不停地拍数据，拍完之后不能马上看到结果。等拍完了一圈数据之后，回去用这个软件计算出来，你可能会觉得得到的这个模型不够好，需要重新回去补拍数据，这就非常痛苦了。

所以 2015 年的时候我们又做了一个在线的方法。在线的方法可以做什么事情呢？你一边扫描数据，一边看构建出来的场景，这样就能得到一个干净的模型。用这样的方法，可以一边扫描一边看结果。它的好处就是，如果觉得结果不够好，就继续多扫描一会儿。如果觉得结果已经够好了，那么可以快速地把这块区域跳过。这是在线方法的好处。

我们介绍了一个离线方法和一个在线方法，这两种方法各有优缺点。离线方法的好处是，你不用拍视频，只要拍一些离散的图片，但坏处是看不到生成的结果，需要拿回家之后才能算出来。在线方法的好处就是你一边扫描一边就可以看到结果，但在这个过程中你需要一直拍视频。所以这是两种不同的方法。这是我在浙大大概 100 平方米的实验室，这个实验室整个扫描下来大概需要 70 分钟，可以构建出一个 3D 的带语义的场景。这是渲染出来的结果。这是我讲的第二个例子，室内场景的建模。

第三个例子我想讲一个与 3D 打印和智能制造有关的工作。这个例子的目标

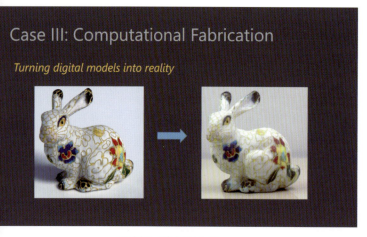

案例 3：数字化上色

是什么呢？前面两个例子是我们把真实世界里面的物体数字化、把真实世界里的物体做到计算机里面去。在这里，我们做的事情是如何把一个数字化的模型变成实物，即实际的物体。

我举一个全彩色三维打印的例子。我们知道现在 3D 打印机已经非常强大，可以制造出非常复杂的形状。也就是说，不管拓扑结构有多复杂、形状有多复杂，3D 打印机都能为你制造出非常精致的 3D 模型。

但是当前的 3D 打印机在色彩方面的支持是非常弱的。这个弱主要体现在两个方面：第一是彩色打印机非常贵，打印机本身就贵，打印的耗材也非常贵；第二是 3D 彩色打印支持的材料非常有限，基本上只支持两种，即一种是塑料，一种是石膏粉，而且这个色彩非常糟糕，和我们现在的二维彩色喷墨打印甚至彩色激光打印相比，差得很远。

所以我们就想解决这样一个问题。我们首先研究了一下传统制造业是怎么上色的。那有很多方法，这里我就不多说了，比如说贴花纸、电镀、用手去描，等等。不管是什么样的方法，其实都需要烦琐的手工操作，而且有的时候是需要特殊设备的。

这是我 2014 年、2015 年的时候参观的一个江苏的陶瓷厂。这个陶瓷厂很大，人民大会堂有一部分瓷器都是他们提供的。我去参观整个陶瓷厂时，发现整个瓷器的生产过程，绝大部分流水线都是自动化的，比如说拉坯、烧窑。但有一个流程还是全手工。这个流程就是贴花纸，即上色。

在那个上色的厂房里面，整整齐齐地坐了一百多个女工人，每个工人前面摆了非常多的碗，还有温水，她们需要用手把花纸非常仔细地贴在杯子的边缘上，得

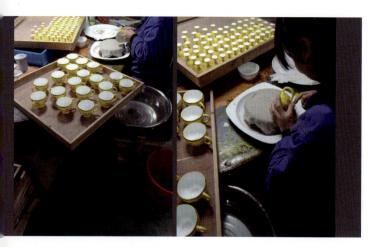

中国传统上色方法

非常仔细，因为边缘上的花纹360°回来必须接牢，如果接得不齐的话，这个杯子就成为次品了。所以一只杯子做下来可能要20分钟的时间。

所以在传统制造业里，不管是什么样的工艺，要给一个复杂的物体、一个形状表面去上色都是非常麻烦的。但是传统工艺有没有好的东西呢？传统工艺也有非常了不起的事情。比如有一种工艺叫作水转印。它会用到一种高分子膜，这种膜是可以溶于水的，喷上活化剂可以加速这个过程。这个膜上是可以有图案的，当你把要上色的这个物体浸到水里去时，膜上的图案在水压力的作用下会紧紧地包裹在物体的表面，这样就上色了。

这个工艺有几十年的历史了。在日常生活中，我们用到的很多产品，比如说家具、汽车外饰、汽车面板上的内饰，包括很多电子产品上贴的那些东西，都是用这个工艺做的。所以这个工艺很有意思。但大家知道这个工艺的问题在哪里吗？它的问题在于只能做这些比较简单的、重复性的纹理，不能做复杂的图案。

举个例子，右图左边的东西是传统水转印可以做的，比如大理石的纹路、迷彩服这样的一些图案。为什么可以做呢？因为反正是重复性的，颜色上到哪里看上去都差不多。但是右边这些东西它就做不了了。这些东西是我们的艺术家、设计师做出来的。也就是说复杂表面上的每一个点要上什么样的颜色，在数字模型上就已经定义得很清楚了。你不能随便给它上一个颜色，稍微错错位就不对了。比如说眼睛部分，眼睛部分就要有眼睛的纹理，嘴唇部分就要有嘴唇的纹理，不能错位，错位后效果就不好了。

所以，我们在2015年的时候做了一件工作，叫作计算水转印。在水转印前面加了"计算"两个字，我们就是想用计算机来对整个水转印的过程进行一个精确的计算、

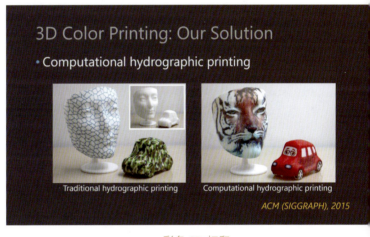

彩色3D打印

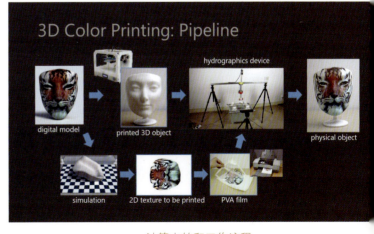

计算水转印工作流程

控制。

　　整个过程是这样的。首先，我们输入一个数字化模型后用一个普通的单色 3D 打印机打印一个素模，素模是纯色的、没有图案的。然后我们写了一个程序，做了一个算法，来模拟这样一个三维模型：当它浸到水里的时候，水转印膜到底是怎么形变的，也就是说水转印膜上的图案到底是怎么贴到或者是附着到物体表面上去的，这是通过计算来实现的。

　　通过这样的计算，我们就知道了水转印膜上每一个点和三维物体表面每一个点之间的对应关系。有了这样一个对应关系、映射之后，我们就可以把数字化模型上的那些颜色映射到水转印膜上去。这样我们就知道水转印膜上到底是一个什么样的图案。算出这个图案之后，直接用二维喷墨打印机把这个图案打印到水转印膜上，这样就得到了一个有图案的水转印膜。然后再把这个有图案的水转印膜连同素模一起送到水转印设备——我们自制的原型设备里去执行水转印过程。最后我们就可以得到这样一个和数字模型一样的带颜色的真实物体。

　　大家可能会好奇，就是这样浸到水里去，出来后这个颜色牢固吗？是不是很容易掉色？这个大家可以放心，因为你们看到的很多摩托车、汽车外面的装饰本质上就是这个工艺，风吹雨打日晒都没有关系。因为在一般情况下，在上完这个色之后，在表面喷一层清色的漆，透明的，就可以用很多年。漆将表面保护得非常好。

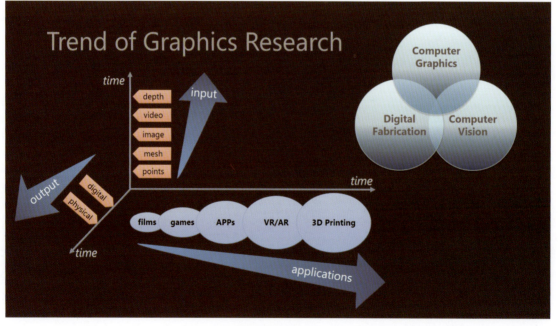

图形学的发展趋势

这个水转印工艺很有意思。大家可以在淘宝上去买一个套件，大概三四百元。然后自己就可以玩了，在家里就可以玩，很多小孩喜欢玩这个。然后你可以在淘宝上买一个杯子，找一个美工，给它涂一些颜色，数字化的颜色，然后可以执行这个水转印的过程，就可以得到这个上色的模型。

简单的物体我们做一次上色就够了，复杂的物体怎么办？如果需要全身360°上色怎么办？那就需要做多次的水转印，一次肯定不够。需要做多次，每一次上色不同的部位。那不同的部位之间会有一些重叠怎么办呢？那就需要通过计算让它们能真正地对接在一起，这是靠有精度的计算来达到的。

这三个例子就说明，我们在做的很多事情从本质上来说就是希望做一些工具，做一些软件，做一些算法，使得普通人，而不是专业用户，可以用这些工具、软件来产生很多的3D内容。我们希望这些内容能用在比电影、游戏更广阔的应用里面。

最后谈一下我个人对图形学研究发展趋势的看法。我们可以从三个维度去分析，包括输入、输出以及应用。从输入上看，图形学的输入数据最早是点云、网格，到现在我们更多地利用互联网上的图像、视频以及新型传感器给我们带来的深度信息来设计算法。输入变了，算法也会变。从输出上看，图形学原来就是生成数字化模型，现在开始切入制造这个领域。我们在做物理化的输出。从应用上看，前面也说了从电影、游戏到现在的移动APP、VR、3D打印，我们在面向更广阔的应用领域。这些都推动着计算机图形和计算机视觉以及数字制造等学科的交叉和融合。我相信这也是计算机图形学未来非常大的发展机会。

最后借这个机会感谢我的学生和我的合作者，谢谢各位。

Computer Graphics 2.0: 3D Contents Generated by End Users

▶▶ Zhou Kun

Hello everyone! It's my great pleasure to be able to come to Beijing Film Academy for this exchange of ideas. This is my second visit to Beijing Film Academy. The title of my report today is Computer Graphics 2.0, with the subheading that explains our goal of helping end users to create 3D contents.

As you may know, computer graphics is narrowly defined as visual effects generated by computers including graphics, images and movies. Therefore, computer graphics predominantly involves research in three areas: modeling, animation and rendering. Modeling is constructing a 3D scene, a model. On top of this static part, we have to also do a dynamic part, namely, animation. Ultimately we need rendering to generate the final images.

At the early stage of computer graphics, even up until today, most research centers focus on these three core issues. We have produced many such tools and softwares for artists and designers to use. Films and games produced with these tools and softwares become content consumed by ordinary users. However, ordinary users are not directly connected with the creative process itself. Therefore, we call this process the 1.0 stage. The 1.0 stage is an analogy to Web 1.0, or the early stage of the Internet. People know that Web 1.0 refers to news websites and gateways at the early stage of the Internet and ordinary users only visited these websites to read and browse content professionally produced by editors working at these websites.

Computer graphics 2.0, which I'm going to talk about, is analogous to Web 2.0 now. During the Web 2.0 stage, most content on the Internet is produced and shared by ordinary users. At this stage, graphic 2.0 research is still focused on modeling, animation and rendering, with the addition of production, which we will talk about in detail later on. Many softwares and tools will be produced out of this research to be used directly by end users, ordinary users. Ordinary users will create the majority of the content using these tools and softwares. The content can be applied directly in mobile APP, VR and 3D printing. Therefore, producers of content will be ordinary users instead of professional users. PGC, or Professionally Generated Content, prevalent in the past will be replaced by UGC, or User Generated Content today, a complete sea change.

It is an abstract topic. Next, I will give you three examples. We will use these three examples to demonstrate our research at this stage, namely, computer graphics 2.0 stage. The

first example is a case of a digital avatar. The second one is the modeling of an indoor scene; and the final one is about our work related to 3D printing.

The first one is a case of digital avatars. We would like to create highly realistic digital avatars on mobile smart phones, which are able to carry out interactions with ordinary users. We know that digital avatars are quite common now in CG films. We have many methods to capture actors' facial expressions in film productions and apply these facial expressions to virtual characters.

Besides facial expressions, there is also hair, which is equally important in CG films. However, unfortunately modeling of both faces and hair and their animation depend on some very professional equipment and complex computing, which is the reason why we seldom see realistic facial animation or hair in interactive applications. For example, facial expressions we see in many VR communities or games are dull and insufficiently expressive. Hair is normally displayed in forms consisting of rough polygons.

We started our attempt in 2011 and 2012, first solving the problem of faces. What we tried to achieve was to enable any user to be captured if he or she entered the camera's vision field, using an ordinary web camera which could be bought for a mere couple of hundred Yuan. What was captured was not only limited to 2D feature points, but also 3D geometric shapes in real time. Furthermore, the user's facial expression was also identified. Then by applying these facial expression parameters and head movements to any digital avatar, we could generate a digital avatar animation in real time, which was what we wanted to achieve.

We hope its application is not limited to film studios and animation studios. We hope it can be applied in any environment, especially on mobile phones. For example, in an Internet café , all the lights in the room are turned off and faces are illuminated only by the light of mobile screens. Or when someone is outdoors, directly under the sun light, part of his or her face will be in the shadow. We hope this algorithm will work well under whatever extreme conditions there might be. Therefore, we started in 2013 and continued in 2014, 2015, and 2016... it took us four years to solve this problem.

So what about hair? We know modeling of hair is an extremely difficult task in CG and it takes a truly proficient and experienced modeler to achieve excellent results. How did we solve the problem of hair modeling? We used machine learning to calculate each 3D strand of hair directly from images, predominantly from single images.

This was a case made at SIGGRAPH in 2016. On the left is a portrait photo and on the right are some 3D hair models calculated automatically. On a PC, it only takes us one minute to complete all the calculations. Furthermore, the hair moves in 360 degrees, not only limited in the front. This is only one example of the algorithm. We have produced satisfactory results not only with long hair, but also with very short hair, which can be quite a challenge.

Besides modeling static hair, we also need to animate it, using the dynamics simulation of

hair. The dynamics simulation of hair is a really difficult task because a normal person has more than a hundred-thousand pieces of hair. The calculation of collisions, friction and interactions between 3D curves in a space is truly time consuming. So it takes a lot of time to process hair in Maya and 3D Max. To solve this problem, we designed a method to calculate hair movements in real time in 2014.

Finally, we can integrate the face and the hair to create a fully dynamic digital avatar. In this example, you can see that a user is operating an ordinary camera to digitize the movements of the head and facial expressions, which follow the user closely. The dynamic simulation of the hair is also calculated in real time. Real-time interaction, including real-time facial animation, dynamic simulation of hair, all with real-time rendering on a PC like this was a first time for us.

This is the first example that I'm going to talk about: digital avatars, or modeling of human figures. The second example is an indoor scene. What are we hoping to achieve here? As you know, consumer-grade depth cameras are available which can be used to scan a surrounding for point clouds. However, point clouds alone are not enough for many applications. We hope to obtain 3D models with semantics. Only then, models can be really utilized in VR applications.

The backdrop of this research is consumer-grade depth camera's becoming widely available, such as Microsoft's Kinect and Intel's RealSense, and also the depth camera on iPhone X. From the second quarter of 2018, most Android mobile phones will also have depth cameras. With a depth camera, you can scan objects in your surroundings and digitize them. Large amount of 3D data can be obtained this way. However, all these 3D data is raw data, or point clouds without semantics. Some research methods utilize plane and distance field to describe geometric shapes. However, these models without semantics are not suitable for many applications of graphics, such as VR applications.

Therefore, we think if we want to generate a model with semantics based on the scanned point cloud's data, what kind of algorithm will we need? This involves the combination of graphics and vision. We need object identification for semantic segmentation. We created a simple method in 2012, an offline method.

What kind of process is it? A user takes a photo and we will do semantic segmentation using the depth images combined with the color information. After the segmentation, we will find a match in a 3D model database, choosing a model that matches the segmentation area the most. A morphing process ensues on the matching model to make it match the input depth data, and then a 3D model is constructed at last.

What about a large scene? What can we do? You need to take several photos. The previous photo and the subsequent one need to have a certain degree of overlap for a global position. You can take photos continuously and construct the scene afterwards. For example, this is my office at Zhejiang University, a dozen square meters in size. We took three

photos and it took some simple user strokes to construct the 3D scene on the right, with a computation time of roughly two minutes.

There is a problem for this kind of offline method. You need to take photos continuously but won't see the result immediately. After a round of photo taking and calculations with the software, you may consider the result model unsatisfactory and need to take more photos, which can be quite a pain.

Thus in 2015 we produced an online method. What can be done with the online method? You will see the constructed scene while scanning data. This is a really clean model. Using this method, users will see the result while scanning; and the advantage is if the user doesn't like the result, he can continue to scan a bit more. However, if the result is deemed good enough, the user can quickly get to another area, which is the real advantage of the online method.

We have introduced an offline method and an online one, both with pros and cons. The advantage of the offline method is that you don't need to take videos, only separate images. The disadvantage is that you won't see the result immediately, but you need to do the calculation later with the software. The advantage of the online method is that you will see the result immediately while scanning. However, you will need to continue filming during the whole process.

In my third example, I would like to talk about our work related to 3D printing and smart manufacturing. What's our goal? The two previous examples show that we can digitize real objects in the real world and embed real objects into computers. Here, we are trying to turn a digital model into a real object, to materialize digital models.

I'm going to give you a full color printing example. We know now 3D printers are very powerful and can produce highly complex shapes. No matter how complex the topography is or how complex the shape is, a 3D printer can produce the intricate model.

However, the color support of current 3D printers is rather weak. The weakness is reflected in two aspects. Firstly, color printers are very expensive. Both printers and printing materials are expensive. Secondly, the materials supported by 3D color printing are limited. Only two materials are supported, namely plastic and gypsum powder. Performance of both in the area of color is subpar, far below that of 2D inkjet printing, or even color laser printing.

We set out to solve this problem. First of all, we researched how traditional manufacturing industries apply color. There are many methods, which I'm not going to go into details about, including decal papers, electroplating and hand painting. All these processes are tedious and cumbersome manual operations and some even need special equipment.

This is a porcelain factory in Jiangsu which I visited in 2014 and 2015. The factory is huge and some of the porcelain ware displayed in the Great Hall of the People was supplied by them. When I visited the factory, I discovered most of the processes on the assembly lines are automated, such as casting and kilning. However, one process is still purely manual and this

process is decal processing, or coloring.

In that coloring workshop, more than one hundred female workers were sitting in alignments with bowls and warm water placed in front of each of them, while carefully adhering the decal papers to the edges of cups. They had to be very careful since the patterns that circle the edge of the cups must be placed perfectly. Otherwise, the cup could be a defective one. Consequently, it took 20 minutes to finish each cup.

So in a traditional manufacturing industry, regardless of craft, coloring a complex object or a surface is a difficult process. However, do these traditional crafts have any merits? There are some great traditional crafts. For example, one craft is called hydrographic. It uses a polymer film which is soluble in water. Sprayed with an activator, the whole process is accelerated. The film may contain images and when you immerse the object in the water, the image on the film will wrap tightly around the object, due to the water pressure, and color it.

The process is decades old. In our daily lives, images adhered to many of our products such as furniture, car exterior decorations and interior decorations on the dashboards, as well as many electric products, have been processed with this method. So we can say the craft is of great significance. However, can anyone tell me what the problem is of this technique? The problem is that only simple, repetitive patterns can be processed with this technique, but not complex images.

Let me give you an example. The effects on the left can be produced using traditional hydrographic, such as marble patterns or fatigue patterns. So how can we achieve this? That's because they are repetitive patterns with uniform colors. However, the effects on the right can not be achieved with traditional hydrographic. These were produced by artists and designers. The color of every point on these complex surfaces has been clearly defined in digital models and random coloring is not going to work, not even a slight misalignment. For example, eyes need to have patterns for eyes and lips need to have patterns for lips. Misalignment of patterns will lead to unwanted effects.

So in 2015 we did something called computer hydrographic. By adding "computer" in front of "hydrographic," we tried to indicate our intention of using computers to perform precise calculations and control in the whole hydrographic process.

The whole process is like this: first of all, we input a digital model and then use a normal single color 3D printer to print a monochromatic model without any patterns or images. Then we write a program, an algorithm to simulate how the hydrographic process morphs onto this object when it is immersed in the water, in other words, how the hydrographic image adheres to the surface of the object, which will be realized through computing.

Through our computing, we can establish the corresponding relationship between every point on the hydrographic film and that on the 3D object. After we establish the corresponding relationship, or mapping, we can map colors on the digital model to the hydrographic

film. This way we know exactly what kind of an image will be on the film. After the image is calculated, a 2D inkjet printer is used to directly print the image onto the film. Now we have a hydrographic film with an image. The film and the monochromatic model are then sent to the hydrographic device together and our prototype device is programed with the printing process. Finally, we have a real object with color, just like the digital model.

You may be curious to find out whether the color is stable after the water immersion. Will the color fade easily? Please be reassured since essential decorations you see on many motorbikes and also on the exteriors of cars are using this technique and they stay intact, though exposed to the elements. This is because under normal circumstances, after the coloring, a clear paint will be sprayed onto the surface which will protect the surface for many years.

This hydrographic technique is really very interesting. You can buy a tool kit on Taobao for roughly three to four hundred Yuan. Then the fun can begin. You can do it at home. Many children love it. You can buy a cup on Taobao, find a graphic designer and color it with digital colors. Then you can perform this hydrographic method to have a colored model.

One of coloring is sufficient for simple objects. What about complex objects? What can we do to color a whole object in 360 degrees? Multiple hydrographic processing is needed. One time is not enough. We need several repetitions. Each time a different part is colored. So what about the overlapping areas? To handle overlapping areas, we need to ensure perfect joining of these areas through precise calculations.

These three examples have demonstrated that many of the things we do essentially are tools, software, and algorithms that we hope will help ordinary users, but not professional users, to create large amount of 3D content. Using these tools we hope content can be applied in films and games more broadly.

Finally let me share with you my personal opinions on the developmental trends of graphic research. We will analyze it from three perspectives including input, output and applications. In terms of input, the earliest input data of graphics is point clouds and mesh. Now we use depth information from images on the Internet, videos, and new sensors to design more algorithms. Input changes and algorithms will also change. In terms of output, computer graphics originally were about digital model creation. Now we have moved into the field of manufacturing. We are producing physical output. In terms of applications, we talked about films and games, to mobile APP, VR and 3D printing of today. We are expanding into wider areas. All these are promoting the interdisciplinary and integrative mode between computer graphics, computer vision and digital manufacturing. I believe there are great development opportunities for computer graphics.

Finally, I would like to take this opportunity to thank my students and my co-workers. Thank you.

Real-time Visualization, High Power Computing and Rendering for Content Creation

◎ Dominick Spina

I'm Dominick Spina from AMD Studios and I'm going to talk about virtual reality and how AMD is powering virtual reality experiences for film-makers, from content creation to distribution.

So first, I'd like to talk about how we got there and the reason we got into virtual reality was virtual production; and I am going to show a couple of examples of how AMD technology was used for virtual production.

What is the definition of virtual production? So there are two basic definitions: there is the narrow definition, which is as a starting point, virtual production is defined as "computer graphics on stage," or a process of shooting a movie with real-time computer graphics, either all-CG movies (such as *A Christmas Carol* or *The Adventures of Tintin*) or visual effect movies with live action (such as *Avatar* or *Real Steel*). A more expanded definition is that, virtual production is a collaboration, an interactive digital filmmaking process which begins with virtual design, digital asset development, and continues with iterative and nonlinear processes throughout the production.

So what we're saying here is that film-making is now becoming more real-time and is taking virtual production through the whole process.

The traditional division of labor in movie-making is like this: we have pre-production, production, and post-production. The movie was made mostly in production. That's the traditional way. Most of the labor is in production, and there is a post-production phase. Around 1990 came computer graphics, which we are all very grateful for, and pre-production and post-production were pretty much the same, but computer graphics took

Dominick Spina on ICEVE

the majority of the work load in post-production. Then by 2000, the balance started to shift. There was more and more CG and computer graphics being used in post-production. Pre-production and post-production remained the same, but was beginning to shift.

From 2007, we started to introduce digital cameras into production and there was more digital production in that phase of it, and then pre-visualization was being added to the pre-production stage, as post-production technology was continuing to be computer-graphics heavy. Now we are bringing the pre-production CG elements, production elements, and post-production elements altogether. The boundaries are starting to disappear. We are taking assets from pre-production to production to post-production and making it seamless.

I all start with motion capture, of course, performance motion capture. This is an example of an actor on a motion-capture stage (the figure on the left). This is actually the beginning of what we call virtual reality. We take virtual situations, virtual environments, and we put actors into them. So performance, or motion capture, is the digital recording of an object or person, and using that information to animate a digital character.

Usingmotion captureto animate a digital character

So how do we do that? We do that with motion capture technology and to do that we have motion capture suits and markers. The motion capture suit is tight spandex in order to have motion capture markers placed on them so that motion can be as accurate as possible and the motion then can be transferred to a digital model.

Avatar was one of the first films where full CG, 360-environments were created, and actors were motion caped and put into a CG environment. This all starts with another very important piece of the puzzle, and that is the virtual camera. A virtual camera is a devise that provides cinematographers with a real time view of the virtual world. This allows them to shoot visual effects, virtual characters as if they were right in front of them. There are markers on this virtual camera, so that we can track that, and the camera moves are tracked with the rest of the scene. One of the pioneers of using a virtual camera, is James Cameron and for *Avatar*.

Later on, other film-makers that you recognize, such as Steven Spielberg and Peter Jackson, were also very involved in the beginning of virtual production.

The next part of this evolution is the Simul-Cam. A Simul-Cam is our version of AR, and so this is probably one of the first AR tools used. A Simul-Cam is a virtual camera that displays real-time composites of live action in a virtual world. So this allows you to shoot live action and visual effects seamlessly. This was also a big, big step in digital movie-making.

In an older film, such as *Jurassic Park*, the way it was done was to use a film plate and then add in virtual characters, but the camera motion is very limited and you don't have the range that you would if you actually were on a Simul-Cam where the director can actually move about and block their scene anyway they wish.

Compare a modern Blockbuster action film, with lots of handheld shots, motion capture rigs set up for actors and vehicles to move around in.

Steven Spielberg did a Simul-Cam test for a movie called *Robopocalypse*, which I don't think was really ever made. But in order to do that we had to bring a lot of real-time rendering and computation to the sets. In order to do that we had to really make use of computer graphics and graphic's hardware. We had to do the same for *Avatar* and there were digital set pieces involved with that. The Simul-Cam was used so that we were able to track the actors in relation to the digital set pieces, and as well as to the actual set.

In virtual production you immerse yourself in the content as you create it. In virtual reality you immerse yourself in the content as you consume it. So that is the difference between the two. Why is VR not a leap for us in virtual production? Because the

Virtual production in the film *Avatar*

Virtual camera

virtual camera and the HMD are really the same thing. They both give us a window into the virtual, CG world. The only difference being that one is for creating, and one is viewing. So this is kind of the bridge between what and how this technology evolved. Then the models that are used in digital films these days are so intense that we need to have really high computing power for graphics.

An example of something is the invention that AMD is now selling, and that is the SSG card, which is able to handle two terabytes of data on the GPU. This allows us to bring graphic technology onto set so that we can have virtual cameras right on the set and we can help bring real-time rendering right to the pre-production and previous stage of the pipeline.

Now we are talking about VR, and VR entertainment, and how do we deliver that to the public? AMD does that as well and so what we need to do now is we saw the film-makers were in their virtual world, and the actors were in their virtual world, and now we want the

consumer and audience to be in their virtual world as well. So AMD powers the devices that are used for consumption. We are involved in rendering, designing, and stitching. The GPUs are very important for all of these processes.

What we are trying to show here is this is the way that film-makers are actually wanting to do to make movies these days. The next *Avatars* are coming out and there are new techniques to advance this, but the point of this all is that the amount of data that's being used to make these films is increasing, and so the need for more real-time rendering is very important.

Hollywood has been doing AR for a long time and now we are bringing that to the public. So AMD is working very closely to deliver movie content and virtual reality to the consumer. So we are working with companies like The Third Floor, that does Pre-Vis, and Rewind, and Maccines Scott, and these are all companies that are doing content, film-related content. The idea behind all this is that we are trying to create film assets, game assets, and virtual reality assets all at the same time, so that people can use the same assets throughout all of these types of content.

How are we bringing this to the audiences? With all these HMDs. There are many of them out there now. There is some research shown that in next year, there will be tethered controller headsets, there will be headset with controllers/non-controllers, smart phone-based VR devices, but all of these are going to be growing exponentially in the next year or two so that the audiences can actually experience film-related VR experiences.

Bring VR contents to the consumer with HMD

AMD is also very tied into these deliver systems. We also power most of these devices and people are watching movies on Netflix, and Hulu, and HBO and things like that, so the delivery mechanisms are all there—we just need to create the content. 83% of all VR consumption will be powered by AMD processors, and that's a pretty large number. We at AMD Studios in Los Angeles are driving the VR initiative for film-making. We are also very involved in the emergence of location based VR and we are working with companies such as Howie's Game Shack, VR Room, and Awesome Rocketship, which are all trying to build a delivery mechanism for location-based theaters and theme parks. IMax is another delivery mechanism that we are working very closely with to bring VR experiences to the cinema.

With the growing home market for VR, the rising of new virtually empowered filmmakers, and the sustaining support of AMD—the future of VR seems very promising, thank you for your time.

运用实时可视化与高性能渲染技术打造高品质影视内容

▶▶ Dominick Spina

我是 AMD 制片厂的 Dominick Spina，今天来与各位讨论一下 AMD 是如何从内容创造到内容分销各层面为电影制片人带来虚拟现实体验的。

首先我想从 AMD 的发展历程谈起，我们踏入虚拟现实领域的契机缘于虚拟制作，一些先例告诉我们，AMD 的技术能够成功地应用于虚拟制作。

我们先来了解一下什么是"虚拟制作"，这个概念背后有两个基本定义。先从狭义定义入手，"虚拟制作"指的是"舞台上的电脑动画"，或者说电影拍摄与电脑动画实时同步进行，应用于全电脑动画制作的电影（如《圣诞颂歌》或《丁丁历险记》）或真人电影的视觉效果制作（如《阿凡达》或《铁甲钢拳》）。再来看看广义的定义："虚拟制作"具有协同性、互动性，是一种数字电影制作过程，以虚拟设计、数字资产开发为源头，重复、非连续地贯穿整个制作过程。

我们今天主要关注的是电影制作的变化：不仅越来越实时化，而且逐渐将虚拟制作纳入整个制作过程。

传统的电影制作分工是这样的：分为三个阶段——前制作、制作和后制作。一部电影的制作主要完成于制作阶段。这就是传统的制作方式。电影制作的大部分工作都是在制作阶段，还有一个后制作阶段。大概在 20 世纪 90 年代的时候，电脑动画技术出现了，多亏有了这个技术。前制作阶段与后制作阶段非常相似。但是电脑动画一出现，就把后制作阶段的大部分工序都解决掉了。到了 2000 年，三个阶段之间的平衡关系开始有了变化。后来又出现了一种新的电脑动画技术被应用于后制作阶段。前制作阶段和后制作阶段仍然保留着共同点，不过变化已经开始出现了。

2007 年的时候情况是这样的。那时我们开始在制作过程中引入数码摄像机，那个时期出现了更多的数字化制作元素。前制作阶段还加入了前视觉化技术，后制作阶段则不断侧重于电脑动画技术。"我们不断地将前制作阶段的电脑动画要素、制作元素和后制作要素相互糅合。"这时三个阶段之间的界限就开始淡化了，我们把前制作阶段的数字资产转移到了制作阶段，再到后制作阶段，使其无缝衔接。

这种处理的第一环节是"动作捕捉"，这里说的自然是表演性动作捕捉。以一位男演员为例，他正站在动作捕捉舞台上。等会儿我们可以看看他的表演内容，

这就是我们所说的虚拟现实的源头。我们布置虚拟的场景、环境，然后把演员放入这样的背景之中。所以说表演或者说动作捕捉就是对物理人的数字记录，并以记录数据为基础，绘制出数字人物模型。

那么问题来了，我们是如何做到的？答案是运动捕捉技术。这就需要运动捕捉装置与标志。运动捕捉装置是一种弹力纤维，可用于固定运动捕捉标志，如此一来便能尽可能地精确记录运动数据，捕捉完成后运动数据可以被转化为数字模型。

电影《阿凡达》是现在观众都非常熟悉的前制作，这是纯电脑动画、全景制作的电影之一，演员们都通过运动捕捉完成拍摄，再转入电脑动画场景中。这个话题要从虚拟摄像机说起，通过虚拟摄像机，电影摄影技师可以看见实时的虚拟世界场景，如身临其境，眼前就是虚拟效果或虚拟人物。虚拟摄像机上面安置了一些标志，剧组人员能追踪摄像机在场景轨道上移动拍摄时捕捉的画面。作为虚拟摄像机的先驱者之一，James Cameron 就是用它拍摄了《阿凡达》。

后来其他电影制作人，如 Spielberg、Peter Jackson，也开始参与虚拟制作了。

虚拟制作革命的下一棒接力者是协同工作摄像机。协同工作摄像机是一种人工智能工具，也是一种虚拟摄像机，可在虚拟世界场景中实时显示现场的物体运动合成状态，因此摄影人员可以同时拍摄出现场画面与虚拟特效画面。这是数字电影制作环节中最重要的一环。

以前的电影比如《侏罗纪公园》，采用的是老式的拍摄方式。这是电影拍摄棚景，我们往里面放入虚拟人物，但是若能用上协同工作摄像机，就不需要这么麻烦了，因为导演可以四处走动，封锁任何场景。

如今的动作大片里有许多手持相机拍摄的场景，而运动捕捉装置能使演员一边表演，一边完成追踪拍摄。

Steven Spielberg 为电影《机器人启示录》测试了协同工作摄像机，尽管我一直觉得这个测试没有成功。在测试中为了达到这种效果，我们引入了许多实时渲染合成场景，而且不得不运用了大量的电脑动画技术，与在《阿凡达》中所做的是一样的。真实的场景、数字合成人物实时完成，用的就是协同工作摄像机。

而在虚拟现实则是让消费者沉浸在消费的内容里，两者的区别在于此。那么为什么虚拟现实不算是让虚拟制作者实现巨大技术飞跃呢？原因在于，虚拟摄像机与头戴式（微型）放映装置其实是一样的，两者都是通往虚拟电脑动画世界的渠道。唯一的区别在于，前者是创作工具，后者是浏览工具。这就是某种嫁接技术的本质与演变历程的桥梁。现在我们运用到的电影制作里的模型种类特别多，在这种情况下我们的确很需要高超的电脑技术能力来绘图。

举个例子，这是 AMD 在售的自创产品 SSG 卡（标准信号发生器芯片），其可用于处理 GPU 的 TB 数据。有了这样的工具，我们就可以把图像技术传输到布景里，现场的虚拟摄像机一就位，就能把实时渲染转化到前制作阶段以及渲染管

道的前端。

现在再来看看虚拟现实与虚拟现实娱乐，AMD 在这方面可谓翘楚，我们现在的努力方向源于这样的现象：电影制片人进入虚拟世界了，演员也进去了，现在我们想要把消费者与观众带进去。为此 AMD 开发了专门用于消费的虚拟设备。我们加入了渲染、设计与拼接技术。这些处理技术都离不开 GPU。

我们准备为大家展示的是当今的电影制片人制作电影的理想方式。当然《阿凡达》与它之后的大批作品正依托着这门新技术不断提升作品品质。一言以蔽之，制作这类电影所需要的数据正不断增长，它们需要更加丰富的实时渲染技术，这一点很重要。

这也表明长期以来，好莱坞一直在运用增强现实技术，而且我们目前正在为将其引入公众视野做准备。AMD 一直致力于为内容消费者产出电影内容与虚拟现实。我们的合作对象包括 Third Floor、Pre-Vis、Rewind 以及 Maccines Scott 等公司。这些公司都专注于内容创作，尤其是电影相关内容创作。我们背后的理念都是一致的：致力于创造电影资产、游戏资产与虚拟现实资产，三者协同进行。如此一来，消费者只需一项设备就能体验这三种内容。

那么我们是如何将内容呈现给观众的呢？靠的就是头戴式（微型）放映装置。这是某项调查的结果，未来一年，全自动头戴设备、智能手机遥控设备与虚拟现实设备将会面世，数量增长趋势十分有前景，观众能够切身体验与电影相关的虚拟现实内容。

AMD 还与虚拟内容的投放系统十分紧密。众所周知，我们已经开发了大量此类设备，观众可以在 Netflix、Hulu、HBO 等平台上观看影片，投放机制已经十分完备。万事俱备，只欠内容。今年全部的虚拟现实消费内容里，有 83% 的内容将由 AMD 投放于电脑和控制台。这个数字十分可观。我们在洛杉矶的 AMD 团队都是精益求精者，为了电影制作不断追求虚拟现实创新。我们还很积极地投身基于虚拟现实的本地化制作。我们的合作伙伴包括 Game Shack、VR Room 与 Awesome Rocketship 等公司。他们都在不断尝试着为本土化剧场与主题公园搭建投放机制，IMax 就是另一项我们正大力投入的投放机制，它可以将虚拟现实体验项目引入电影院。

VR 的家庭市场持续扩张，擅长使用虚拟手段的电影制作人也不断涌现，再加上 AMD 的大力支持，相信 VR 的未来前景会一片光明。我的演讲到此结束，谢谢大家。

V-sense — Extending Visual Sensation Through Image-based Visual Computing

◎ Sebastian Knorr

First of all, I want to talk a little bit about our project: V-sense—Extending Visual Sensation through image-based rendering. I am currently working at the Trinity College, in Dublin, and I'd like to give you a brief overview of what we are doing there. We have a team of about 22 researchers working in the areas of Free Viewpoint Video for VR/AR content creation, and 360° video. For example, 360° video streaming, also quality control, and prediction of visual attention and the light-field imaging technology, particular in HDR light fields. We also do research into super resolution and denoising light fields; and finally visual effects and animation, for example, color transfer, style transfer in videos, but also in lighting and shading in 3D animations.

I cannot talk about all the topics, but I will concentrate on two of them: Number 1 is Free Viewpoint Video for AR and VR content creation. Here is an example, where you can actually see Free Viewpoint Video, which was used with a few cameras, and then you do some intermediate view reconstruction without getting the full geometry. Here is some recent work which is actually done by Collet, which uses full geometry, and in this case they used more than one hundred cameras, both sensors and infrared light.

Considering what they are doing, we are doing something in between. We are using a hybrid approach using a few cameras, for example, smart phones, to get full 3D geometry. The input images that we use, they are all captured with smart phones, and we do segmentation of the objects, and then we do the calibration of the scene. Maybe the cameras are even a little bit

Sebastian Knorr on ICEVE

Free-viewpoint VR Video

shaky, and then we use three different methods to reconstruct the scene. We fuse this together, the first one is structure from silhouette, point cloud estimation, and finally we integrate the skeleton animation, in case of a human. Once this is fused together, we finally get the 3D reconstruction of the object. In this case of a character, some people also calls this volumetric video instead of Free-viewpoint Video, but we call it Free-viewpoint Video.

So what are the applications for this?

Here is one example where we have integrated this 3D reconstructed character into the real scene. So it is for AR.

This was captured through Microsoft Hololens, as one example; but then we also went into virtual reality, because one of our goals is actually that we create technologies, but we also want to apply them in real scenarios. So what we did is we took a very famous play that was written by Samuel Beckett, and this play only has three actors, they are on the stage, and each of them has a monologue. The audience is sitting there, as what you are doing, and they watch them, but the funny thing was that actually there was a lighting engineer and he controlled who was speaking, by putting light on them. Whenever he spot the light on an actor, the person starts to speak.

VR project: Beckett in virtual reality

So in virtual reality this is getting much more immersive. What we did is we captured the scene, each individual actor in front of a green screen from different perspectives, and in this case we use DSLR cameras, and then, we of course keep the actors, we do a full 3D reconstruction.

We designed the whole scene in Unity, and we brought these characters into this environment. At the end, the audience actually comes onto the

stage, and the funny thing is that we don't need the lighting engineer because the person who is watching this is the lighting engineer. He can look at this person, he can go to this person, and then that actor starts to talk.

This is what the director had to say about it: "The play is an interaction between the light operator and the actor, mediated by light technology. Arguably, in our version, we acknowledge the role of the user as active. We recognize new opportunities for narrative and give the power of activation over to the end user, whose gaze becomes this spotlight. The user thus embodies the interrogator and is empowered to independently discover the story merely by looking at the characters. The user also has 6 degrees of freedom to move around the environment so that the experience is one of active immersion, as opposed to passive observation."

If you have a Microsoft studio, with one hundred cameras, you probably can get better results, but as I said, we only used six cameras in this case to get this 3D construction. It was more about the story itself.

Another topic that I'd like to talk about is quality in VR, especially about artifact detection and correction in stereoscopic 360° videos. When you go to YouTube, or Netflix, or other platforms and download some stereoscopic 360° content, you will notice there are many, many artifacts, stitching artifacts, and other artifacts. The whole processing chain starts from the storytelling, then the acquisition from the multi camera rig, the post production, coding and streaming, and finally the display.

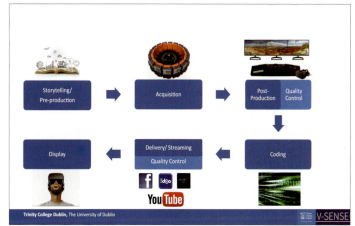

Cinematic VR process chain

We focus on two elements that are the post production and the streaming. I will now talk about the post production.

One problem in post-production is actually when you stitch all the content together. In order to know how it looks, you always have to render it and then you see, "Oh there are some stitching artifacts. There are some stereoscopic errors in it," and so on.

So you have to go back to the post production. Have to fix it, render it, maybe, you have to do this a couple of times, which is just time consuming. So we want to give feedback to the artists. Detect automatically the artifacts and highlight for the artists so they can fix it in

post-production without actually doing all this rendering and previewing steps.

So what kind of artifacts can I cure?

I cannot go through all of them, it will take too much time, but here are some simple ones, which happen to all, even in monocular 360° videos. If you have a multi camera rig, you have two areas that are actually problematic: one area is the gap area, that is the area which is not seen by any of the cameras, which is normally very small—so it is not a big issue; but the other part is that overlapping area, or cross-fading area. This is the area where, because the cameras have a certain size, you cannot bring them into the center of projection, which you actually would need to do because you are projecting a 3D scene onto a surface of a sphere. It is a 3D to 2D mapping, that is what you have. So the cameras have a parallax and see the scenes from slightly different perspectives.

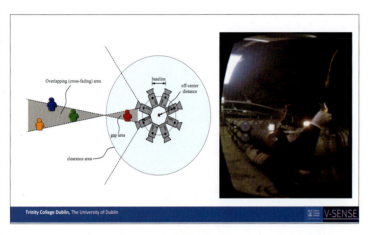

Gap area in 360-video

In this example scene, you can see this green object, and the blue one, and the orange one. The green one is seen by all the cameras, but the blue one and the orange one are seen differently from different cameras. What actually happens is that you can see it on the left, so the computer has to decide which information it is using, or it isn't using, unless we are talking about an AI. You can see the background is actually used. In this case, one has to rotoscope this foreign object, so it is really, fully there; but in stereoscopic 3D there are more artifacts.

One thing is geometrical misalignment, which is when you watch something with vertical parallax problems, you would probably have a headache after one or two minutes already. Another issue is binocular inconsistencies; especially when you do the stitching of the left and right view independently, you will get different warping artifacts. Then they are also very simple whenever we use multi camera rigs and it is also known from native 3D productions, traditional productions that you can have the color mismatch between the views, as you can see here very clearly.

So now, as I said, we are working on this automatic detection of artifacts, and therefore we have developed a framework, which is actually a framework that is based on patch and saliency for quality control.

First of all what is saliency?

When you have a 360° video, we are interested in the artifacts that the people will see and normally you don't see the full sphere because we have a headset and you only see the view port. We did a lot of tests and we noticed that actually, no one is looking to the sky, of course, and only a few people look at the ground. Normally you look around at the equator. We did many tests, subjective tests, in order to estimate the saliency, or the visual attention, and then we tried to weight the artifacts according to the visual attention of the audience.

The second thing is we want to localize artifacts and highlight them. What we did is we applied a Voronoi diagram, and extracted patches on the sphere, and then we analyzed each patch individually at the beginning and then whenever there is an artifact, we highlight it with different color codes. Blue means no artifacts and red means there is a strong artifact.

So then we analyzed a couple of cameras. We took 96 stereoscopic images captured with different cameras,

Vertical parallax

Binocular inconsistencies

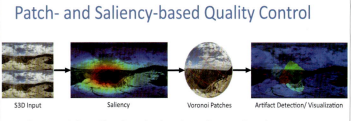

Patch- and saliency-based quality control

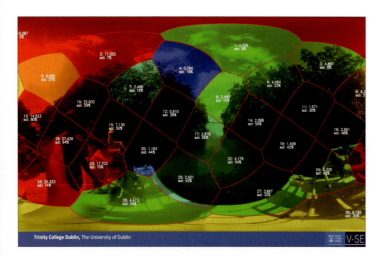

Patch- and saliency-based quality control

such as the OmniCam 360°, Jaunt Camera, Google Odyssey, Pano Cam, Nokia OZO, Facebook Surround, and then there was a self-constructed camera that was also in it. We took this material from the Internet, and analyzed it. For color mismatch, we can see how to detect the colors. For example, in this area, where everything is red, "Oh my god, there are lots of color mismatches," but we also put additional information into the patches, for example the saliency.

This way, an artist could go through this and see, "Oh my God, there's color mismatch," and now he has to take a look at the saliency: Does it make sense to correct it? For example, patch No. 18, has 94% saliency. That means almost everyone is looking at it. So it definitely has to be fixed.

But if I go to the top, only 2% are looking to the sky, so actually it is not important to fix an artifact in this area. Time is money, you know this, right? And post is money.

Another artifact that we also detect automatically is sharpness mismatch. We add some blur on one of the images, to test the sharpness mismatch tool. We detected the sharpness mismatch in the middle of the image. In other examples we again used saliency in the middle artifact detection.

But we also detect other artifacts. On the bottom, you can actually see that is a stitching and blending artifact. Flare differences in lenses. These aren't really sharpness mismatches, but it is good we detected them. There's many, many artifacts to detect, this is just the beginning.

V-sense——基于图像可视计算的视觉感知增强

▶▶ Sebastian Knorr

今天首先要讲的是我们的项目——V-sense（视觉感官）：通过图像着色来拓展视觉感官。我现在就职于都柏林的三一学院，将向大家略述一下我们的研究内容。我们的研究团队目前有 22 人，研究领域有自由视点视频（FVV），主要运用于 AR（增强视觉）和 VR（虚拟现实）以及 360°视频（即全景视频），如 360°视频流、质量控制、视觉关注度预测、光场成像技术，主要用于高动态范围和光场中；还有超分辨率、光场降噪；最后，还有视效和动画，例如，视频诊断传送、颜色转换和三维动画中的明暗运用。

由于今天时间有限，我只集中讲其中两个。一是利用 FVV 创建 AR 和 VR，大家可以从左边的视频中看到，FVV 是利用多台摄像机来摄像，在没有全面几何结构的情况下，完成一些即时视觉重构；而右边的是近期的一个其他作品，该视频运用了全构型，制作过程中用了百余个红外线摄像头。

而我们的技术是介于这两者之间，将两种方式结合，采用多台摄像，包括如智能手机之类的设备，便可得到三维全构型。通过结合上述两种方式，我们使用的这些输入图像都是由智能手机拍摄的，之后我们开始分割图中物体，并进行场景校准，因此你甚至能发现镜头有些不稳。我们将三种不同的方式融合以重构场景：一是轮廓的结构；二是点云估算；最后是将人类骨架动画也整合其中。这就是融合后我们所得到的这个人物的三维重构，有人称之为立体视频，但我们还是将其叫作自由视点视频。

该技术有哪些其他的运用呢？

在这里我举一个例子。在这个例子中，我们将三维重构的角色放入了现实场景中，即在 AR 中运用。

这是由 Microsoft Hololens 拍摄的，是 AR 中运用的典型例子，但 VR 中也有它的运用。我们的目标之一是创造科技，但也想将其运用于真实情景中。我们用了一个有名的剧，由萨米尔·贝克特所写，剧中只有三个演员，他们在舞台上都有自己的独白。观众坐在下面观看他们，其中有趣的是，有一个灯光师，他来控制谁该讲话，即灯光照向谁，谁就开始讲话。

这在 VR 中会更加有沉浸感，我们所做的是将场景录制下来，对演员分别从不同角度进行绿棚录制。在这里我们采用 DSLR 摄像，通过演员的录像实现三维重构。

之后我们在 Unity 中设计整个场景，并将这些角色放入该场景中，所以最终我们将观众带上了舞台。这一次，我们不再需要灯光师，因为他就是这个观众，他看向谁或走向谁，谁就开始讲话。

该片导演说过："这部剧其实就是灯光师和演员的互动，辅之以灯光技术的调节。可以说在这个版本中，我们很注重用户角色的活跃性。我们发现了创新的叙事手法，并将主动参与的权利交到终端用户手中，用户眼神所及之处就是聚光灯焦点所在。也就是说，只需要注视着演员，用户就能充当探索者的角色，具备自主挖掘故事情节的能力。用户还可以用六个自由度转换环境角度，相比于被动观赏，可谓拥有极其活跃的沉浸式体验。"

如果是在微软工作室里。有一百个摄像设备，那么效果会更好。而我们在整个制作中只有六个摄像头，因为故事内容更重要。

接下来我来讲一下高质量 VR，尤其是关于视频损伤监测和 360°立体视频修正。事实上你在 YouTube 和 Netflix 等视频网站下载 360°立体视频时会发现有拼接等多种损伤。大家看一下整个流程的概览就会知道，先是讲故事，接着是多角度摄像、后期制作、编码、流传输，最后是播放。

我们集中于两个部分：后期制作和流传输。我现在讲一下后期制作。

有一个问题是，将所有内容拼接时，要想知道最后的效果，就必须为其着色，之后你才会知道哪些是拼接损伤、哪里有立体误差，等等。

所以你需要回到后期上，修复、着色，反反复复很多次，实在很耗时。我们想实现自动视频损伤检测，标注损伤位置，以便艺术家后期修复，从而省去了着色等耗时步骤。

那我能处理什么样的损伤？

我讲些简单且有代表性的例子，包括单目和 360°视频的情况。有了多角度摄像装置，有两个区域会产生问题：一是空白区域，任何摄像机也无法捕捉到该区域，但由于它的面积一般很小，所以不是什么大问题。但另一个区域——重叠区域或过渡区域则不同，由于摄像机都有一定的尺寸，所以不能放到投影仪中间，即使这样做很有必要。因为将 3D 场景投射到一个球体表面上，呈现的就是 3D 到 2D 的映像，摄像头有视差，所拍摄的场景会有细微的差异。

举个例子，这里你可以看到绿色、蓝色、橘色。通过所有摄像头看绿色，效果都一样，但用不同摄像头看蓝色和橘色，效果就不同了。那么接下来，就如左侧图所示，计算机需要决定它所用的信息，及它不用的信息，除非我们在谈"人工智能"。大家可以看一下图中背景，需要转描这个物体，它才能完全可见，但是

在立体 3D 中会有更多的损伤。

其中一个是几何形状未对准，看上去像这样。受这个上下视差的影响，人可能看上一会儿就会头痛。另一个问题是双目不一致，当对左右边的图像分别进行拼接时，便会产生左右图所示的不同的弯曲损伤。可以看到一个图中脸被完全拉伸，但这对于用多摄像装置来说很常见，在纯 3D 及传统制作中也很普遍，不同视角间会产生颜色不匹配，这非常明显。

所以目前我们致力于研究自动损伤检测，制定了质量控制的框架，此框架以图像块和显著性为基础。

那么，首先什么是显著性？

在 360°视频中，我们在意的是肉眼可见的损伤。一般来说，我们不可能看见整个球体，因为我们的头戴耳机，只能看到视窗里的东西。我们做了很多测试，发现没人看天空，只有少数人看地面，多数人只看赤道位置。我们做了很多主观测验，从中估计显著性和视觉关注度。之后我们试着衡量损伤，我们的依据是观众的视觉关注度。

其次，我们要定位损伤并标注它们。我们通过运用沃罗诺伊图来实现，在球体上提取图像块，首先对各个图像块分别进行分析，之后再对其进行标注。大家可以看到有不同的色码，蓝色代表无损伤，红色代表强损伤。

之后我们分析一系列摄像机，通过不同的摄像机捕捉 96 个立体图像，其中的一些你可能听过，如 OmniCam 360°, Jaunt Camera, Google Odyssey, Pano Cam, Nokia OZO, Facebook Surround 及自装相机等。我们通过网络获得这份图并分析它。在讲颜色不匹配的时候，我们就是这样检测损伤的，比如，这个区中全是红色，就说明有许多不匹配。但我们也在图像块中加入很多信息，比如显著性。

这样，人们便可通过显著性发现颜色不匹配之处，再通过分析显著性数值决定修复的必要性。例如，18 号图像块的显著性为 94%，这表明所有人都能看到它，它就必须被处理掉。

而顶上的那部分只有 2%，那就没有修复损伤的必要，毕竟后期制作中时间就是金钱。

还有一个我们自动检测的损伤，即清晰度不匹配。以这张图为例，为了使用检测工具，我们对一个图像做了模糊处理。从中间的椭圆中可以看到我们所做的检测。用显著性做损伤检测的例子还有很多。

我们也检测其他的损伤，底部你可看到有一个拼接和调配损伤。这并不是清晰度不匹配，但也被我们检测到了。我们的检测工作还远远没有结束，这只是个开始。

王之纲

对虚拟现实艺术本体性的思考

◎ 王之纲

 大家下午好,今天下午听了三位专家、教授的讲座,感到非常震撼。内容好得不能再好了,非常有震撼力的信息和内容传递给了我们。

 从一个创意者角度来讲,从一个艺术家、设计师的角度来讲,可能会发现这些信息里面有一些新的创意可能性。同时给我的一个特别强烈的感受是,教授、专家还有工业化体系里的企业,他们在追求自己能力极限的突破,为创作者提供更好的工具去进行这种创意和这种制作。而从艺术家的角度来讲,有的时候,他会换一种思路,换一种思维的方式来考虑这个问题。所以我今天给大家做的这样一个讲座,其实是希望能够给各位稍微不同一点的创作思路,然后可以跟大家进行共同的讨论。

 我的第一页是鲍德里亚的一句话,他是法国的一位著名思想家。我隐去了它的主语。"不仅不需要模仿现实,而且可以产生现实。它塑造着我们的审美情趣、饮食、衣着、习惯,乃至整个生活方式。"这是他一九八四年写下的一段话。它的主语是电影、广告、肥皂剧、时尚杂志和形形色色的生活指南,它们当时是媒介的一种总称,尤其是时尚和娱乐的一种总称。

 所以说鲍德里亚当时对媒介提出了一种质疑和提问:什么在塑造我们的生活方式,什么在塑造着我们的文化?

 现在回到我们的主题,刚才说的那些算是我的一段开场白。我这个问题会一直保留到这个演讲的结束。虚拟现实是什么?——虚拟现实一方面努力将现实数字化、虚拟化。我们可以看到大量的应用,比如说虚拟博物馆、文化遗产保护、艺术教育、纪录片等;另一方面,它竭力将现实中不存在的精神性的事物现实化,把它们带入一个虚拟现实当中。比如说我们的游戏、数字艺术,还有电影等。我们举个简单的例子,一个与 VR 和文化遗产保护相关的例子,它是清华大学美术学院在做的一个"973"的数字文化保护的理论方法研究的项目。其中做了大量敦煌方面的研究,在数字虚拟的这样的一个体验馆,里面承载了整个敦煌的数字保护以及再创造的研究成果,这里面涉及三维、扫描,包括新的技术、色彩还原等

敦煌数字虚拟体验

敦煌 VR 体验

方面的研究成果。

我们跳到下一张幻灯片，这个是我们清华大学美术学院的博士生马立军和他的导师鲁晓波教授一起合作完成的一些敦煌的数字文化保护工作以及他们在 VR 场景的应用。所以说我们会竭力地把我们现实中的东西数字化、虚拟化，然后带到我们的虚拟世界，这样可以更方便地去体验、去感受。

我们看看从虚拟世界里我们能够感受到什么。

我现在介绍一个叫 Julius 的艺术家，大家在互联网可以找到这些视频。

我在 VR 这个设备里提供了这个作品，因为它是双眼的，所以非常震撼。因为我关注这个艺术家已经很长时间了，他用他的分型算法创作了一系列令人叹为观止的艺术作品。所以，他们在做虚拟的艺术作品时，VR 又是一个非常好的载体，让他们更好地、沉浸式地去感受他们的艺术世界。

对于 VR 的影视动画，我们现在放三部我很喜欢的 VR 影片，《The Rose and I》可能很多人都看过，我第一次看这个作品的时候被深深地打动了。一个非常 Q 非常可爱的小星球的感觉，小人从里面爬出来，然后完成了和他的玫瑰花一系列的互动。

因为我是一个做动画的，当我第一次看到这种表现的时候，当我把空间的体量和角色的表演结合到一起时，我觉得 VR 的动画一定有非常广阔的发展前景。后面的《珍珠》就更有名了，它是奥斯卡的提名作品；还有一部就是我国的一个工作室创作的《拾梦老人》动画片。我觉得影视动画，尤其是 VR 动画，都是有非常好的前景的。

我们可以看到，虚拟现实作为观看和交互的联合体以及各种艺术形式的融合体拥有无限的可能性。正如之前我所说的，我认为所有VR装置都是媒介。我们把VR当作一个媒介来使用，所有其他的艺术形式都可以融入或嫁接到我们现在的VR的系统上，促进新的探索，帮助我们探索新的可能性。

那么，下面我谈一谈仿真、再现、拟像。"仿真"是把真实事物模仿过来，"再现"是意识、情感、艺术的加工。"拟像"在这里是很专业的一个词，也是鲍德里亚提出的，它其实是对复制品、仿真品的再仿真。所以说，实际上这个拟像之后又会是什么？那我们得打一个问号，我觉得这个是我们未来要共同探讨解决的问题。

优秀的 VR 作品

这时候我觉得鲍德里亚还有一句话可以给大家分享一下，拟像比仿真更胜一筹，它已经不是对真实事物的模仿，而是对模仿物的再模仿，是对非真实物的模仿，是没有本源、没有所指的像。所以这里面更胜一筹的是它的双关意义。我觉得所有的胜、所有的超越，其实都有双刃剑的含义，所以我觉得需要保持更多的思考性。

那么我想问个问题，虚拟现实是否有独立的艺术性？它本身可以说是一种技术，或者一种载体、一种媒介。那他是否会有自己独特的艺术性？我们先考虑一下，虚拟现实给它的最大的特征是什么？

沉浸与交互。我觉得这两点对 VR 来讲是非常重要的。沉浸，是一种自然的、非压迫性的感受。我们是寂寞的，相当于我们泡在浴缸里、温水里的感觉，非常的舒服，一种非常自然的感受。

就交互来讲，其实交互双方追求的是刺激，也就是对方的反应是什么。你要求跟你的环境互动，改变环境，以至于改善你和你的环境之间的关系，那么我们下面说的就是从感官沉浸到精神

感官沉浸 -> 精神沉浸

虚拟现实艺术的沉浸是技术性沉浸，即体验者的沉浸感是虚拟现实技术带来的感官"错觉"，以"刺激"-"反应"模式使体验者进入虚拟现实技术营造的"景"中。

未经节制的感官泛滥，会令感官麻痹；艺术的精神性、超越性都被下放至错觉体验和感官刺激之中，

在大多数虚拟现实艺术中，体验者忙于感官体验，而疏于精神沉思，重于感受，而轻于理性。耽于"体""少于""悟"，所以在大多数情况下体验者得到的是身体和心理的感受，而体验结束之后随之而来的是精神上的"虚无感"。

沉浸的过程。

很长时间以来，我已经看了很多 VR 作品，有游戏，还有影视作品。我发现现在大多数 VR 的内容偏向于技术性的沉浸，也就是说感官沉浸。它们给人一种逼真的视觉、逼真的听觉或者说逼真的环境的感觉。

让你沉浸进去，给你强烈的刺激：身体的刺激、视觉的刺激、听觉的刺激。但实际上我举的大多数的沉浸感例子，对于精神层面的沉浸是比较忽略的，我觉得精神层面的沉浸应该是 VR 里面的更高层面的追求。

我不会一句句地解释 PPT 中的这段话。在我与朋友们、学生们，还有其他一些人讨论关于 VR 体验之后的感觉时，很多人会提出一种空虚感，就是非常激烈的交互刺激之后你摘下头盔，或者脱离这个环境之后具有的一种很强烈的空虚感。

所以我在想：这种空虚来源于哪儿？是来源于整个感官的爆炸性感受吗？现在放一张图，跳跃性非常强，这是南宋马远的一幅画——《寒江独钓图》，这里面有两个词叫作留白。其实在中国的传统文化里面，留白是一个非常重要的概念，即给人一个空间，去感受言外之意。

精神沉浸

我觉得这个是一个非常有意思的感受。从本身来讲，你可以看到这个江面上什么都没有，你感受到了那种孤寂感。但其实放空自己的那个过程就是有更多的思考的那种空间的过程，所以我希望我们的 VR 作品能够有那样的一种追求。

我记得我们的美学大师宋白华先生说过，艺术意境的创构是使客观景物作为主观情思的"象征"。我想知道，对我们 VR 未来内容的这种创建来讲，是否有可能实现从造景到构境的这种内容的转化呢？

"景"和"境"这两个词从中文来讲看起来很相似，但其实在意思上还是有很大的差别。就"景"来讲，基本上是一种客观的呈现；而就"境"来讲，更多的是和心境、意境连接在一起。加入了主观的一种呈现和加工，所以我觉得对于如何产生、如何创作真正具有中国传统味道的虚拟现实的作品或者艺术，这些文化层面的部分是需要考究、需要研究的，也需要做相关的这样的结合。

下面我们简单用图来呈现一下。

首先说个人经验、感官刺激和理性思考。虚拟现实构建了整个的一个空间或

氛围，它自然与其外面的现实世界是隔绝的。它能够让体验者很轻易地沉浸在虚拟世界中。

那么他在感受信息的时候会更加的专注，在这个过程当中虚拟现实就会呈现这样的一个融合的状态。我觉得最重要的是个人经验，因为对于所有的作品来讲，当个人经验和所呈现的交互氛围产生化学反应的时候，一定会产生非常有意思的效果，这也是艺术家所追求的。

最后一点是突破第四面墙，第四面墙是一个戏剧的理论，用传统的戏剧的观念来讲，我们的观众和我们的表演是隔离的，即其间有一堵看不见的墙。对舞台上的演员来讲，是默认观众不存在的。但是现在，通过VR体系可以把这样的空间打破。表演者、表演内容、整个环境和体验者可以完全融合在一起，共同创造出一种新的叙事模式。

我还想说一说"间离效果"。"间离效果"是德国的一个非常著名的戏剧家布莱希特提出的。其实我刚才看到的像浙大的周教授、AMD的总裁、都柏林的教授，他们和我们是一个研究方向。就是把视频的精度做高，使我们呈现的效果越来越好。那么这里有个问题，那就是，从我个人来讲，从行业产业来讲，这个研究方向一定是正确的，但我想知道，在我的艺术创作中是否真的需要那么高精度的艺术图像？

我这是给我自己提出了一个问题，"间离效果"就是对一件物品或一个人物进行陌生化。首先很简单，把物品或人物都不言自明的、为人熟知的和一目了然的东西剥去，使人对之产生惊讶和好奇心，这个其实是一种陌生化的处理方式，说到这里我现在放一个我们电影学院正在展示的一个作品，它是古罗马竞技场的VR作品。

这个是我们鱼果团队为青岛1907电影博物馆做的一个VR体验设计。当时在做这个电影博物馆的时候，我们就希望第一时间把VR的元素融入进去，因为这一定代表着电影的未来，我们把这可能性已经放在了电影博物馆里面。

我们先放一下这个作品。这是一个主视角和一个固定视角的切换，我们的观众会随着角斗士在这个升降梯里面升到地面上，

VR作品《角斗士》

观众可以通过这个手柄自由在这个场地里切换来改变观看视角，以调整两位角斗

士距离的远近。我再解释一下,观众开始是作为一个旁观者,跟随着两位角斗士升入整个格斗场的这样的一个场景当中,在整个角斗过程结束之后,他要做一个选择,这一点在那个画面里有所展示。

观众站在恺撒的位置上,可以选择战败的角斗士是生还是死。在这种情况下,观众不仅因观看激烈的打斗而血脉偾张,还会面临对生和死的抉择。这其实就是我们在 VR 里面深层隐含的意义,就是你是否可以轻易决定一个人的生死。

在我们之前的电影博物馆运行的时间里面,我们访谈了很多的体验者,80%~90% 的人都会选择生。只有少数人希望看到效果,他们就选择了死。这其实是创设了一个情景,在这个情景中,观众要决定某人是生还是死,从而激发其对人性的思考。

国外的艺术家会利用虚拟现实技术,会利用他们手头已有的新的 CG 科技来进行叙事性的表达,解决一些社会问题。这个录像带的名字是"流放之外:丹尼尔的故事"。

丹尼尔是同性恋社区的一员,这个作品是源于在 YouTube 上的一个非常短的视频。这个视频里面有一段丹尼尔和家人争吵的录音。这个作品的导演和他的团队发现,这是一个很好的可以挖掘的点,于是他们找了专业的、获得过托尼奖的团队去重新编排这个故事,然后做了一个 13 分钟的 VR 作品。我在尼斯电影艺术节的时候体验了这个作品,真的非常震撼。你能切身感受到他要传达的情绪,和人在那种状态中的那种挣扎。

《流放之外:丹尼尔的故事》

然而我在研究的过程当中发现一个有趣的问题,即为了保证游戏顺畅运行,那里面所有的模型质量都非常低,因此它们只是游戏级别的模型。但是我切切生生感受到了其生命力。所以说一些过于真实的场景反而会让你产生距离感,你会质疑它们是不是真的,然而没有逼真的图像声音和动作的完美结合,会让你有更真实的感受。这就是刚才我们所说的:去掉那些我们所说的习以为常的东西,VR 作品能让我们直接感受到它的本质和核心冲击力。

在我们做 VR 艺术作品的时候,我们非常注重反思的力量,因为对于虚拟现实的艺术而言,它的形式本身就是非常"工具性"的。但是当代艺术又是对工具理性的一种反思,所以我觉得 VR 艺术的整个体系,是对于这种集权、技术理性

这种一致性的一种反思，是科技形式对科技与人的关系进行的不断追问。这是我觉得虚拟现实所应该承担的责任。

后面还有一个案例就是 Zero Days VR。在这个作品中，你会以一个病毒的视角进入虚拟世界。这个作品源于一个很有名的纪录片，但是这个艺术家以另外一个视角，设身处地地把人变成一个计算机病毒的状态，呈现了整个故事，非常精彩。所以我觉得 VR 艺术是一个让我们提出问题或者进行反思的非常有效的工具。

这是我们最近的一个 VR 作品，是在参加一个创客马拉松的时候做的。当时在现场搭建了一个这样的沉浸的环境，同时还提供了一个 VR 空间定位系统。

于是我们在创作的时候就在想，在这样的一个环境里面，我们该做一个什么样的作品。我们后来想到的是现实和虚拟世界的这种距离感，于是就做出了这么一个射击游戏。在这个游戏中，佩戴头盔的人看到的是一个很抽象的类似于射击靶场的空间，他用手里的枪来射击一些人形的靶子，当他射中的时候，会有一个很正常的加油鼓励的声音。而在外面的观众看来，他正在拿枪来射杀在战场废墟上逃命的小孩子，并且每一次射中都伴随着小孩的惨叫声。在这个作品中，我们想要表达的是：当戴上 VR 眼镜看到的东西和在外面传输的东西不一样的时候，当所有的身体反应是一致的时候，我们所有观众会问道："哇，这个人怎么了？这个玩家难道是疯了？他为什么要射杀这个小孩？"他们也会盯着我看，说："你这人疯了吗，你为什么设计这样残忍的一个游戏？"然后，当体验者摘下了他们的头盔，他们再看到真实的情况之后，就都沉默了。

我们问过一些有关他们的体验的问题，他们很长时间都说不出话来。他们对这样的作品会有一些自己的想法。所以我是觉得体验完了以后会发觉这是一种完全不一样的感觉。我想说的是这种交互艺术虚拟现实的艺术，真正重要的就是把人带进来，就是把人作为一个参与者，放到这个体系里面，然后产生戏剧冲突，这个时候你的戏剧感受和你作为旁观者去看这个戏剧、表演或关系的感受是完全不同的。

所以我们也会提出一些问题，比如虚拟和现实的界限、虚拟生命是否也是生命、我们的道德边界应该在哪里、什么时候该射击、什么时候不该射击、我们对价值判断的依据是什么。很多时候我们认为是正确的时候，实际上有可能完全是错误的。

最后，还是回到我演讲开始时的第一句话，我把前面换了一个主语："虚拟现实不仅不需要模仿现实，而且可以产生现实。它塑造着我们的审美情趣，饮食、衣着、习惯，乃至整个生活方式。"虚拟现实在当今和未来会承担这样的一种重任——我们应当创作什么样的文化？其实，所有在座的各位和所有创作者应该共同思考并且承担这个责任。

谢谢大家！

Reflection on the Noumenon of Virtual Reality Art

▶▶ Wang Zhigang

Good afternoon. Three professors have given us their impressive lectures, which have brought us an abundance of information.

A creator, artist or designer may get inspired by speeches and from them create new ideas. What impresses me is that professors, experts, and industrialized companies are trying to break through the limit of their ability, so as to provide better tools for creators in creation and production. But artists may sometimes change a way of thinking when considering the issue. So today I am giving my lecture to offer slightly different ideas about creation that I want to discuss with you.

On the first page of my PPT is a quote by Jean Baudrillard, with the subject removed by me. "It does not need to stimulate reality, but can create reality. It is shaping our aesthetic perception, diet, clothing, habit, and even the entire lifestyle." This was written in 1984. The subject of the sentence is movies, ads, soap operas, fashion magazines, and a variety of lifestyle guides, together known as media—especially fashion and entertainment.

Baudrillard was raising a doubt and a question about media: what is shaping our lifestyle and culture?

After my opening remarks, let's get back to our theme. Now I am going to raise a question that will run through my speech, that is, "what is Virtual reality (VR)?" — VR is a digitalizing and virtualizing of reality, spawning a great number of applications, such as virtual museums, cultural heritage protection pieces, art education, and documentaries, among others. VR is also putting intense efforts into making nonexistent, spiritual things a reality, or, in other words, a virtual reality. They include games, digital art, and movies. A simple example concerns VR-enabled cultural heritage protection — a "973 project" on the theoretical approach to the research of digital cultural protection, led by the Academy of Arts & Design, Tsinghua University. During the project, we conducted lots of research into Dunhuang. The digital museum encompasses our achievements in its protecting and recreating of cultural heritage, backed by 3D scanning, new technologies, and color reproduction.

Next one: This is a Dunhuang digital cultural protection project and its application in VR scenarios, made by our academy's doctoral student Ma Lijun and his tutor professor Lu Xiaobo. This is how we digitalize and virtualize things in our reality and bring them into our virtual world, allowing you a more accessible experience.

Let's find out what we can experience in the virtual world.

Next I am going to talk about Julius the artist, whose videos can be found online.

I watched this work wearing a VR device, and it is stunning because it adopts a binocular vision. I have been paying close attention to Julius, who has done a series of marvelous art works using the fractal algorithm. VR is indeed an excellent medium of virtual art work creation because it provides artists with a more immersive experience in their artistic world.

As per VR animated movies, I am going to show you my three favorites. I bet most of you have watched "The Rose and I," which I was deeply moved by when I first watched it. A little guy climbs out of such a cute, tiny planet and interacts with his roses.

When I first saw how the magnitude of space was combined with the performance of actors, I, as a cartoonist, believe in the promising future of VR cartoons. "Pearl" is a more famous one, which received an Oscar nomination. "The Dream Collector" is a wonderful work made by a studio in our country. So I think there are good prospects for animation movies, especially those made by VR.

As can be seen, VR — the combination of watching and interaction, and the integration of all types of art forms — has unlimited possibilities. As I have just said, I hold that all VR devices are media. When treated as a medium, the VR system can integrate or implant all other art forms, which will promote new exploration and help us explore new possibilities.

Well, next I am going to discuss simulation, reproduction and simulacra. "Simulation" means the imitation of real things, and "reproduction" processing consciousness, emotions, and art. "Simulacra," a term introduced by Baudrillard, refers to an imitation of reproductions and replicas. Then what will be the result of simulacra? This is a question we will work together to solve in the future.

There is another quote by Baudrillard that I want to share with you. When simulacra outcompete simulation, they are no longer the imitation of real things, but the imitation of imitations, something not real. They are merely copies that depict things that either had no original to begin with, or no longer have an original. Here "outcompete" is a pun. In my opinion all efforts to surpass or go beyond other things are two-edged swords, which will provoke some thinking.

Then I want to ask you, "does VR have independent artistry?" VR is a technology itself, a

barrier, or a medium. When it comes to the existence of its independent artistry, let's start with reflections on its greatest feature.

Immersion and interaction. Two points essential to VR. Immersion is a natural feeling, not oppressive. We will feel lonely, as if bathing in the warm water in a bathtub, forming a natural comfort.

In the process of interaction, one seeks stimulation or reaction. People tend to interact with and change the environment, so as to improve the relationship between the VR user and the environment. The next topic deals with the process from sensory immersion to mind immersion.

Having watched many VR works for a long time, be it games or films, I have noticed that most of them emphasize immersion in the technological sense, or sensory immersion, where lifelike views, sounds, or environments are created.

The works are aimed to get you immersed and give you intense stimulations: physical, visual, and audio. But actually, most of the VR works I mentioned have paid little attention to minding immersion, which I believe is a higher level of pursuit in VR.

I am not going to explain this paragraph in my PPT sentence by sentence. In my discussion about VR experience with my friends, students, and other people, most of them have talked about emptiness, a strong feeling in those who take off their VR headsets and leave the environment after exciting interactions and stimulations.

So what I have been trying to figure out is where the emptiness come from. Does it come from the explosive experience of all the senses? Next I will show you a picture, which seems irrelevant to our topic. This is a painting, "Fishing Alone on Cold River," by Ma Yuan of the Southern Song Dynasty. It reveals a concept of "empty space," key to traditional Chinese culture, leaving some space for viewers to read between the lines.

I hold it is an interesting experience. From the painting itself, you can see nothing on the river, yet you still feel the loneliness. But when you let your mind wander, you are actually given space for thinking. This is exactly the pursuit I hope VR works can focus on.

Mr. Song Baihua, a Chinese aesthetics expert, once said, to construct artistic conception is to allow objective scenes to "symbolize" subjective feelings and thinkings. I am wondering whether VR contents can shift from creating scenes to constructing conceptions.

"Scenes" and "conceptions" resemble each other in the Chinese pronunciation, but differ a lot in meaning. "Scenes" are basically an objective presentation; but "conceptions," are more associated with mindsets and thinking, and are a presentation and processing that incorporate subjective ideas. So these cultural elements should be factored in when we create VR works or

art that has a taste of traditional Chinese culture.

Next, I will show you a graph to explain how we can combine the key elements.

First, personal experience, sensory stimulation and rational thinking. VR builds the whole space or atmosphere, which is naturally isolated from the outside world and enables viewers to easily immerse themselves in the VR world.

Thus, viewers will be more attentive to information, during which process VR will display such an integration. To me, the most important factor is personal experience. When a chemical reaction occurs between the experience and the interactive atmosphere, interesting effects are bound to follow. This is also what artists are after.

The last point is about breaking the fourth wall. The fourth wall is a theater theory. In traditional plays, the audience are totally ignored and separated from the performers by an invisible wall. But now, the wall can be broken by VR technology. The performers, the performance, the entire environment, and the spectators — all can be integrated into an interaction to create a new model for storytelling.

I would like to discuss the "alienation effect," put forward by German playwright Brecht. In fact, the speakers, Professor Zhou of Zhejiang University, AMD president, and the professor from Dublin, have the same research area with us — improving the definition of videos for better presentation. I will raise a question, and, in my point of view and from the perspective of the industry, I believe the development is on the right track. But I am not sure about the necessity of high-definition artistic images in my art creation.

This is a question I asked to myself. The alienation effect intends to make a thing or a person strange. The first step is simple — depriving the thing or the person of his self-evident, familiar features, arousing astonishment and curiosity in other people. This is an estrangement device. Speaking of that, I am going to show you a VR work about the Roman Coliseum currently on display at our Film Academy.

This is a VR work designed by our E-GO members for Qingdao's 1907 Film Museum. We hoped to integrate VR into our design at the very beginning, because it represents the future of cinema and we wanted to embrace that future. And so we did.

This is our work, where the shift between a first-person view and a fixed camera angle is possible. The viewer follows the gladiators into an elevator that lifts them onto the arena, where the viewer can freely switch between different views with the controller. Simply put, the viewer begins as a spectator, who enters the scenario with the two players, and makes a choice at the end of the fight as indicated in the last frame.

From the perspective of Caesar, a viewer can decide life or death for the defeated fighter.

In such a case, you not only get excited by watching a fierce fight, but also have to decide life or death. Whether you have the right to make this decision is a profound implication in our VR work.

Of the viewers we interviewed, 80% to 90% chose to spare his life, and the remainder chose to kill him to see the effects. This creates a scenario where the viewer gets to decide if someone is going to live or die, prompting reflection on humanity.

Overseas artists have used VR and new CG technologies for storytelling to address social issues. This video is called Out of Exile, Daniel's Story.

Daniel is a member of LGBTQ community. This work is adapted from a brief video on YouTube, which contained a recording of Daniel's argument with his family. The director and her team found the value in the video, so they invited a professional, Tony Award-winning team to make the 13-min VR work based on the story. I watched this work at the Nice International Filmmaker Festival, and it was really impressive. You can truly feel his emotion and struggle in that situation.

But during my research, I discovered something interesting—all models in that work are of low quality in order to guarantee the smooth running of the game, so they are only game-level models. But I still felt the vitality. This means some excessively realistic scenes will distance you and make you wonder about their authenticity; with an absence of lifelike imagery, the right combination of sound and movement can make the experience more convincing. That is what I have been talking about— by removing all things we are familiar with, VR works can impress us with their nature and have a core impact.

In fact, when we work on VR and other arts, we still need to focus on the power of reflection. VR artworks are achievements in the form of tools, but modern art is a rational reflection on tools. Because in my opinion, the entire art mechanism is a non-uniform reflection on the rationality of totalitarianism and technology, and a continuous inquiry made by a technological form about the relationship between technology and human beings. I think this is the responsibility VR should assume.

Another example is Zero Days VR. The artist enters a virtual world as a computer virus. In this famous documentary, the artist has adopted a brand new perspective and put viewers in the position of a computer virus, making the whole story quite intriguing. So I regard VR as an effective tool that prompts us to question things.

This is our latest work. Some of you may find it difficult to understand. This is an environment we built during an event "SHIFT Hackathon," where we were provided with an immersive, external environment and a VR-like room scale system.

So I was thinking about what work we could create in such an environment. That's when we came up with the idea to show the distance between the reality and the virtual world. When what we see through VR and what the audience sees as projected on the screen become different, without anyone knowing such a difference, the audience would wonder why anyone in their right mind would shoot and kill kids, and why I designed such a cruel game, but after the viewer took off his headset, all the audience was silent after seeing the truth.

When asked about their experience, most viewers would be speechless for a long time, but they still got their own opinions about the work. So I think they would have a totally different feeling after their experience. What I mean is the interactive VR art should bring people into the environment as participants, and create dramatic conflicts. This experience will generate a feeling sharply different from when you enjoy the play, the performance, or the relationship as an onlooker.

We have also pondered some other questions: What is the boundary between virtual reality and reality? Do virtual lives count as lives? Does our ethical boundary decide when to shoot and when not to shoot? Where is our ethical boundary? What is the basis of our value judgment? Often what we believe is right can be deadly wrong in someone else's eyes.

At the end of my speech, I would go back to the first sentence and change the subject to virtual reality. VR will take the responsibility in this age and in the future. What culture should we create? In fact, all of us and all creators should jointly think about it and shoulder the responsibility.

Thank you!

Gianluigi Perrone

The Leadership of China in the Virtual Worlds: the Social VR Project Which Is Going to Change the Future of Virtual Economy

◎ Gianluigi Perrone

I'm an Italian filmmaker, who has been based in Beijing for 5 years and I run a production company for virtual reality called Polyhedron VR Studio. We create immersive experience for the international market and China. I am introducing a new project for the first time.

Virtual worlds. What are virtual worlds? Think about the Internet, as we know it now, as a flat version of what is going to happen in the future. In the sense that now it is the pages, and they are basically documents. These documents have been three dimensionalized, and they became video and more. Now think about walking, in the pages of the website, as if they are rooms and these rooms, they are in buildings, that are the websites. These buildings are in a world, which is the Internet; and in this world people can work, people can make friends, people can socialize, and this is the concept behind Social VR.

Now Social VR is theoretically part of what we are talking about these days, here and in different conferences around the world. There is the idea that in Social VR they are going to collide all the parts of virtual reality, and the idea that we are bringing now is a form of distribution for all the immersive content. Usually, we talk around the world about where it is possible to create distribution to have immersive content, for the future. Probably Social

Gianluigi Perrone on ICEVE

Second Life

VR will be the answer, or one of the answers, and there are several platforms that serve now as Social VR. You probably know about Spaces from Facebook, you probably know about High Fidelity on Spaces VR; Bit Time; Waves (The Wave VR); Scenes Space; and I'm talking about Sansar.

To know this Sansar, we have to do some steps back into the past. Some years ago, there was the platform Second Life. Second Life is a desktop virtual world, which means it is on the screen, you cannot get in with the headset and it's been developed a lot by a company in San Francisco called Linden Lab. For around 10 years, Linden Lab has created a community of users and creators that live their life in Second Life. Live a new existence, a parallel existence, an artificial existence in Second Life, where they can attend events, create events, create areas, buildings where these events happen and they transfer funds for around 700 Million dollars per year. This is a model that Second Life has been used since its creation until now, in a community of creators that have control of the space. Sansar is basically the immersive version of Second Life. It's a more developed and evolved graphical version of Second Life, and is available in its Beta version for a couple of months. In fact, this is the first time our partners have introduced it to the Chinese market.

How does it work? Basically, Linden Lab provides for the platform. So the platform is Sansar. Then a group of creators are building the areas where it's going to happen, the existence for the users they are introducing into the virtual world. So this means that a group of creators, who come from Second Life, and have experience from Second Life, were chosen by Linden Lab to bring their experience to create the model of Virtual Estates. That is going to be

Sansar (1)

in Sansar.

So what does it mean, Virtual Estate? Basically, as the word states, it is real estate put into the virtual world, into the virtual reality; which means that we create areas where people can, again, attend events, create their own events, do meetings, develop their work, and then of course trade, spend their money: buying, selling their products, creating their properties; and this, on models, can be replicated in blocks. This is one of the main points of the "safe" economy for Virtual Estate.

Then another element for the Virtual Estate is aiming towards a target population. Where to bring the users of the platform and foreseeing the trends for the next models to come? Up until now, in Second Life, Linden Lab, with its own economy, with its own legislation, and with its own value, has created an area of 32,500 square kilometers, which is an area bigger than Belgium, or Taiwan, to give you an idea. So there is a country on this planet, which is Second Life. The knowledge, the experience of Second Life is now transferred to Sansar, into their creators. The work we are presenting now is to make possible that the properties that they are going to make reach Sansar, they are going to have almost the same value of the real properties that exist in real life. It means that you have your own houses and they have value. So through a process of block-chain, we are trying to make it possible to have the virtual property at the same value, or at almost the same value, the property that is actually going to be in the real world. The interest of the users is to acquire land. So you can buy territory, and then build your own design, or it can be designed by a group of creators: house, offices, buildings,and stadiums, whatever you want to make your own business. To create your own events, to sell

your own products, to improve your own property— to have complete control of the space.

So why choose Sansar and not another social VR network? If we have to play, if we have to do a video game or whatever, it's okay to have doodle avatars; but of course if we are playing seriously, there is a difference. There is a consistent difference. Somebody probably will ask, isn't Sansar basically just a higher quality, better level, good looking platform? Not at all. This is just the box. The thing that we are to present is the creation of Virtual Elite.

We are not saying that the other Social VRs are going to fail. Social Networks like Facebook, or the Chinese social networks are for everybody. You go there, but you don't make money through them. You can make money from advertising, you sell your image, but we are talking about something different. We don't consider the other social networks as competitors in the sense that what is our plan, again, is to create a Virtual Elite. This is quite a puzzle concept for what we want to create and it's not for everybody of course. Let's think about being able to just wear the smart glasses and travel, through time and space, to reach our business partners. Let's think about forgetting all of the problems of time and space that we can face and trading with something that is going to change our life.

If we want to spend money, in a project like that, and I'm not talking about the money you can buy an APP on Taobao, I'm talking about a lot of money with which. Do you think you will choose a platform which is new, which has been developed for only a few months, years and they have everything to learn and everything to mistake; and you want them to make their mistake with your money? Or you think it will be better to go to someone that has an experience, that has knowhow, that passed through a lot of mistakes, and they solved these mistakes, and then they have gotten to the point to erase any proof. So the experience of Second Life creators goes directly into Sansar and it is a structure that is not possible to be recreated without, again, that experience.

One of the parts is the privacy, in the sense that you are moving. You are moving your properties. You are moving your funds. You are moving your own identity, your own virtual identity into a space that gives you the privacy that you cannot even have in the real life, inside of your houses; and there is control, complete, because you will not have the problem of having to go through the limits that our life creates. Going through the limits that our social networks can give because you have the control of the social system, a legal system and also, you know, an education system that controls everything and it's transferred onto a new platform. You have to consider that Second Life has been able to create a new country, virtual country, with, again, 700 Million dollars per year of trading when Virtual Worlds were something that nobody knows about. Now, Virtual Reality is booming and this is the immersive version of it. The experience is there.

Sansar (2)

 No time and space, in the sense that you will not need to run for meeting somebody, or wait a lot of time for getting a conclusion, and waiting for building your own property, for creating what you want. So this project is the first step into something bigger. The intention we have is to create a space, an area, a community, where the credit is not money, it's not fame, it's not power—but it is human credits. When we are exhausted, we say, "Oh my god, I would like to go live on another planet. Maybe a planet where the past of the world is not the past anymore." Or we say we want to go live on a desert island. Well indeed, why are we not doing this? There will be a world to live on, where there is already a regulation and respect and harmony for everybody. This is what we are creating, for a Virtual Elite, for people who are willing to pay, to understand, and to follow rules that in a few decades will be the standard of human life, or the alternative for human life.

 So we are presenting for the first time, this project in China. We realized that China is the perfect place for developing this kind of Virtual World. The reason is there is already the approach to technology, the interest in virtual reality in this country. The way that people think is changing, everyone is basically paying with WeChat or Ali pay which will make it easy. In China, they are real. In Europe, it's unthinkable actually. This structure, and many other skills that China has, make it possible to put China in the leadership of the Virtual World. I'm Italian, and as an artist and designer for a long time, we have the leadership in such a way, we are famous for this. This is why people go to Italy for visiting. Video Games are for the Japanese. Cinema is Hollywood. After all, they made the rules for the industry and they are

still there. But for innovation, China is becoming one of the leading countries and we truly believe that the virtual world is the medium that is going to give to China the leadership, the international leadership. This government is making the difference, recently, for creating harmony and peace all over the world, for creating a world where everything is going to be safe. With our project in technology we are giving one of the keys. We believe that it's possible, of course, through years of study and development, but at the same time we think there is a right approach in the people of China for going in this direction.

Sansar (3)

One of the ideas for the creation for this land is the development of Smart Cities. Smart Cities where life is safe again and in harmony. Smart Cities where people can work, can live, can enjoy their life, without problems because they are self-governed. We thought a lot about Smart Cities, it's a concept established, it's an idea established, but indeed it's not yet practical, not until now. The idea that we are going to envision this kind of areas, where this kind of life will be real and possible. We show some examples of the city where you want to live and you're a part of it too. This project, which I'm talking about, as I said before, is not possible to be copied. It's not possible to be repeated because basically the structure passed through the creators of Sansar. Of course, you know, we suggest to go through our creators, our team, to start to test this kind of passage and basically it's previsualization of areas and the way they may work.

But another step is the education. It means that we want to present a project for teaching to young Chinese, not necessarily young, to create their own spaces to become creators. This is in the senses, this is not just being able to use Unity Engine, it's basically the thing that a worker will do with the bricks. I'm talking about being designers and architects of the Virtual World. Starting with the concept of what can be a new society. This is something that will appeal indeed to Chinese creators of Second Life. We are open to find partners here, they are able to foresee what is going to happen, because this is a process which is unstoppable. And we call this the project that is really far away in time. It is the name of all the continents when this planet, Earth, was really young. It used to be called, when they were together. So we present today Pangaea, the name of our project.

中国领军的虚拟世界：将会改变虚拟现实产业的社会化 VR 项目

▶▶ Gianluigi Perrone

我来自意大利，是个电影制片人，来北京 5 年了。我开了一家虚拟现实制片公司，名叫多面体 VR 工作室（Polyhedron VR Studio），为中国市场和国际市场生产沉浸式体验产品。目前我正在致力于引进一个全新的项目。

虚拟世界。什么是虚拟世界？想探索未来，不妨把我们现在的互联网看作未来互联网的平面版，当前互联网上的一个个页面，其本质就是一个个文件。这些文件实现从二维到三维的转变后，就成了视频之类的东西。再想象一下在网页之间漫步穿梭的感觉，就好像它们是大楼里一个个的房间。这些大楼就是我们的网站，而大楼所在的世界就是互联网。在互联网的世界里，人们可以交朋友，这就是社交 VR 的概念。

理论上来说，不管是在这里，还是在各种国际会议上，VR 社交已经成了最近的热门话题。大家都想在 VR 社交上实现虚拟现实各种元素的碰撞与融合。今天我们要分享的是通过何种方式分享这些沉浸式内容的问题。关于未来要在什么样的平台上进行沉浸式内容的分享，各种观点往往认为 VR 社交可以帮我们找到答案，或者说给出其中一种答案。现在有不少 VR 社交平台，大家或许了解 Facebook 的 Spaces、Spaces VR 的 High Fidelity、Bit Time、Waves（又称作 The Wave VR）、Scenes Space，以及我今天要讲到的 Sansar。

想了解 Sansar，首先得往回看。几年前，有一个平台叫作第二人生（Second Life）。它是一个桌面虚拟世界，是在屏幕上的，用户无法通过头戴式设备进入这个世界。旧金山一家叫作 Linden Lab 的公司对它做了很多改进。十年来，在 Linden Lab 的工作下，一大批用户和创建者都在第二人生里找到了自己的生活，一种全新的、平行于现实世界的虚拟生活。在第二人生这个平台上，用户可以参与各种事件、创建各种事件、划分各种区域、搭建各种建筑作为事件发生的场所，平台上的年交易额高达 7 亿美元左右。这是第二人生自创立以来沿用至今的模式，在这个社区里大家都是创建者，对这个空间有控制权。Sansar 基本上就是能营造沉浸式体验的第二人生，它有更好的画质，而且其测试版可以试用好几个月。实际上这是它第一次进驻中国市场。

这些都是怎么实现的呢？基本上就是 Linden Lab 提供平台，也就是 Sansar。然后由一群创建者来创建各个区域，也就是这个虚拟世界当中用户生活的区域。换句话说，Linden Lab 会从第二人生的老用户里挑选出一批创建者，利用他们的

经验创建 Sansar 上的虚拟地产模型。

虚拟地产是什么意思呢？简单来说，根据字面意思就是虚拟世界、虚拟现实里面的房地产。创建了这些区域，人们就可以参与各种事件、创建各种事件、举办会议、开展工作，当然也可以做交易、花钱，即做买卖，创建自己的资产。在模型里这些都能够通过区块进行复制，这就是虚拟地产的经济安全性。

虚拟地产的另一个要素是面向的目标群体。要把平台用户带向哪里？对下一代模型有什么样的展望？目前在第二人生上 Linden Lab 已经形成了自己的经济体系、法律体系和价值体系，占地面积达 32 500 平方千米，超过了比利时或中国台湾的面积。可以说，地球上还有一个国家，它就是第二人生。现在第二人生的知识和经验都转移到了 Sansar，转移到了其创建者身上。我们现在想努力实现的目标是把他们创建的资产移植到 Sansar 里，让它们和现实生活里的资产有差不多的价值。这意味着用户会有自己的房子，而这些房子是有价值的。通过区块链，我们试图让这些虚拟资产能够拥有和现实世界中的资产相同或者几乎相同的价值。用户的兴趣点在于获取土地。你可以买地、自己设计并建造房子，或者是让其他创建者帮你设计，可以设计住宅、办公室、大楼、运动场，可以随心所欲地开展自己的事业，创建各种事件，出售自己的产品，改善自己的资产，你在这个空间有绝对的控制权。

那么为什么要选择 Sansar 而不是其他 VR 社交网络呢？如果我们想玩一个电子游戏，那没什么关系。如果想要动真格的，那区别可就大了。可能有人要问了：Sansar 这个平台不就是画质好一点、设计美观一点吗？并非如此，这只是表面。我们想要做的是虚拟精英产品。

并不是说其他 VR 社交平台就会失败。像 Facebook 或者是中国的社交网络等，它们是面向大众的。用户进入这样的网络，但并不通过网络挣钱。用户可以通过做广告、出卖自己的形象赚钱，但我们说的是另一回事。在我们看来，其他社交网络构不成竞争，因为我们想要创建的是一个虚拟精英产品。这个概念听起来令人摸不着头脑。当然，这不是面向所有人群的。我们来想象一下，只要戴上一副智能眼镜，就可以进行时空旅行，去和我们的商业合伙人碰头。这样就可以抛开时空的各种限制，去从事一些可以改变个人命运的事业。

如果我们想在这样的项目上砸钱，我说的可不是在淘宝上买一款应用那么一点小钱，而是一大笔钱，你觉得你会选择一个上市只有几个月、几年，还有很多东西要学，还要不断试错的新平台吗？你会愿意拿你的钱去帮他们试错吗？还是说，你会选择一个有经验、懂行、有过丰富试错经验并试错成功、有危机应对能力的平台？Sansar 直接利用了第二人生创建者的丰富经验，没有这些经验根本做不出这样一个平台。

其中一个问题有关隐私。因为你在变动，你的资产在变动，你的钱也在变动。你将自己的身份，一种虚拟身份，迁移到了一个可以给予你充分隐私的空间里，这是在现实生活中、在你家里都难以得到的隐私权。你有完全的控制权，因为真实生活当中有的限制在这里都没有。你可以掌控整个社交体系，这既是一个法律体系，也是一个教育体系。你掌控一切事物，并且可以移植到新的平台上。想象

一下，虚拟世界还不大被人所知的时候，第二人生就可以创建一个每年交易额高达 7 亿美元的虚拟国家。而现在，虚拟现实技术迎来了蓬勃的发展，Sansar 又是有沉浸式体验的第二人生，其发展前景值得期待。

这里没有时空的概念，也就是说，不需要专门跑到某个地方去见某个人，或者是经过很长一段时间才得出一个结论或者建好自己的房子、创建出自己想要的东西。这个项目是我们宏伟蓝图中的第一步。我们的目标是创建这样一个空间、区域、社区，在这里金钱、名誉、权力都变得不再重要，重要的是人类本身。当我们在现实世界里筋疲力尽的时候，可能会经常说："天哪，我想搬到另一个星球，在那里没有过去。"有些人则向往热带的荒岛。为什么不做一个更好的选择呢？这里就有这么一个世界，里面已经实现了法制、尊重、和谐，这就是我们在创建的世界，为虚拟精英们和愿意为此掏腰包的人，帮助他们理解并遵循里面的规则，几十年后这种生活方式将成为一种标准，或者另外一种选择。

所以我们将这个项目首次引进中国。我们认为中国是最适合发展这样一个虚拟世界的地方，因为中国不仅有技术，还有对虚拟现实的热情。人们的观念在发生变革，基本上人人都在使用微信和支付宝，这会大大简化我们的工作。在中国，这些情况都是真实存在的，而在欧洲，简直是无法想象的。中国的这种结构，还有很多其他技能，让中国很有可能在虚拟世界这个领域占据领导者地位。我是意大利人，做过很长一段时间的艺术家和设计师，我们在艺术设计领域领先并以此闻名。这也解释了为什么游客爱去意大利参观。现在我们说到电子游戏就想到日本，说到电影就想到好莱坞，它们不仅为行业制定了规则，现在也依然活跃。但是就创新行业而言，中国正在走上领先地位。我们坚信，中国在虚拟世界技术上可以达到世界领先水平。中国政府为建立这样一个和谐、和平、安全的世界做出了重要贡献。我们也将通过技术做出我们的贡献。相信通过几年的研究和研发，这一切都能够得到实现。与此同时，我们也寄希望于中国人民的力量。

其中一个想法是建立智能城市。在智能城市里，人们能过上安全而和谐的生活，在这个适合工作、生活、享受的地方，不会有各种各样的问题，因为这是一个自我管理的城市。关于智能城市，我们想了很多，这是一个概念、一个想法，目前还没有付诸实践。这个想法是，在这里生活是能够实现的，也是真实的。我们会提供一些范例，而且用户也是其中一部分。正如我之前说过的，我提到的这个项目无法复制，因为项目构造基本上来自 Sansar 的创建者。当然了，我们的创建者和团队会进行测试，基本上也就是对这些构建出来的区域和其运行方式进行预览。

接下来就是教育的问题。我们想要教会中国的年轻人（也不一定非得是年轻人）创建自己的空间，摇身成为创建者。这是有意义的。他们不仅要会用 Unity Engine。这就好比建筑工人和砖块的关系。我的意思是要教会他们成为虚拟世界的设计师和建筑师。从了解何谓新社会的概念开始学起，这将吸引第二人生的中国创建者。在这里，我们向大家敞开大门，寻找合作伙伴，他们必须是有长远眼光的，因为这个项目是不可阻挡的趋势所在。我们这个项目的名字有久远的历史意义，是地球还很年轻之时所有大陆连在一起时的名字。我们的项目叫作泛大陆（Pangaea）。

曾智

更加"真实"的现实,探索下一代全景拍摄技术

◎ 曾智

各位嘉宾大家下午好,我是来自成都观界创宇科技有限公司的曾智,我们公司以及团队可能是国内最早从事全景拍摄设备研发的团队。很高兴大会组委会邀请我来,与大家分享一下我们在这几年研发 VR 拍摄设备的一些心得以及我们对未来方向的一些思考。

首先,这个 VR 拍摄设备,肯定是因为 VR 和 AR 爆发所引发的一些全景拍摄需求。我们的兄弟公司 IDEALENS 是专门生产 VR 头显设备的,所以我们对 VR 内容的需求及 VR 内容的匮乏深有体会。除了 VR 游戏的 APP 应用以外,视频也是非常大的一个需求。因为全景视频特别适合 VR 设备观看,而且可展示一种全新的体验,所以我们建立了这样一个团队。我们很早就开始研发 VR 全景的拍摄设备。在全景拍摄设备出现之前,大部分团队还是使用这种传统的相机拍摄,用传统的相机,比如 GoPro,组成一个"支架"或者"狗笼"来拍摄。它存在一些缺陷,首先同步就很难保证,这会使全景视频出现一些瑕疵,同时它的开关机、数据的导出和管理都存在一些问题,所以做出一款为全景视频拍摄的设备是很有意义的。

这两年,市场上也出现了很多款相应的设备,包括小的、中型的、大型的,我们可以看到它们的数量是从少到多,当然它们的成本也是从小到大,这里面就面临着成本及效果之间的折中。

这是我们公司最早推出的一个全景

曾智在 ICEVE 大会现场

"IDEALOEYE P21"相机

相机,我们叫它"IDEALOEYE P21",这款相机有 21 个镜头。为什么要有这么多镜头?就是为了对更好画质的追求。同时它能实现一个基本的实时拼接,并且能够生成高达 8K 的全景视频,还支持 3D。这个出来得还是很早的。后来我们为了让这台设备的成本下降,让更多人可以使用,研发了一款 C4,这款 C4 只有 4 个镜头,使用起来成本会低,同时能保证效果。这一两年,我们研发这几款全景相机设备时,也参与了各种应用场景,包括体育赛事直播以及演唱会、重大会议,还有一些综艺晚会等。甚至我们的机器也参与了一些 VR 短剧的拍摄,从中积累了很多经验,而且也得到了实际应用的检验。

接下来,我重点跟大家分享的是,在研发这些设备的过程中遇到的一些问题以及解决方案。

第一个问题就是画质与拼接之间的矛盾。实现更好的画质为实现缝合拼接带来很大的困难。如果拼接简单,最后出来的画质会达不到要求,这是为什么呢?

红龙全景相机组

首先，如果要获得更好的画质，我们当然希望使用更好的相机、更好的镜头，但是这种设备往往体积过大。

这是一组红龙的摄像机组成的全景相机的装置（rig），我们可以看到它相邻两个镜头之间的距离非常大，这样会导致我们用两个镜头拍摄的画面，特别是比较近的画面，视差很大。

视差就是同样的一个场景在两个镜头画面里出现了很大的偏差，给后期拼接增加了很大的难度，最后如果不经过人工修改的话，会很难直接输出质量很好的片子。另外，相机的 FOV(视场角)越小，它的靶面上像素的利用率就越高，出来的画面就越清晰，画质就越好。但是小 FOV 相机组成的全景相机装置（rig）很难——少量的话——覆盖 360°的球面，所以往往需要很多相机，包括我们出的这款 P21 相机，它就需要 21 个镜头才能覆盖要拍摄的整个环境，并且它的每一个镜头的 FOV 实际上也不算很小，也是广角镜头，大于传统的相机。这种为了追求更好的画质使用小 FOV 的相机，会导致相机数量很多，相机数量多了，拼接的效率自然会下降，难度也会加大。这也导致了画质和拼接的矛盾。

另外一个我们遇到的问题是，为了在 VR 和 AR 里面去体验，我们希望真实地呈现看到的虚拟环境，使其能够尽量逼真，但是全景相机拍摄的画面本质上还是二维的图像。从这个可爱的图里可以看到，实际上全景相机拍摄的画面也是由一些球面的画面组成的，它本质上是二维的，是没有三维信息的，真实感难以得到提升。

全景相机只能拍摄二维图像

可能有人会说，全景的视频也有 3D 的，但是 3D 全景视频存在一些固定的缺陷，因为我们现在所采用的 3D 全景视频模型，一般假定我们的左右眼看到的画面像右上图一样围绕着一个圆圈移动，所以在我们的实践画面里面，如果我们戴上眼镜朝正前方看，我们看到的其实只有最中间的一列像素对应的画面，但是其他的像素其实往往是在其他位置上看到的信息，这样必然会导致拼接过程或者 3D 效果中的一些瑕疵。另外，根据我们目前全景 3D 视频的模型，它基本上只能保证中间一圈有 3D 的效果，我们往上看，特别是往上再旋转一下，3D 效果肯定是没有的，而且往往会引起一些不太好的畸变、各方面体验很差的感觉。而且，由于它本质上是二维的图像，所以缺少了自由度。我们不能在全景视频中漫游观看，因为在看一个高质量的全景视频的时候，我们往往有要去移动它或者看某一个物体背后的冲动，但是实际上，现在的全景视频不具备这种支持。

对于上面这些问题，我们团队在实际的研发过程中，也尝试着去进一步提高体验来弥补这些问题带来的不好的影响。

首先是全景相机的硬件设计。最开始我们列举了市面上出现的各种全景相机，可以看到它们其实都是根据具体的应用场景设计的，因为很难有一款相机能支持所有场景，或者做所有应用环境的拍摄。所以根据不同的场景我们要合理选择，包括传感器（Sensor）靶面大小、镜头大小以及镜头的FOV。对于一些比较日常使用的环境，我们对画质要求不是那么高，我们可以使用两目镜头，它的FOV很大，它的画质往往会受影响，但是因为它的两个镜头的距离很近，它的拼接很简单，拼接结果也会很好，拼接效率也会很高。但是一些大型的应用，包括拍摄一些比较远的场景，就需要一些更好更高级的相机组建一个装置（rig）来实现更好的画质，因为它的拍摄是比较远的，对近处的拍摄不会有太多东西，所以我们不用太考虑拼接问题。这是硬件。

另外一方面是重点，就是尽量减小相邻镜头的光心距离，我们刚才看的那张图里面的红龙机器，它的光心距离很远，会导致拼接很难。所以根据我们的应用场景合理地选择相机之后，就要尽可能地减少相邻相机的光心距离。

这一点可以通过以下几个方法实现：一个是可以适当地增加相机的数目；另一个是加强结构的紧凑度，甚至还有一些厂家使用一些创造性的结构，采用反射的方式。本来很大的镜头，如果说直接向外排列，像红龙一样，那么它会有很大的光心距离，但是它用这种巧妙的方式可以保证镜头之间的距离是缩小的。用更好的相机实现难度更低的拼接，我觉得这是非常有创意的。

另一个改进思路，就是提高拼接算法，我们团队从一开始就使用基于光流的拼接算法。一个好的算法可以提高拼接对视差的鲁棒性。就是说虽然由于设计的原因画面可能存在视差，但是由于算法足够好，我们可以通过拼接进行弥

减少相邻相机的光心距离

补。这个光流其实在拼接里面的意思跟我们传统理解的光流不一样，它主要还是为了计算像素之间的匹配关系，就是当我们要把两幅画面进行拼接时，需要知道这两幅画面之间是怎么对齐的，而光流的方法能保证我们获得像素之间的对应关系，能够实现更好的拼接。另外，我们前面说了，这种光流的方法，要使用像素之间的匹配关系去计算，这个计算量往往是很大的。如果直接采用这种方法，或者是以前传统的做法，它的计算是很慢的。而全景视频要求很高的拼接效率，甚至有一些应用要求直播，即需要实时地播放，所以我们团队一开始在GPU上实现了光流算法，利用GPU的并行化把算法也进行并行化，以加速整个拼接过程。经过努力，我们发现通过GPU加速之后，拼接速度基本上能够提高数十倍，在C4上我们基本上是实现了实时的光流拼接，我们能达到每一帧只需要三十分之一秒以下，可以实现直播级的，而且这个直播过程是使用光流拼接，达到了非常好的拼接效果。

再一个改进思路是，我们希望全景相机拍出来的全景画面提供深度数据。从这张示意图上可以看到，上面是我们拍摄的一组全景画面，下面是我们根据画面的情况来实时算出来的深度，这样就相当于赋予了我们全景画面融于一体的感觉。现在有很多常见的RGBD相机，它们采用的深度测量方案包括了常用的这些：结构光、飞行时间。这个"ToF"叫作"time of flight"（飞行时间）；另外一个比较传统的方法叫作双目立体。我们发现全景相机天然地具备双目立体深度计算的硬性条件。从这个图上可以看到蓝色的表示全景相机里的一组镜头，红色点是观测点。通过FOV的设计之后保证每一个观测点都被两个镜头拍到，这样就可以利用双目立体的方法，利用它们在画面中的视差计算目标点的深度，这个方法可以把全景相机的深度计算出来，使我们的相机变成一台RGBD的相机。加入深度之后

为全景视频增加深度数据

有什么好处呢？像素深度计算其实跟前面的光流算法类似，它也是基于准确的像素匹配。

从上面这张图可以看到，我们需要知道每一个像素点在不同的相机上出现的位置在哪，从另一角度说，我们需要把两个镜头拍到的画面对应的点找出来。这其实跟光流计算很类似。增加深度信息数据对全景视频有哪些意义呢？首先它可以保证进行更准确的拼接，因为我们在拼接过程中最大的障碍就是视差，但是如果有了深度信息，知道了什么是前景、什么是背景，然后前景跟前景对齐，背景跟背景对齐，同时在融合过程中也可以利用深度信息，因为最近的应该叠加在上面，那么我们就能够保证实现更准确的拼接。另外，深度数据对于做后期特效的团队特别有用，如果他们要往全景视频里面叠加东西的话，如果没有深度数据，他们就很难准确叠加。比如我们看到的这个画面，我们希望做一个虚拟的鸟围着一个人转，如果我们不知道它的深度数据，那么就非常麻烦了。如果提供深度资料，再去做特效，就会收到事半功倍的效果。另外一个深度数据对全景视频的好处，就是帮助实现局部六自由度。我们有了深度数据之后，当我们观看者头部在微微移动的时候，我们可以根据深度数据，重新渲染出适当的画面，来保证能够看到近似于六自由度的效果，这也是深度数据非常有用的地方。

全景视频加上深度数据，就能够保证真正立体的真实视界吗？我觉得是不够的，它还是一个平面，只是说对于这个平面上的每个点，我们知道它在三维空间中的位置，而要实现真正立体真实感的全景视频，则可能有两种思路：一个是重建；另一个是光场技术。它们之间既有联系也有区别。重建其实是为了得到空间中每一点的光学信息，包括颜色各方面；光场比它更进一步，它要把空间中每个点上朝各个方向光的情况都要记录下来，这使我们可以获得更好的效果。但是现在还没有实现。另外，重建是我们公司现在的一个重点。我们把它叫作"四维重建"，因为它实时地进行三维重建，包括了空间中的三维以及时间中的一维，三维重建可以把它看作照片，四维就是建筑的三维模型，在每个时间点上能够实现一个有点类似于刚才教授讲的"freevideo"那种效果，这样能够让观测者从各个角度观看我们拍摄的对象。我们公司在做这一块时，基本上是使用RGBD相机组进行环拍，我们现在面对的还不是像全景相机一样对整个环境进行四维重建，我们现在第一步还是对一个小范围的对象进行重建。RGBD相机主要是我们自己研发的，是利用前面的深度计算技术实现的，同时充分利用GPU的并行加速计算来保证整个重建过程的快速性、实时性，从而获得像实时直播一样所拍对象的四维模型。

我已经讲得差不多了。总结一下，我分析了全景内容制作过程中的一些问题，希望通过加入深度数据来改进全景内容的效果。为了实现真正更好的、更真实的立体感，希望未来面向实时四维建模进行工作。

谢谢！

To Develop New Technology of Panoramic Shooting for Better Presentation of Reality

▶▶ Zeng Zhi

Distinguished guests, good afternoon! I'm Zeng Zhi and I work for the IDEALOEYE. Our team might be the first one who started to work on the research and development of panoramic shooting at an earlier time than other domestic companies. It is my pleasure to be invited by the committee to share some of our experiences on the R&D of VR shooting devices in recent years and our thoughts on directions in which further exploration will develop.

First of all, VR shooting devices are designed to satisfy the requirements of panoramic shooting that was caused by the outburst of VR and AR. Because our brother company IDEALENS has been specialized in VR headset production, we have deeply understood the deficiency and demand of VR content. Besides the need for more APPs for VR games, there is also a high demand for VR videos, among which the panoramic videos are very suitable for watching through VR devices and bring the audience a brand-new experience. Therefore, we built a team that has worked on the research and development of VR panoramic shooting devices since a very early time-period. Before, there was panoramic shooting device, most of the teams shot VR videos by taking traditional cameras, like GoPro cameras, to form a "bracket" or a "GoPro Cage," although it had defects in synchronization of panoramic videos, with turning on and powering off, and the export and management of data. It would mean a lot to create a better panoramic video shooting device.

In the last two years, the market has witnessed the development of a few types of panoramic devices, including small-sized, middle-sized and large ones. We can see the quantity of camera lenses increased its size, as well as the cost, which would result in a compromise that we had to deal with between cost and VR effect.

This is our first released panoramic camera, IDEALOEYE P21, with 21 camera lenses. Why did we put so many lenses on it? That was for a better image quality. This camera can realize a basic real-time tiling, generate 8K panoramic videos and support 3D as well. Still, we created a new type called C4 to reduce the cost of this early released device for more users. With just 4 lenses, C4 enjoys a lower cost and a steadier image. Through the research and development process of these panoramic cameras in the last two years, we've applied our devices in various application scenarios, including sports, live shows, concerts, major

conferences, gala evenings and even some VR short plays, by which we've accumulated much experience and been approved by practical appliance.

Next is the major content of my sharing, which is about the difficulties we've met through the research and development process and their solutions.

The first one is the contradiction between the image quality and tiling. Solutions for better image quality result in huge difficulties in tiling, while making it easier for tiling typically leads to unqualified image effects. Why? First of all, when we're working for better image quality, we'd hope that we could use better cameras with better lenses, but unfortunately, these devices usually have a large volume.

This is a panoramic camera rig that is consisted of Red Dragon cameras. We can see that there is a large distance between two adjacent cameras in it, which leads to a huge parallax between images, especially in very close scenes, which are shot by two different lenses.

Parallax is the great difference that might show when two lenses are shooting the same scene and it raises great difficulties in later tiling procedures, which means that high quality videos could not be produced directly without manual tiling. On the other hand, the smaller the FOV a camera has, the higher its utilization rate of pixels on the target surface would be, accordingly, the image would be of higher definition and quality. Be that as it may, it is very hard for a panoramic camera rig consisting of small FOV cameras, if there aren't many, to cover a 360-degree spherical surface. So, many cameras are needed in most cases, for instance, our product, P21, needs 21 lenses to cover the entire environment that is required, and the FOV of each wide-angle lens, is not that small in fact, bigger than traditional cameras. As said above, to use small FOV cameras for better image quality would involve more cameras, thus tiling efficiency is reduced and the level of difficulty in tiling is increased. This is how the contradiction between image quality and tiling is created.

Another difficulty we've met is that, although as lifelike as we'd hope to represent the virtual environment, we would see when having VR and AR experiences, the images shot by panoramic cameras are still 2D ones in essence. As we can see from this cute picture, these panoramic images consist of some spherical images that are 2D images in essence and have no 3D information, without which the sense of reality that the images convey is hard to be improved.

Well, some might say that there exists 3D panoramic videos, but, the videos have their own inherent defects. Generally, the 3D panoramic video models we're applying would assume that images of both eyes would move around a circle as what's shown in the right picture, hence,when we put on lenses and look straight forward, only the line of pixels in the middle corresponds to what is seen but other pixels are usually information seen from other positions. Therefore, defects are generated during the tiling process or show in the final 3D rendering. Furthermore, basically, the existing 3D video models can only guarantee 3D effects

in the circular area in the middle, if we look upward, especially with rotating our head a little bit, there would be no 3D effects at all but some deviations or poor experiences. Besides, these 2D images lack a degree of freedom, we can't conduct panoramic roaming. When we are watching a high-quality panoramic video, there often has been an impulse to move it or check the backside of an object in it, but in fact, current panoramic videos do not support that.

When conducting research and development practice, we have made efforts to further improve users' experience to reduce the bad influences of these matters.

Firstly, we have optimized the hardware design of the panoramic cameras. All kinds of panoramic cameras on the market, as you can see from what we've listed out, are designed for specific application scenarios because it is hard for a single camera to support all scenarios or be applicable to shootings of all application environments. So, we have to make proper choices on the size of sensor target surface, the size of lenses and FOV according to different scenarios. For daily usage environment, there won't be a high demand for image quality, so we could use binocular lenses with a big FOV that might affect the image quality, while the close distance between two lenses makes the tiling easy to conduct and have a great effect and a high efficiency. But for some large-scale application scenarios, including shooting distant scenes, rigs set up by better and higher-level cameras are needed to realize better image quality, and tiling could be left out of consideration because the shootings would be conducted from a far distance and there would not be many objects close to the lenses. This is about hardware.

The second is a very important one, which is to reduce the distance between the optical centers of adjacent lenses as much as possible. As the Red Dragon cameras we've seen in the picture earlier, the larger optical distance the lenses have, the harder the tiling would be. So, after choosing a proper camera for a specific application scenario, we should reduce the distance between the optical centers of adjacent lenses as much as possible.

There are several methods to realize this reduction, one of which is to properly increase the quantity of cameras and another is to enhance the compactness of the structure, speaking of which, some companies even have applied creative structures that make sure the distance between cameras is lessened by reflection, which is very clever because large lenses, if set outwards like the Red Dragon cameras, would have very large distance between their optical centers. To realize easier tiling with better cameras is very inventive in my opinion.

Another idea is to improve the tiling algorithm. We've applied a tiling algorithm based on optical flow since the very beginning. A good algorithm can increase the robustness of tiling to parallax. That is to say, even if parallax might exist between images because of design, it can be made up through tiling if the algorithm is good enough. The term "optical flow" that we used in the tiling process has a different meaning with what we used to know about it. The optical flow is mainly used for computing the matching relation between pixels, and it guarantees that we can get the correspondence between pixels as we have to know how two images align when

we are conducting tiling to them. On the other hand, as I've just said, the computing is based on the matching relation between pixels and it is often fairly large-scale, so the computing speed would be very slow if we use the optical flow method directly or in traditional ways as before. However, panoramic videos require the tiling to be highly efficient and some applications even ask for live broadcasting in real-time, so at first, our team realized the optical flow algorithm on GPU and the tiling process was accelerated by using GPU parallelization to parallelize the algorithm. With our efforts, the tiling speed can be over ten times faster after applying GPU parallelization, and we've basically realized real-time optical tiling on C4, which needs less than 1/30 second for each frame and has a great tiling effect through the live broadcasting by using optical flow tiling method.

Last but not least, we hope that panoramic images shot by panoramic cameras can provide depth data. As we can see, the upper part is panoramic images that we've shot, the lower part is the depth that we've computed in real time based on these images, by which we could feel the panoramic images integrate. To measure the depth of an image, many common RGBD cameras would apply these frequently-used methods, such as structured light, ToF, which stands for "time of flight," and a traditional method called binocular stereo. We've found that panoramic cameras are naturally equipped with quality to compute binocular stereo depth. What is in blue in this picture shows a set of lenses for panoramic cameras, while what is in red is our observation points, each of which would be guaranteed to be shot by both lenses after FOV designing so that the depth of target point can be computed by their parallax out of both images by using the binocular stereo method. This method has the depth of panoramic cameras computed, making our camera into an RGBD one. So, what benefits do we have with the depth? Similar to the optical flow algorithm, depth computing of pixels is also based on accurate pixel matching.

As what's shown in this picture, we need to know where each pixel shows in different cameras, in other words, we need to find out the point from both images shot through the two lenses. It is similar to the optical flow algorithm. What does it mean to have panoramic videos after adding depth data? First, a more accurate tiling is guaranteed. As parallax is the biggest obstacle in tiling, with depth information, we can align foregrounds and backgrounds of images after we figure out what is foreground or background, and the depth information can be applied during the integration, putting the closest on the top to make the tiling more accurately realized. Besides, depth data is very useful to visual effect teams. If they want to overlay something in the panoramic videos, it would be very hard to overlay accurately without depth data. For instance, as you can see, in this image we wanted to create a virtual bird flying around a person. It would be very difficult for us to realize it without having its depth data, on the contrary, the effects work would be greatly done with the depth data provided. Another benefit that depth data brings to panoramic videos is to help the realization of local 6 DoF.

With depth data, when the observer moves his head very slightly, we can generate a proper image by re-rendering to make sure what he sees approximates to an effect of 6 DoF. This is where the depth data can be very helpful.

Can a panoramic video guarantee a true stereo view with depth data? I think it is not qualified enough because it is still a plane, although we know where each point occupies in three-dimensional space. To realize panoramic videos that could deliver a sense of true stereo reality, there might be two ways: one is reconstruction and the other is light field technology. While there is connection between them, there are differences. Reconstruction process is to get the optical information of every point in space, including information on colors and other aspects. Light field method goes further and records all the optical information of the light flowing in every direction through every point in space, by which we could achieve great effect, but it has not been realized yet. Now, the main emphasis of our company is reconstruction and we call it "4-dimensional reconstruction" because the technique can realize real time 3 dimensional reconstruction, which means 3 dimensions in space and 1 dimension in time. 3D reconstruction can be seen as pictures, then 4D reconstruction is a 3D model of an architecture, by which an effect similar to the "free video" in the professor's speech can be realized on each time-point so that observers can watch, from every direction, the subjects we've shot. When we're working on this, basically, we use RGBD cameras to conduct loop shooting. What we're facing, different from panoramic cameras, is not conducting 4-dimensional reconstruction to an entire environment. We reconstruct small-scale subjects at the first stage. The RGBD cameras that we used are mainly products of our own research and development by applying the technology of depth computing that I've talked about earlier, in the meanwhile, we've conducted the GPU parallelization to speed up computing in order to guarantee the rapidity and real time performance of the entire reconstruction, which would be like live broadcasting, and in the end we can obtain 4D models of the subjects through the reconstruction.

My sharing is almost finished. In summary, I've analyzed the difficulties we've met during panoramic content production, and we hope that we can improve the effect of panoramic content by adding depth data. In order to realize better stereo images of reality, we would carry out 4-dimensional reconstruction modeling in the future.

Thank you!

信息传播

◎ 钱晓勇

大家好，我代表强氧公司Cgangs（创动力）团队在这里跟大家分享一下这几年的经验。强氧公司Cgangs团队本身是一家硬件公司，做了很多全景相机、立体相机、导播台这样的设备。我本人是个导演，在强氧公司Cgangs团队里面拍了一堆片子，各种网店、VR电影什么的都干过。干完之后，我觉得应该停下来去思考一下到底我们在干什么东西。作为这样一家公司，既拍东西，也从事广电行业，核心是什么呢？我们的核心叫作信息传播。

信息传播给谁？传播给人。那么我们需要简单了解一下人类认知心理。人体的感觉基本上就这么一些：触觉、味觉、嗅觉，这些感觉的距离、范围都非常小。触觉，基本上汗毛能长多长，你的触觉范围就到那儿了。味觉，基本上嘴有多大，你的味觉范围也就在那里。还有嗅觉，嗅觉稍微远一点。其实这些我们都叫作近距感知。我们主要感知的器官是：听觉、视觉，它们的范围相对来说就很大。感知的范围越大，它的信息量就越大。最终我们人类进化到现在，我们主要靠视觉和听觉去感知周围的环境，而其他那些感觉，其实信息量很少，它们是辅助的感觉系统。但是其实我们人类的生存空间比这些感觉器官的范围大很多，所以我们的生存本能促使我们去突破感觉器官的限制，更好地适应未知。这就是信息传播的意义。

我们再来讲一下人类信息的处理。认知心理学告诉我们，它主要分成四块，第一块就是感知，我们前面讲的各种感觉器官；还有一个叫"判断"，它叫control（控制），我觉得太物理了，通常我们都用"判断"；然后是记忆，最终做

钱晓勇在ICEVE大会现场

人类的感知

出反应。一旦有记忆存在,我们就知道感受来的信息并不是直接起作用的,外在感知与内在记忆形成一个交互的关系。所以我们对外在的信息,在内部有很强的规则去筛选,不是所有的信息都能引起我们的注意。判断这些信息的过程,其实是学习和决策的过程。

在过去的时代,我们通常把处理已知经验的方法叫作个体经验、人类经验。我们从小读书,一开始背课文,那基本上就是个体经验与人类经验了。升级上来,处理未知其实是靠逻辑,逻辑的核心是什么?是分类。对于近代科学的起源,其实分类学是最关键的,林奈把整个动物、植物分了一遍,从此以后开始有进化论,因为在这些共同的依据里面,找到了一条新的解释方式。

我们人类对于不同信息也存在一个筛选过程。首先是我们接收信息的过程中信息有没有足够的强度。其次是与我们的基本生存需求有没有关系。比如说我饿了,这个时候边上有一个卖吃的的话,我马上就能意识到,然后才是与我基本生存的相关度。比如我喜欢吃中餐,那么边上卖西餐,对我来说就不是很关键;然后有个自我逻辑判断。

接下来是高级生存需求。对这里面的信息我把它分为两种:一种叫作基本信息;另一种叫作高级信息。基本信息就是很直接的衣食住行、内在感觉,比如说我的脚痛、手痒等。高级信息比较抽象,它是形而上的,比如说理想、希望、娱乐,类似于这些东西,但核心还是生存信息。本质上,人不关心与我无关的信息。所

人类的信息处理

以有个强弱变化,比如说我家小孩子摔一跤,我看到后,就觉得很心痛,别人家的小孩子摔一跤,我也心痛,但没我自己家小孩子摔一跤那么痛。如果碰到一个小动物摔一跤,说不定我还觉得它摔得很可爱。所以,人其实不关心与自己无关的东西。要有足够的强度、相关度和逻辑作为信息接收的主要条件。信息接收的速度和影响力通常成反比,这个很关键,我快速接收的东西,它太基本了,其实它的影响力是有限的。有人宣传一个饭店时,我饿的时候非常容易听得进去,但是吃完我就把它忘记了。有些电影看完之后,我要想一想,我记得很深刻,有些看完就不想,它叫"爆米花电影"。其实也就是这样了。

这一部分我总结一下跟我们有关的东西。第一个,人需要的信息是不能被凭空创造的,任何完全形而上的东西其实没有意义。人的感觉器官形态决定了不同信息的强度。比如开发一款新设备,通过气味去观看一部电影,我就觉得这不太成立,因为这个信息量实在太小,这根本就不是人类主要接收信息的器官。外在信息的逻辑必须与内在的逻辑存在契合部分。你写的一个故事能不能完全架空呢?你不依附于人的基本价值观念,基本上没有人看。就好比心理学上有个手段叫作"暗示",暗示的目的是一定要激起受者的自我暗示,如果受者不能激起足够强度的自我暗示,那么这个暗示是无效的,你说一百次都没有用。一切能接收的信息其实是源于生存的本能。

第二部分,我们讲一讲高级信息。高级信息这部分有一个概念,即信息本身

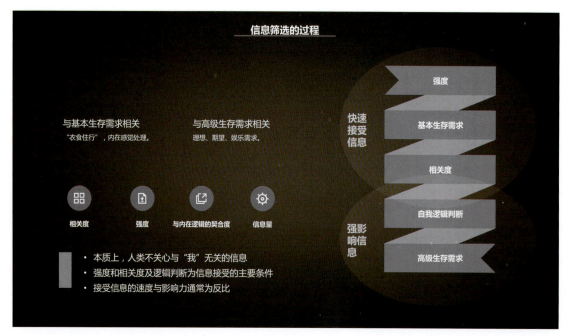

信息筛选的过程

没有真伪，逻辑才有。谎言的本质是有人很真诚地骗你，这个世界上最真诚的就是骗子。他一定用最能打动你的方式把一些错误的东西发给你，但是他骗你的时候绝对是真诚的。作为人类群体来说，他们是非常愚蠢的，他们使很多你不可思议的事情在我们周围发生；但是作为个人来说，他是非常聪明的。核心是什么问题？就在于我们人是一个社会化的动物，你要在社会化里面生存，就一定会把社会化判断为凌驾于你自己之上，不然你的日子很难过，所有东西都以我为主，这是很难过的，但是你做个人行为的时候就完全可以自我判断，这个时候人都精得不得了。社会化判断的本质是，所有形象其实都是各种意见领袖代表和专家研发出来的，他们告诉你未来趋势是什么，或者替你去判断未来是什么。我觉得有的时候我们可以停下来自己去判断。这两种情况其实是可以并存的。

　　信息传播的方式决定了信息的作用，第一个是直接信息，是受众自己采集的，他其实信不信你第一眼看完就知道了；还有一些是间接信息，即通过各种渠道的社会信息，比如看直播、新闻联播、天气预报获得的信息，它们其实都是经过加工的复合信息，对这种信息我们的接受度都会很低，都是要打折扣的。但是太基本的信息量太少，我们对信息的需求其实很大，所以我们大部分接收的都是高级信息。我们做媒体做内容，其实都在处理复合的高级信息，我们要知道不是信息量越大越可信，而是如何把一个高级信息伪装成一个基本的直接信息，这是基本技巧，这样你的受众才会相信你在里面的传播内容。

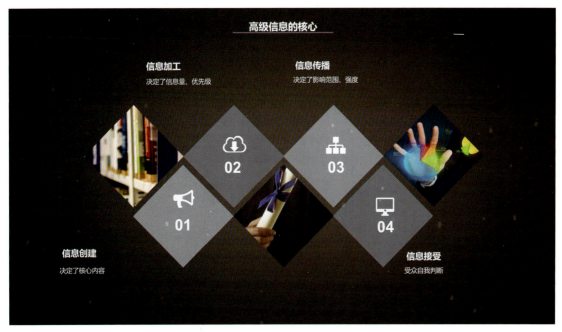

高级信息的核心

高级信息的核心其实经过了这样四个阶段。第一个阶段是信息创建。我说过了，信息不能凭空创建，它一定要有一定依据和变形。第二个阶段是加工。加工就是变形的过程，你可以把不相关的信息调和进去，然后决定哪一些信息量大、哪一些是优先级的，比如看一场足球比赛时，你会有很多信息：第一，场上信息；第二，球员介绍，包括赌盘这种信息。其实一场球赛包括了七八种信息，每一种信息包含了不一样的用途，每一种信息根据用途会有一个优先级的提炼。在国外，如果赌球的话，可能就是各种胜率的分析是主要信息；在国内，可能是球员背景、场上局面是主要信息，这是不一样的。

第三个阶段是它的传播模式，直播还是录播，传播模式决定了它的影响和强度。我们很多朋友搞过VR直播，我自己也搞过，影响范围惨不忍睹。最终要达到的目的就是信息接受。观众会自我判断，你这个是不是他想要的，你做不到准确，他就不要，或者说他不大信你，就随便看一眼。关于这一部分我要说的是，高级信息是现代人的主要信息，高级信息的加工决定了个体的接受度，也就是说你做的内容准不准确的问题。高级信息的传播决定了影响范围，第四个阶段其实最重要，即一切信息都可以伪装成真实。我个人认为信息没有真伪问题，真伪是一个逻辑性，不是信息本身。

我发言的第三部分是创建信息。说是信息，其实我们现在谈的就是内容创作。内容创作也不见得是电影，所有依赖人类感官组织起来的东西都是内容。核心信

息内容的价值观必须原生，它必须一直都有。你所能创作的是它的形式。这就是为什么有人说莎士比亚把所有人类故事都讲完了。我们现在有很多作品，包括最近很多电影，它们的核心讲的无非是人类情感那一套。有没有什么超越的？我认为没有，但在形式感上有超越。时代不一样了，对观众来说，被接受的环境完全不一样了。你再拿古典的歌剧、话剧那一套，对现在的观众来说已经与他们脱节了。

什么叫作有效信息呢？受众接受、符合需求、符合逻辑判断。信息表达是创作核心。舞台剧剧本，它们有各种形式感和包装，包括它们的节奏、单幕剧，都是表达的一种方式，但是你要讲的东西往往是最简单的人类逻辑的产物，然后暗示必须激起受众的自我暗示，你所讲的东西必须和他原生的价值观做一个嫁接，要不你就是在上课，在讲一项教科书上的内容，大家听得很无趣，你的表达就完全没有意义了。你做一项内容，涉及包装、信息、强度、渠道、受众。其实是做不到面面俱到的，只能根据你的优势资源去判断你要加强哪几部分，所有努力想做到面面俱到的，往往都是妥协到极点的平庸的东西，因为你不能把所有的低板拔高，你只能把高的地方打下去，所以内容创作核心还是逻辑与选择，但是凡是有选择，就有所放弃。

这一部分讲的就是没有凭空创造的有效信息。你不能凭空去讲一个故事，做一个栏目，做一个形而上的东西，所以说，我们到底在做什么东西，对个人来说，实现自身的高级宣传需求，实现自我价值，这是非常高层面的东西。其实也有低层面的东西，就是干干活、收收工资，让自己活下去，那就是基本生存需求。然后再往上面提一点，这就是有效传播中的实现社会价值。我们前面对比了个人和群体，我们认为个人是聪明的，群体是愚蠢的，但是从本质上来讲，群体才是更高级的推动力，它会不停地发展，朝一个越来越高级、越来越现代的角度发展，但个人不会，所有个人包括我在这上面讲的都是我个人的观念，它是一定会被淘汰的，但作为一个群体就不会，它一定是持续发展的，尽管有时候会走一点弯路，拐到某个角落里。所以对我来说我希望我们这个团队也能一起来做有效的信息传递，我们也尽量去涉及有效的工具，比如立体直播，等等，最终达到有效传播的目的。

谢谢大家！

Information Communication

▸▸ Qian Xiaoyong

Hello, everyone. On behalf of Cgangs, I'd like to share with you what we've learned from our work in recent years. Cgangs is a hardware company that has produced various devices, such as panoramic cameras, stereo cameras and EFPs. In Cgangs team, I've worked as a director and shot a lot of films, while concurrently operating our online shop, producing VR films and such. With all these things done, I think that maybe we should stop to think about what exactly we are doing. For a company who shoots films and works in the radio and TV industry as well, what is the core of it? The core is information communication.

To whom do we communicate the information? People. It's better to take a look at some basics of human cognitive psychology. Basically, we have these senses: tactile, gustation and smell, all of which have quite short ranges. For tactile, the range of it will reach where the far end of your fine hair can reach. Similarly, the range of gustation reaches where the corners of your mouth can extend. Although smell can reach a little longer, we call these three the close range senses. Auditory sense and visual sense, which are our major senses, have relatively large range. The larger the range is, the more the sense contains information. Since humans evolved, auditory sense and visual sense have been two major senses for us to perceive the environment while other senses have been auxiliary ones because they contain limited information. Compared to the range of these senses, our survival space is much larger in fact, so our life instinct spurs us to break through the limitation of sensory organs for better adaptation to the unknown. This is the meaning of information communication.

Next is how humans process information. As what cognitive psychology tells us, the process has four steps. First of all, we sense by the organs we talked about earlier. Then, we judge. Instead of the word "control," which relates too much to physics I think, usually we use the word "judge." Following that is to memorize, and in the end, we react. Once there exists memory, we would know the information we sensed from the external world. We interact with internal memory more than function directly. Within the internal, we have a firm standard to select external information, which means that not all information would attract our attention. This process in which judgments are made by us on information is that we learn and how we conduct decision-making.

In the past eras, the method that we process the known experience is usually called individual experience or human experience. For instance, we recited textbooks at the first stage of learning when we went to school during childhood, and basically, it can be seen as individual experience or human experience. When it comes to a higher level, processing the unknown relies on logic. What is the core of logic? The answer is classification. In fact, taxonomy is of the most importance to the origin of modern science, as the evolutionism has been developed since Linnaeus had already classified all the animals and plants. A new interpretive mode had been found among all the common evidence.

To different information, we human will conduct a process of selection. Firstly, whether we'll accept the information depends on how much strength it has. Secondly, the selection process has to see if the information has something to do with our basic needs to survival. Say, I'm hungry, and I'll react immediately if there is a stall selling food right by my side. The correlation with my basic needs to survival comes next. For example, I like Chinese food, so it won't be that crucial to me if the stall sells Western food. We would have a logical self-judgment on information.

Next is advanced needs to survival. Speaking of them, here I'd classify information into two kinds, one of which is basic information and the other is advanced information. Basic means it is all about basic necessities of life or inner sensation, like my foot aches or my hand itches. As for advanced information, it is more abstract, and of metaphysical matters like ideal, hope, entertainment and such, but still its core is survival information. In nature, people don't care about information that is not related to oneself, so the strength of information would change. For example, I would feel very sad when my child falls over right by my side, and I would be sad as well when seeing others' children fall over, but not as much. If the one who falls over is an animal, I probably think its falling over is very cute. So, in fact, people don't care about information that is not related to oneself. Strength, correlation and logic are essential conditions to information acceptance. How soon will information be accepted is inversely proportional to its influence. This is critical. The things I've accepted in a very short time are so basic that they just have limited influence. If I'm hungry, it would be very easy for me to accept the promotion of a restaurant, whereas I will forget it as soon as I finish eating. For some film, I enjoy thinking about it after watching and I'll remember it well, but I'd never think about those popcorn films after they end. So, that's about it.

I'd like to give a summary on what's related to us in this part. First of all, information that humans need cannot be created out of thin air, and anything absolutely metaphysical has no significance at all. The form of human's sensory organs decides the strength of different kinds of information. For instance, I don't think it is feasible to develop a new device that would

let us watch a film through smell, because the sense of smell contains too little information, besides, the nose is not a major organ for humans to receive information. The logic of external information has to agree with internal logic to some extent. Can you write a story without grounds? There would be no readers if you don't rely on the basic concept of value. It's like "suggestion" in psychology. The goal of suggestion is to arouse self-suggestion of the receiver, and if enough strength is not aroused, the suggestion would be in valid even if you repeat it a hundred times. Every piece of information that can be accepted originates from life instinct.

So, the second part of my speech is about this advanced information. It has a concept that there is nothing true or false about information itself but logic. The truth of a lie is that the liar is lying in an honest way. A swindler or a fraud has the greatest honesty in the world and the ability to input wrong information in your mind in a way that would arouse your feelings most. He is absolutely honest when he deceives you. The human group is very stupid so that there are numerous unimaginable things happening around us. But, an individual is very smart. What is the main reason? It's that we are socialized creatures. You have to put socialized judgment above oneself to survive in a society, otherwise, you would feel miserable when you are self-centered. You can make complete self-judgment when it comes to individual matters, and in most cases, people would become particularly smart. The essence of socialized judgment is all the images are developed by opinion leaders, representatives and experts, who would tell you what the future trend is or make a judgment for you on what the future is. I think maybe we could stop following others to make our own judgments sometimes. But, actually, both ways can co-exist.

The communication method of information decides its function. Direct information is collected by the receivers. You would see very directly whether he believes it or not. Indirect information is that which is received through all kinds of channels such as live streams, news broadcasts and weather forecasts. However, these kinds of information are processed and complex so that they have very low acceptability. But, our demand on information is tremendous and what we've accepted in most cases are advanced information because basic information contains a limited amount of information. In fact, it is complex, advanced information that we are processing when we produce media content. We have to know that the content would not be better accepted if the amount of information is larger. The fundamental technique is to disguise advanced information as basic and direct, so that your audience will believe the information inside the content.

Basically, the core of advanced information would be developed through four steps. The first one is to establish information. As I've said earlier, information can't be established out of nothing because it must have its basis and it would be transformed. Then, to process,

which actually is to transform, in order to make unrelated information mixed inside and decisive, to decide which kind of information contains larger amount and enjoys priority. For example, when watching a football match, you would get a lot of information, including what's happening on the football field, the background introduction of football players and bets on the match. For a single match, seven or eight kinds of information can be included and each of them has its distinct function, on which the priority extraction of information could be based. In other countries, the main information would be analysis on the win rate if there is gambling on this match. It is different from our main information that might be background introduction of football players and real-time commentary on the match itself.

Then the mode of communication, live streaming or recorded broadcasting, decides its influence and strength. Many of my friends have produced VR live programs and so have I, which has too small a range of influence to mention. The ultimate goal of communication is to get information accepted. A receiver would conduct self-judgment on whether the information is something he needs. They would not accept it or pay it any attention if it is inaccurate or it is delivered by someone whom they do not trust. On this part, what I'd like to express is that advanced information is the main information for modern people and its processing decides how much acceptability it has to each individual, that is to say, whether your content is accurate matters. The communication mode of advanced information decides its range of influence. Then comes the fourth one, which is actually the most important. All information could be disguised as truth. Personally speaking, I think there is nothing true or false about information. Being true or false is a matter of logic rather than that of information itself.

The third part of my speech is to talk about information architecture. Information being said, here we are actually talking about content production, which might cover everything, not merely films, that is constructed by human sensory organs. For the core information, its content must have a native sense of value which exists all the time. All you can create is its form. This is why there is a saying that Shakespeare had already written all kinds of human stories. We could see the core of his works, and many films made later, Which is no more than human feelings. Is there any piece of work surpassing this? In my opinion, none. However, the form of information has surpassed. Time has changed. The environment in which the receivers would accept information is totally different. To audiences nowadays, there is a disconnect between them and classical operas or dramas.

What is effective information? Those that can be accepted by audience, satisfy demands and conform to logical judgment. Expression is the core of producing content. All the forms, designs and rhythms of a play, including one-act plays, are ways of expressing, but what you'd like to talk about is usually the simplest product of human logic. Audiences must be aroused

to develop self-suggestion, which means, what you're talking about must have something in common with their native sense of value, otherwise, you are like teaching them and broadcasting something from a textbook and this kind of self-expression would make no sense at all because people get bored of it. When you are producing contents, there would involve design, information, strength, channel and audiences, and it is very hard for you to give mature consideration to all aspects. You can only decide which parts should be strengthened based on the pre-potent source of your own. Contents that wanted to cover all aspects often turn out to be of the greatest mediocrity, because you can only limit to make up the fact that you cannot level all of it. So, the core of content production is still logic and selection, whereas once there is the latter, there is compromise.

So, this part is to say that there is no effective information created out of nothing. You cannot tell a story, produce a program or create something metaphysical without grounds. Back to the question: what exactly are we doing? At a very high level, an individual is trying to realize his advanced demand for advocation and to realize his own value. At a low level, it's about basic needs to survive, that is, working and living on salaries, and if we level it up a bit, it's realizing one's social value through effective communication. We've compared the individual and the group. We think that an individual is smart while a group is stupid. However, in essence, groups are the most advanced impetus, which would keep on developing towards a state that is more and more advanced and more and more modern while an individual would not. All opinions of an individual, including what I've been talking about, is doomed to be obsolete. But with sustainable development, a group won't be obsolete, although it might take an indirect route in the process. For myself, I hope our team can work together to transmit effective information and try as much as possible to involve those effective tools, for example, stereo live stream platforms and such, to realize effective communication.

Thank you!

International Conference &
EXhibition on Visual Entertainment

2017 ICEVE 北京国际先进影像大会演讲集

高质量影像与先进制作流程主题论坛

Lytro Immerge: Virtual Reality Cinema with Six-degree-of-freedom Viewing

◎ Kurt Akeley

Lytro Immerge is a VR cinema product with the unique capability of allowing full six-degree-of-freedom viewing. Let me give you a little bit of history and background. Lytro is a ten-year-old company. I have been working at Lytro for seven years. During that time, we have built a lot of technology for capturing, processing, and playing back light field imagery. The original light field cinema in 2012, the Lytro Illum, has a 40-mega-pixel sensor. It was actually capable of generating pretty compelling light field images. Over that time, we built the company up to about 100 employees and we have a pretty substantial IP portfolio.

We made a change in the business about two and half years ago, and switched from doing consumer products to doing professional products, which has been a lot of fun. So the Lytro Immerge briefly fills up a position in the market that is unique at the moment. It is more fundamentally immersive for VR capture than the standard 360 degree kind of videos that many of you have seen. It has higher image fidelity than what you can get by doing 3D rendering even with the amazing things that today's game engines can do.

Last year, when I talked about this product at this very conference, I showed what I meant by six-degree-of-freedom. The fact is that viewers can move arbitrarily within the view and at all times the view that the viewer sees is correct for that position and that orientation. To do that, we capture the light field within a viewing volume, so as long as the viewer's head stays still, that volume that the viewer experiences has the correct perspective and even the correct lighting.

This year I can show something that is a little bit more compelling. In this video,

Kurt Akeley on ICEVE

Lytro at a glance

The light field viewing volume

Stunning realism and rich infomation

there is someone in an immersive experience with a VR headset on, and then at the lower right there is a screen that is showing what one eye of that headset is also displaying. As he moves his head you will see the effect that his movement has on the image. He moves forward, moves backward, tilts sideways—it doesn't make any difference where he moves his head, the image that is being created is exactly correct.

So as he moves forward, the view moves forward, back, sideways. That is the actual implementation that I couldn't show you last year. Likewise last year, there were a lot of questions about who is using it and what they are doing. Well they couldn't be answered until now.

There have been two full live action productions, and one full computer graphic render production. They have been very well received. The one called *Hallelujah*, the first one, has been viewed at a lot of places, very favorably. I know particularly that it is currently being viewed at the Museum of Contemporary Art Montreal at the "Leonard Cohen Exhibit." This is a Leonard Cohen piece of music that has been done, so they were particularly impressed with this.

Let me first just review a little bit of this business of light field, this will be a high level discussion and we will get more technical a little bit further into the talk. Basically, by ignoring light field, the choices you have for reproducing or having an immersive experience boil down

to two things: The experience can be created by modeling, standard computer graphics build the model of, for example, an elephant, and rendered the model of the elephant. This works very, very well for the parallax sense of immersion. 6 degrees of freedom, no problem. With computer graphics, we can render the elephant as easily from one position to another. When we do the lighting, it will be correct for that position. It is great for those purposes, and what it says here is that it has low realism. That is not quite fair.

You know the modern game engines can do remarkable things, but they are still not as good as cinema. In cinema, it is still very challenging to convincingly model people in the way that fools the viewers. It's not possible at this point, and it is impossible in game immersions at this point.

The other way to do immersion is to capture images and to play them back. Unfortunately that experience by and large is an experience that is limited to basically a single center of perception. There are some tricks that get a very rudimentary form of binocular parallax. But they can't really do a view volume. When you move your head, the world moves with you. Actually, at this point, I can't stand that anymore, so I really, really think that one of the huge advantages of this 6 degrees of freedom of immersion is just the comfort of reviewing. You feel that you are in a world where the objects are sitting still and not moving with you.

So those are the two standard choices light field provides. The third choice is where we can have our cake and eat it. Where it is possible to have the fidelity of imagery, and also have the 6 degrees of freedom sense of immersion that you get with the geometric rendering. By doing that, we gave people an alternative to not have to make that artistic trade off of having either less than convincingly real or less than convincingly presence-like.

Choice:Realism vs Immersion

So that is how our Immerge positions itself in the market.

I mentioned that we have done several productions. Our goal as a company is to make customers satisfied and happy, and I can report to you that so far we have been able to do that. So I want to talk to you a little bit about the feedback we had. Why do they like working with Lytro?

I think if you have to boil it down to just one thing, it would come back to this issue

of being able to reproduce human beings extremely convincingly. It's hard to do, it's very difficult, I think it's impossible to do with pure geometry today. It's hard to do even with imagery, and we are successfully doing that. So that would be the single most important thing, but there is more.

For example, being able to do those extremely convincing humans, but also have that sense of presence, that palpable sense of being in an environment that is rigid around you and that you can therefore move closer to, farther from, look at things, change your viewpoint and it all just stays right where it is supposed to be. That sense of presence is extremely powerful.

Filming with Immerge

We do that by getting the head parallax correct, so that the view is correct. Where you move your head, the binocular parallax is correct. Once you can get the parallax correct for a given view, binocular is just doing it twice. There is nothing really hard about binocular parallax at that point.

And then finally, getting the view-dependent lighting to be correct. Remember for things like faces, trying to model them, a simple reflectances or simple BRDF doesn't work. There are sub-surface scattering. There are a lot of complex lighting effects in human faces, especially around the eyes. Trying to model all that at the game engine rates is essentially impossible, but capturing it with images and playing it back with light field technology works.

I am just gonna show off a little bit about what I mean by view-dependent shading. Highlights move in a real sense as I mentioned last year. The highlight is just another form of parallax, you are an expert at figuring out whether the highlights are moving correctly or not. They move differently than the objects, but they move in the way that is consistent with the lighting properties of the scene and of the objects being illuminated and if they do not work right, you can tell. Getting all that stuff right is really, really important for a sense of presence and immersion.

Our rig has almost a hundred cameras on it, and we use them multiple times, so by the time we are done, we have captured on the order of five hundred views of a scene. We then sythesize into this light field and playback, as a result we can do our analysis in a much more robust way than if you just got a handfull of cameras. So we can deal with real cinematic lighting of the scene in ways that simple binocular systems are much less robust to, and much

less capable of doing.

The system is designed to be used by professionals in ways that they are used to doing things. A couple of things to point out: one is that the camera, the physicalness of it, allows the person using the camera, the director, to sit behind it and view the scene as it is developing, to interactively see the views of the different cameras, typically the extreme view to see exactly what has been captured. Then the subsequent post-production all works with industrial standard, typically Nuke.

So we have a whole bunch of plug-ins and the people who develop at Lytro are people who have used these things year after year in the industry, so they know exactly how they need to be used and what we need to do to make the whole system effective for professionals. As a result, it works very well for capturing and doing post production. Remember that the core thing captured here is imagery so it is a very comfortable fit to a standard post production facility. These are reasons why the people we work with enjoy working with Lytro and are successful working with Lytro.

Immerge 1.0, it's our intention to make a variety of rigs, just like standard cinematic capture involves different lenses and even sometimes different cameras. That is going to make sense for cinematic light field VR capture as well. So we have plans for several different rigs. I am describing the one that was used to capture the imagery for the productions that I have mentioned to you.

This is a planar capture system, which might be a little surprising. Like we are capturing a volume, but we were doing it with a plane. The way we are doing that actually is the planar system has a limited field of view, and we actually have to capture the scene in five separate takes.

Having done all that, all this information, almost five hundred camera's views, is synthesized together into a single light field that is accurate for any viewing position within a volume, we call it the viewing volume, it is a little less than a meter in diameter.

You might think well that is quite a constraint. A lot of us think that capturing a 360 degree video with a 360 degree field view capture system and then indeed that is possible, but it turns out that it's not actually very practical for professional applications.

I will just mention a couple reasons why: One, by capturing just a limited field of view, it's possible to have control over that separate from the rest of the environment in particular to be able to do lighting. There is a lot of fancy lighting happening behind the camera, as you would see on any other set. But you can't do all this fancy lighting if the camera is capturing 360 degrees. So having a limited field of view captures has been less of the concern than we expected initially. 90 degrees is enough.

We certainly have plans to do capture systems that are closer or perhaps exceed 180

degrees but we are relatively uninterested in doing this high quality captures for an entire 360 video for professional applications. It makes more sense to piece these things together.

 A couple of technical notes: one is that the planar array actually keeps the cameras far away from the edge of the viewing volume, which means that it's easier to allow objects to get closer to the viewing volume and still remain in focus with the cameras. So there are some real practical advantages to a non-convex rig like this, a planar rig is one example of a non-convex rig.

 Now I wanna to dig in a little bit more on this whole business of 6 degrees of freedom playback. This is the part of the system that I have done most of the architecture on.

 What I am gonna to say, flat out, is that you cannot do this by stitching images together. You cannot do this by warping and distorting images. These approaches, this sort of classic image based algorithms, simply will not produce a convincing result. What you need to do is one pixel at a time, build the headset image, by choosing the right pixels in camera images and bringing them together, taking advantage of some information that has been computed along the way, to make each final image. This is the only way to get the kind of result that is really desired here.

 The way we do that is called re-projection. It is expensive, but it's essential and it's a light field approach. The pay-off is, if you do it right, then everything works right. The way I would like to think of it, technically, is all the parallax cues are correct—the head position cues, the binocular cues, the view dependent shading cues. Everything about how it would have look from a view point is accurately reconstructed.

 That's our goal. That is what we set out to accomplish.

 In order to understand re-projection, it's useful to start by just reviewing what is meant by projection. I am just gonna talk about one point in the 3D scene. This is not a realistic thing, but it's good for understanding what is going on to the system. So a simple planar projection camera, just a side note, ultimately we cannot be doing planar projection in a system that does 360 degree fields of view, but to keep this simple, I am just doing planar projections here.

 How do we project that 3D point in the scene onto the camera image plane?

 Well, we do two things: we cast

a ray from the center of perspective through the point of the scene, then we compute the intersection of the array with the image plane, and that is the projection. Mathematically, projection is a reduction in dimension. There was a 3D point in the scene, it has become a 2D point on an image plane.

That's projection, that's how cameras work.

So having done that, now we want to create a new view. How about doing that?

Basically, three important steps: firstly, the biggy, we are going to go through every pixel of every camera image and compute the distance or the depth from the camera to the object in the scene that illuminated that pixel to the 3D scene point.

We compute all those steps. So that is a lot of work, but remember, we have a lot of camera views, so we can do that. Once we have done that huge chunk of work, which is all done as part of our preprocessing step, and it doesn't actually happen during playback, then the second step is to just do the projection in reverse. So we know where the center of the projection is, we know where the 2D projected point was, we know the depth: those things together allow us to recompute, this time mathematically, rather than optically, the 3D scene point and then once we've got the 3D scene point, we can project it to the new view, compute the new intersection, and then we are done.

We call this a reprojection because it is a projection from data that was already projected. So it's a second projection; and that is the core algorithm for what happens in our system during playback. One other note, there is an interesting property here called the reprojection angle, the angle formed between the rays from the camera center of perspective and the ray from the view center of perspective. It's always better to keep that angle smaller, that is a fundamental reason we have so many cameras on our rig.

Why do we need a camera every 10 centimeters, why do we need 500 cameras to capture all this info? Because we want to keep that reprojection angle small. If it gets large, lots of bad things happen. I will just mention two: One is if there is any error in the depth at all, then the reprojection ends up being in the wrong place. You can see how that is a pretty strong property of what the angle itself is.

The second is, remember we are trying to reproduce view-dependent shading, but those views here have very,

very different angles to the point and consequently they will have very different shading effects if there are specularities, reflections, or anything interesting going on. So we wouldn't be able to reconstruct anything well if we did things with large reprojection angle. In practice, these angles are kept very, very small.

That is an overview how reprojection works. I am going to take a few minutes here without getting in too much detail. I will just talk about why it's hard. I am going to list seven reasons why it's difficult to do. The first one is something I think a lot of us call disocclusion, this is a very simple problem, as you can tell by just moving your head around here. When you look from a different position, things just look a little different, things that you couldn't see before come into view, consequently, when you reproject one image to another at a different view point, there are things in the new image that weren't in the original image. They won't show up. The only way to fill in those voids, these disocclusions is to reproject multiple camera images which have different view points, typically surrounding the view point that you are trying to create. It doesn't take many usually, so I just say up here, we are gonna need several cameras in order to handle these disocclusions. Of course you can think of fiendishly difficult situations, but generally several works.

Good? Unfortunately not so good. Here is where it gets more complicated. We want to do view-dependent shading, remember that means we need to keep that reprojection angle small. Well if the view you are trying to recreate nears a camera, meaning its center of perspective is physically, mathematically at least, close to the center of perspective of a camera view then that camera view can provide good pixels of rays for most of the new view, but suppose the new view isn't near any of the cameras, so considering our planar rig, suppose that it's near the front of the view volume instead of in the plane of the cameras, it's quite possible that you need all of the camera images to create one headset view.

So it's not that you need them all for one pixel, but you need them all to create a single headset view while simultaneously ensuring that you do not have large reprojection angles. That's hard. That is a complicated data management system required to be able to do that.

A third thing, ideally, there would be a right place to put a pixel. I did not talk about pixels, but cameras don't actually capture points, they capture pixels. And that pixel has its own small solid angle, and it may actually view multiple objects in the scene. If it hits a silhouette of something close by, part of its colors is from the nearby object, part of its colors is from a further object or a background.

Uh oh, what do you do with that?

That's hard. If you reproject it with either the depth of the near or the far object, some color is gonna end up in the wrong place and the bigger the reprojection angle the more wrong places it gonna end up in. This is another reason to keep that angle small, but this is a serious

problem and there is lot of technology in our systems to deal with this.

The fourth one, spacial continuity. If I move like this, it won't do to have things suddenly change color. So I'm gonna have to do what's done in computer graphics over and over. The standard solution is we sometimes call it "lurping" in computer graphics, we have to interpolate. We cannot make any sudden changes in how we do that reprojection based on the head-position, or else we are gonna get caught. You are going to see it when you move your head, we do not want that. I did not even mention temporal continuity, that is hard as well.

Image resolution, to be convincing, we need a lot of pixels, and in order to get the view-dependent shading right and all this parallax right, we need a lot of more pixels. Remember, there were 500 camera images captured at 30 frame per second, it's quite a mountain of data, so we would have to support these huge amounts of data and substantial bandwidths that are required and we have to do all that at a frame rate that is accepted by modern headsets, which I think at this point is a minimum of 90 frame per second and it is gonna get higher rather than lower. It's an amazing amount of computation. Remember every pixel of every frame has to be computed by pulling together the right pixels from the camera images.

Finally, we must do this, because it turns out the cameras that we distributed this year don't do this. The videos, the immersive experience, our customers have seen so far this year do not correctly anti-alias silhouettes and those of you who know about computer graphics recognize that is sort of a crime. It really isn't acceptable these days not to do good sampling.

What I want to do is switch from that section to talk a little bit about new product Immerge 2.0 that was introduced just earlier this week, so you are hearing about it right away. This is a result of work a lot of us, certainly including myself, have been doing for the last year. Really, two exciting things have happened. The first is we have been able to push the fundamental image resolution up substantially.

Here the actual way we store images on our system is an equirectangular projection, that's why they look distorted here, but they get put back together appropriately. This is the kind of non-planar projection that is required for large fields of view. This just models the relative change in the number of pixels. At 5K, we are the market lead in image resolution. This makes a real measurable difference. If I can put you in a headset, you would be able to see this difference right away. This is mostly just a plumbing and bandwidth challenge. It's relatively uninteresting, technically not to say it isn't hard.

What's more exciting to me is that we have been able to solve this anti-aliasing problem. It's not that there are more pixels, it is that there are better pixels. The pixels along an edge have their colors blended between foreground and background in a way that collectively causes the edge to appear smooth.

In the *Hallelujah* video, the image on the left is what we released, the image on the right

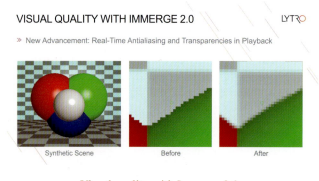

Visual quality with Immerge 2.0

Lightfield work *Halleluja*

is anti-aliased. The original looks kind of jagged. See the ripples moving up and down. The anti-aliased looks a lot better.

The area under the singer's right arm, is what we have learned to call it a key hole, like *Alice in Wonderland* looking into a key hole. These are some of the most difficult things to deal with because the background is occluded almost anywhere you look. It's quite possible in extreme cases that no camera capture parts of the background. If the key hole is close to the camera and the angles end up being high, you might not have anything to put in that background. So these are really interesting challenges. All of this is immensely obvious, when you have your head in the headset, and it makes a huge difference to that sense of actually being there where the parallaxes are there, the shading is right, and now you are not seeing those time and false motion artifacts that result from animated anti-aliasing.

I have just being really excited and satisfied to be able to get this technology in. At this point I see no fundamental reason why we can't move this system progressively towards true cinematic playback quality, whatever exactly that is. There are no fundamental things in the way and that's where we are headed.

Lytro Immerge 系列相机：用六自由度观看的 VR 电影

▶▶ Kurt Akeley

Lytro 公司的产品 Lytro Immerge 系列相机是一款 VR 光场相机，具有六个完全的自由度视角，功能十分独特。在我正式开始之前，我先给大家讲一讲相关的发展历史和背景知识。Lytro 公司创立已有十年时间，我在这家公司工作了七年。在这七年里，我们研发了许多图像捕捉和图像处理技术，以及光场图像回放技术。Lytro 公司最初在 2012 年发布的光场相机 Lytro Illum 的配置在当时来看很不错，有一个 40 万像素的传感器。这款相机实际上能够拍摄出相当引人注目的光场图像。在那段时间里，我们终于努力扩大了公司规模，大约雇用了 100 名员工。我们旗下的原创作品选辑库也相当丰富，掌握着许多知识产权资源。

大约两年半前，我们公司开始调整产品线，原先做普通的消费类产品，现在转做专业的摄影产品。我们一致认为这样的调整很有意义也很有趣。我想这也就是为什么 Lytro Immerge 系列产品当时能在相关市场上占有一席之地。现有的标准 360° 相机许多人都见过，我认为比起这种相机，使用 Immerge 进行 VR 图像捕捉能获得更为身临其境的体验感觉，这是一个最大的不同点。它也具有更高的图像保真度，而且比寻常的 3D 渲染技术所获得的图像要高清得多，甚至在那时就能完成一些当下游戏开发引擎才能实现的惊人制作。

所以我去年参加这场会议时，也特意提到了 Immerge 光场相机。当时我向观众展示了这些幻灯片，用动画方式在屏幕上向观众阐释何为相机的六个自由度。简而言之，拍摄者所能看到的客观实体可以在他的视野范围内任意移动。在任何时候，拍摄中所在的视线角度相对于他的位置和方向来说都是正确的。为了做到这一点，我们捕捉了拍摄者视体内的光场，因此只要操作者保证他的头部不偏离这一空间，那么他就能找到正确的拍摄视角，甚至也能找到相应的灯光安排。

而今年，我想给大家展示一些更具吸引力的最新 VR 科技产品。请看这个视频，你们会在屏幕上看到有一个人正戴着一款头戴式 VR 视图器，体验沉浸式虚拟现实。屏幕右下角的视频窗口则把佩戴者在视图器内所看到的内容同步展示给我们。我想提醒大家仔细观察一下，当佩戴者移动头部时，你会发现他的实体移动对 VR 形象是能够产生影响的。从这个小视窗你就会观察到，不管佩戴者的头部是向前移动、向后移动，还是向旁边倾斜，视窗里的 VR 形象都会做出十分精

准的相应动作，两者没有任何区别。他的动作恰恰就是他所创建的图像。

当他向前移动时，视图也会向前。向后移动和侧向移动也都是如此。这就是我去年还不能完全为大家演示的新技术的实际操作情况。同样，去年也有很多关于这一技术的问题，比如它的使用者是谁，他们会利用这一技术研发哪些产品、制作什么作品，等等。虽然到目前为止我们还无法回答这些问题，但我相信人们至少在今年就可以给出一些比较翔实的答案。

目前已经有了两个完整的实景真人作品，一个完整的计算机绘图渲染作品。这些作品一直很受欢迎。其中有一部叫《哈利路亚 (Hallelujah)》，它是我们第一部应用这一技术的成片。在这里我简单给大家介绍一下。这部 VR 作品在很多地方公映过，后期宣传非常顺利，很受欢迎，它目前正在蒙特利尔当代艺术博物馆内的莱昂纳德·科恩展上放映。这部作品源自莱昂纳德·科恩的同名歌曲，因此观众对这部电影的印象非常深刻。一年来这部作品的推广宣传也取得了许多骄人的成果。

简单讲完这些，我们再来回顾一下光场这一话题。这会是一次高层次的讨论，我们多谈一些技术方面的问题。基本上忽略你需要再制造的光场选择，沉浸式虚拟现实体验可以归结为两件事情：人们可以通过建模实现这一体验，用标准的计算机制图建立大象的模型，再渲染大象的模型。对于沉浸体验的视差感而言，这是一种效果非常好的制作方式。用上六个自由度，没问题。而借助计算机图形学，我们可以很容易地把大象一个位置接一个位置地渲染完。当我们着手处理布光安排时，灯光也会随图像的位置相应调整。这一技术对于以上这些应用目的来说当然很好，但是我在这里要讲的是它的实现程度还比较低，目前清晰度还不太高。

你们都知道，现代游戏的开发引擎可以制作许多效果非凡的作品，但它们的成像效果依然不如电影好。就电影制作而言，想要用低水平、低清晰度的工具创建真人模型，愚弄观众，基本上还是一件非常有挑战性的事情。也就是说，根本不可能。游戏中沉浸式体验的制作经验无法完全复刻到 VR 电影制作上。

另一种方法则是捕捉图像，并将这些图像回放。不幸的是，目前这一技术总的来说还有局限性，基本上只能围绕单个中心来感知图像。好在现在已经研发出一些改进办法，能帮助我们在图像捕捉中初步实现双眼视差。但尽管如此，这些改进办法也仍旧无法真正找到相应的视体。当你移动你的头部时，这一虚拟世界就会随你而动。其实在那时候我再也忍受不了诸如以上的种种不便和缺点，所以新研发出来的六自由度沉浸式相机的确具有独特的优势，进步意义明显，我今天回顾起开发历史时，也愿意以它作为安慰式的收尾。体验者自己操作时会觉得他们处在一个静止的虚拟世界，物体还好好地待在自己身边，没有随着头部的移动而挪动位置。

也就是说，除了前面所提到的两个标准方案，光场可以提供第三个选择，我

们可以通过光场顺利地实现制作期望。不仅如此，光场还可以保证图像的逼真度，并且操作者还可以借助计算机图形渲染在虚拟现实世界中体验到全新的六自由度沉浸感。通过这一办法，我们顺利为人们找到了一个可行的替代方案，既不会减弱这种艺术性制作的真实程度，也不会令人十分不相信 VR 制作的现实存在性。

以上这些就是我们的 Immerge 系列相机能在市场上占据一席之地的原因和发展历程。

我刚才也提到了我们完成的几部作品。作为一家企业，我们的目标是让购买技术和产品的客户满意和高兴。关于这一点我可以很自豪地告诉大家，到目前为止我们已经有能力做到这一点，所以接下来我正好想和你们谈一谈我们收到的反馈意见。客户为什么喜欢和 Lytro 合作？

如果你们希望听到一个简明扼要的答案，那我会说，是因为 Lytro 的产品能够在虚拟世界中再现人类模型，拟真度令人信服，精度也非常高。想要做到这一点很难，非常困难。我认为目前人们还不可能用纯粹的几何绘图实现这样的拟真再现，即使用成像也很难做到，而我们正借助新科技有所突破，顺利完成了这一任务。在过去，我们认为这项技术突破是当时最为重要的一项任务，但我相信往后还会有更多的重要研发成果。

例如，能够做出极其逼真、令人信服的人类模型，也能给使用者以真实存在感。我们希望体验者能明显感受到虚拟环境真实存在于他们的身边，他们可以或近或远地接近那些虚拟物体，或者能打量它们。他们可以改变自己的视角，也可以干脆一直待在相应位置，保持不动。我认为有朝一日这种真实存在感会非常强烈。

我们打算通过利用正确的头部视差来实现这一点，以此保证视角的合理性与正确性。体验者不管把头部朝什么方位移动，都要保证他们的双眼视差也相应正确。人们每校正一次一个给定视角的视差，双眼视差相当于完成了两次校正。在这一点上，实现双眼视差并不存在任何困难。

最后还需要校正与视点相关的灯光位置。另外还要记住，用计算机绘制像面孔这样的东西时，需要尝试对它们进行建模，仅用简单的反射系数或简单的 BRDF 工具是行不通的。除了面孔之外还有散射的次表面。人脸包含很多复杂的灯光效果，特别是在眼睛周围。而实际上，想要以所有游戏开发引擎的速率对以上这些表面进行建模是不可能的，但是我们可以通过图像捕捉，并利用光场技术进行回放，这是能够实现的。

所以现在我打算稍微为大家展示一下刚才所说的"基于视点的阴影"的制成效果。虽然这不是用我们的操作系统做出来的成品，它只是一个图像捕捉视频，但原理是相通的，你们应该能体会得到，这正是我去年所提到的那些真正意义上的高光效果。高光部分仅仅是视差的另一种形式，想必你们都很擅长计算高光是

否在正确的方位上移动。我们都知道，这些高光的移动方式与物体的不同，但是它们的移动需要和场景的布光道具，还有被照亮的物体保持一致。如果这些高光的移动方位有误，你们就可以利用这套开发工具指正改进。所以说，对于 VR 的真实存在感和沉浸式体验感而言，绘制好所有的素材是其中一个非常重要的步骤。

这套设备安装了近百个相机，我们平常工作时会多次使用这些相机，所以当我们完成某个项目时，光是针对其中一个场景就能捕获五百个不同角度的视图。然后我们会把这些视图合成到相应的光场之中，并进行回放，因此我们能够着手分析更为强大、全面的视图，这可要比仅用几台相机得到的拍摄效果好得多。因此我们也就可以借助这些数据，更好地处理真实电影的场景布光问题。简单的双眼视差系统没有这么强大，不具备这样的操作能力。

这个操作系统从头到尾都是为专业人士所设计的，很多细节设计都与专业人员的日常操作习惯相符。另外，我还需要说明几点，其一和相机有关。一会儿你们就能看到光场相机的物理特征。导演在使用这款相机时，可以坐在它的显示屏后监制身前正在进行的场景，还能以交互方式查看角度各异的摄像机拍出来的不同视图。你们现在看的是其中一个典型的极端视图，导演能够通过这些视图准确把握相机所捕捉的图像内容。接下来就是后期合成制作，我们所有的后期制作都按照统一的工业标准进行，典型的合成工具是 Nuke。

另外，我们还有一系列配套的插件程序。而且在 Lytro，开发这些工具的员工恰恰也是在 VR 这个行业日复一日、年复一年使用这些工具的人，所以他们完全知道这些工具应该怎样使用、我们公司又该如何改进开发工作，从而让我们的产品能够为专业人士服务。所以说这套程序非常适合图像捕捉和后期制作。这里要请大家记住的一点是，我们刚才一直在讲的被捕获的核心内容指的就是图像。因此这一产品非常适用于标准的后期制作。同样这也可以解释为什么与我们合作过的客户都非常享受与 Lytro 的合作体验，并且屡屡成功牵手，加深合作友谊。

我们打算借助 Immerge 1.0 产品制作各种各样的配套设备，这些设备好比那些装有不同镜头的标准的电影图像捕捉设备，有时甚至能够配备不同的相机。这样的设备对于影片的光场 VR 捕捉同样也有意义。而且我们针对不同用途的设备制订了不同的研发计划。我现在所描述的这一套设备已经顺利捕捉过几部 VR 作品的图像，这些作品我前面都和你们提到过。

实际上这是一个二维捕捉系统，你们可能会有点感到惊讶。这就好比我们捕捉视体的过程，两者都是基于二维平面完成的。没错，我们的操作系统其实是一个二维系统，而且视角有限，所以我们在实际操作过程中不得不通过五个独立的取景镜头捕捉场景。

完成上述所有工作之后，我们会把将近五百个相机视图的所有数据合成到一个单一的光场之中。这样一来，这个光场对于视体内的任何观察位置而言都会十

分精确。我在这里所说的视体直径略小于一米。这就是迄今为止我在舞台上所做的一切。

你们可能认为对于 VR 制作来说，这一个局限性很要紧。我们很多人都会考虑用 360° 视场捕捉系统来捕捉 360° 视频。这个想法确实有可能实现，但是事实证明，对于专业的设备来说，这个办法其实并不十分实用。

我只想提一提其中几个原因。首先，通过捕捉有限的视场，人们有可能实现把这一视场与周围环境的其余部分分开控制，这样尤其有助于实现灯光布置。你们可以看到摄像机后其实有许多奇特的灯光布置，恰如你们在其他任何设备上所看到的那样。但是如果相机正在捕捉 360° 视频，就无法完成这些所有的灯光布置。因此有限的视场捕捉已经不如我们最初所预期的那样令人担忧。我认为 90° 的捕捉就够用了。

当然，我们也计划研发出能够实现接近或可能超过 180° 的捕捉系统。但是相对来说，我们对研发专业设备上的高品质捕捉系统，录摄 360° 视频这件事就不太感兴趣了。我觉得还是把这些视频素材拼在一起更有意义。

有两点技术注意事项需要说明：其一是平面阵列实际上能使摄像机远离视体的边缘，这意味着它更容易让物体接近视体，并且能保证物体仍然处在摄像机的对准焦点范围内。所以这样一个非凸形设备其实有一些很实用的优点，平面设备恰好就是非凸形设备的一个应用范例。

好了，现在我还想更深入地和大家谈一谈六自由度回放这一话题。这是操作系统的一部分，我大部分的架构工作都是在这一系统上完成的。

有一点需要和大家说清楚，我们不可以借助拼接图像来实现这一点，也不能倚靠图像变形和图像扭曲。上述这些方法可以说都是经典的基于算法的图像实现手段，但是放在这里，它们根本不能绘制出具有说服力的图像。你需要做的是选择相机图像中的正确像素，并将它们放在一起，利用好拍摄过程中的一些数据。你应该一次确定一个像素，绘制头戴式视图器图像，最终就能绘制出每个图像。我认为想要得到刚才提到的那种绘制效果，这是唯一的办法。

我们把这种操作称为二次投影。二次投影的成本比较高，但是非常关键，很有用，属于一种光场方法。二次投影的回报也比较大，如果你能利用好这一方法，那么所有操作都会导向正确的结果。其中我想谈到的一个技术问题是在二次投影中所有的视差线索都是正确的，包括头部位置线索、双眼线索以及和视觉相关的阴影线索。我们可以精确地重新构建物体在某一个视角的方位、大小，等等。

这就是我们的目标，是需要我们完成的工作。

为了帮助大家更好地理解二次投影，我们有必要先回顾一下投影的含义。在这里我给大家介绍一个非常简单的相机模型。我要和大家探讨的只是 3D 场景中的一个点。它不是一个现实物体，但对我们理解操作系统内正在运行的程序步骤

很有帮助。我在画完这张图像之后，会再检查一下自己的幻灯片。我勾画相机的方式和计算机图形学者勾画相机的方式相同，都是把图像平面放在透视中心之前，因为这在数学上很容易实现。物理相机则是以另一种方式进行工作。这里两者的争论无关紧要，我主要还是谈谈这个模型。这样一个简单的平面投影摄像机只是一个边注，我们当然不能在一个做360°视场的系统中进行平面投影，但是为了解释得简单些，在这里我暂且只演示平面投影。

我们如何将场景中的三维点投影到相机的图像平面上？

我们需要做两件事情：我们首先从透视中心投射一束光线，穿过场景中的这个点，然后计算阵列与像平面的交点，这就是投影。从数学角度来讲，投影就是维度的减少。场景中原来的三维点现在已经成为一个图像平面上的二维点。

这就叫投影，即相机工作的方式。

完成这些之后，现在我们要创建一个新的视图。这又需要哪些步骤呢？

基本上有三个重要的步骤：第一步，放大。我们首先要完成每个相机图像的每个像素，场景已经将像素照亮到三维场景点，我们需要计算相机到这一场景中的物体的距离或深度。

所有这些步骤都需要进行计算，所以我们的工作量会很大。不过请记住，正是因为我们有很多相机视图，所以我们才可以做出这样的效果。刚才我们说到，需要为每个相机视图的每个像素计算这些步骤。这些工作其实都是图像预处理步骤的一部分，实际上在回访过程中并不会出现。一旦我们完成了这些繁杂的操作，就可以开始进行反向投影了，这是第二步。我们知道投影的中心在哪里，我们也知道二维的投影点在哪里，我们也知道深度。借助这些数据，我们可以重新计算三维场景点的位置，这一次是数学意义上的计算，而不是光学层面的。一旦我们计算出三维场景点，就可以把它投影到新的视图上，计算新的交点，然后这一步就完成了。

我们之所以把这一步称为二次投影，是因为它是基于已有投影数据的一次投影。这就是二次投影最基本的含义。这是我们的操作系统在回放过程中所运用的核心算法。还有一点需要注意，二次投影有一个有趣的属性，叫作二次投影角度。相机透视中心的光线与视图透视中心的光线之间所形成的角度就是二次投影角度。一般来说，把二次投影角度控制得越小越好，这也是我们的设备上装有那么多相机的根本原因。

为什么我们每10厘米就需要一个相机镜头？为什么我们需要用500个镜头来捕捉所有这些信息呢？因为我们想让二次投影角度尽量小一点。如果这一角度太大，没有控制好，就会出现许多难以处理的情况。在这里我只想提一提两种可能出现的情况：其一是假如有关深度的数据出现任何错误，那么二次投影就会投影在错误的位置。所以你们会发现，二次投影角度本身是一个非常强大的属性，起

决定性作用。

其二，你们应该还记得，我们目前正在试图重新构建视点相关的阴影，但是这些视点彼此之间的角度有很大的不同，因此如果存在镜面反射、反射或者其他任何有趣的现象，它们就会产生非常不一样的阴影效果。也就是说，如果我们的二次投影角度过大，我们就无法重新构建任何阴影。而我们这个草图之所以会向大家演示很大的二次投影角度，是因为这样画起来更容易、更清楚。实际操作可不是这样的，这一点请大家牢记。在实践中二次投影角度一定是非常非常小的。

我们刚才简单讲了一下二次投影的原理，接下来我会再花几分钟时间和大家讲讲为什么这一操作实现起来很困难，不会涉及太多的细节。我认为有七个原因导致二次投影难以操作。我们很多人把第一个原因称为空洞问题。这是一个非常简单的问题，你们转动一下自己的头部就能理解空洞这一概念。当我们从不同的视角观察某一物体时，不仅呈现在我们眼前的三维图像会有所不同，而且我们还能看到许多在初始位置观察不到的东西。因此，当我们以全新的视角，把一个图像重新投影到另一个图像上时，后者会出现一些在原始图像中无法找到的新内容。原始图像中是没有这些内容的。填补这些空白和图像空洞的唯一方法是重新投射多个相机图像，这些图像需要具有不同的视角，且通常要围绕我们打算创建的视点展开。一般来说也不需要太多的相机，我在这里只是说我们需要配备几个拍摄位置不同的相机，以便处理这些空洞。但即使是这样，你们也可以想象一下实际操作中会遇到的困难有多大，因为通常需要处理好几套图像。

解决空洞的办法当然很巧妙，但不幸的是，工作量一点儿也不小。这也就是问题为什么会变得更复杂。刚才我们讲过，既然我们想要做视点相关的阴影，就意味着我们必须保证二次投影角度很小。那么如果我们试图重新创建的视图和相机的距离比较近，就意味着它的透视中心至少会在物理意义和数学意义上接近相机的透视中心。这样一来，这个相机视图就可以为新视图的大部分区域提供良好的射线像素。但是假设新的视图不在任何相机的附近，那么我们就需要考虑运用集多个相机于一体的平面大设备。假设它接近视体的前部而非相机的平面，那么我们很有可能需要借助所有的相机图像来创建头戴式视图器里所显示的视图。

我们完成以上这些操作并不是完全为了某个像素，而是为了创建一个单独的头戴式视图器内的视图，同时确保二次投影角度不会过大。这一步很难操作，我们需要借助复杂的数据管理系统才能完成这一步。

接下来是第三个原因。在理想情况下，我们能找到一个正确的位置来投影某一个像素。大家应该还记得，刚才我画草图时提到的是场景点，而不是像素。但相机捕捉的其实不是一个一个的点，它们捕捉的都是像素，而且这些像素本身就有小小的立体角，所以实际上我们可以查看场景中的多个对象。这相当于碰到了附近某个物体的轮廓边缘，所以它的一部分颜色来自附近的物体，还有一部分颜

色则来自另一个远距离的物体或场景背景。

那么现在问题来了，我们该如何在二次投影中处理像素问题？

处理起来很难，因为无论你用近处还是远处物体的深度来对像素进行二次投影，像素内的某些颜色总会出现在错误的位置。而且二次投影角度越大，出现错误的投影位置就越多。这也是需要控制二次投影角度的另一个原因。这是一个需要严肃对待的问题，我们的操作系统运用了许多技术来解决这一问题。

第四，空间的连续性。假如我像这样移动，就不会突然改变物体的颜色。因此我必须一遍又一遍重复计算机图形学里才会用到的操作。在这里我们需要用上插值法。我们在进行基于头部的二次投影时不能做出任何的突然改变，否则就会陷入困境。我们向前移动头部时，就会看到这个效果，问题是我们并不想看到这个结果。我甚至还没有提到时间的连续性，这也同样困难。

还有就是图像分辨率。为了让投影更具说服力，为了保证视点相关的阴影以及所有的视差都处于正确位置，我们需要很多很多像素。大家要记住，在每秒30帧的情况下所捕捉到的500个相机图像的数据会相当庞大，所以我们必须有足够的硬件来存放这些海量的数据，也需要大量的带宽。而且我们还必须以现代耳机所能接收的帧率来完成上述工作。一般来说，头戴式视图器每秒至少90帧，而且帧数只会更高，不会更低。由此可见计算量会多么惊人。要知道，我们必须把相机图像的正确像素都牵引到一起，而后计算每个帧的每个像素。

最后要注意的是，我在这里写下的是"应该"而不是"必须"，因为事实证明我们今年所推出的VR产品不会有这样的操作。我们的客户迄今为止所看到的VR视频、所感受到的沉浸式体验，其实并没有对物体轮廓予以恰当的边缘柔化。在那些了解计算机图形学的人看来，这是一件很可耻的事情。那些天一直都没有做出完美的样片，现在想想真是难以接受。

接下来和大家讲讲Immerge 2.0系列的最新款光场相机。这周初我们刚刚发布了2.0产品，所以你们可能马上就会听到这个消息。去年这一年我们团队中有很多人一直在为2.0版本的研发努力工作，当然也包括我在内。现在新产品研发成功，有两点非常可喜的进步。第一是相比1.0版本，我们能够大幅度提升2.0相机的基本图像分辨率。

我们的操作系统所应用的存储图像的方式实际上是等矩圆柱投影，这就是为什么图像在这里看起来有些失真。但是它们又能够恰当地放在一起，结合出物体的形貌。这种投影就是大型视场所需要的非平面投影。它们只是能把像素数量中的相对变化模型化。就5K分辨率这一层级而言，目前我们所研发的2.0相机的图像分辨率可以说是市场中的佼佼者。如果我现在能让你们戴上头戴式视图器，你们马上就能发觉5K分辨率和1.0版本分辨率的巨大差异。其清晰度差得非常大。这样的清晰度主要是对波导管和带宽的要求比较高，这两个硬件的性能很重要。

这一硬件问题聊起来就比较枯燥了，从技术层面来讲也不是很难实现。

除了分辨率之外，让我更加兴奋的是我们已经能够解决抗锯齿这一问题。抗锯齿并不意味着图像包含更多的像素，而是拥有更好的像素。经过抗锯齿处理后，边缘线上的像素自有的颜色会融合于前景和背景，这样一来边缘就会显得十分平滑。

为了更好地体现《哈利路亚(Hallelujah)》中的抗锯齿效果，我放上了两张对比图片。左边的图像没有经过边缘柔化处理，右边的图像则有抗锯齿效果，你们一看就特别容易发现两者的不同。抗锯齿部分的轮廓边缘看起来平滑多了。

我要说的是我们还会在歌手右臂下方的区域重复演示这一步骤，你们所学会的这一步叫作基准孔。就像《爱丽丝梦游仙境》（Alice in Wonderland）里面的洞穴一样关键。这些都是绘制过程中最难处理的步骤，因为无论你以什么视角、在任何位置观察，背景几乎都是被遮挡住的。因此在极端的情况下，有一部分背景很可能没有被任何一台相机捕捉到。如果基准孔离相机镜头很近，而且角度最终也很高，那么在这台相机的捕捉背景范围内你最好都别放任何物体，因为可能什么都捕捉不到。所以说这些都是非常有趣的挑战。柔化与未柔化的差异非常明显，尤其是当人们对着头戴式视图器观看视频时，会感受到巨大的视觉冲击，能明显感受到抗锯齿效果极大地增强了 VR 的真实存在感，会觉得视差所在即真实所在。而且，阴影也在应有的投影位置，你们现在所看到的阴影不是抗锯齿技术所导致的那些时间伪影、运动伪影和假的动作伪影。而现在经过技术突破，我们已经能够把抗锯齿技术应用到 VR 领域，我真的很激动，也很满意。

从这一点来讲，我找不到任何理由说我们无法进一步增强操作系统的功能，逐步使其达到真正的电影高质量回放水平。我相信，不管高质量回放需要怎样的技术，我们都有能力朝着这个方向继续前进。目前在这方面还没有出现根本性的技术突破，但这恰恰就是我们努力的目标。

Jim Chabin

The Next Generation of Consumers

© Jim Chabin

Seven years ago, the students and the faculty of BFA showed me a 3D film, *Alive at the Expo*, which was a 3D movie made at the Shanghai World's Expo; and to think that this many years later we are working in so many new fields, just this short period of seven years is amazing to me.

I want to talk to you about the next generation, the next generation of technology, and how it is gonna be used, and why it's being implemented. For that, we're gonna to talk about the next generation of consumers.

The AIS is working on technologies such as augmented reality, virtual reality, virtual production, which allows the director to be in the scene when he is making the decisions about how to produce. Artificial intelligence as we know that all of this is going to take great computing power and artificial intelligence is going to allow us to make our movies better, high dynamic range or higher quality color gamut, HDR, and cloud computing because all of this is going to create a need for high speed computing that is not going to be available on the computers in your typical post-house.

For example, *The Jungle Book*, from Disney last year, in that film only the little boy was real. Everything else in that film, in the jungle, all of that is created by thousands of artists working thousands of hours, with thousands of computers, and thousands of hours of rendering to create that experience and as more and more of the movies are made this way, because special effects and digital compositing are the best way to make these movies, as more and more of them are required, we need more and more computing power to achieve that, and that's why we are moving into the area of cloud computing. The other aspect of cloud computing is, if

Jim Chabin on ICEVE

The future of movie making

we are all working on a movie but the movie is up in the clouds. I can have it created even in Beijing, working with the creative team in London, working with a creative team at Disney in Hollywood, on the very same movie. So this is where we think movies are going.

Why? Movies are more expensive to make, therefore we will all be paying more for a movie ticket in the next years when we go to the movie theaters, and we can watch movies now and stream them at home. So we have to make better and better movies, and that is in doing no small part because the next generation of consumers is coming along. Now these are people who are 16 to 19 years old, and right now, if you know someone who is in that age group, they will spend about 9 second to determine whether or not to stay watching a video or to scroll, and we've all seen it, but the young people are sitting there scrolling, or on WeChat, or looking at videos. The consumers of today are multi-tasking and they want constant stimulation. So if we're going to make the movies and television programs of the future, we have to know that we have a different consumer. This is a group of people who are absorbing a great amount of their videos on Facebook, or other social media, as opposed to traditional broadcasters and services.

Globally, 64% of young people want greater engagement with their content. They don't want to be only passive watchers of a TV screen. They want to be in the movie. They want to have more of a connection to the content. That's why we are looking at VR and AR and all of these other technologies. We want to grab the attention of these young costumers and give them more engagement.

They spend their day widely on social media. A 17-year-old today, met one of their closest friends online. They likely know how to not only write code, but shoot, edit and distribute, studio quality video content. The young people coming up today, and this, I am sure for students or people associated with the film academy here know, are coming up with an understanding of not only how to make movies but make good quality movies. Charles Wang told me that one of the first VR projects that was brought to him at BFA was by a student who 3D printed his VR camera rig, and that was the first VR project brought to BFA.

So this is a young generation that are very capable of making good quality content, and if they are going to pay money to go to the movie theater, or watch something or stream it, it

needs to be powerful and good. So this is a future where people like me, of my age, learn to use the mobile phone and use the laptop. This is a generation that is coming up absolutely at home with it and using it in their daily lives.

Let's talk about virtual reality, because there is something coming up from Steven Spielberg that I think will bring virtual reality back to the center stage in the conversations. Right now, about 7% of consumers, which was aresearch done in the United States, use VR on a weekly basis. About 11% are in a household with some sort of viewing device or use one weekly. We're at the very early stage of VR. Society, we see, uses virtual reality in industrial applications, by doctors and industrial manufacturers, automotive companies who can replicate a work situation and solve that problem much easier using virtual reality than not.

YouTube remains king for online veideo,but Facebook video is growing rapidly

VR application in Industry

VR in the next year or two, I think, will be very busy being applied in the industrial area; but also at arcades, and entertainment centers. Jake Black, of Create VR, and his team, created *Spiderman VR*, *Ghostbusters VR*, *The Walk VR*, for Sony Pictures, and he is working on several for Sony now. Jake and I went to the VR Center in Tokyo. It's a massive VR center with many, many employees, restaurants, and a virtual beach, and a virtual rock climbing experience. You can virtually snow ski. It is massive and, we think that in the next year or two, this is where you will go to get great virtual reality because the cost of getting it at home, and the quality that you get at home, is not as great. So you will go to an entertainment center and maybe a movie theater to experience VR.

Right now, virtual reality is about as familiar to the average consumer as the smart watch. So someone has an apple watch, or knows about an apple watch, or is aware of what an apple watch does. That same number of percentage of the population kind of understand what is

VR. So we are at the early stages where most of the population knows very little about VR; but the people that we have researched have indicated that virtual reality is here to stay. There are so many very big companies, all of the Hollywood studios, most people making movies now, showing great interest in working in VR or AR. We believe very strongly that virtual reality is going to be a part of our future and it will be so certainly over the next ten years.

Finally, we did a test in the United States where we showed people a TV commercial on a flat screen, and then we showed them the commercial in a virtual reality headset. The blue line at the top shows you the response that the consumers had when watching it in virtual reality, and the other graph shows you what their response was when watching an online video. So a VR experience has a much more powerful impact on the viewer, and that is good news for the movie studios, for advertisers, and major retailers who see VR as a way to really connect with consumers.

For the last few years, Steven Spielberg has been working on his next movie. His next movie is called *Ready Play One*. It is a movie based on the book by author Ernest Cline and it is a book about virtual reality. The movie comes out on March the 30th from Warner Brothers.

For most of you, you can remember *Avatar* and prior to *Avatar* most people were not aware of 3D movies; and after *Avatar* so many people saw that movie, that the whole world understood what movies in 3D were like and the value of seeing them. Last year, 1.2 billion 3D movie tickets were sold worldwide. 1.2 billion!

So this movie is coming out at the end of March from Warner Bros and our sense is that it may inspire a new generation of young movie goers to become excited about working in VR, and that after this movie comes out, many more people will be talking to you about VR than before it came out and so we're excited about that film and it will be here in just a few, short months. The estimates are that 100 million people worldwide will see this motion picture; and if 100 million people worldwide see Steven Speilberg's vision of the future using virtual reality, it will make all our jobs talking about virtual reality and working in it that much easier.

新一代影视消费者的特征

▶▶ Jim Chabin

七年前,北京电影学院的师生们向我展示了一部3D电影《世博之光》(Alive at the Expo)。我还记得它当时是为上海世博会拍摄的3D纪录片。数年之后,我和北影的师生正在多个新领域进行交流合作,突然回想起这部电影,我很惊讶地发现那次交流经历恍如昨日,七年的光阴忽然在记忆里显得格外短暂。

今天我想和在座的各位谈一谈新一代的行业发展,包括电影业会有什么新生代科技、它们将如何被运用到电影制作之中、我们又为什么要应用这些新的科技手段。为此,我们接下来还要提到新一代的电影消费者。

国际先进影像协会(AIS)正在研究诸如增强现实(AR)、虚拟现实(VR)、虚拟制作等技术。比如说虚拟制作可以使导演在决定拍摄过程和细节时身临其境,能站在模拟场景中看问题;还有人工智能,我们知道人工智能拥有强大的计算能力。借助人工智能,我们可以把电影制作得更完美。另外,我们还在研究诸如高动态范围图像或更高质量的色域、HDR和云计算等新技术,因为所有这些技术都会产生对高速计算的大量需求,而在典型的后期制作中,光靠我们自己很难在计算机上实现这种计算。

在这里我想举一个例子来说明。去年迪士尼拍了一部动画片《奇幻森林》(The Jungle Book),里面只有主人公毛克利是真人演出,其他全是虚拟出来的。电影里的所有其他角色、丛林里的所有场景,都是数千名艺术家花了成千上万个小时画出来,再用上千台电脑和数千小时进行渲染,最终才创造出这种奇妙的效果。目前越来越多的电影都会以这种方式制作,为什么呢?因为这些电影最佳的制作方式就是借助于特效和数字合成技术,而且随着此类电影日益增长的市场需求,我们也需要越来越强大的计算能力来辅助制作。这也就是为什么我们正在进军云计算领域。这里稍微讲一下另一个原因:假如我们现在需要制作同一部电影,而且这部电影在云端,那么我就可以一边在北京制作,一边与伦敦的创意团队合作,甚至还可以和好莱坞迪士尼的创意团队合作。以上就是我们认为的电影行业可能会有的发展方向。

你们可能会问为什么。现在拍电影的成本比以前高了不少,所以在未来几年里,如果我们想去电影院看电影,就得花更多的钱买电影票;但与此同时我们又可以在家里看电影。因此我们拍出来的电影也必须越来越好。这一点非常重要,因为下一代的消费主力军已经出现了。他们现在是16~19岁。假如你们认识一些这个年龄段的人,就会注意到这一消费者群体往往只会花大约9秒的时间来决

定是要继续看完一个视频,还是跳过去看下一个。我们会发现,这群年轻人坐在那里要么不断滑屏,要么聊微信,要么看视频。也就是说,如今的消费者习惯一心多用,倾向多元化消费,他们需要源源不断的媒体刺激。所以假如我们想制作面向未来的电影和电视节目,就必须先了解这一全新消费群体的消费习惯。他们和传统的消费者大不相同,以前人们会听广播,喜欢走进电影院消费,现在的年轻人却更偏爱浏览 Facebook 或其他社交媒体上的大量新奇视频。

现在全世界有 64% 的年轻人都希望自己能与所接触到的媒体内容有更多的互动。他们不希望自己被动消费,不愿只是作为荧屏面前的旁观者,而是期待能进入电影,和电影里的故事或场景产生更多的互动碰撞。这就是为什么我们如今会十分看重 VR 和 AR 以及所有其他类似的新科技。我们想吸引这些年轻人的注意力,给他们提供更多的参与机会。

如今新一代的消费者每一天都会大量接触社交媒体。17 岁的年轻人也许会在网上结识自己最亲密的朋友。他们不仅知道怎么写代码,还知道如何拍摄、编辑和发布视频,而且这些视频的内容质量丝毫不逊于传统摄影棚里拍出来的作品。毫无疑问,属于你们这些青年的新时代即将到来。在座的各位都是这所顶尖的电影学院的高才生,我相信你们不仅知道怎么拍电影,还懂得如何制作出高质量、高水准的电影。之前王春水教授告诉我,北影的第一批 VR 作品是北影的学生自己完成的,其中有位学生用 3D 打印机打印出一套 VR 摄影设备,成功制作出北影的第一个 VR 作品。

简而言之,新一代消费者本身就具备很强的制作能力,拍得出高质量作品,因此当他们走向电影院付费观影,或在家通过下载自己看电影时,都会对影片报以更高的要求;这就意味着我们也必须提高制片水准。未来的趋势是像我这个年纪的人不能和新科技的发展脱轨,要学会用手机、用笔记本电脑。毕竟新一代年轻人在家时完全离不开这些必备的电子产品,日常生活也都用得上它们。

接下来我想和大家谈一谈虚拟现实(VR)的发展。我之所以会想到 VR,是因为我认为史蒂文·斯皮尔伯格的新作品让 VR 再度成为焦点、走进人们的视线。美国的一项研究表明,目前大约有 7% 的消费者每周都会使用 VR;其中约有 11% 的人会在家中利用设备每周观看 VR。如今我们正处于 VR 的早期发展阶段。比如说,医生和工业界的厂商已经把 VR 用于业务实践,汽车公司则使用 VR 模拟或重现车间的操作情况,以便更容易地解决生产中遇到的问题。

我认为未来一两年之内,VR 会大规模应用于工业领域;但除此之外,它还会成为游乐场和娱乐中心的常客。我们都知道,Create VR 公司总监 Jake Black 带领他的团队为索尼电影公司制作了《蜘蛛侠:英雄归来》(Spiderman VR)、《超能敢死队》(Ghostbusters VR)、《云中行走》(The Walk VR)这三部 VR 作品。有一次我和他去参观东京的 VR 中心。这个 VR 中心规模非常大,员工众多,餐厅也数不胜数。我们在那里看到了虚拟的海滩和虚拟的攀岩体验活动,甚至还有虚拟滑雪。我们认为在未来的一两年内,消费者会在这种大规模的展出中心获得超凡的

VR体验。毕竟相比之下，在家观看VR不但成本高昂，而且影片质量会受家用设备减损，影响观影效果，所以到时候人们说不定更乐意去娱乐中心和电影院体验VR。

如今VR对普通消费者来说就像智能手表一样扬名在外。他们之中有的人买过苹果手表，或者了解苹果手表的用途；而恰恰也有相同比例的消费者差不多能理解什么是VR。现在VR的发展还处于初级阶段，大多数普通人对VR都知之甚少；不过我们所调查的消费者纷纷表明，VR行业方兴未艾，他们看好VR的发展前景。眼下有许多大公司都表示他们对VR或AR有着浓厚的兴趣；这些公司全都是好莱坞的工作室，其中多数人都正在拍电影。我们非常相信未来VR会成为行业的一部分，至少今后十年肯定是VR大显身手的时代。

最后要说的是我们还在美国做过一个VR观影测试。我们首先在平板显示器上向消费者播放了一个电视广告，然后让他们戴上头戴式VR视图器，重新看一遍这个广告。顶部的蓝线显示的是消费者在观看VR广告过程中的反应，另一个图表则告诉我们他们观看二维在线视频时的感受。我们发现相比传统的广告形式，VR体验会给受众带来更大的视觉冲击，影响巨大。对那些认为VR可以密切联系消费者的电影工作室、广告商和一些主要的零售商来说，这无疑是重大利好。

在过去的这几年里，斯皮尔伯格一直在忙着制作他的下一部电影。这部电影叫《头号玩家》(Ready Play One)，根据美国科幻作家恩斯特·克莱恩（Ernest Cline）所著的一本关于VR的书改编而成，3月30日在美国上映，由华纳兄弟发行。

就大多数消费者而言，他们都记得《阿凡达》(Avatar)，可是在《阿凡达》问世之前他们也许都没听说过"3D电影"这个词。而《阿凡达》上映之后，很多人都去看了这部电影，全世界也随之明白什么是3D电影，理解观看3D电影的价值所在。去年全球共售出12亿张3D电影票，12亿张！

我们知道华纳兄弟在3月底发行《头号玩家》时预感这部电影会在新一代的电影观众中掀起新一轮VR热潮。在VR世界工作的可能性会使他们感到特别兴奋，而且这部电影公映后也可能会有更多的人兴致勃勃地谈论VR、关心VR，VR会一改之前的小众状态，不再默默无闻。所以我们都很激动，只要再过几个月它就能上映了。据估计，届时全世界将会有1亿人观看这部电影。一旦全世界能有1亿人通过影片了解史蒂文·斯皮尔伯格关于未来世界善加利用VR的美好憧憬，那么今后无论是谈论VR的发展还是VR的制作，我们的工作都会开展得比现在更容易、更顺利。

Bill Collis

Empowering Content Creative Workflow

◎ Bill Collis

I'm Bill Collis and I've worked at a software company called The Foundry for the last twenty years, ten of which I was CEO. I'm now the president of The Foundry.

I want to talk about three things. The first, is to briefly discuss some of the challenges that the visual effect industry is facing when dealing with the complexity of the work we are being asked to do; and then briefly have a discussion about how our product Nuke is being used to solve some of those complexity problems; and thirdly, probably most interesting, is to have a look at some of the research projects we're running at The Foundry in order to drive the next versions and releases of Nuke.

So, I think it's fair to say, consumers today are demanding ever more impressive visual effects. When you go to the cinema, you expect an incredibly high-quality. It isn't just viewers in the cinema though, it's consumers whenever you are interacting with a brand, any of the large brands, they expect visuals of a similar level of quality to a top movie, and also, designers are expecting similar levels of quality because they are using those sorts of images to drive digital prototyping and visualization of the products we use today.

And there are loads of big technology trends that are driving even more complexity. VR/AR, this equally could be a light-field camera from Lytro, these all are just increasing the complexity of image processing that we are having to manage and the amount of data that we are having to manage. And films today are really the most complex visual projects in the world.

Bill Collis on ICEVE

Let's just have a look, if you are making a top Hollywood movie, what are you dealing with? You are dealing with petabytes of data to start with, vast quantities of data created by artists typically distributed around the world. Thousands of artists are on a big film, who

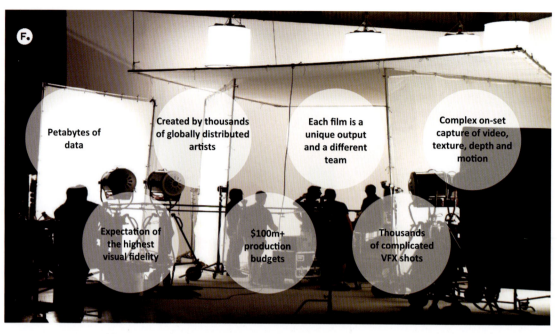

What are you dealing with if you are making a top Hollywood movie ?

Foundry solves challenges in three fast growing industry segments

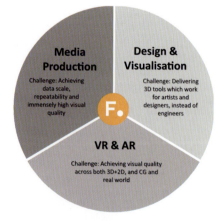

What does The Foundry do?

could be in multiple locations, or on multiple continents. Very often each film is unique, so the production team starts again and builds up a team in order to make the latest film. So, you are spinning up new groups of people all the time. Very complex on-set capture of, not just the images, but all sorts of other data, such as depth, motion, textures. And budgets, yeah, budgets of hundreds of millions, well over a hundred million dollars, and a typical movie today might have thousands of really quite complex VFX shots. And then if you add in VR/AR, light fields, it just becomes a whole lot of harder: lots of more data and lots of more demands on the image processing.

What does The Foundry do? I hope many of you have heard of us. We are a software company and we provide many of the tools that artists today use to do this work on these types of high-end projects. There are three areas we work in, again, I don't need to go into lots of detail here— making films is the main one, so media production services, films, episodic TV work, commercials; then designing visualization, so product design, working with big brands to help them visualize their products; and then finally, VR and AR, which as we keep on hearing, is a big growing area.

Let's just have a quick think about what Nuke is. Nuke is a compositor. It's basically been designed for assembling very, very complex shots, but today it's very much used as a hub by many professionals. Anyone where they are doing complex image processing with moving sequences.

In our first example, there is no heavy VFX at all. Basically the job that the artist was given was to add snow to this shot. To make it look like a wintry shot from its original summer weather. If you look at the complexity of what goes in, it is not a heavy VFX shot at all. It's typically one that could be one of thousands in a movie. The first step would be some digital calibration work at where things are. Do a Point Cloud Generation, so we get the raw geometry. Create a mesh from that geometry. We can then, on top of that, start projecting textures. Project more textures. Do a bit of painting on to UVs. Add some particles and the snow coming down. A bit of color grading and there we are. Today, this is very run of the mill and that's what any digital compositor would be expected to do, and the complexity in there is, what we're actually doing is vast, we are working and taking some 2D images, we're working out what the 3D geometry

Example 1

Example 2

of the scene is, projecting new textures onto it, and adding particles to create the final shot.

A more complex example would be the work done by Iloura, down in Australia on *Games of Thrones* with the show's immense battle scene, and it really does show, the scale of visual effects work that are now commonplace. It's amazing just how little of the footage used in battle scenes is actually real film footage and how much of it is CG. But, then again, the complexity of what is going on here is just staggering, the amount, this pure quantity of 3D elements, and compositing, and animation.

Though both those bits of work were done using Nuke as a compositor, I think it's fair to say that any high-end movie you go and watch today will have had Nuke at the very heart of its image processing pipeline. Nuke has been used by every Special Effects Academy Award nominated film, I think, for the last 9 years now. So it's very much the industry standard software and it runs across the film, television, commercials, VR, AR, 360 films, and other content.

Surrounding Nuke, at The Foundry, Flix, our story boarding software, Modo, 3D animation, Mari, texture painting, Katana, lighting software, all of that is part of The Foundry pipeline.

Some new products coming from The Foundry, and possibly the most interesting one is Elara. That cloud-computing is becoming very important is because of the vast amounts of data. At the Foundry, we've created a Visual Effects pipeline, a complete visual effects pipeline, that runs in the cloud, accessed by your a browser, called Elara. It's in beta today and will be released early next year. It does just make so much sense to keep all your data and then do all your processing in the cloud with these massive data-sets.

So, the final bit of my talk, what I really want to discuss was the research at The Foundry because I think it's the most exciting area for fellow researchers. We've always had a large research team for the size of the company we are, we've got about 13 or 14 PhD students beavering away on multiple projects with lots of different companies, and lots of different partners. So, I was going to talk about just a few of them.

So Project Fame is the first one and, sadly, I can't show you the visuals on this one

because the partner we work with is ILM and we're not allowed to show the footage. It's all to do with using AR to insert film quality animation into an AR scene, and by that, I mean, we want to take a film quality model, work out what the lighting is in the scene, apply that lighting to the character and then allow the character to real-time interact with the scene and be able to view this through a tablet, or phone, or headsets— any of the various headsets. It requires a lot of very fast real-time analysis of the scene and real-time compositing to make that happen.

And the great thing about these projects and research teams is the technique that we develop in these research projects, then get fed back into the product and into the next releases and in new kinds of our products.

The next one I'm going to talk about is Alive. This is actually a light field project and it really, from The Foundry's point of view, was set up, and it was designed to show how Nuke could be used to work with light field data and the challenges that we would face in doing that. What we're doing is actually using a GoPro camera rig in order to capture the scene, for my examples it's an arch being filmed. We then go ahead and do a Lidar Scan of the same space in order to get the 3D geometry.

And now we go into a studio and use a camera array, not quite up to the standard of the Lytro one, not a commercial one, in order to do some light field capture of some actors. We capture the live action component, the depth map associated with it, from that camera array, and then we use Nuke to composite the 3D data into the 3D scene, in order to produce an experience. So typical film workflow, to do this in the past, you would've captured the actors in 2D against a

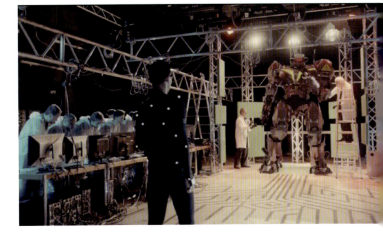

Light field camera array

green screen and then composited them into the sequence, but of course if you then try to look at them in the sequence from a different point of view and move your head around, you wouldn't have caught any of the parallax, so it would have looked very unnatural.

Nuke can composite the light field data and play it back from Unreal Engine, and you can move your head around and get the correct parallax. You obviously can't move around the scene, but you can move the head and are able to have a much more natural view of what's going on. So that was Alive.

Dreamspace

The next one is Dreamspace. At The Foundry, over about the last 3 or 4 years, we've run this project called Dreamspace with a number of partners, which was again putting together virtual production workflows. And I think what we've noticed that is interesting, three or four years ago, we were expecting by today that many and many more films would actually be made using virtual production and that hasn't come about yet. So it's still really only high budget movies from the biggest studios that use virtual production on a regular basis and I think that's mainly because of the complexity involved; but we're still expecting over time that more and more films will be made this way. Nuke again sits at the heart of our virtual production workflow and again, the great thing about this work is it allows us to develop a whole load of technology with Nuke to do real time compositing. So, you can actually take a Nuke node graph, compile it, and play it in real time using Nuke engine.

So I want to finish by summarizing where we've been. We know now that the quality that's required by visual effects, brands, AR/VR experiences, light field experience, is growing ever more. Nuke is the natural default image processing solution for putting these together and at The Foundry, we've been developing this technology now for 20 years and using the research team and projects I've just shown you to continue to develop and push the boundaries of what you can do with really, really high quality image processing.

先进技术助力影视制作流程

▶▶ Bill Collis

我是 Bill Collis，在 The Foundry 软件公司已经任职二十年了，其中十年担任公司的首席执行官，现在我是 The Foundry 的董事长。

今天我想谈三个方面的内容。首先简单探讨一下我们视效行业在处理所授任务的复杂度时面临的一些挑战；接着聊一聊我们的产品 Nuke 是如何解决这些复杂度问题的；第三个方面可能是最吸引人的一方面，即为了促进 Nuke 的新版本以及新发布，我们目前在 The Foundry 所做的一些研究项目。

我觉得现在的消费者总是在追求更震撼的视觉效果。当你去电影院看电影，你会期望这场电影具有相当高的品质。其实，不仅是电影院里的观众，客户也是这么想的，无论你是在跟哪个品牌沟通合作，任何一个大品牌，他们都期望能够看到与顶级电影程度相当的视觉效果，而且设计师们也期望看到相当程度的视效，因为他们要使用这种高视效品质的画面对我们现在使用的这些产品进行数字化样机开发和可视化。

而且现在有很多大的技术趋势促使复杂度比以往更高。VR（虚拟现实）或 AR（增强现实）可以等同于一个 Lytro 光场相机，全部的这些东西只是增加了我们必须做的图像处理的复杂度，并且增加了要处理的数据量。现在电影是世界上最复杂的视觉效果项目。

让我们看一看如果要做一部顶级的好莱坞电影你要处理哪些内容。首先是千万亿字节的数据，这海量的数据是由艺术家们创作出来的，他们通常分布在世界各地。一部大电影有几千位艺术家参与制作，他们可能会在多个地方工作，可能分别在各大洲工作。大多数情况下每一部电影都有自己的需求，所以，一部最新的电影，制作团队会再次启动并建立一个团队开展工作。所以你要一直不断地吸收新的项目组进来。除此之外，还要进行非常复杂的现场图像捕捉，不仅要捕捉图像，还要捕捉其他各种数据，比如深度、动作和材质的数据信息。还有预算，数百万美元的预算，远远不只一百万美元，现在一部典型的视效电影可能会有上千条非常复杂的视效镜头。如果再加上 VR（虚拟现实）或 AR（增强现实）、光场，工作量就会更加繁重：要处理更多的数据，对于图像处理的需求也会多很多。

The Foundry 是做什么的呢？我们是一家软件公司，艺术家们做很多这种高端项目时使用的工具有很多是由我们提供的。我们主要在三个领域开展工作，在这里我无须探讨很多细节——制作影片是最重要的一个领域，比如媒体制作类服务、

电影、电视剧集、商业广告；然后是设计可视化，比如产品设计以及与一些大品牌合作，帮助他们实现产品的可视化；最后是 VR（虚拟现实）或 AR（增强现实），我们总是能听到别人说这是一个很大的不断发展的领域。

让我们来快速地看一下 Nuke 这个软件是什么。Nuke 是一个合成软件。它主要是用来将非常复杂的镜头集合起来，但是现在，它更多的是被很多专业人士用作一个枢纽。任何一个人，他们都可以在 Nuke 上使用运动序列做复杂的图像处理。

我们的第一个示例里完全没有很繁重的视效处理。基本上艺术家在这里要做的工作就是给这个镜头加上雪，让它从原本的夏季景色变成一个冬季镜头。如果你仔细看里面的复杂度，它根本不是一个很繁重的视效镜头。这是很普通的一个镜头，而一部电影里可能有上千个镜头。第一步是对事物的位置做一些数字校准的工作。生成点云，这样我们就能得到原始的几何。利用几何做一个模型出来。然后我们可以开始在上面投射更多的材质，对 UV 做一些绘制，添加一些颗粒，然后雪就飘下来了。再做一些颜色分级。现在这是非常稀松平常的，对任何一个数字合成软件，大家都期望它能做到这样，而且里面的复杂度、我们实际在做的工作是巨量的，包括制作出来一些 2D 画面，实现这个场景的 3D 几何，在上面投射新的材质，然后增加一些颗粒，呈现出最终的镜头。

还有一个更复杂的例子，是由 Iloura 制作完成的作品，这是他们在澳大利亚做的《权力的游戏》剧集中宏大的战斗场景，这些场景真正地体现出了现在普遍的视效作品的规模有多大。让人感到神奇的是，这些战斗场景里使用的素材只有很少一部分是真正的电影素材，很多实际上是 CG 镜头。而且这里面的复杂度也令人震惊，包括数据的数量、3D 元素的纯数量、合成和动画。

虽然这些作品都是通过 Nuke 作为一个合成软件来完成的，但是我觉得现在你去看的任何高端的大制作电影，它们都在图像处理流程线上把 Nuke 放在了非常核心的位置。我认为在过去的 9 年每一个获得"奥斯卡视效奖"提名的电影都使用了 Nuke。所以，它是相当符合行业标准的软件，适用于电影、电视、广告、VR、AR、全景电影和其他内容的媒介。

在 The Foundry，围绕着 Nuke，Flix 是我们的剧情梗概故事版软件，Modo 是我们的 3D 动画软件，Mari 是材质绘制软件，Katana 是灯光软件，所有的这些软件都是 The Foudry 流程线的一部分。

还有一些 The Foundry 的新产品，其中可能最吸引人的一个是 Elara。之所以云计算变得相当重要是因为现在有海量的数据。在 The Foundry，我们创建了一个视效流程线，这是一个完全用于视效的流程，它通过云来运行，由 Elara 这个浏览器进入。现在它还在被测试，我们会在明年早些时候发布它。把所有的数据保存起来，然后通过云对这些大量的数据集合进行全部处理，这样操作是非常有意义的。

最后，我非常想要探讨的是我们在 The Foundry 的一些研究，因为我觉得这对研究员们来说是最令人激动的一部分内容。相对于公司规模来说，我们总是保有一个很大的研究团队，大概有 13 个或 14 个博士生辛勤地进行研究工作，与很多不

同的公司、合伙人在很多项目上展开了合作。接下来我只取其中几个例子来说。

第一个是Fame项目，遗憾的是我不能把这个项目的视效画面展示给你们看，我们的合作伙伴是ILM，我们不可以展示相关影片素材。它们的内容都是关于使用AR将电影质量的动画嵌入某个AR场景的。意思是说，我们取一个电影质量的模型，计算出场景中的灯光，将灯光应用到角色上，然后让角色实时与场景互动，并且使观众能够通过一个平板、一部手机或任何一种头盔显示器都能看到互动。这个设想的实现需要对场景进行大量的非常迅速的实时分析和实时合成。

这些项目和研发团队最棒的一点就是在这些研发项目中我们研发出某种技术，技术会被反馈到产品中，最终新的技术又能在该产品的新发布和新型产品中得以体现。

下一个例子我要说的是Alive，实际上这是一个光场的项目，而且从The Foundry的角度来看，它的设立与设计是为了展示Nuke可以如何被用来处理光场数据和我们在用Nuke处理光场数据时所面临的一些挑战。我们正在做的事情实际上是用一个GoPro相机装置来捕捉场景。这里被拍摄的场景是一个拱门。我们接着往前，在同一个地方做一次激光雷达扫描来获取3D几何。

现在我们来到工作室里面使用一个相机阵列，这个相机阵列可能达不到Lytro的标准，它不是一个商业型的阵列，但是我们要用它捕捉几个演员的光场信息。我们捕捉实时动作元素，用这个阵列来捕捉与实时动作相关的深度地图信息，然后我们用Nuke把3D的数据合成到3D的场景中，从而制作出一种体验。这是常见的电影工作流程，过去我们的工作流程是在绿幕前面捕捉2D的演员动作及信息，然后将它们合成到序列里面，但是如果你试图转动头部从另一个角度看序列里的他们，你是不会看到任何视差的，看上去会非常不自然。

但是Nuke可以合成光场信息，然后用Unreal引擎回放，你就可以转动头部，获得正确的视差。你显然不能绕着这些场景转来转去，但是你可以转动头部并能够以一个更自然的视野看到正在发生的事情。这就是Alive。

接下来是Dreamspace。过去的三四年，我们在The Foundry与很多合作伙伴展开了Dreamspace这个项目，这个项目也是把很多虚拟制作的工作流程结合到了一起。我觉得有一点很有意思，三四年前，我们就在期盼此时此刻会有更多的电影是用虚拟制作技术制作的，但是这还没有完全实现。现在还只是有大工作室制作的预算高的电影经常使用虚拟制作，我觉得这主要是因为虚拟制作涉及的复杂度。但是我们仍然期望，随着时间推移，会有更多的电影以这种方式制作。对于虚拟制作工作流程，Nuke也处于中心地位，而且我想再一次表达，这项工作很棒的一点是它让我们能够使用Nuke研发出大量的技术去进行实时的合成。你真的可以做一个Nuke节点图对它进行汇编，然后使用Nuke引擎实时播放。

最后做个总结。视觉效果、品牌、AR或VR、光场体验对于质量的要求都在不断地提高。Nuke是一种自然的默认图像处理的解决办法，它可以将这些东西归在一起，在The Foundry公司，这20年来我们一直致力于研发这项技术，未来我们的研发团队和项目也将持续研发，不断地突破高质量的图像处理所能达到的边界。

Stephani Maxwell

A Unique Approach to Collaboration Across Artistic Disciplines for Creating Works of Art

◎ Stephani Maxwell

I'm a professor in the School of Animation at Rochester Institute of Technology, and I teach a number of different kinds of courses. I was actually trained as a filmmaker and also an animator. I come from a Science background and I am a diver. So I'm kind of all over the place. So I speak a couple of different languages.

At one point, when I was learning science, at UCLA, an adviser asked me what I was doing in my college program, and I told him I was doing psychology and I was taking some Russian, and doing some art and science courses and I loved science and I loved math, and he said to me, "Uh oh, you might wind up a jack of all trades and a master of none." That became a cloud over my head for a few years. Thinking that maybe I'm not going to accomplish anything in depth; and I went forward with that idea until I met somebody important in my life. When I moved out of science and into art at the San Francisco Art Institute, Larry Jordan, who was my adviser asked me again, "What is your background like?" and I said, "Uh oh, here we go." And I told him, "I have science, and I have language, and I've traveled, and I've done art and had also made films back in Los Angeles, we were making film back when we were kids." He said, "Oh, you're a Renaissance person. So no longer was I insubstantial or under the impression that I was not going to be able to accomplish something; but I would accomplish my goals in life from a position knowing a lot about a lot of things."

So I encourage a lot of students, in fact, to know a lot. Not to be too specialized in something, and to know that somehow these

Stephani Maxwell on ICEVE

things, they get interwoven into what your efforts are and what you do in life. So I want to address a particular kind of approach to creating films. Creating art works that I call "True Collaboration."

The concept of true collaboration, is where you have artists come together, and scientists too. I've actually worked with, as Astrophysicist, a composer, and another filmmaker on a work, and it's really a magical experience. There's no one who is a director when they approach this kind of true collaboration.

That might be hard for people to swallow, especially for films, the director basically has the vision and then everybody will divvy up the chores and perform the task to realize that vision. So, in true collaboration, artists or whomever, scientists, or people working in different disciplines, come together and they invent. They create a work that comes from them all in a mutual kind of way.

At RIT, in 1997, I went over to the Eastman School of Music, which is in Rochester, New York, where RIT. is, and I hung out in the halls and I found somebody that actually I could talk to about perhaps doing a program in common with RIT, where we would use our filmmakers or animators, and their composers and performers, and create works together.

It evolved into this conversation about looking at the genesis of art work and how that

TRUE COLLABORATION

In *true collaboration*, artist participants have an equal part in the conception and creation of a work. As partner artists, they share a common vision to which each artist contributes his/her imagination, expertise and skills, and together they make important creative decisions as a committee. The principles and practice of true collaboration represent a viable, healthy and productive model for creating complex, innovative cross-disciplinary works of the highest caliber and originality for audiences. This approach to art making contrasts with traditional and industry practices of specialization in production without creative control. The Rochester, New York based, cross-disciplinary, inter-university *ImageMovementSound* festivals, that ran for 12 years 1997-2008, was founded of the principles of *true collaboration*, and produced over 190 works and 340 participating collaborators and artists.

2008 IMAGEMOVEMENTSOUND FESTIVAL
ROCHESTER • NEW YORK

The Image Movement Sound Festival

genesis can be from, at the scratch, at the very beginning, an effort by all the artists involved. I already knew from already having done previous films, which I'm not an expert in, for instance, doing music. So I always sought out those artists that had that expertise and had that conversation. So I was already kind of primed for working in a collaborative way rather than giving my vision as a filmmaker and telling people what it should sound like, or how it should be performed, or what instruments. I would leave that up to somebody else.

The Professor at Eastman School of Music, and I, then founded something we called The Image Movement Sound Festival. Now you can see, by the words, there shoved all together, that we really take it very seriously. Composers and performers at Eastman, and filmmakers, image makers, we have people that have Theater, Literature, from Computer Science from all kinds of technologies who have participated in these festivals; and then the second year, SUNY, which is State University of New York at Brockport, which is 30 minutes away. Eastman is 12 minutes away by car from Rochester and then SUNY Brockport is 30 minutes away, so we're pretty much well positioned and that encourages collaboration, geographically. So Susana Newman, at SUNY Brockport, came on board, she's a choreographer. She's retired now, she's Professor Emeritus. She brought to this mix choreographers, dancers, movers and so forth. So what we would do every year, and this was for 12 years, we lasted 12 years.

Every year at the very beginning of the year, we would have a call meeting of artists. Notices would go out across the campuses and it became big, we even got other people wanting to be involved: Nazareth College, and Alfred University, SUNY Geneseo; we had independent artists also participating. And what we do, it's just a very kind of interesting process and I'm going to let you know that we're still doing it, but in a different way, because The Image Movement Sound Festivals have ended. What we would do, it'd be a whole day affair, an artist, each one of them, would do a presentation: "I'm so and so, I live here, I come from music or film, and here's a sample of my work." So we would hear something of the compositions that they've created, we would see film clips, we would have people sometimes performing dance, live dance, we'd have live music; and everybody would have about 10 minutes to do these introductions, and then we'd call a lot of doughnut breaks. Where we'd provide food and drink and a place located nearby to our auditorium, where people could sit, stand and start networking. Everyone is wearing a name plate and you start mixing. And what happens is there is this momentum that builds, generally people hang around for the whole day and they start mixing and networking, and they start to form groups. After 3 weeks, we start to assume, as the directors, people have formed groups, and then they wrote a proposal, and then we made sure it was doable and there was a vision there. These projects might have two collaborators, it might have 3 or 4. We had one project that had 3 filmmakers, a choreographer, and a music

composer.

Now you put 3 filmmakers together, they are, you know, what do they have to give up? They have to give up, alright? They have to give into the ideas and the life experiences and the practices of other artists and that's a very difficult concept to absorb and then live up to. So in true collaboration, when artist come together, they start knocking around ideas and the final idea may have come from one individual; but they discuss it, they start to imagine in their own art forms how they might realize a particular aspect of a collaborative work, and what we found was that this process works very well.

As a teacher, I wanted to present to my students an opportunity to work cross discipline without having them understand what that process is. It's a very magical kind of way of going out and making art. It's nobody's personal vision, there's no director, and essentially what you do is from time to time, meet each other and update, you send samples, you discuss. I have composed with one composer I met though the festival on 4 projects and when we would get together, we would show samples, or we'd listen to samples and we might, you know, it's a matter of how it might work, how does it work, how do you feel about it? So, you really have to get to know your collaborators and sometimes, this composer, Michaela Eremiasova, and I wouldn't really even talk about the work. We would internalize the music, and the images, and let them kind of bask in time and what happens, ultimately, is that each other's art form influences the other artist's art form. For instance, with Michaela, her music, sometimes I wouldn't understand what the samples were. I would listen to it, and somehow, in my mind, I was hearing something else, but then I would hear it, what I would do, and this is what I recommend, I would basically step back and understand that they are trying to tell you something. That there is something to learn from it and let it influence how you proceed in what you do. So this kind of step by step building of an artwork is very malleable. So you've let go of your ego. The win is you are creating this unusual work.

The result in work is what happens, is all the elements of the work: the sound, the music, the performance, the live performance of dancers or actors, they all tend to wrap around each other. We kind of liken it to like a double helix. The things that are connected, and feed, and respond, and converse with each other. Yet these strands of these different art forms have an independence and an autonomy and drive you into the work, and through your work, and release you in the end. So it's a very special experience and I really want my students to experience this.

Beyond the festival's ending in 2008, we still have our call meetings. The call meetings happen twice a year, so we can bring on people so they can find each other again. These days, they are doing these call meetings because they are looking for a composer, a filmmaker, a

choreographer, and it's not necessarily going to be a collaborative work, when they are all going to be beginning from scratch, sometimes that happens, but usually it's a filmmaker who is working on a project and wants to work with a composer. Now there's nothing that is uncollaboarative about that, because what happens is, each artist is to be valued in a project and has something to say, and say it through their art forms. So our filmmakers, actually, after a while, they get the idea to start listening to their composer.

One of my students the other day, got up in front of the class, it was a nice moment, she said, "Yes, I met with my composer two days ago," and she's in the middle of her work, and she said, "so he had some really great ideas so I'm going to be changing this particular area of the film." So, you know, it's this strength, I also feel when you're working with artists that there's a respect there. I can't tell a composer what to do and I know, I know that they have something that they want to invest in this work. Typically, this happens when a composer comes on a project, a director might say, "Well, I want you to do this and I want it to sound like that." The composer says, "Oh sure, I can do that." Then turn around and go, "Fuck." You know, because they have better ideas than you.

I said we had a call meeting once a year in the fall time for the projects. Over the next 6 months they would make their projects. At the end of 6 months, we would do the festivals in multiple venues, and we would have performance, big performances, technically well set up and celebrated. There are no guest artists on the festival, everyone has to work the festival. They have to do the publicity, they do the reception, they work, and do tech, and so forth.

Many times, what will happen, is people get so invested in their strand of work that a lot of technical innovation takes place. This particular film has a student who is multi-disciplinary at RIT who created a camera system that could stretch and elongate dancing figures. So this was a collaboration between a choreographer and a filmmaker, and a composer.

I'd like to encourage this approach to art making. Of course, I know in a studio system this is not the way, it's not the pipeline and the way production proceeds, but I like to give people this experience. People who come away from this, these projects, have gained a lot of confidence. They've done creative art work, these films and performances get re-performed, they go to festivals, they have won a lot of awards and they are an example of how people can collaborate, on a very basic level, by exerting themselves as artists or scientists in their field and knowing that energy put into the work is a fraction of theirs, in a collaborative style.

通过跨学科艺术家的合作来创新艺术作品

▶▶ Stephani Maxwell

我是罗彻斯特理工大学动画学院的一名教授，教授好几门课程。我学过电影制作和动画，有理工科背景。此外，我还是个潜水员，去过各种地方，所以会说几种语言。

我在加利福尼亚大学洛杉矶分校上学的时候曾经有个辅导员问我在学校里都做些什么，我告诉他，我在学习心理学、俄语、艺术课程和理工科课程，还告诉他我喜欢理工科和数学。他便对我说："你最后可能会成为一个样样通但样样松的人。"这句话困扰了我好几年。难道我无法在任何方面有深入的建树吗？这个想法一直跟随着我。直到我遇到了生命中的贵人，当时我放弃了理工科，去旧金山艺术学院学习艺术，我的辅导员赖瑞·乔登问我："你有什么样的背景？"我告诉他说："我学过理工科，学过语言，去过各个地方，从事过艺术，在洛杉矶的时候还拍过电影，当时我和一起拍电影的小伙伴都还是孩子。"他说道："哦，你是个文艺复兴式的人才。"从此，我不再认为自己将会一事无成，相反我会实现自己的人生目标，成为一个对什么都颇有研究的人。

所以我也鼓励很多学生去广泛涉猎各种知识，不要过分专注于一个方面，要多去了解各个方面，将其交织到你的人生经历中去。所以今天我想和大家介绍的是一种特别的、制作电影的方法，我称之为"真实合作"。

真实合作就是要让艺术家们、科学家们都聚到一起。我有一部作品就是和天体物理学家、作曲家以及另外一个电影制作人共同拍摄完成的，这个体验真是太奇妙了。采取这种真实合作的方式时，没有谁是导演。

这或许让人难以置信，尤其是对电影而言，在电影中基本上都需要导演来操控大局，其他人分头负责一些琐事，做好自己的工作，朝最终的目标努力。但是在真实合作中，不管是艺术家、科学家，还是其他领域的人，就只是聚在一起，共同创作。他们创作的作品是集体的结晶。

1997年我还在罗彻斯特理工大学时，我去了一趟同样位于纽约罗彻斯特的伊斯曼音乐学院。我在大厅里闲逛的时候遇到了一个人，我们讲到了项目合作，且一致认为可以利用我们这边的电影制作人和动画师、他们那边的作曲人和演员，来共同创作作品。

这么一次偶遇演变成了更加深入的谈话，我们开始展望一部艺术作品、如何从头开始、都需要艺术家们做什么样的工作。之前拍电影的经验已经告诉我，我在某些方面并不擅长，比如说音乐制作。所以我总是在寻找有这项技能的艺术家，和他们展开对话。注重合作的工作方式是我的首选，我不会以电影制作人自居，告诉人们电影里的音乐应该是什么样子、应该怎么演奏、用哪种乐器演奏。我会把这些工作交给别人来做。

伊斯曼音乐学院的教授和我创立了一个"影像运动声音节"。从名字可以看出，我们把所有元素都集中到了一起，说明我们很认真地在做这件事。参加这些盛会的包括伊斯曼音乐学院的作曲人和演员，以及电影制作人、影像制作人，还有戏剧背景、文学背景、计算机科学背景、各种技术背景的人。第二年，距离我们有30分钟车程的纽约州立大学布洛克波特分校也参与了进来。伊斯曼音乐学院从罗彻斯特过来有12分钟车程，纽约州立大学布洛克波特分校有30分钟车程，地理位置非常理想，这更加促进了我们的合作。纽约州立大学布洛克波特分校的苏珊娜·纽曼加入进来，她是一位舞蹈编剧。她现在退休了，是一位荣休教授。她为我们带来了一批舞蹈编剧、舞者，各种专业人士。这是我们每年都会做的事情，而且坚持了12年。

每年年初，我们都会召集艺术家会议。届时会在各大校园发放通知，会议很盛大。许多单位和个人都想参与进来，有拿撒勒学院、阿尔弗雷德大学、纽约州立大学杰纳西奥分校，另外还有独立艺术家，我们做的事情很有意思。我想告诉大家的是，这个活动现在还在继续，不过方式不一样了，因为影像运动声音节结束了。现在的活动会持续一整天，每个艺术家都上台做演示。"我是某某人，我住在这里，我是搞音乐的，或者是搞电影的，在这里向大家展示一些我的作品。"我们会听到他们的编曲，看到电影片段，有时还有人表演跳舞。我们会有现场舞蹈和现场音乐，每个人都有10分钟时间介绍自己的作品。此外，还时不时茶歇一下，就在会场旁边，提供食物和饮料，人们坐着或站着，开展社交。每个人都佩戴名牌，这样就可以互相认识了。人们相处了一整天，互相认识、交往之后，往往会形成不同的小组。活动举办三个星期后，我们这些组织者就开始设想，既然人们形成了不同的小组，那么是否可以共同写出一篇提案，由我们来判断其可行性，并寻找是否有机会去实现设想。这些项目可能会有两个人一起合作，也可能是三个人或四个人，甚至有个项目涉及五个人，包括三位电影制作人、一位舞蹈编剧和一位作曲人。

三位电影制作人共同执导，他们每个人总得放弃点什么，必须有所取舍，对吧？每个人都必须去接受其他艺术家的想法、生活经验和行为方式，这一点很难做到，也很难坚持。而在真实合作中，艺术家们聚到一起开展思维碰撞，虽然最

终方案可能只是某个人的想法，但这是经过讨论达成的，他们会开始想象怎么样用自己的艺术表达方式去实现整个合作作品的某个特定方面。最后我们发现这种合作方式进展起来非常顺利。

作为一名教师，我希望给学生们提供一个机会，让他们可以在不懂流程的前提下也能实现跨领域合作。这种艺术创作的方式非常奇妙。不是某个人的个人意志体现，这里面没有导演，基本上，你要做的就是不时去和别人碰面，更新信息，呈现小样，再展开讨论。我曾经和一位在艺术节上遇到的作曲人合作过4个项目的编曲工作。我们碰头的时候，会演示小样，或者一起听小样，讨论如何运作的问题，询问对方的看法。所以你必须去了解你的合作伙伴。甚至有时，我和这位作曲人（她叫 Michaela Eremiasova）还会聊很多无关工作的事情。遇到困境的时候，我们还会把音乐融到画面中，让时间去解决问题。这种合作的最终结果就是，一方的艺术形式会影响另一方的艺术形式。打个比方，Michaela 的音乐有时候我是听不懂的，不明白小样播放的是什么。不过我会用心去听，脑海里会浮现别的东西，但是依然要继续往下听，这也是我建议大家要做到的，听多了我基本上就能脱开音乐本身，从宏观角度听懂里面想表达的意思。从中我们可以有所收获，它会影响你接下来的工作。这样一步步创作一件艺术作品的过程充满了各种变数，所以你得放弃自我，这样将收获一件非比寻常的作品。

最后的结果便是，作品的所有元素，包括音效、音乐、表演、舞蹈演员或演员的现场表演等，全都捆绑到了一起。我们将这种现象比作双螺旋，种种元素互相连接，互相汲取，互相影响，互相对话。但是这些不同的艺术形式也有其独立自主性，它们会把你带到作品当中，最终通过作品让你的理念得到释放。这是一种非常特殊的体验，我特别希望我的学生也能有这种体验。

虽然我们组织的艺术节在2008年就收官了，但我们还是会召开会议。每两年一次，召集各路人马，这样大家又能见面了。最近这段时间，他们召开会议是为了寻找作曲人、电影制作人和舞蹈编剧。并不见得每次合作都要出来一个作品。他们从头开始做规划的时候，往往是电影制作人在策划一个项目，并且想要找到一位合作的作曲人。现在没有什么事情是不通过合作实现的，因为项目当中的每位艺术家都很重要，都有一定的发言权，可以通过自己的艺术形式发声。所以实际上我们的电影制作人总会不时地去倾听一下作曲人的意见。

前几天我的一位学生正致力于自己的一部作品，走到全班面前说："两天前我见到了我的作曲人，他有非常棒的想法，所以我准备按照他的想法改变电影的编曲。"这一刻真令人欣慰。就是这么一股力量，我也深有同感，当你和艺术家合作时，你们之间是有尊重可言的。我不会去指导作曲人该做些什么，因为我知道他们对这个作品有自己的想法。在普通的项目中，一位作曲家加入一个项目中后，

导演可能会说："我想让你做这么一件事，我希望音乐做出来是这样的效果。"然后作曲人会说："没问题，我办得到。"但是一转身就是一句"呸"，因为他们有更好的想法。

我们每年秋天都会为项目召开一次会议，接下来六个月就是项目实施时间。六个月之后，我们会在不同的地点举办艺术节，进行各种演出，非常盛大、精彩、喜庆的演出。艺术节上没有哪位艺术家是嘉宾，人人都得出一分力，要做宣传、接待、技术支持等方面的工作。很多时候，人们专注于自己的工作时，会研发出很多技术创新。这部电影的工作人员里有一位是在罗彻斯特理工大学研习多门学科的学生，他发明了一种摄像机系统，可以拉长舞蹈者的身形。这就是舞蹈编剧、电影制作人和作曲人之间的合作。

我鼓励大家在艺术创作时使用这种方法。当然，我知道一般摄影棚里不是这么做的，这不符合他们的制作流程，但是我希望大家能有这么一种体验。但凡参与过我们项目的人，都变得更加自信了。他们创作出了极具创意的作品，影片和演出反复上映，他们也得以参加各种艺术节，赢得了很多奖项。这些经历告诉我们，人们可以以各自领域里艺术家或科学家的身份参与到工作中，做出自己的一分贡献，从而实现最基础的合作。

《悟空传》《绣春刀Ⅱ》《羞羞的铁拳》等制作分享

◎ 王勇猛

大家好，首先感谢会务组的邀请，今天非常荣幸能够代表MORE VFX 站在这里与大家进行一些经验的交流和分享。

首先请允许我简短介绍一下我们公司。MORE VFX 成立于 2007 年，它是目前中国人自己体量最大的视觉特效公司，以制作世界级的视觉特效为使命。我们在不断地进行技术积累，不断地进取。信誉和品质是 MORE VFX 坚守的核心。公司主导或参与制作的影片也多次获得各种奖项。多年来我们与国内众多的视效导演、顶级电影公司保持了良好的关系。公司现在有北京和成都两个制作基地，聚集了大量国际级的视效总监、技术专家和艺术家。一往无前的唯一力量就是热爱你所做的一切。这是我们的企业宗旨。MORE VFX 在以下几个地方有自己的特长。

首先有概念设计，然后生物角色，动力学特效、高效的流程以及动态的预演。这是一些概念设计的作品。这是我们在《重返 20 岁》这部电影制作过程当中视效预览的一个实践，视效预览结合了交互式摄影控制，因为它有一个差不多三四分钟的长镜头，是非常连贯的。利用交互式摄影控制系统，我们在三维软件里面首先设置好它的运动路径，然后一比一还原当时在现场所搭摄影棚的大小和比例。到了现场后，利用交互式摄影控制，我们可以一遍遍地用同样的轨迹去拍摄同样的效果，最后再把它们叠加到一起。这个镜头讲述了这个男人从青年时代到中年时代演变的过程。

MORE VFX 业务领域

生物角色特效

生物角色方面也是我们的强项。除此之外，我们在动画电影方面也进行了很多尝试。首先有张扬导演、宁浩监制的《年兽大作战》；另外我们还参与了《大鱼海棠》中三维部分的制作。这个页面介绍了2011—2016年我们的一些作品。2017年是公司相对丰收的一年，因为有视效量超大的《悟空传》上映，在这个影片当中我们进行了上千个镜头的视效制作。它的特效类型有坍塌、消散、妖云、环境，特别全面。

还有《绣春刀Ⅱ：修罗战场》，里面有写实的道具，有 CG 的城市、水下的沉船等。还有《记忆大师》，它是前一阵子上映的影片。在《记忆大师》中有非常多写实的道具，还有超写实的云。还有刚上映的《羞羞的铁拳》，在里面我们进行了好多补景方面的制作。这四部片子非常有代表性，我个人认为其中的视觉特效有两种：一种是我们没有见过的、要靠想象力创造出来的东西；另一种是我们要把它融合在一个非常现实的环境当中，让观众并不能发觉它是电脑做出来的。

下面我将这几部影片当中的一些案例介绍分享一下。首先是《悟空传》，大家可以看到《悟空传》当中的金箍棒是一个前所未有的大家都没有见到过的概念。在金箍棒的制作过程当中，金箍棒的特效大致分了几个部分：首先是有熔岩状态的金箍棒，还有熔岩形成金箍棒，以及金箍棒长出裂缝、膨胀，然后裂缝加膨胀，胀大后收缩、剥裂，大概有这么多的视觉效果。我们在制作过程当中，首先导演会给我们他设想的概念，他会想这个金箍棒是熔岩的，但具体熔岩在形成过程当中应该如何实现呢？这就需要加入我们的想象了。大家可以看到，金箍棒的内部充斥着熔岩，熔岩会照亮外部的环境，同时外侧的熔岩会凝固，形成金箍棒真正的形态。

这个镜头是非常有意思的：孙悟空在掏耳朵，掏耳朵的同时甩出来一片岩浆，然后岩浆快速凝固形成金箍棒，但是岩浆在最终与他耳朵断开的地方，会有非常有黏性的拉丝的感觉。我们在制作过程中，用单纯的流体去模拟是做不出来这种效果的。因为流体虽然有黏性、有流动性，可以去调节，调得非常黏，但是在它非常黏的同时又有弹性的感觉是很难实现的，所以我们用了一部分编程的方式进行修正。用流体打了个底，模拟了一些基础的效果，同时通过程序化去控制它的弹性。在这个效果当中，很多人会说金箍棒熔岩下坠、凝固过程中用流体去模拟会得到更好的效果，但是我们在实践过程当中发现，像当前这种效果不需要真正

用流体去模拟，可以用正常模型给它一个形态之后，用程序化方式加一些。做的时间呢，它的版本的迭代也是非常快速的，也不用流体，动辄解算几个小时。

大家可以看到第一层就是模型最基础的样子，第二层是用程序化在模型的上面通过随机的方式估出好多熔岩的凸起。第三层就是通过程序化的方式让鼓出来的熔岩有了重力倾向，有了重力倾向之后，你就会感觉它是一个可以流动的物体。下面金箍棒会有一个膨胀的过程。导演在对我们进行视觉效果要求的时候，他提出要金箍棒变大，大家应该看到很多有金箍棒的片子，一般金箍棒变大就是一个缩放，一个很细的金箍棒

金箍棒特效

缩放成一个大的，但是在《悟空传》这部片子当中，要求金箍棒长大。什么叫"长大"呢？它是通过分裂、膨胀不断产生新的碎块，不断填充然后变大的，所以它不仅仅是缩放。在这个处理过程当中，我们首先用程序化去分割了金箍棒上好多的碎块，利用程序化的方式让它往外长出，长出之后会测算两个碎块之间的距离，当这两个碎块之间的距离超过一定范围之后，会有新的碎块产生、填充上，所以它是不断生长、变大的一个过程。同时，在金箍棒的渲染过程当中，我们在 shader 面也用了很多程序化的方式，比如中间发出亮光的这些岩浆，其实在 shader 当中我们加入了很多的随机性，最终金箍棒呈现了一个非常好的视觉效果。

接下来再介绍一下《悟空传》中的妖云。在《悟空传》当中，导演是这样设定的：在这个小镇中，它是一个为非作歹的妖怪，但是最终被孙悟空收服之后，是孙悟空脚下的筋斗云。妖云在整个《悟空传》当中是最为抽象、变化多端的视觉特效。首先导演要求它要有感情变化，那么，特效就需要用激烈的旋转、扰动以及闪电的颜色变化体现它是一个活生生的生物。

在具体的制作过程当中，导演有要求，妖云会有一个头，它的头像是一个龙头，但同时又是一个不断翻滚像龙卷风的形态，所以我们在制作过程中需要一个具象的流体的发射器，我们用模型先做了这样一个龙头，这边第二张图中大家可以看到稍微具象的一个龙头。我们再用程序化的方式把它扰动，让它本身有这种云扭动的形态、这种动态，然后再用动态的模型去发射进行解算。另外一个难点就是，我们在制作闪电的时候，因为闪电是在巨大的云层当中随机发生的，闪电通过 L-system 软件去生成树状的闪电，同时用粒子的方式随机产生在云层的各个位置，也用粒子的方式去控制了闪电的颜色。

最后一部分大家看到的是，妖云被人类攻击后慢慢结冰。妖云是一个不停扰

妖云特效

数字化重建真实明星的脸

《绣春刀Ⅱ：修罗战场》视效

动的流体，被人类的子弹击中之后，它会从接触点开始慢慢扩散变成冰，也就是说，在这种流体的解算过程中，你需要控制当它开始接触之后，接触点开始慢慢凝固，到后面全部凝固。当前面凝固的时候，其实它后面还在扰动，这是一个非常难解决的问题。我们首先利用了各种自定义的粒场进行了控制，然后在真正缓存基础上，通过帧与帧之间的融合，最终把它锁定在这样的一个状态。

下面看一下《记忆大师》当中的视效解析。其实在《记忆大师》当中就充斥了我刚刚所说的观众看不出来的视效。我分享一下数字替身的制作，在本片当中应用了大量黄渤的数字替身，由替身演员去拍，但是我们后期把整个脸部换成黄渤的脸，在这里就用了三维扫描技术以及数字角色还原。

三维扫描技术我们曾经使用过图片的，也有基于图像的，在这个项目当中我们使用的是基于图像的三维扫描和还原。通过整个角色还原，黄渤脸上非常多的细节和写实的效果都被展示了出来。在整个镜头制作过程当中，首先我们需要跟踪还原当时摄像机的运动，得到一个稳定的三维空间。然后在 Maya 当中，我们把数字替身的三维模型跟实拍的角色进行透视各方面的匹配，最终通过面部肤色、光影、肤色的渲染达到和整个环境融合。在合成过程中我们也会对镜头的聚焦点、畸变进行非常微妙、细微的变化，让它能够彻底地融入这个环境。

下面是《绣春刀Ⅱ：修罗战场》的视效。我想跟大家分享的是我们在雨夜小镇大全景制作过程中的实践。雨夜大全景是明代的写实场景，所以我们首先对这个场景当中用了哪些建筑物进行分类，归纳出我们大概要有哪些类型的"资产"。

在我们公司当中，我们提出一个"一级资产"的概念，也就是说，每个单元是一级资产，然后用这些单元通过组合形成最终的场景，这是我们提出的概念。大家可以看到在这个场景中有大量的资产。正常 Maya 当中，打开这个文件可能要十几到二十分钟，但是通过我们公司的流程优化，我们内部打开这个场景只需要几十秒，就不到一兆的文件。这个场景因为是雨夜大全景，所以做雨是一个非常重点的问题。首先我们分了中近景的许多雨，这些雨是通过粒子进行制作，替代了模型。我们在进行雨的渲染过程当中，是真正把场景放在了里面，它有真正场景的折反射、灯光反映，所以它看起来更真实。雨滴的制作，是通过各种扰乱

流程 1.0

流程 2.0

的场进行制作的。远景也会有大量的雨，同时还有雨雾形成的一些水汽，最终结合到一起。另外，我们还做了雨滴砸在房檐上溅起的水花以及从这个房檐滴落下来的水花，但是由于最终效果是非常暗的夜里的场景，所以并不是太明显。我们的灯光也对所有的灯进行了测试，这是当时测试的效果，但是导演给出的反馈是要一些非常寂静、荒凉的效果，所以我们砍掉了百分之八十的灯，这是最终灯光呈现的效果，只有寥寥几户人家亮着星星点点的光。最终再进行合成。这是效果。

2016 年，我们公司做了非常大的流程 1.0。在此之前，我们还停留在用 Maya 文件进行上下游文件交接的过程。那时我们做了《疯狂的年兽》这部动画电影，在灯光渲染的环节会产生各种各样的奇怪问题，文件不知道为什么就是渲染不了，灯光制作人员打开这个文件甚至是半小时、一小时，这个文件可能会卡住二十分钟，当时我们非常痛苦于灯光的问题，所以我们决定做一个大的流程来优化灯光。

谈到流程，肯定会有一个节点图，这个节点图我觉得不是太重要，重要的是我们在流程 1.0 的搭建当中进行了数据拆分，也就是说每一个部门拆分出有用的数据，然后到下游组进行组装；同时注意 Maya 当中的 GPU Cache。之所以说《绣春刀》当中的场景这么大，我们的文件却可以保持这么小，就是因为制作人员去

摆放的时候，他所有摆放的都是 GPU Cache，渲染的时候，我们就挂上了渲染代理，这样就能保证他的文件非常轻量、操作快捷，同时也能保证渲染的正确性。在我们的流程中，也做了一些实践，引入了 shotgun。shotgun 的管理是非常方便的，有利于制片的统筹和管理，我们统一了内部的代码管理、桌面端管理，然后统一插件管理，拆分各组数据。最后做了版本管理。

这是我们在流程 1.0 时代的一些经验。首先是内部的插件管理，我们在内部做了一个 APP Manage System，就是所有的制作总监、基础人员做的插件是通过系统进行统一管理的。这是我们插件的 Shelf-Config System，这个工具是针对某个项目的，或者说同一个工具在不同的项目里是有微调的，需要统一的工具给大家配置。配置完成之后，所有制作人员的环境已经改变了，用的是插件。这是 MORE Desktop，这是我们的一个软件，通过这个软件，制作人员可以看到他被分配的任务、要启动的工具、要得到的反馈、需要的参考以及本镜头所有的详细信息。也就是说，在我们的工作流程中制作人员打开 Desktop 就能得到所有信息。这是内部一个插件的演示。

下游组去拿上游组的所谓的元素的时候，他可以看到上游组从某个镜头出来的所有详细信息，每一个资产都可以导入某一个资产，也可以整体更新所有的场景。这一页演示的是我们内部制作人员的工作。首先他通过 Desktop 获取工作内容，选择任务，启动相应 DCC 软件；在软件内进行工作；用工具进行 Delis（视频）的提交，进行元素发布（Publish），之后通过 Desktop 又获得了总监的反馈。如果通过了，它再通过我们的发布进行元素提取，下游组会得到上游组提交的所有这些拆分。其他组也是一样的，它们的数据内容的获取、任务的分配都通过同样的工作流程。也就是说，通过这一系列我们在公司内部统一制作流程，拆分出来的数据有 GPU，有记录下的场景信息、文件、层级信息等各种内容，这是我们做的一些尝试。

到了 2017 年，也就是今年，我们总结了 2016 年流程的弊端，比如我们把流程优化太倾向于灯光部门，导致上游组的平衡性降低。还有版本管理，当时我们用 Linux 系统，它有一个叫软链接的功能，我们做到自动更新，但是实际上从制作人员反馈上来说，不希望它能自动更新，因为某一天某人突然打开它时会发现里面的内容、缓存被改变，所以他想要一个他能完全控制的版本。2017 年我们在流程更新时做了这样一些改进。首先我们在 2017 年引入数据库，通过工具去查硬盘，这种速度会比较慢，我们把这些信息全部输入数据库之后，通过数据库查询，速度是非常快的。

同时我们搭建了 MORE 的 API，把常用的代码功能封入各个即时可调用的模块，这样我们内部的插件编辑是非常标准化和高效的。桌面端也进行了升级，在功能性上、模块化上做了一些努力。也就是说，下游组在流程 1.0 的时候只能拿

某个部门的数据，但是到流程 2.0 的时候，由于我们的把控能力更强，而且我们把数据交给了数据库管理，所以每一个部门都可以拿到任一部门的你想拿到的数据，平衡性也就更强，可以跳过某些部门直接拿到数据。比如说我是灯光部门的，我可以拿动画部门、LAYOUT 部门的东西，也可以拿资产直接进行测试，所以平衡性强。版本追踪更强。现在任意拿某一部门任一工作人员的工作文件或者是他发布出来的内容，我可以追踪到他文件当中使用到的任何一个元素，他是从哪个部门哪个版本文件里拿过来的，一直追溯到资产部门，所以，这个对版本管理是非常有效的。

接下来，我要聊一聊到了 2018 年，我们可能会做流程 3.0 的更新，到时候会有一些什么样的元素呢？首先，我认为导演和视效总监总是会期望能够在后期流程中越来越前置地看到更接近渲染的效果，所以我们会朝这个方向努力。

我们内部有研发部门，这是我们内部研发的工具，这个工具弥补了 Maya GPU Cache 的不足，在 Maya 中只有一个节点，它没有任何的层级、元素，通过我们的优化，我们的显示也是通过 GPU 去做，但是你可以选到这个资产原来所有的层级，你可以对这些层级进行进一步的编辑，然后通过这个 GPU 直接送去渲染。Open source 的东西也会影响我们流程的变化，比如 USD，OSL 或者是 MATERIALX 这些，我认为它都有可能加入中国制作公司的流程当中。另外，就是引擎。我当前贴出这两个引擎，即 UNREAL 和 Unity，但是我了解到还有很多 Open source 的引擎，这些引擎可以加入流程中，比如说让导演更早地在动画部门看到相当接近渲染的效果。最终我认为，做流程就是数据，每一个部门的有用数据。所有 AI 也一定会进入这个行业，因为 AI 处理数据的能力是非常强大的。

最后我想表达的是，MORE VFX 是一个非常希望能听到大家的想法、跟大家开放交流的公司，希望有更多机会跟大家交流。如果大家给我们留言的话，我们也能看到。

谢谢大家！

Production of *Wu Kong*, *Brotherhood of Blades II*, and *Never Say Die*

▶▶ Wang Yongmeng

Welcome. First, I would like to thank the executive board for inviting me, and I'm honored to share my experience and ideas as the representative of MORE VFX. My topic is "Film Visual Effects Production and the Pipeline of MORE VFX."

First of all, I shall talk a little about my company, MORE VFX. Founded in 2007, it is the largest visual effect agency run and owned by Chinese, with the ambition to hit a world-class level with consistent efforts in technological development, as well as commitment to accreditation and standards. A number of our films, produced or co-produced, have won various awards, and we have established firm connections with Chinese VF film directors and top-notch film companies. We have two production centers in Chengdu and Beijing, with many internationally renowned VF producers, professionals, and artists. We believe that the overriding force is passion for whatever we love. Now I'll talk about what we are really good at.

You need to begin with concept design, then digital realistic bio-characters, dynamic simulation, efficient pipeline and pre-visualization. Here is a sample of our concept design in Miss Granny. The preview uses interactive camera control for a continuous long shot that lasts three or four minutes. We designated the path of the camera and reconstructed the studio in actual size and proportion. Then we went to the studio, let the camera shoot the same place on the same path multiple times. Eventually, we combined what we had to tell the story of a man growing from a teenager to a middle-aged man.

We are also experts in bio-character. What's more, we have made some experiments in animatic movies. For example, *Mr. Nian* directed by Zhang Yang and produced by Ning Hao, and the 3D part of *Big Fish Begonia*. This page includes part of our work from 2011 to 2016. 2017 was a big year for us because of *Wu Kong*, a movie relying heavily on visual effects. We contributed more than a thousand shots to it, including collapsing buildings, dispersing an evil cloud, and ambiance.

The second is *Brotherhood of Blades II: The Inferno Battlefield*, with realistic set-ups, and cities, underwater wreckage in C.G. Yet another is *Battle of Memories* with realistic set-ups and extra-realistic clouds. The last is *Never Say Die*, which came out only recently. Much of its pickup is produced by us. The four movies are rather representative. When it comes to visual

effects, there are two types: one is purely imaginative, nobody has seen it anywhere; the other is trying to fool the viewers into believing it as something real. Both appear in the four movies.

Now I shall elaborate the ideas with examples from the movies. Here is the Jin Gu Bang, or Golden Cudgel, in *Wu Kong*. It is a fantasy weapon that no one has ever witnessed. Its visual effects can be divided into stages. The cudgel begins as molten lava, then it comes into form, cracks, swells, then contracts and the surface fractures. That's basically what it's like. As we worked on it, the director told us what was in his mind, say, the molten lava. But how to materialize the concept? Here was where our imagination came in. Now we see that the cudgel is filled with lava, which illuminates the surrounding, while the lava on the outside cools down and evolves into Jin Gu Bang.

This is a curious clip. Wu Kong, or the Monkey King, is picking his ears, throwing a ball of lava out, and the lava quickly forms into the Golden Cudgel. Pay attention to the sticky, molten-sugar-like feeling when the lava finally is detached from Wu Kong's ear. We found that fluid alone didn't do the trick. Stickiness and fluidity can be adjusted so that it feels thick, but if you want stickiness plus elasticity, sorry, it just can't be done. A fluid model functioned as the base, with certain basic effects, and elasticity was realized with a special program. They may say that pure fluid works better to represent the falling and cooling of the Golden Cudgel. However, as practice tells us, fluid is neither necessary nor superior, and a programmed and shaped non-fluid model works just great. Another advantage of this approach is quick iteration, sparing hours spent on fluid mechanic resolving.

The first layer is the base, and on the second, a number of lava bumps are added with a stochastic program. The third layer augments the bumps with gravitation so that they seem flowing. Then the cudgel grows, as the director explicitly calls for. The golden cudgel getting larger features in many movies, it's usually a matter of scaling. But in *Wu Kong*, we have made it "grow" dynamically. It swells like cell division, spitting out cracks, then fills itself and grows again. It's so much more than scaling. The cracks are automatically generated and dictated to grow out. When the measured distance between a pair of cracks exceeds a threshold, a new crack is generated to fill the space. Now we have a process of continuous growth. In rendering, customized programming is applied to the shader for the shining lava and others, with randomized factors. The result is perfect.

Next, the evil cloud in *Wu Kong*. As the director imagines, the cloud used to be a monster bedeviling a small town and became Wu Kong's private jet after the monkey king defeated him. Of all the visual effects in the film, it is the most elusive and myriad. The director said that it needs to be emotional. So we had to use violent swirling and turbulence, and lightning with changing hues so that the cloud seemed like a real creature.

Furthermore, the director told us that the cloud must have a head that resembled, at one time, a dragon and a tornado. So we needed a concrete "emitter" of fluid material. We began

with a concrete dragon, as in the second picture, we programmed some distortion to make it like a twisted cloud. At last, a dynamic model is used to resolve the emitting problem. Another challenge is the lightning, which is randomly generated in the thick clouds. We used L-systems to generate the flash trees and randomly arrange their positions and colors, as particles, among the clouds.

This shows how the cloud, a fluid turbulence, slowly freezes after people attack it. The process starts from where the bullet pierces into it, which means that the fluid mechanics resolution is needed from the moment of contact. Until it is completely crystallized, the back side of it is still struggling. It's surprisingly challenging. For this visual effect, we applied customized particle fields to control the cloud, and fused the frames based on a cache.

Now let's see a VF resolution in *Battle of Memories*. Actually, the movie manages to hide many visual effects from the audience. I will talk about digital substitute, which is intensively applied in this movie. Huang Bo, as the viewers see, was in many cases played by a substitute, whose entire face was replaced by that of the real star, and 3D scanning and bio-character recovery.

We have tried out photo-based and image-based 3D scanning, and for *Battle of Memories*, we choose the image-based approach. As it turns out, the rich details of the face of Huang Bo are represented in a highly realistic manner. For a start, we tracked down the movement of cameras when the scenes were shot, and constructed a stable 3D space. Then we used Maya to match the 3D model of the digital substitute and the real actor, in terms of perspective and other factors, before rendering the hues, light and shadow of face and skin so that the constructed Huang Bo was fully immersed into the environment. Subtle adjustments concerning the focal point and distortion were also implemented.

Here is a VF breakdown shot in *Brotherhood of Blades II: The Inferno Battlefield*, the panorama of a showered town in slumber. The scene is set in the Ming Dynasty, so we first sorted out what kinds of buildings were needed, or "assets."

We have introduced the concept of "first-order asset." Each unit is a first-order asset, and each scene is constructed of such assets. A considerable collection of assets are identifiable in this scene. It usually takes more than ten minutes to open this file in Maya, and we manage to open the optimized file, less than 1MB, in less than one minute. Rain is key to this panorama. We start from the close and medium shots, where rain drops are generated as particles instead of models. Refraction, reflection, light and other parts of the scene are fully incorporated so that the rain would seem more real. The rain drops are generated in various turbulence fields. There are also rain drops in the distance, with brume and fogs, and all these elements are integrated into a scene. Actually, we have created animations of splashes falling on and off the eaves, but it is really dark, so probably few people noticed. We ran a thorough test on light, and let's see the result. But the director wanted a lone and silent feeling, so we deleted eighty percent of all light, and here is the finalized effect: a handful of lights in scattered houses. Then

we put them together. Done.

In 2016, we developed a huge Pipeline 1.0, before which we had given and taken Maya files directly. Then we were engaged in *Mr. Nian*, an animated movie. Weird problems were abundant in light rendering. Somehow the files might refuse to be rendered, or take thirty, sixty minutes to open, only to be stuck for another twenty minutes. The light dilemma motivated us to do massive streamlining for it.

The node plan is a requisite of any pipeline, yet not a key part in our 1.0. The key is data split, that is, each department only sends what is useful to the downstream where the "splits" are reorganized. Maya's GPU Cache also makes a great contribution to downsizing. *Brotherhood of Blades II* is a good example. There are some huge and complex scenes, yet we have effectively kept the size as small as possible, and the magic ingredient is GPU Cache: all the assets are GPU Cache and they are rendered using proxies in Maya. It's quick, easy and accurate. We have also experimented with shotgun. Shotgun proves a powerful managing and organizing tool for us, with which we have synchronized codes, desktops, plug-ins, split data and realized version management.

Now I'll talk about some lessons from Pipeline 1.0. First, we developed an APP Manage System to synchronize the plug-ins for all producers and junior employees. The Shelf-Config System is a customizable tool for updating necessary software among members of specific project teams. After the configuration, the team will feature a unified development environment. The More Desktop allows our employees to view their assigned clips and related tools, resources, feedback, and specifications. More Desktop is an all-in-one information hub. Now let's see how these internal systems work.

When a downstream developer receives what we call "elements," he is accessible to their specifications and assets for import and synchronized update. This page shows one of our employees. First, he learns what he is expected of on More Desktop, then he chooses a project, opens the corresponding software, and works in it, submits his work with Delis, publishes the element, and receives feedback from his director. If the element is accepted, his downstream will receive the necessary "splits," which are generated during publishing. In other teams, DCC acquirement and project assignment are worked out in basically the same way. With this company-wide pipeline, the "splits" include GPU cache, scene specifications, files and hierarchical positions, among others.

In 2017, we summarized the flaws of the 2016 Pipeline. For one thing, it is designed disproportionately to serve the needs of the light department, causing imbalance along the upstream. Another thing is version management. The Linux system, which we were using, has a feature called soft link, enabling automatic update. However, automatic update seems to be undesirable because few people want to jump into a development environment where objects and cache can be changed by God-knows-who. They want full version management

and that's what we did in 2017. We introduced databases in 2017 so that our developers can make inquiries much more quickly than if they use the above mentioned international system instead, as long as the data input is finished.

At the same time, we created API for More Desktop, encapsulating frequently used functions into ready-to-call modules. The result is a standardized and efficient plug-in edit system. We also enhanced the functionality and modularity of desktop clients. More specifically, in Pipeline 1.0, the downstream only receives data from a limited set of departments, while the database-empowered Pipeline 2.0 offers every department the access to any data from any other department. Thus a more balanced system is created, allowing "jumping" to departments above your immediate upstream. For example, if you are a member of the light department, you can get stuff from the animation and layout departments, and run tests on the assets yourself. The upgraded version management means that I can track the entire history of any element in any member of any department all the way to the department that produced the asset. This makes an effective version management system.

The next topic is about 2018 and the potential 3.0 update. What's new? I believe that film and VF directors have always wanted to preview the results, if only approximating, as early as possible, so that's what we will be working on.

We have an R&D department that has developed a wonderful tool that fixes a major flaw in the Maya GPU Cache, that is, Maya Cache only allows for one node, but no layers or elements. Now we can select and edit all the layers of an asset before rendering with the same GPU that is displaying the asset. Open source programs have also made some differences, say, USD, OSL or MATERIALX. I think they can be useful for Chinese VF producers. Another thing is the engine. Here I show two of them, UNREAL and Unity. Yet, open source engines are many; and incorporating them into your pipeline allows film directors to watch almost-finished renders. Ultimately, pipeline is about data, useful data in every department. So AI will definitely enter this field with its startling data-processing power.

Last but not least, MORE VFX is open to your ideas and feedback. We really look forward to discussing the future with you guys. If you have anything to tell us, just leave us messages. We read them.

Thank you!

International Conference &
EXhibition on Visual Entertainment

2017 ICEVE 北京国际先进影像大会演讲集

未来影像
主题论坛

权龙

计算机视觉、视觉学习和 3D 重建：
用无人机和智能手机捕捉三维的世界！

◎ 权龙

首先，我非常感谢组委会提供这个机会让我们来参加这个"跨行业"的聚会，毕竟行业不太一样，我们是做计算机视觉研究的，能够有机会跟这里很多做内容的专家交流一下是很好的机会。今天主要讲一下我自己做的一些工作，还有我们自己对最近一些比较热的计算机视觉和人工智能的看法。

先给大家看一个演示。这就是一个典型的用无人机采集的三维模型，是大疆的一个大众无人机去拍的，几百或者上千幅的照片就可以产生这样一个模型，可以看一下相机的姿态。所有这些内容都是网上实时下载的。www.altizure.com 是我们的一个网络云平台。大家只要用无人机或手机或任何一个相机上传图片，我们就可以把相应的三维模型建造出来分享，还有后期编辑或者嵌入第三方三维应用系统，甚至 3D 打印，等等。

先举几个小型模型的例子。这是用无人机拍摄的。大家看，细节可以无限地看清楚，也有拿一般相机拍的。这是一个摄影师拍的摩托车，是由几百幅图片构成的——只需要图片就能够全自动地将摩托车的三维模型重新建造起来。同一位作者的另外一个作品是巴黎圣母院，这些照片都是普通的数码相机拍到的，去过巴黎圣母院的朋友通过这个三维模型都可以看到，建筑上的每一个雕塑都是极为精细的。

关于大规模的航拍模型，这个例子是美国城市奥斯汀将近 100 平方公里（千

权龙在 ICEVE 大会现场

三维模型重建（1）

三维模型重建（2）

米）的城市景观。从图片到三维模型的建造、浏览，这一系列的过程都是全自动的、在线实时展示的。欢迎大家上 www.altizure.com 随意浏览千万 www.altizure.com 用户的作品，免费试用的作品都是公开的。

无人机航拍三维模型重建（3）

无论是无人机航拍风景、建筑，还是大家用智能手机拍摄物件，甚至人物，www.altizure.com 都会如实精确地将其重建为三维模型。这是一个用手机拍下几十幅照片之后建造成的人脸的精细建模，精细程度是非常高的。

大家做电影的可能都知道，一般做人脸模型都会戴游泳帽，什么头发、眼镜都不行。这个就是个很好的例子，大家能看到，连眼镜都是做出来的。大家要知道这个眼镜玻璃怎么去表述其实是很有意思

人脸模型重建

的，你仔细看这个模型在几何上是怎么恢复的，可以去体会这个精细程度。

我们毕竟是从不同领域过来的，我自己是做计算机视觉、人工智能这方面的，所以我就跟大家分享一下我自己怎么去看现代技术和人工智能的一些应用吧。我先讲一下个人对人工智能和计算机视觉的理解。人工智能的关键就是计算机视觉，

因为通过视觉带来的信息基本上是人的五官感知里面占百分之八十的信息。

众所周知，我们处于一个人工智能的热潮中，每天到处能看到 AI 的字眼，那么大家知道 AI 热潮的沸点出自什么吗？AI 的热潮源自计算机视觉在识别领域的成功。2012 年，借用一本英语书名"A Year of No Significance"，中文是《万历十五年》，2012 年对全世界都是非常平凡的一年，然而后来我们才意识到，对于视觉领域，这一年非比寻常。因为在这一年，在计算机视觉年会上，ImageNet 的识别率被证明骤然提升了近 10 个百分点！对于那一年参加会议的人来说那年可能跟别的年份也没有什么区别，但是正是这一年，长期被抛弃的深度卷积神经网络被正名了！之前在此如果你的文章用了神经网络，基本直接被拒。现在恰恰相反，如你没有用神经网络，基本上希望渺茫。

2012 年以后用的方法基本全是深度卷积网络，它对图像识别的计算机视觉乃至整个人工智能带来的影响是大家现在都知道的。

现在回顾起来，2012 年提出的这个工作的卷积网络其实在 1998 年已由 Yann Le Cun 发表和证实。Yann Le Cun 被当之无愧地称为"深度卷积神经网络之父"。这是他在 1998 年发表 diagram 画的神经网络。如果我们仔细对比一下，它跟 2012 年做的卷积网络如出一辙，只是图片尺寸不一样。1998 年输入的图片是非常小的，32×32×1，而且没有 RGB，只有一个频道是黑白的，到 2012 年时已经是 224×224×3，RGB。输入的尺寸增大了一百多倍，加之 RGB 是三个频道。这样讲的意思就是方法原理早在 1998 年就已经完全成熟了，那么大家会问：为什么会等 15 年这么长的时间？

这就要归功于硬件的革命性发展！

做 GPU 的人本来也不是为了做视觉；做人工智能的人，主要是为了做游戏。然而殊不知，为游戏而生的 GPU 把计算机视觉和人工智能重新做了定义，因为长久掣肘人工智能发展的恰恰是硬件。随着 GPU 的发展，人工智能所需要的计算机显示很容易地被加速几十到几百倍。例如 Alpha Go 把职业选手击败，虽然 Alpha Go 只是一个非常狭义的人工智能问题，但它并不是广义的。由此，人工智能、计算机视觉都被重新定义。

简单回顾一下三十年的计算机视觉。什么是计算机视觉？计算机视觉的精髓在于我们对图像进行的理解。对图像能够彻底地理解是很抽象的，没人知道什么是"理解"，我们也不知道如何定义"理解"。更具体、更踏实一点来讲，就是对具体可分类物体的识别和三维重建。我们要做的最重要的事是在图像里面寻找所谓的特征，就是图像特征。

什么是图像基本元素，为什么要定义它们？在语音和文字里基本元素是简单和具体的，例如文字、文章，然后是段落、句子，再然后是字、每个笔画，这是非常清楚的；语音里面也是同样，有音素。能够提取和处理基本元素就可以做后

续的很多事情。当打开图像的时候，我们并不知道什么是图像里面最基本的元素，大家知道 Pixel，其实它以前叫作"picture element"，意图是想定义一种特征，但其本质上并不是，其只是数字记录单位。对于可视化特征的定义和处理是计算机视觉研究的关键所在。

计算机视觉里面有两个大的问题：一个是识别；另一个是重建。大家可以看到，两个都有"re"，它们本质上都有反向问题，解决这些反向问题的出发点就是必须规范化使解空间平滑与稳定。首先要从数据中提取特征，然后用统计的方法做识别，用几何的方法做重建。

概括来讲，计算机视觉发展基本上就是被特征、识别和重建这三大部分所定义。在神经网络之前，对特征的寻求主要是被三维重建，也就是几何所主导，因为那时我们对特征的定义都是手工设计，而且要用到数学分析和几何模型，其中最关键的是用到重建的一些观察和理解。当下，谈重建的开始变少，特征加识别基本上替代了重建，因为特征可以自动地通过网络学到。

那我们再看看计算机识别能够达到什么样的水平。譬如大家常常在媒体中看到或听到所谓对图像的理解，只要你去收集几百幅、几千幅照片，而且你可以描述这个东西，那么你就可以把样本给计算机学习；下一步再让计算机去识别同样的但是以前没有见过的图片。

这类可以清楚定义出来的任务，计算机不仅可以做得很好，而且可以做得比人类更好，一旦能够机械化、自动化，它肯定比人的能力更强。但是我要强调一下，它并不是比人类更聪明，它跟以前一样蠢，其实没有任何智能。举个例子，识别一个猫和狗，这是个猫，这是个狗，其实什么是狗和猫你只是给了几百个例子，只是写了个"狗"字或"DOG"，如果你要把它换成"猫"，换成"CAT"，其实它根本没有理解。在这里我要讲一下，它没有语义上的理解，这样说来，深度学习带来的东西最终还是有很大局限性的。

现在大家知道，人工智能深度卷积神经网络，这里面最关键的是，说它非常强大、非常有益也不是没有道理，而且它确实会带来一场革命，而这场革命我们认为最重要的是在数学上、统计上出现了一个建模的工具，它非常方便。以前做一个小的数学模型都比较困难，现在做一个庞大的数学模型都不需要很高超的编程能力，能写脚本即可。如此说来，这可谓一场革命，谁曾想本质上它只是由下而上的数据驱动，是从底层开始的数据统计的一个解释，没有一个任何自上而下地推倒出来的，就是从高往低进行对我们感知和知识表述的认知。大家也知道知识有很大一部分不是概率的，也不是统计的，它是更高层次的一种表述方式。

那么这就定义了现在整个计算机视觉和人工智能的一个发展。如果再回到计算机视觉去看这件事，这种特征基本上有两类：第一类就是我讲的是手工制的，手工制的在计算机视觉里面也是非常成功的，其实在卷积网络之前也有非常有效

的机器学习方法,很多统计机器学习方法已经很强,大家在过去用的基本上是特征 SIFT,就是手工提取的特征。手工提取的效率非常高,它的量和维数都是很低的,现在如果抛开手工不看,看自动的,这种特征都是自动学习的,自动学习这种东西现在都是量很大的,动辄就是几千几百万参数,像这样量大的统计特征在过去肯定是不可能的,但它更有效。其实它可以做得更好,但它的效率不一定是最高的。

我们可以看看计算机视觉里面学习识别的套路。从传统来讲,计算机视觉里不仅有识别,更重要的是深度感知,这是非常重要的。大家都知道,我们人有两只眼,深度的感知对我们是非常重要的。我们教计算机视觉课,就是让你拿两只眼看东西,一只眼睛对距离是没有感觉的,两只眼睛才能有深度的感觉,才可以做更多的应用和识别。这个原理没什么新奇,从几何到相机的发明,到摄影测量再到计算机视觉,都有自己非常扎实的数学统计和几何理解。到了计算机视觉里面,对这种深度的理解,目的是什么?计算机视觉就是要把这些东西全部自动化,这是最关键的。

我举两个自动化的例子来展示一下做深度信息感知这件事难在哪里。比方说两幅图像,同样的物体,我们同样可以得到三维信息,自动匹配,每个点都要找到它在另外一幅图像上的对应点,这就是图像匹配,如果重新定义,其本质就是识别,这是从小、从局部来看的。

从大规模去看,现在我们在深圳、北京做过的重建项目基本上都是对几百万幅图片做三维重建的。我要把匹配的图像找出来,先找两幅,每一幅都要找到对应图片。去找的话,如果用任何传统的方法,找两个是要平方的,那么平方上了百万级几乎都是不可求的,这是算法的复杂度。图像识别得好,效率就会提高。

图像的匹配和检索在计算机视觉不同的地方叫法不同,其实本质上都是用特征去识别。像我们现在这种真正的三维重建方法,在这种深度学习之前基本上就是这些套路:要先检测特征,再做匹配与识别,再做相机定位。然后就是密集点云重建,也有人叫多视角三维。点云一开始是没有结构的,你要把它变成任意拓扑的曲面,曲面还要贴纹理,由于最近深度机器学习带来的革命影响了整个计算机视觉和人工智能,所以它对三维重建的影响是很大的。现在这里每一步最终都要拿深度学习去重新定义、重新研究的,所有东西基本上都离不开特征,因为以前我们的几何带动了手工的提取,那肯定是非常好用的,但是现在我们也在研究,实验也已经证明深度学习学出来的特征更强大、精准度更高。还有,大规模的数据加入学习可明显提高效率。

在密集点云的三维重建现在也在颠覆传统算法,以前传统的那些算法在一定意义上都是手工去调很多参数,现在更强大的方法是端到端的方法,即把照片放进去就可以全部出来,并且里面所有的特征和方法全部是基于整个深度学习的。

这是我们团队最近做的一些工作，在不同尺度空间里面做匹配，这也是很难的，航拍是一方面。还要街景，因为三维建模是无限的，你只要能拍照片，距离更近，精度就会提高，但是在技术上最终带来的是图像识别和图像匹配的挑战。

可以去看一下我们在科大带领的团队，它也是一个科大的创新公司推出的平台，叫 www.altizure.com 或 www.altizure.cn（在国内）。在这样一个平台上，我们先要做内容，希望任何有无人机的，只要拍到照片去上传就可以了，这是对无人机的。最近大家都知道，智能手机里面带相机。以前我们也不太相信智能手机里面相机能做得有多好，但是现在很多例子都能证实智能手机里的相机做三维重建就已经足够了，这是非常好的，所以这是我们的一个重点。

关于我们这个平台最重要的一件事情：现在大家都知道人工智能、计算机视觉都是数据为王。要有内容，并不是仅仅有算法就够了，我们的平台每天在做大量数据的三维重建，也收集很多数据，我们要用这些数据去做学习，用它们进一步改进我们的算法。这其实是在做一个闭环，让大家以众包形式去上传数据，然后进行三维重建，我们在后台学习，然后对算法进行改进，最后把世界描绘出来。我们这个平台不仅在国内，在国际上也没有别人做得比我们好，希望大家有机会的话可以去尝试一下。

www.altizure.com 是一个开放的、在线的、全自动的三维建模系统。世界各地的用户，专业的、业余的，通过各种方式，如无人机、照相机、手机或其他方式，采集图片上传到系统，借助 altizure 的数据处理服务产生三维模型，然后自行下载它们的三维模型进行后续的开发、分享。在整个工作流程当中，系统在不断地被数据充实，通过对数据的深度学习，不断优化我们的算法，形成一个良性的闭环。日久天长，全球的用户拍摄建造的模型将覆盖整个地球，也就是我们的 Altizure Earth。就人工智能来讲，光有技术和算法而离开内容也只是空谈。

这就是我想跟大家分享的。大家都知道人工智能、计算机视觉，其实计算机视觉是 80% 的人工智能，媒体讲来讲去人工智能这些事，如果计算机视觉没什么革新的话，人工智能也不会取得什么进展，所以人工智能最后是被计算机视觉所定义、所寄托的。视觉有突破，它才能有突破；视觉没有突破，它不能突破。

谢谢！

Computer Vision, Visual Learning and 3D Reconstruction: Capture the 3D World with UAVs and Smartphones!

▶▶ Quan Long

First of all, I'd like to thank the committee for giving us such a great opportunity to take part in this conference. Although we are in a different industry, and we are specialized in techniques, that is, computer vision. I think it is also a great opportunity to communicate with all of you, most of which do produce content in other domains. So, I will basically talk about the things that I've been working on, and our thoughts on computer vision and AI, which are hot topics lately.

To begin with, I'd like to show you a demonstration model. This is a typical 3D model captured by a drone and this is taken by a popular DJI drone. Such a model can be built up with hundreds of, if not over a thousand, photos. All of these photos can be downloaded in real time. Altizure.com.cn is our online platform. With uploaded photos from your drone, cell phone, or any camera, we can rebuild the object in 3D with post-editing, or embed it into third parties' application systems, even 3D printing, and so on.

Let me show you some simple examples. This kind of model is rebuilt with drone photos. You could see details extremely clearly. Here are some other models, rebuilt with photos by regular cameras. This is a motorcycle model rebuilt with photos taken by a photographer. There are hundreds of photos, and yes, just with photos, you could rebuild them into a 3D model. Next is a 3D model of the Notre Dame in Paris, the work of the same photographer. It is rebuilt by photos. As you might have known, if you had been there, every sculpture is exquisite.

What's more, we have even larger data, for example, this is a city in America: Austin. It's city-class data, which covers nearly a hundred square kilometers. All that you see now is being presented online in real time. Then we have models of other cases—everyone is welcomed to browse the website: www.altizure.com to find more works by millions of Altizure users. All of these are open to the public.

Altizure will rebuild anything into 3D model accurately and precisely, whether they are

scenes or architectures taken by drones, or objects and figures taken by your smartphones. This one, it's taken by a phone and with dozens of photos, we can do precise modeling of human faces.

As you're all from the film industry, you must know that face modeling usually requires the swimming cap, neither the hair nor the glasses are allowed. This is a great example to show that even the glasses can be rebuilt, as you could see. You have to know that it is very interesting about how to describe these lenses in 3D modeling. If you see how this model is rebuilt in geometry, you would understand the difficulty to achieve such exquisiteness.

We come from different fields after all and I am working mainly on computer vision and AI, so today I will basically share my thoughts on technology and applications of AI. First of all, I'd like to share some of my own thoughts. In fact, the core of AI is the computer vision. The reason is that visual information constitutes 80 percent of our sensing.

As we all know, AI has been such a hot topic in recent days. We can see the words of AI everywhere. Do you know when it started? In fact, it is mainly defined by computer vision and visual information. Although there is so much information here, the key is AI The year of 2012 was a year of no significance for computer vision, which our company wasn't founded at that time. There was an annual gathering in the field of computer vision. In that year, the rate of recognition had raised 10 percent, which is a very significant step, but for those who attended that meeting, at that time, they might not reckon that year was different from others. However, since 2012, the name of deep convolutional neural network has been used again and gain. Before the convention, your paper would have been rejected directly if you used the word "neural network." On the contrary, you may have slim hopes now if you didn't use it.

Nearly all the methods are related to deep convolutional neural networks since 2012 and they have contributed a lot to the later development of AI, as everybody knows.

Looking back, the most important work of 2012 was related to the year of 1998. We know that people now consider Yann Le Cun as "the father of deep convolutional neural networks." This is a diagram of neural networks excerpted from a passage that he published in 1998. If you read very carefully, you would find that it is basically the same as the diagram used in 2012, except the size: The input of 1998 is pretty small, which was $32 \times 32 \times 1$ without RGB, and it only had one black and white channel; but by the year of 2012, it was $224 \times 224 \times 3$ with RGB. So its volume had become nearly 100 times more than the old days and it had three RGB channels. This is saying that the methodology had been well developed in 1998, so you would ask why it took such a long time: 15 years.

In fact, it is mainly the revolution of hardware that made it happen.

Actually, those GPU researchers didn't make the first move for computer vision. A.I.

researchers did it for games. Nevertheless, the revolution had reshaped the computer vision and AI It is the hardware that restricts the AI's development. The computer display needed for AI can be easily accelerated dozens, or hundreds, of times with the development of the GPU. In addition, the Alpha Go defeated its professional chess opponent last year, although it is an AI program in a narrow sense rather than in the broad sense. Since the revolution, AI and computer vision have been reshaped.

We've been working on computer vision for twenty to thirty years, so what is computer vision? To put it in simple words, it refers to image understanding. But the word "understanding" is difficult to achieve, and nobody knew what "understanding" was. Neither did we. In a more specific and steady perspective, the most important thing that we've been doing in computer vision is trying to search for the so-called features, which are the visual features.

What are the fundamental elements? Why do we search for that? In phonetics and philology, it is easy to find their fundamental features. In philology, first you have a passage, then sentences, characters and every stroke. The gradation is clear. It is clear in phonetics as well. As you might have learned, there is phoneme, and with the minimum element extracted and reintegrated, everything could be achieved. But when it comes to an image, we don't know the fundamental element when we open an image file. As we know, "pixel" used to be called "picture element," which indicated it as some element, but it was not one, essentially. It is just a technical product, objectively. The search and pursuit of visual feature are of the most significance in computer vision.

After that, there are two major applications in computer vision, one of which is recognition and the other is reconstruction. We can see the prefix "re" in both of these words. They both require reversing operations, but both of their reversing operations need regularization as a start to make it smooth and stable, and then the effective features captured from data recognition with a statistics method can be reconstructed in a geometric way.

The development of computer vision has been defined by three matters: features, recognition and reconstruction. Before the neural networks, the search for features had been dominated by 3D reconstruction. Features in the old days were hand-crafted with the application of mathematics and geometry modeling. To capture features, observation and understanding were the most important reconstruction procedures, but since the neural networks, reconstruction has been mentioned less than before. Features plus recognition could basically by-pass the reconstruction. Because features can be learned through Internet automatically.

The question is: to which level the computer recognition can reach? You might have heard a lot from the media, but it is simple actually: to be able to understand an image is to

collect hundreds of, or thousands of, photos first, and show the samples to the computer to learn if it could describe this thing. What you need to do next is to let the computer recognize the same thing.

These tasks can be defined clearly, the computer could not only do them well but also do them better than human beings. Once mechanized and automated, it must be better than human beings, but I have to point it out, it is not as smart as people think; it is as dumb just as it was before and it has no intelligence at all. For instance, if it recognizes a cat and a dog; this is a cat and that is a dog, but what does a dog or a cat mean to it? It was just given hundreds of samples. You just write the character, "狗" or the letters, D-O-G, and if you change it into "猫" or C-A-T, it doesn't understand any of this and I have also to say, it would not understand semantically, either. Based on these facts, what deep learning has brought us still has significant limitations.

The first thing to consider is that the AI deep convolutional neural networks as we know are very powerful and beneficial, which is not without reason; and it indeed would bring a revolution, which would cause great changes, and most importantly, on mathematical or statistical tools for modeling. This would make them more convenient for more people. It was hard to build a much smaller mathematics model, but now it might not need any complicated programming when doing a much larger mathematical model. With a description and another few lines of codes, you could do the modeling. Therefore, it could be considered the same as bringing on a revolution, but in essence, it is just a bottom-up thing, that is, an explanation to statistics of bottom oriented data; it has no top-down operation — a recognition of our cognition and knowledge description from top to bottom. As we know, most of our knowledge is not of probability, nor is it statistical. In fact, it is a higher level description model.

And this redefines the development of current computer vision and AI. So let's go back to the features of computer vision. There are two types, as I've said earlier: one is the "hand-craft" feature, which has been very successful in computer vision. Before machine learning, we applied a lot of methods, many statistical machine learning programs had been well developed, like SIFT, which we used for hand-craft features. They were very effective because of their small volume and dimensions. Now let's put aside the hand-craft features to see the automatic learning features. The volume for automatic learning is often as huge as a few millions. Such huge volume would never be possible in the old days, but automatic learning is even more effective and offers better performance, although the efficiency is not the highest.

Next is the recognition learning mode in computer vision. In a traditional way, computer vision contains not only this, but also depth, which is very important. We all know that we have two eyes to perceive depth and this is crucial. Every time we teach lessons of computer vision, we would take the eyes as the starting point. A single eye has no sense of distance, only two

eyes together can have the sense. With a sense of distance, we could make more applications and have recognition. This is not a newborn idea, since geometry to camera, photogrammetry, and the computer vision, with its step by step behavior, has been a long process, which has its firm understanding on mathematics and geometry. What is important for depth in computer vision? The computer vision needs all these things automated, and this is the core.

As for automation, I'll take two examples to explain the difficulties of obtaining depth information. First, let's say that we have two images of the same object. We could obtain their 3D information, and matching could be automatically done to find the corresponding pixels in the other image, which is the process of "imaging." And if you describe it into a new idea, "recognition" it is. This is how we deal with depth locally.

For a larger scale, the Shenzhen and Beijing cases have used millions of images to do the 3D reconstruction. First, we have to find the overlapping images for every single image, and the process would be impossible to complete in any traditional way because two images would require power of N times; and a millionth power of N could be beyond calculation. The efficiency will be improved with the help of image recognition.

Although "matching" and "retrieval" are two different names in computer vision, they are the same thing essentially, both of which require feature capturing. These are the workflows and pipelines of current 3D reconstruction, which had been basically used as traditional processes before deep learning. We start from feature detection, to matching and recognition, and then camera positioning. The next step is dense reconstruction, which is also called "multi-view stereo." Then make it into a point cloud, which has no structure at the first stage, and you need to make it into a curved surface, even with texture sometimes. Nowadays, the deep machine learning has brought on a revolution and had great influences on computer vision and AI. Of course, it has made huge influences on 3D reconstruction, and every step that I've mentioned just now would be redefined by the deep learning in the end. Just like what I said earlier, everything could not be done without the "feature." We made efforts in geometry to advance the hand-crafted feature learning, which was definitely effective, but now, we have done research and experiments, which has shown that features learned by deep learning are better and of higher precision. The efficiency is also improved evidently by using a large-scale data.

Also, there is the 3D reconstruction of dense point clouds. The revolution has over set its algorithm. The traditional algorithms had to adjust parameters by hand-crafted methods to some extent, but now there is a stronger method, "end-to-end point reconstruction," by which we get everything done with image input, and all of its features and methods are basically based on deep learning.

This is what our team has been doing recently. We've learned local descriptors, which are very difficult. The aerial photo shooting is just one aspect, and you would also need streetscape. Although the 3D modeling is infinite and you would get higher precision, if you shoot photos closer, there would still exist technical challenges in image recognition and matching.

I recommend you to look over our platform Altizure.com or Altizure.cn, which is set up by our HKUST team and an HKUST innovation company. For our platform, the first thing is to do content. So, I hope anyone who has a drone to upload his or her photos to our platform will do so. Besides drone, you all know, smartphones carry great cameras now; even we did not believe how well the smartphone cameras are made, we have to see that there are lots of cases to prove their great performance, and many of them have been made well enough to do the 3D modeling. This is good and this would also be one of our priorities.

Actually, there is another important thing for our platform. At present, everybody in the field of AI and computer vision knows data is the first consideration. We value content besides the algorithm. We do 3D reconstruction and collect data on this platform every day, and we need to use them for learning and to further improve all of our algorithms. Our ideal is to serve as a closed loop, where all of you could upload data, in the way of crowd-sourcing, and with our automatic reconstruction and learning, we'll improve algorithms and map the world. There is no platform that could make this as good as ours inside our country, or on the international stage. I hope that everyone could have a try if time is available.

Altizure.com is an open online system that can construct 3D models automatically. Users all over the world, including professionals and amateurs, capture pictures by drones, cameras, smartphones, etc. and upload them into the system. They can download their 3D model that is generated by the Altizure data processing service for subsequent development and sharing. Our system is also enriched continually by data during the whole process. In this case, our algorithm can be optimized by deep learning of data so that a positive closed loop is formed after a considerable period of time. Countless models from around the world, captured by global users, will contribute to our Altizure Earth. AI technology and algorithms are only prattle without content.

So this is all that I'd like to share with you. As you all know about AI and computer vision now, in fact, computer vision is 80% of artificial intelligence. The media is talking a lot about AI, this or that, I'll say that if there is no revolution in computer vision, AI will obtain no improvements either. Since AI is defined and related to computer vision, it would only make a breakthrough if computer vision makes a breakthrough. If computer vision has no breakthrough, nor will AI.

Thanks!

虞晶怡

给予 VR/AR 双眼和大脑

◎ 虞晶怡

非常荣幸再次来到北影做演讲，我想给大家汇报一下我们过去一年在 VR 和 AR 的一些进展，特别是利用人工智能的方法。

我们迅速回顾一下 AR 和 VR，这个在去年我也有讲到，VR 和 AR 是非常老的理念了。早在 1965 年的时候就有 VR 和 AR 的头盔，而内容的制作也可以追溯到 1995 年的 Eric Chen，一位华裔计算机科学家做的 QuickTime，他的想法非常简单，就是拿照相机拍很多照片，然后做一个图像扭转，拍的时候从不同角度去拍，把一些特征点匹配一下，然后用权龙老师的方法进行登记，给它校准，校准以后叫作接缝裁剪，或者是图像分割，从上到下，把图片切一下，左边管左边的，右边管右边的，这条缝让它切得非常完美，这样下来从左到右让它看起来顺畅。这个技术其实早在 1995 年就有了，去年前年很多公司说做 AR 和 VR，把图片调成 360° 就叫 AR 和 VR 了。现在这些公司绝大部分都已经破产了，投资人也已经血本无归了。

我们其实也做了一部分这样的内容，但是有点不一样，我们做了一个叫 Gigapixel VR 的体验，现在照相机的分辨率如此之高，如果我们拍一个亿万像素级的 360° 全景照片，能不能够带个头盔看呢？我们很快会公布一套 SDK，它会在你的 PC 上，戴上头盔你可以从很远的北京看到很近的北京，当然也许你看到的有可能都是雾霾。

接下来让我们谈谈怎样把 AR 和 VR 做得更好，这是今年讨论的主题。为什么去年和两年前的 AR 和 VR 公司都没有成功呢？还是一个道理，就是它做的

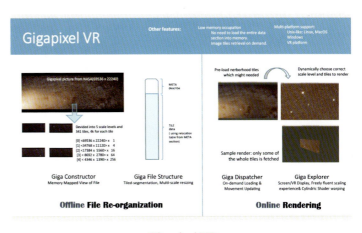

Gigapixel VR

事和产生的内容完全不符合人眼睛观看的体验。

人眼睛怎么观看世界？人眼观看世界有三个因素。第一个因素叫作双目视觉，左右两只眼睛能够看到 3D 的一个视觉；第二个是你闭上一只眼睛也能看到一些 3D，为什么呢？因为你的眼睛在不停地对焦，焦距在不停地变化，有时候在我身上，有时候在屏幕身上。除去这两点之外，还有一点非常重要。它也是在过去五年里非常重要的一个突破，即语义，也叫深度学习。你看到我这个人站在这个舞台上，你不会认为我是飘在空中对不对？因为你必须知道一些基本知识，这些基本知识决定了语义是可以学来的。所以人要做到三维视觉，就一定要做到这三件事情：双目视觉、动态对焦和语义。

我们一个个来看，怎么样用来做 AR 和 VR 的提高？这个叫作虚拟现实，很多年以前，CMU 计算机的大神 Takeo Kanade 说，我们不应该叫"虚拟现实（virtual reality）"，应该叫"虚拟化现实（virtualized reality）"。这个英文名字很巧妙，有什么区别呢？"虚拟现实"说的是虚拟，所有的东西都是虚拟，像虚拟一般的现实。"虚拟化现实"是把现实虚拟化。这是两个完全不一样的概念：一个是玩游戏，一个是把真实的场景虚拟化。做到"虚拟化现实"的关键是人工智能，我称之为"智能视觉"——有智能的视觉。什么是有智能的视觉呢？

第一个——怎样产生双目视觉（叫立体视差）？双目就是有 360°，这至少比单目好吧。你说这很简单，拿两个相机拍 360° 不就得了吗？原来不是一个相机拍 360° 吗？那我拿两个相机。每个相机是个鱼眼镜头，这样拍能不能拍出 360° 的效果呢？不太能。如果那么简单的话，那些美国初创公司也不做了，对吧？

问题在哪里？如果你拿两个鱼眼相机，拍 360° 的全景照片，照片从中间看，两个眼睛真是能看出 3D 的效果，就像看你的 3D 电视一样，但是把你的头轻轻一转，你会发现不对，同样一个 3D 的点，不但有水平方向的偏移，还有竖直方向的偏移，这是为什么呢？也很简单，因为你头一转，三维的点距离，像平面的深度，是不一样的，这样投影就会造成不但有水平方向的偏移，也有竖直方向的偏移，这就产生了瑕疵。

那么解决这个问题的方法是什么呢？很多的美国初创公司都做，从脸书、谷歌到 Matterport，它们都做，用不同的解决方案来做。讲到底，这个方案基本上都是用一项同心马赛克（concentric mosaic）的技术在做。权龙老师也是这个领域的专家，而且是这个领域的权威，早在很多年以前就在做基于图像的建模，等等。

想法很简单，拿一个相机旋转一圈，在一个三维空间旋转一圈，旋转以后你不是拍了一个视频吗？从左到右拍了好多视频，把每一帧视频都取出来，把每一帧视频切开，正中间切开，从左数第 5 列，从右数第 5 列，分别把它们粘贴在一起，红色的列和蓝色的列连接在一起，这样在数学上就能够保证不管怎么看，始终能够保证看到只有水平方向的 3D，你不可能产生竖直方向的 3D，这项技术就叫同

心马赛克。

那么这个想法到底怎么运用到我们现实生活中呢？谷歌有个方法。我们把相机排一个阵列，排一个圆形的阵列，那么每一个相机拍一个图片。排成阵列以后，把每一个图像从正中间剖开，左半边有半边图，右半边有半边图，把所有左半边的图用 Eric Chen 1995 年的方法拼成 360°的，把右边的也拼成 360°的。

这个效果好不好，我们看一下。上面的是用左半边图拼的，下面的是用右半边图拼的，拼完之后，两个图看着都挺不错的。但是一叠就晕眩了，为什么？因为从上到下，你没有考虑过它的一致性，拼的时候是不是一致的，那怎么解释这个问题？权龙老师肯定有很多新的算法。我说个更简单的，怎么直接做呢？与其用一个环形的拍摄系统，不如把它变成一个多边形的拍摄系统，那么为什么多边形好呢？因为多边形是 2、2、2、2 的拍摄系统，每两个相机之间有一个几乎完美的三维视觉，拍摄的难度就变成了拼接的跨度比较大，因为它是个多边形。那么这个问题也很容易解决，就是当你拍摄的时候，要拍得很有技巧，可以把那个拼接缝的地方，纯色的地方，让人看不出有什么瑕疵，把这个技巧剪到那一边，就发现能够解决问题了。

更有意思的是，去年、前年，那么多 VR/AR 公司破产了，它们产生了大量的 2 维数据，我们有没有办法直接把它们的二维数据转换为三维数据呢？也就是说，他们拍了一个二维的环视 VR，我们能不能自动把二维转化为三维？这个是能转换的，用两个方法。

第一个方法刚才讲了，是几何空间，就是三维世界，你们知道空间的线是怎么分布的。第二个方法是语义，就是你知道我人是站在这个台子上的，你可以把我分割出来，可以做一些标签，这就是基于深度学习的一些方法，所以用最新的方法来做二维的全景转换非常有意思，它们就是基于几何信息、语义信息，基于场景是怎么分布的，桌子在哪里，台子在哪里，地面在哪里，把这些信息全都大杂烩一样地拼在一块，最后用一

问题：双目图像拼接的一致性

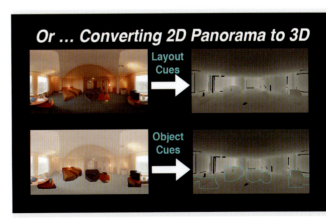

通过视觉算法将二维图像转化为三维图像

个视觉的算法来估算出 3D 的信息。

光场相机阵列

我们来看一下效果，只拿一张 2D 的环视图，你在家里拍的一张就大约能够得到一些三维的信息。当然，效果现在已经做得非常好了。到时候我们也会开放一个软件包给大家测试。这是另外一个例子。比如说，我可以看到这里有一张床，我们应该把这张床分割出来，那么床大概是一个盒子状，我可以用大概的盒子来进行估算，可以产生一个相对好的三维，这就实现了从二维到三维的直接转换。

刚才讲了用两个相机或更多的相机来解决第一个问题——双目视觉，也讲了从 2D 到 3D 的转换。下面讲第二个话题——单目。你用一个眼睛看我，仍然能够看到我的深度，为什么？因为你有动态对焦的功能。这个动态对焦的功能是非常神奇的，因为人的眼睛是一个大光圈系统，它可以不停对焦。怎么做动态对焦系统呢？不要看这个公式，它特别复杂。

我拿一个相机阵列，好多好多的相机，就是早上 Kurt Akeley 说的光场相机。拿很多很多的相机去拍，拍完以后，当要重对焦的时候，我就取不同图像里的不同像素，把它们融合在一起，根据深度变化，取不同的像素，用不同的像素来进行混合，就能够产生动态对焦了。

反正就是一个软件，你可以测试一下。怎么搭建相机阵列？也不用那么昂贵的，50 万美元什么的不用，你去拿一些 GoPro，便宜的 GoPro，拼在一起拼个阵列就行了。这个 GoPro 特别好，它可以提供自动的同步，你就可以拍出光场的视频来了。

我们看一个光场的视频，去年我就演示了，这个光场的视频可以做实时的动态重对焦，我可以把焦距从后面把它推到前面的景深，然后再把动态重对焦推广到相机，即刚刚说的环视相机上面，最后可以推广到前面的前景人物身上，这个动态重对焦马马虎虎。

如果我去《计算机视觉》发个文章，可以发的，对吧？但我拿给你们北影来看，你们说这个质量不行，为什么不行呢？这么多的多边形在那里，它叫锯齿（aliasing），有瑕疵。为什么会有瑕疵呢？因为我的样本、我的相机数量不够，除非我用很密很密的相机去拍，才能拍出很好的效果，否则就会有这样的瑕疵。

去年的时候我就讲过这样一个问题，怎么解决这个问题呢？很有意思，那就是加入更多的信息——深度信息。你可以拿昂贵的 FARO 相机，做一个 360° 的

三维粗糙重建，得到一些粗糙的三维信息；再把粗糙的析出光场信息叠加在一起，就可以产生一个密集光场，就可以产生很好的效果。

我们看一下效果。这是拿一个FARO相机拍的，就像这个大礼堂一样的场景，你看到点云很稀疏，效果很不好，但是这个点云已经足够把我这个非常稀疏的光场插值到非常密的光场。有了这个信息，我就能做非常高效的动态重对焦效果。这里跳过其中的数学解释，因为时间的限制，基本上它是用计算机视觉的方法去把三维的点和二维的像素匹配起来。因为有好多图像拍完了，所以你可以做一个三维到二维的匹配，然后你会发现这个问题是可解的，用Matlab写几行代码就能够解决这样一个问题了。

我们看一下效果。这个是把深度信息加进去了，它仍然是一个析出的光场，加进去后你会发现现在动得好均匀，这是一个真的大礼堂，这是我们科大上课的一个礼堂，然后我可以做很高清的动态重对焦了。

现在焦距是在中间，你可以把焦距移到前面来，然后你会发现，有了粗略的深度信息，你就可以做一个非常好的动态重对焦了。除此之外，还能做虚拟看房，大家都知道北京的房子太贵了，我去看一个房，不可能从昌平跑过来看，太远了，如果能做一个三维的粗略重建，再加上一些光场信息，那就可以做一个3D的漫游，我可以在空间走来走去，而且好像是真的漫游一样。这套系统也会很快发布。

使用FARO拍摄的场景点云

结合深度信息的光场渲染

三维空间漫游

大家知道，手机上要看这样一个东西，数据量太大了，所以必须做一些压缩。这其中有很多技巧。那么，怎么样来做实时 3D 漫游呢？这都是很快要面向大家的。你说这个方法很好，我现在用光场相机拍一下，然后拿一个 3D 扫描仪扫一下。如果我没有 FARO3D 扫描仪呢？你去买一个 iPhone X 也可以，iPhone X 后面有一个主动照明、主动结构传感器，可以自动地做一个三维扫描。你也可以做一个三维扫描，然后再跟这个光场结合在一起，这样也行。

使用动态光场重建植物模型

你说我没钱，我是穷学生，那我没有 iPhone X，没有那么多钱买它。没关系，因为这个光场已经拍摄了很多图像，拍摄完光场，其实可以直接扔给权龙老师的 Altizure 软件，这个 Altizure 只要有很多图片就可以做 3D 图片，所以我只要把这个图片扔给任何一个三维重建引擎，它就可以给你一个粗略的 3D 重建，所以在这里我就不一一说光场重建了，它是非常专业的。

我想顺便说一下，利用这个光场系统，大家会将很多物件数字化，物件会越来越有意思。你家里有一样东西，拿个光场拍一下，最难拍的是什么呢？是花花草草。花草这样的东西是最难拍的，因为颜色很接近，所有都是绿叶、红花。另外，它有很细的经脉，非常讨厌，有大叶子、细的经脉，那怎么做呢？我最近尝试了一下，我拿 Kurt 早上说的那个光场相机拍摄，每一张生成了一个三维的析出点云，然后我把这些点云进行融合。我们称之为动态光场结构（light field structure from motion），这个已经是去年的结果了。大家可以看到，我把叶子、经脉重建得很好。今年的结果一定可以把它建立得更好。

刚刚讲了两块：一块是说双目视觉；一块是说动态对焦的效果。下面我想讲第三块内容，即语义，它非常重要。先讲讲为什么会有这个语义的问题。

首先我们在上科大搭了一个光场环拍系统。去年我也演示过这样一个光场环拍系统。它由 60 个动态相机和 80 个静态相机组成，随时可以从 360° 进行拍摄，拍摄完了以后，你就可以对人物进行重建了。

你想重建很容易，这是重建的一个我，可以把我身上的褶皱都重建出来。但是问题来了，其实人的重建非常难，因为人的重建有非常多的遮挡，比如说你看到我前面的手会遮挡到身体，然后手有时候会捏脸，脚在前面，这构成非常复杂

的遮挡。

所以这60个相机产生的效果其实还是不够的。需要处理这样一个遮挡，单单从几何的角度是没有办法处理的，你怎么知道我是在前面还是在后面呢？需要怎么处理呢？需要语义。如果你能够把我的身体进行一个分割，从图片里你就会知道我的手是什么姿势，就可以用这个姿势去指导我的三维重建。用这个指导方法，我就能够做很有意思的工作。

光场环拍系统

比如说，我可以根据这样一个3D的分割姿势分析知道怎么能够把一帧遮挡的扭曲到一帧没有遮挡的，没有遮挡的时候，我就没有阻塞（occlusion），我就可以把没有遮挡的部分去补洞，把有遮挡的地方补掉，就能产生一个global temocclusionplate。你就能够看到这个不同的框架里面重建和叠加在一起的效果。

我们来看一下这个效果，这是我去年演示给大家看的跟美国茱莉亚音乐学院合拍的一个叫环球音乐会的效果，这个效果并不是特别好。我今天是自我批评，我们看去年的效果，你要看它的腿，

人物模型重建

看他的手、手臂和身体接触的地方，这些地方大致有点意思，但是你如果看腿和遮挡的这些地方，就会发现很大的瑕疵。为什么呢？你没有办法区分什么部分是什么部分，没有办法做到鲁棒的三维重建，但这个效果去年还是很OK的，还是能拿一些投资人的钱的。今年就不行了，因为其实效果还不是那么好。

这是我们今年利用这样一个语义的方法做的一些效果，那你现在看腿和手之间的分割（这个叫时空之弦），效果就好很多了，当中各种遮挡屏蔽全都可以解决掉了。但是它是不是完美的呢？还差一点。仔细看脚还没有特别好，脚、鞋这个东西是所有人体重建里面最难重建的东西之一。最难建的一个是头发，一个是脚、头顶，脚底也难重建，但别的遮挡部位，从效果来看，已经处理得很好了。

美国茱莉亚音乐学院：环球音乐会

VR 短片《Pippa's Pan》

我们再来看一个片段，因为这里是北影嘛，我总是要炫耀一下，去年我们有个短片入围了戛纳电影节，对吧？叫作"Pippa's Pan"，如果感兴趣的话可以去看一下。拍的是两个患有阿尔茨海默病的老人。这两个老人是分开拍的，因为我们这套系统不可能同时拍两个人。

你可以看到现在他的头发、身体几何都做得非常好，手指那里还是有点瑕疵。所有细节的东西都非常难重建，还是有待提高。但效果本身已经很有意思了。这个故事说的是两个患有阿尔茨海默病的老人彼此进入记忆里面，然后回忆当时他们恋爱的故事。如果有兴趣可以去看一下。

这个故事很有意思，是跟谁合拍的呢？是和金融大鳄索罗斯的孙子合拍的，他不爱做金融，喜欢拍 VR。这是跟小索罗斯一起拍的一个非常有意思的片段。好，我的演讲快要结束了，我还有两个部分要讲。

第一部分，除了几何之外，还有没有更重要的东西？有，就是材质。刚才说过了，几何的东西重建得再好最后看到的效果总是不够真实。我不知道大家最近有没有看阿里的范冰冰的一个效果。如果我看，这个范冰冰就像僵尸一样，所有的皮肤都是雪白的，也许她真的这么白，但是我觉得是不够真实的，所以材质本身是非常重要的，怎样去复现材质是很重要的。

那材质怎么做？我们说用光场的方法是可以做的，你用不同的角度去拍这个材质，然后进行数据分析。你说从这个角度看亮一点，那个角度看暗一点，我们就做了一套基于深度学习的材质分析。它的做法就是拍，做很多角度的拍摄，拍摄完了以后对它的材质进行重建，用深度学习网络进行重建和压缩，最后解压缩。

我们看一下材质重建的效果。这个是去年为阿里在双十一的时候做的唐三彩的一个效果。我们看到，用光场的效果可以非常完美地复现这上面的光泽。为什么选择唐三彩？因为别人都做不了，上面既有金属光泽，又像是有一点缓和漫反

射的非常复杂的材质，所以你不大能够用一个数学模型来表示，只能用深度学习的数据模型来表示，可以进行压缩。

我们再看一个更难的，比如这个雅诗兰黛的小棕瓶，女士们的最爱。为什么你们在网上看不到一个360°旋转的小棕瓶？因为太难做了，因为小棕瓶本身既反光又半透明，所以这个是用光场重建的效果做的一个雅诗兰黛的小棕瓶。你可以看到上面有上面的材质，下面有下面的材质，你可以看到有半透明的效果，我们就做了很多很多这样的工作。

我在去年成立了一个公司，叫叠境科技（Plex-vr），大家可以去看，我刚才演示的很多小样（demo）在这个网上都有。我们专门做一些这样的工作，包括我们做的一个包的重建，我的学生是跟我一起做的，穷学生一般没有钱，不能买鞋，所以买了一个辣椒瓶，于是我们做了一个透明的辣椒瓶的效果。我觉得这个辣椒瓶效果做得还是蛮惊艳的。

材质重建：唐三彩

材质重建：雅诗兰黛小棕瓶

最后我的结束语有几点：第一点是说其实做科学的人和做企业的人的思路还是应该完全不一样的，做科学、做计算机视觉的人总是讲，我这个东西能不能做到鲁棒啊、能不能做到精准啊。但是如果做商业，你要看到的，特别是做电影的话，你要看到的是它的视觉效果是什么样的。这两个是不等价的，也许你的重建效果不大好，但是能用更好的算法补偿，产生更好的视觉效果，那是极为重要的。

核心在哪里呢？第一，我用各种各样的相机系统，两个相机，一圈相机，相机阵列，环形相机，各种相机。传感器本身是非常重要的，它会让机器开心；用计算机视觉和图形学，可以让人看着非常开心；你还要机器学习，可以让你的投资人高兴。

好，这就是我全部的演讲，谢谢大家。

Equipped VR/AR with Eyes and Brain

▶▶ Yu Jingyi

OK. I'm honored to come back to BFA and give this talk. Today, I'm going to give a brief report on what we've achieved in the field of VR and AR during the last year, particularly, the methods of applying AI.

Let's quickly review some basics of AR and VR, which I'd already talked about last year. VR and AR are very old ideas, in fact, back in 1965 there already were VR and AR headsets. Content production can be traced back to 1995, when the ethnic Chinese computer scientist Eric Chen made QuickTime. His idea was very simple. He thought he could shoot a lot of photos by a camera, and then do image warping. When shooting photos, you had to shoot from different angles, and then match the feature points later, and then conduct registration, as Mr. Quan Long just said, to align them. After alignment, you could do seam carving or apply the graph cut, to cut the photo from top to bottom, leaving the photo in two halves, left side and right side. The seam had to be cut perfectly so that the photo would look smooth from left to right. Yes, the technology had been out there in 1995. Last year, or the year before, a lot of companies declared that they did AR and VR, and what they did was just turn their pictures into 360°. Well, most of these companies have gone bankrupt and the investors have lost all their money.

By the way, we have also done something like what they did, but different of course. We've been able to offer an experience called Gigapixel VR. With the considerably high definition of cameras nowadays, could we watch, on a headset, a 360° panorama with hundreds of millions of pixels? Soon, we will release a set of SDK, which would work on your PC and help you, to watch Beijing from afar, to the nearest area, with your headset on. Well, what you might see will probably be haze.

Alright, so let's talk about how to make AR and VR even better. This is the theme of this year's talk. What on earth did those AR and VR companies that failed eventually do? A reason is that what they did and the content they produced did not meet viewing expectation.

How do eyes of human beings observe the world? There are three factors: The first one is stereo vision, which is the visual sense that your eyes together could see 3D effects. Secondly, you could still see some 3D effects if you close one of your eyes. Why? Because your eye would

focus non-stop and focal distance would change as the eye focuses. Like now, sometimes your focus would be on my body, and sometimes on the screen. There is another important factor except these two, which is also a huge breakthrough during the last five years, that is, semantic, or the deep learning. Well, you would not think I'm floating if you see I'm on this stage, right? I'm saying this because you have to know some basic knowledge, which determines that semantics can be learned. To summarize, if we humans want to have 3D vision, three factors are required, which are stereo vision, refocusing, and semantics.

Let's take a look at them one by one to improve AR and VR technology. So, this is virtual reality, right? But, many years ago, the great CMU computer scientist Takeo Kanade said, "We should not call it 'virtual reality', but 'virtualized reality.'" The difference between these English names is subtle. What is the difference? Virtual reality is all about the word "virtual," which means a reality where everything is virtual, not real. And virtualized reality is to get the reality virtualized. Two concepts, but totally different. One is game playing, and the other is to virtualize the real scene. For the latter, the core is AI that I call "intelligence vision." A vision, which has intelligence. So what is this intelligence vision?

The first question is how the stereo parallax forms. Binocular field is 360°. At least, that is better than the monocular. You would say that is easy. We could shoot 360° photos by using two cameras. They used only one in the past, then, we'll take two. And make sure that every camera applies fish eye lenses. Could we get a 360° effect with all this? Hmm...not exactly, if it were that simple, those American set-up companies would leave, right?

So, why couldn't two cameras get the 360° effect? Well, if you take two fish eye cameras, full-vision cameras to shoot some 360° photos, there would be 3D effects like watching a 3D TV if you use both of your eyes to see photos from the middle. But, if you turn your head just a little bit, you would find something wrong: a same 3D point has disparities not only in horizontal direction but also in vertical direction. Why did this happen? Simple as well. The depths between 3D points and imaging surfaces are different, so projections lead to disparity in both horizontal and vertical direction, and defects form.

So how to solve this problem? There are lots of methods, like many American set-ups are doing, from Facebook, Google to Matterport, to solve this problem. If we go it deeply, these methods are basically following the idea that was called concentric mosaic. Once again, Mr. Quan Long is an expert and an authority in this field, who had worked on image-based modeling, and things like this, many years ago.

The idea is simple. Take a camera, rotate it in a circle in a 3D space. You would get a video after the rotation, right? Plenty of video information from the left to the right. And you take every frame of the video out and cut it right from the middle. The 5th from the left and the

5th from the right. Stitch them together, separately. Stitch the red column and the blue column separately. In this way, it assures in mathematics that you could always see, no matter how you turn the head. But it's a 3D effect only in the horizontal direction, while 3D in the vertical direction is impossible. This technique is called concentric mosaic.

So how do we apply this coefficient into our real life? Well, Google has an idea. We could arrange the cameras in an array, a circular array, so that each camera would take one photo. With cameras in array, you cut each photo right in the middle, then you get a left half of it and a right half of it. Use Eric Chen's 1995 method to join all the left halves into 360° one, and do the same procedure to all the right halves into 360°, that's all.

Is the effect good or bad? Let's have a look. The upper one is stitched with all the left halves, and the lower one is stitched with all the right halves. After the stitching work, these two photos seem fine. But it would get blurred after overlaying. Why? Because you did not consider if it would be consistent from the top to the bottom when you stitched. How to explain this? I reckon that Mr. Quan Long would have a lot of new algorithms. I'll say something easier, that is, how to do it directly. I'd suggest that you use a polygon shooting system rather than a circular one. Why is the polygon one better? As you can see, the dual camera array has cameras in the form of 2, 2, 2, 2, etc. There would have a perfect 3D stereo vision for every two cameras. But, because of its polygon structure, the difficulty in shooting would transform in stitching range. Well, it is easy to solve this problem. When you shoot, you'd better use some tips, by which you pick areas in pure color, or of almost no defects, where the stitching seam can occupy. By using this tip, you would find your problem solved.

So, what is even more interesting? Many VR or AR companies have gone bankrupt, right, which were set up just in last year or the year before. They have produced a huge amount of 2D data. Could we use some method to convert 2D data into 3D data directly? That is, could we conduct automatic conversion to make their 2D panorama into 3D? Well, this is possible. There are two methods.

One of which is geometric space as I've said just now, about what the layout of lines would be like in the 3D world, you know. The other method is semantic. That is saying, as you know that I, this person, am standing on this stage, you could carve me out and do some labeling. So these are some methods based on deep learning. It is very interesting to conduct the 2D panorama conversion using the latest methods, which are based on the geometric cues, semantic cues, layout estimation of tables, stages, or floors. After combining all the information like a hopscotch, we would apply a visual algorithm to infer, to estimate the 3D information.

Let's have a look at the effect. You just need a 2D panorama that you shoot at home, and you would somehow obtain some rough 3D information. Of course, the effect has been very

well done. And we would release a package for you to test. Here is another example, where I see a bed here and we should carve the bed out, to estimate roughly we can use a box, since the bed is like a box. By things like this, we would obtain a relatively good 3D and conduct a direct conversion from 2D to 3D.

So I've talked about how to solve the first issue, stereo parallax, by using two or more cameras, and about the conversion from 2D to 3D. Now, I'd like to talk about the second topic — a single eye. With only one of your eyes, you could still observe my depth, why? Because you have the function of dynamic refocusing. This dynamic refocusing function is really amazing, with which the eyes of human beings could focus constantly as a large aperture system. As for how to make a dynamic refocusing system, do not look at this formula, which is very complicated.

In fact, it requires that you apply a camera array, plenty of cameras, light field cameras like what Kurt Akeley had said in the morning, to shoot photos. If refocusing is needed after shooting, I would take different pixels from different images to blend them. The pixels should be taken according to different depths. With the blending of different pixels, there would be dynamic refocusing.

So it is a software and you can have a test. How to set up the camera array? Well, you don't need expensive devices of 500 thousand dollars. No. You could just get some inexpensive GoPro cameras together to make an array. GoPro is very good, which provides automatic synchronization for you to shoot light field videos.

Let's watch a light field video. I might have shown this one in last year's talk. In this light field video, I could conduct real-time dynamic refocusing. See, I could zoom the focal distance from the back to the nearer depth of field, and zoom the dynamic refocus to the cameras, the dual camera array. OK, and in the end, zoom into the nearest foreground figure. You would ask if this dynamic refocusing is good or bad, well, just so-so.

If I write an article about it, I can publish it on *Computer Vision*, right? But if I send this to you, you would tell me that this is no good. Why? So many polygons on it, right? This is called aliasing. Why would there be defects? Because I don't have sufficient samplings or cameras. Better effects are available only if I use intensive cameras to shoot, or, these kind of defects would form.

In fact, I have talked about this problem. Then, how to solve it? The answer is very interesting, that is, to add more information, depth information. You could use a very expensive camera, FARO, to do a rough 3D reconstruction in 360°. With rough 3D information, you could overlay the rough light field rendering information for a dense light field. In this way, you would get a satisfying effect.

Let's have a look. This is a setting like this auditorium, which has been taken by a FARO camera. And you could see the point clouds are sparse and the effect is not that good. However, it is good enough to interpolate this sparse light field into a very dense light field. And then I could produce a very effective dynamic refocusing effect with the LF information. Here, I'd skip the mathematical method as the time is limited. Basically, it applies computer vision methods to match 3D points and 2D pixels. With this 3D-to-2D matching after shooting photos, you would find this problem possible to solve, by several lines of code in Matlab. Problem solved.

OK, let's have a look at the effect. Now, for this one, the depth information had been added and this is still a rendered light field. With the addition of depth, you would find that now the motion is well-distributed. It is a real auditorium, where we take classes in our campus. Also, I could conduct high-definition dynamic refocusing now.

The focal length is in the middle area right now, and you could move it to the front. Furthermore, you would find that the dynamic refocusing is better with the rough depth information. What could we do besides this is virtual house viewing? As we all know, housing residence is too expensive in Beijing, and it is inefficient to see some apartment, driving a long way from Changping. Think about the distance. But if we could do a rough 3D reconstruction and add some light field information, we could create a 3D roaming space in which we could walk around like roaming in the real world. This system will also be released very soon.

You know, to watch something like this on cell phones, the data volume is so huge, so I must compress the files. There are some compressing tricks about how to do real-time 3D roaming. It will be released to public soon. Well, you would say the effect is good and the method is good as well, so you could use the light field camera to render and shoot, then scan with a 3D scanner. What if you don't have a 3D scanner? No problem. Just get an iPhone X if you have no FARO 3D scanner. iPhone X has an active illumination, active structure sensor that could conduct a 3D scanning automatically. You could do a 3D scanning as well, and combine it with the light field.

You might say that as a student, you don't have much money to buy an iPhone X, so what to do? It doesn't matter. After all, you had applied the light field to shoot lots of photos, right? You could just leave these images to Mr. Quan Long's Altizure software, right? The Altizure software could make 3D photos if you have taken a large number of photos. So, if you threw all my photos to any 3D reconstruction engine, you would get a rough 3D reconstruction. The light field reconstruction is very technical, so I'd like to skip this part this time, OK?

By the way, I guess, with this light field system, you would get many objects digitized, and objects would look more interesting. Say you find an object at home and you shoot a photo

with an LF camera. What kind of objects are the hardest to shoot? Plants. Why are plants the hardest thing to shoot? The answer is they have close colors. Leaves are all green, flowers have similar colors. Secondly, they have very slim veins, slim veins in the large leaves, which are annoying for our work. Then how to digitize? I have had an attempt recently. I took photos by the light field camera and each photo has its 3D rendered point clouds, then I applied a blending algorithm, called light field structure from motion, to these point clouds. This is last year's achievement and you can see the leaves and veins have been well reconstructed. I believe we will achieve a better reconstruction this year.

So I've already talked about two factors of human vision, which are stereo parallax and dynamic refocusing. Next, I'd like to talk about the third factor, semantics, which is very important. Firstly, why has the idea of semantics been raised?

We've set up a light field VR dome in Shanghai Tech University. I had showed this system in last year's talk. It has 60 dynamic cameras and 80 static cameras. It shoots photos from 360 degrees of direction. After shooting at any time, you can conduct the reconstruction of figures.

You might think reconstruction is easy work. Look, this is a reconstructed me, with all the wrinkles on my body reconstructed. Then here comes another problem. In fact, the reconstruction of human is very hard because there are lots of occlusions when you reconstruct a person. For example, you could see my body covered by my hand in the front, or sometimes my hand pinching my face, my feet put in the front. Occlusion can be a challenge.

Therefore, the effect produced by those 60 cameras is not good enough. Occlusion needs to be cleared up. How to clear up this kind of occlusion? You can't do it just in the way of geometry. How would you know whether my hand is in the front or at the back? You would have no geometric method to do so. Is there any other method to clear up occlusion? This is where semantics come in. You could apply segmentation to my body, and you could know what pose my hands are in from the photo, right? You could use this pose to guide your 3D reconstruction. Let's see what kind of interesting work I could do using this pose guide method.

For instance, I could apply this 3D segmentation, pose analysis, to warp a frame image with occlusion into one without occlusion. When there is no occlusion, I could fill up the areas with no occlusion, and get the occlusion area cleared up, by which the global template would form. Also, you would see the overlaying effect of reconstructions within different frames.

OK, let's see what the effect would be like. I showed this to you last year. It was a co-operation work with The Juilliard School. And this is the effect of the global concert. The effect might not be that good. This is my self-criticism. For last year, you have to see the effects of hands, arms and areas that would touch the body, which are sort of satisfying. But if you

look at legs and areas with occlusions, huge defects are there. Why? Because you could not distinguish which part is which, then you could not do a robust 3D reconstruction. This level of effect was OK for last year and could get money from some investors, but it won't work this year, for the effect is indeed not that good.

Well, this is this year's effect that we produced by applying some semantic methods. This is Space-Time Harmony. The segmentation effects are better between legs, hands as well. Occlusion blockage is all cleared up. OK. But is it the most perfect effect? Almost. If you look carefully, the feet are still not good enough. Feet and shoes are the hardest part in human body reconstruction. Two things, one is hair, the other is feet. The hardest: the top of the head, the soles of the feet. We could see other occlusion areas have been handled well.

Let's watch another video segment. I get to show off here; here is the Beijing Film Academy, after all. We had a short film shortlisted in Cannes Film Festival, which is called Pippa's Pan, right? If interested, you could watch the whole version later. The story is about two elderly who have Alzheimer's disease. Their filming had been done separately since this system could shoot the two at the same time.

You could see in the video that the hair and the body's geometry had been well handled, although there still exists a few defects around the fingers. Detail reconstruction is all very difficult to achieve. We still need improvements. Well, the effect has been well-produced though. In this story, the two elderly Alzheimer patients walk into the other's memory and recall their love story. Very romantic story. If interested, you could watch the whole version later.

There is something more about this story. Actually, we shot this VR short film with the grandson of the financial magnate George Soros. Yeah, we shot this great film with Junior Soros, who doesn't love finances but VR. OK, my talk is coming to an end. I'd like to share two more points.

For the first one, the question is, "Is there anything that matters more than geometry?" Definitely yes. What is that? Texture. As I've said, the effect is still not real enough even if I make the geometric parts well-reconstructed. I don't know if you have seen the Alibaba's AR effect of Ms. Fan Bingbing. If I may say, this AR Fan Bingbing looks like a zombie and all her skin is snowy white. Maybe she is as white as the AR effect shows, but I don't think it is real enough. Texture itself is very important, and how to recreate it is also important.

As for how to deal with the texture, we use the light field methods to realize it. After shooting the texture from all different angles, we conduct data analysis. You might say that it looks lighter from this angle and darker from that angle, so we've made a set of texture analysis based on deep learning. It would require lots of shootings from many different angles

and texture reconstruction after that, by deep learning networks, and then compression and decompression.

Let's have a look at the effect of texture reconstruction. This is the effect of the Tang tri-color glazed ceramics that we did for Alibaba on Double 11. We could see the glaze perfectly recreated by the light field effect. Why did we choose the Tang tri-color glazed ceramics? Because others could hardly do this. It is complicated to present, because of not only the metallic luster, but also the diffused reflection. So you are unlikely to present it in a mathematical model. You have to use the deep learning model to present it and conduct the compression.

Let's see another one, which is even harder. This is the little brown bottle of Estee Lauder, ladies' favorite. Why can't you see a little brown bottle rotating in 360° online？ Just because it is so hard to make it. The bottle itself is reflective and semitransparent. Here, I present you the little brown bottle of Estee Lauder by way of the light field reconstruction effect. You can see different textures both at the upper and at the lower part, and its semitransparent effect. And we've done many projects like this one.

I started a company called Plex-vr last year. If interested, please visit our website to see demos. All these demos are on it. We are specialized in this field, including the construction of bags like this one. My students would work with me. For them, money is usually not enough for shoes, so they bought a chilly sauce bottle. And this is the render of a transparent chili sauce bottle. I think this chili sauce bottle makes for a wowing effect.

OK, the last part, concluding remarks. Several points for my concluding remarks: First, people who do science and those who do business have totally different ways of thinking. Science and computer vision men always talk about how to do things in robustness and precision. Businessmen, especially in the film industry, need to see how well its visual effect could be. These two concepts are inequitable. Maybe your reconstruction effect is not good enough, but it is extremely important that you could use a better algorithm compensation to produce better visual effect.

What is the core? First, I would use all kinds of camera systems: dual, circular, array or annular. The sensor itself is very important, which would make machines happy. Applying CV and CG technology makes humans happy. Adding deep learning makes investors happy.

OK, that's all for my talk. Thank you very much.

用 3D 视觉探索内容生成的新领域

◎ 杨睿刚

大家好,我介绍一下我在百度的工作。

我现在实际上有两重身份。我以前也在美国当老师,都在学术界工作。那时候做了很多三维重建的工作,和晶怡、权老师都是在一个圈子里的,但是在来百度以后,工作性质有一些变化,做的是和机器学习相关的一些东西,特别是一些语义学的东西。所以我想,刚才晶怡也说了三维重建在下面应该有很多,很重要的一个就是 3D 语义。今天我就以百度的身份来介绍一下。

我们百度在 AI 方面的一些研究很多是跟语义学有关。先给大家看两个数字:18 年和 4 年。什么意思呢?这个实际上在计算机界是说,在百度看来我们正处在非常变化的一个时代。大家以前用电脑的时候都是带着上网的电脑,后来有了智能手机,于是我们就从 PC 的时代进入了移动的时代,花了 18 年时间。

现在至少在百度认为我们已经进入了一个 AI 时代,比如说在中国我们可以看到很多人都喜欢拿着手机,对着手机说话,这实际上包含很多 AI 的元素在里面,比如说机器翻译等。

我在这里介绍一下百度在人工智能方面的投入,或者说在人工智能上的生态系统,我们称之为 ABC 的这样一个战略。A 是算法,B 是大数据,C 是计算。这是基础层面,在这个基础层面上有很多是可以认知的,我们称之为感知的一些研究,包括音频、图像和视频。

杨睿刚在 ICEVE 大会现场

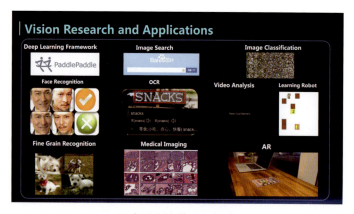

百度研究院的研究领域

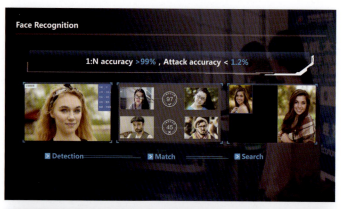

跨年龄人脸识别

还有一个跟今天的主题特别相关的就是 AR 和 VR。在这个层次上面，我们有个认知层，就是说我得到图片了，得到视频了，或者得到语音了，我下面怎么把这些转换成为知识？那么这里就需要 NLP、自然语言处理、知识图谱。其中也包括一个用户画像（User Profile），也就是对大家的、个人的一个用户画像。

在最上面我们有一个 AI 开发的平台，很多执行 AI 的能力我们都在上面开发出来，跟今天在座的各位有很大关系的就是 AR/VR。我们实际上有个 AR/VR 的 kit，在 ai.baidu.com 上面已经开放出来了，在这个平台上面我们构筑了百度自己的应用，包括智能交互系统 DuerOS、search of course，还有自动驾驶等。

下面我用这个示案展示一下在百度研究院里面做的一些工作。我们有做三维视觉的，看视频分析，最重要的应用就是做自动驾驶。还有一个 AR/VR，刚才看了晶怡的演示，我们这还是平面的，晶怡的已经转换成为三维的。我们还做了我们感到比较骄傲的深度学习的一个平台，这个是 PaddlePaddle，它恐怕在国内也是唯一一家中国自主开发的、拥有自主产权的深度学习平台。

我加入百度时间不长，大概只有一年左右。让我感觉跟学术界最大的一个区别就是这个量，我们在学术界可以说可以处理一万张图片，比如说一段视频、一段学术界的文章，被人引用一千次、一万次，这已经非常高了。但是这个规模才

只到工业界的百分之一。举个例子来说，我们做图像分类时，我们内部用的数据集达到上亿张，为了分类需要做八万个物体的分类。为了训练这八万个物体的分类，我们用了将近一亿张图片。

下面简单介绍一下一些比较有意思的工作。一个是人脸识别。人脸识别大家估计也比较了解，基本有三步：人脸的检测、匹配、搜索。这里针对人脸识别我要给大家举一个例子。大家对刷脸、认证估计都比较清楚，但是我个人觉得刷新了我个人对 AI 和深度学习认识的是这么一张图片。

我们现在可以把跨年龄的识别也做得非常好。这是我初中时的一张照片，我想知道大家中有没有人能认出我到底在哪儿。

比较黑，我就介绍一下吧。这是我半年前的照片，那是我大约 20 年前的照片。我们的人脸识别平台能够在里面一下就把我找出来。

我个人是做计算机视觉的，也对深度学习和人脸识别有一定基础，但是这样的一个性能也是打破了我对 AI 能力的预期，这个实际上是有海量数据支持的。在这个数据库用了这样一个分类器、这样一个系统的情况下，我们用了大约八千万张人脸的图像来训练这个系统。

下面我来说说我们百度在 AI 方面的一些工作。大家可能知道百度最大的收入来自广告。在 AR/VR 方面，我们在百度的商务方面做讨论的时候，讨论的最重要的问题就是现在杀手级的 AR 软件有多少个。

我们后来发现实际上是广告软件，广告部门是我们所有的百度搜索里面第一个自给自足的部门，什么叫自给自足的部门？就是说他们每年的收入足以养活我们这样一个 AR 团队，这个团队有 50～60 人，也有很多国内的朋友，现在这些 AR 的功能都已经整合到我们的手机百度上去了。

给大家来做一个演示，这个是我们和兵马俑合作的一个项目。在兵马俑门票上用手机百度扫描一下就可以把这兵马俑的颜色恢复出来，实际上我们还有一个更高级的版本，就是和刚才晶怡一样，我们可以让这个兵马俑动起来。但是文物保护局的人说不行，这个兵马俑就是跪着的，不能动。

AR：兵马俑

这个是我们最近刚刚发布的一个新的功能，叫作 semantic slam，语义的 SLAM。这里我先来班门弄斧一下，即先解释一下什么是 SLAM。权龙老师是这方面的专家。SLAM

可以称为即时定位与地图构建。最简单的就是，对一个场景，我这里有一个相机，然后对着相机进行扫描，SLAM 同时对我的相机进行定位，把三维场景进行重建。但是我们在 SLAM 上加了一些语义，不仅把这个三维场景和照相机重建出来，还把这到底是什么样的物体，用我们的物体识别技术把它识别出来。

这样有什么好处呢？我可以根据不同的语义做出不同的反应。比如说它可以发现这是一棵绿植。我们可以知道这是什么样的绿植、上次浇水什么时候浇的，等等。我们也在上面加入了手势识别功能，那个同学把手这么一挥，通过这个就自动进行了播放，因为我们有这个语义信息，我们也有 3D 地图，所以我们能够让这些虚拟人物在这个场景里面做一下交互。

通过这个语义 SLAM，将来看媒体、看书的经历可能就不会只限于文字了。这本书主要表达了以人工智能为主题的新技术革命已经到来，讲述了人工智能半个多世纪以来的发展变迁。将来大家看书，不光可以看书，还可以问书，这本书的作者是谁？这本书的主要作者是李彦宏。所以说，从这段视频来看，加上语义，把语义和 3D vision 结合在一起的话，就是把语义和三维的信息结合在一起，会给大家带来非常新的一些体验。

下面还有一些时间，我想介绍一下在百度和我的团队非常相关的一些工作，就是自动驾驶。百度最近做的一件事情，我们有一个人称之为 Apollo Project，就是我们自动驾驶的开源平台（Open-Source Platform for Autonomous Driving），就像 Android 一样，我们把自动驾驶做了一个开源的工作，这样的话每个人都可以通过下载我们的软件，把一辆车改成一辆自动的车。

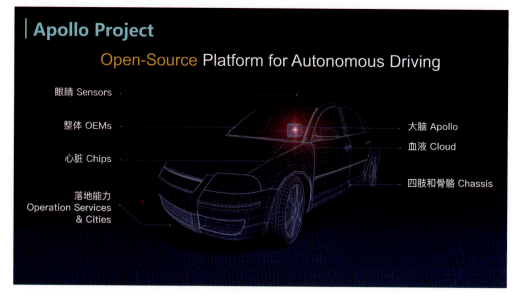

无人驾驶汽车：阿波罗计划

这里我给大家看一下，这是我们的无人驾驶车。它看到的场景就是激光雷达。我们的无人驾驶主要还是用激光雷达，这是激光雷达看到的三维场景。这里又有很多语义的处理要素在里面。我们必须从这些激光雷达的点云里面很好地分析出哪些是道路、哪些是行人、哪些是路障、哪里是信号灯，等等。

我们最近在百度开始的和无人驾驶相关的工作是机器人，这里有一些商务方面的业务，实际上在中国，机器人还是有很多细分的场景。大家可以看到，我们对2020年机器人有多大的市场有一个估计。你可以看到，最多的、大家可以买到的就是扫地机器人。

三维视图在机器人里面也有很多的用途。第一个是导航，就是怎么样让一个机器人在一个场景里面自动行走。

还有一个是地图，就是怎样把这个场景重建出来，让我知道 A 到 B 该怎么样走。还有一个是避障，就是怎样有这个避障的功能。大家如果要做机器人的话，百度也有一个开放的机器平台。其中包括开源的硬件和开源的软件，

机器人的三维视觉

比如说我这里给大家演示一个视频。在这里我们集中了多种技术，其中一个是 SLAM，另一个是 OCR，即光符识别。这样的话我们的视觉传感器在一个很大的商场里面，我们可以知道我们到底在哪儿，我们也可以知道它现在面对的店到底是哪一家店。这就是说我们做了一个多重数据融合的工作。

这里面有些情况下对 SLAM 来说实际上是非常困难的。比如说看到一堵白墙。这堵白墙到底是哪里的白墙？在这种情况下，只能通过 OCR 或者通过 IMU 的其他一些传感器才能准确地把位置找出来。

现在实际上在人工智能方面有很多工作需要从云上升到端，就是从云计算到边缘计算，那这个对很多应用，特别是对机器人、自动驾驶是非常重要的，因为这些都需要。AR/VR 其实也非常重要，AR/VR 我们觉得对语义的理解必须在端上，必须在手机上才能应用。

要不然的话，我有一张图，我希望识别这张图里面的一些物体，到底是个人，还是辆车，等等。如果说上传到云上再回来，这个来回时间至少就几百毫秒了，这个交互的体验会非常糟糕。所以我个人觉得，我们百度也会更加努力，要把我们的能力，很多在云上的能力，放在硬件上，做一个硬件上的加速，变成一个端上的能力。

通过 FPGA 和 ARM 获取实时立体视觉

这里就是一个例子：如何把我们的立体视觉的能力通过 FPGA 和 ARM 加速，达到实时效果？这里我给大家看一下：用这个双目相机，你可以在这个屏幕的右上角看到，可能不是很清楚，用三维技术进行的重建，然后是对这个物体场景做的一个非常简单的二分类。

把可过的和不可过的地方做了一下区分，蓝颜色代表机器人走不过去，白颜色代表路面，代表机器人可以行走的地方。现在这样估计就比较好一些。最后我想说的就是，我们这里有两个平台：apollo.auto 和 ai.baidu.com。关于我说的能力，大家都可以到这里去下载软件 api，sdk 尝试一下。特别是跟今天的 AR/VR 相关的，就是我刚才说的语义 SLAM，刚才说那些物体的重建和跟踪，在 ai.baidu.com 里我们都已经开放了。

我今天的讲座就到这里。谢谢大家。

Exploring New Area of Content Generation by 3D Vision

▶▶ Yang Ruigang

Hello everyone, please allow me to talk about my work at Baidu first.

I have double identities. I used to be teaching in America, working in the academic field. Then I was working a lot in the field of 3D reconstruction, basically in the same circle as Jingyi and Prof. Quan. However, after I joined Baidu, my work has changed in nature. Now my work has more to do with machine learning, especially semantics. So today just as Jingyi said earlier on, there's much to talk about with 3D reconstruction and a very important topic is 3D semantics. So toady I'm going to introduce myself to you as someone who works at Baidu.

Our research on AI is more focused on semantics. Let me first show you two numbers: 18 years and 4 years. What do they mean? Actually in the computer industry, or to people at Baidu, we are in an era with great change. In the past, people used to use the Internet on their computers, then there were smartphones. From the era of PC to the mobile era, it took us 18 years.

Now, at least at Baidu, we believe we have entered an AI age. For example, in China, we see a lot of people holding their phones, talking on their phones. Actually there are many AI elements here, such as machine translation.

Let me give you an idea of Baidu's investment in AI, or the eco-system of AI. We have a strategy called the ABC strategy: "A" stands for algorithms; "B" stands for big data; and "C" is computing. This is the fundamental layer. On top of this layer we have perception research, including research on speech, images and videos.

We also have AR/VR, which is highly related to today's theme. On top of this layer, we have the cognition layer. Say when I get a picture or when I get a video clip or a speech, how can I convert this to knowledge? Here we need NLP, which is Natural Language Processing, and knowledge graphs, including a user profile, or a profile of individual users.

On the top, we have an AI development platform. We have developed many AI capabilities on this platform. The most relevant with everyone here is AR/VR. We actually have an AR/VR kit which is openly available at ai.baidu.com. We have built our own Baidu

APPs on this platform, including the intelligent interactive system DuerOS and of course search functions and autonomous driving and so on.

Next, I'm going to demonstrate what we are doing at Baidu Research Institute by using this demo. Some of us work on 3D vision. 3D vision is also my original field of research. Let's have a look at the video analysis there. The most important application here is autonomous driving; and here we have AR/VR. We watched Jingyi's demo a moment ago. Ours is only two dimensional while Jingyi's is three dimensional. We have also developed a deep learning platform, a real pride of ours. This is PaddlePaddle. It could be the only independently developed, wholly owned deep learning platform by Chinese, in China.

I haven't joined Baidu for long, only for about one year. The difference between the industry and the academia is scale. Say in academia, maybe we are able to process ten thousand images, or maybe we have one video clip or one academic article which has been cited for a thousand times, or ten thousand times. That's a lot. However, in terms of scale, this is only about one percent of that in the industry. Let's take image classification as an example. In order to classify eighty thousand objects, we have used more than a hundred million images internally as the training set to classify these eighty thousand objects.

Next, I will give a brief introduction of some interesting work we do. The first one is face recognition. You may know quite well about face recognition. There are basically three steps. The first step is human facial detection, then facial match and finally a facial search. Here I will give you an example of face detection. You probably have a good idea about facial identification and authentication. For me personally, this is the picture that totally changed my understanding about AI and deep learning.

Now we can achieve wonderful results in identification across age spans. Let me show you. Here is a photo of my class at junior high. I would like to see if anyone can recognize me in it.

It's a bit dark here. So I won't let you guess any more. Let me give you the answer. Here is a photo of me half a year ago. Here is a photo of me roughly twenty years ago. Our face recognition platform can recognize me immediately.

Personally, I have been involved in computing vision and have some fundamental understanding of deep learning and face recognition. However, this performance far exceeded my expectation of AI capability. Actually, there is huge amount of data in the back as support. We used around eighty million pictures of human faces in our database to train this classifier system.

Now, I would like to talk about our work on AI at Baidu. As you may know, the largest

income stream comes from advertisements at Baidu. We had a lot of discussions on the business of Baidu in AR/VR, the most important of which is, "What is the number of the killer app for AR right now?"

Later we realized it's the app for advertisement. The advertisement unit is the first self-sustained unit among all Baidu research units. What does it mean to be a self-sustained unit? That means its annual income is sufficient to support our AR team. We have around 50 to 60 team members in our team. I see we have many Chinese friends here. Many of these AR functions have been integrated onto our mobile version of Baidu.

Let me give you a demo. Here is a project of Terracotta Army on which we cooperated with the museum. You can use the mobile Baidu to scan the Terracotta Army tickets and the colors of these Terracotta soldiers will be restored to their originals. Actually we have an even more advanced version, which will make these Terracotta soldiers move just as the one shown by Jingyi. However, the Bureau of Cultural Relics didn't allow us to proceed, saying that the Terracotta soldiers must stay kneeling without any movements.

This is a new function we just released recently, called Semantic SLAM. I will risk teaching grandmother to suck eggs here, and explain what SLAM is. Prof. Quan Long here is the expert. He has published many articles and innovative algorithms. SLAM stands for Simultaneous Localization and Mapping. Put it simply, in this scenario, if I have a camera, and I scan this camera, SLAM will simultaneously localize my camera and reconstruct a three dimensional scene. It has a simultaneous reconstruction function. However, we added something to SLAM. We added semantics. We not only reconstruct the three dimensional scene and the camera, we can also identify what is in it using our object identification technology.

What are the benefits? We can generate different reactions according to different semantics. For example, this is a green plant. We know what kind of green plant it is and also when we watered it last. We also added our gesture identification function. As you can see, the student simply waved his hand and this video auto played because we have the semantic information. We also have a 3D map, and thus we are able to interact with the virtual characters in this scene.

Through semantic SLAM, reading in the future will not be limited only to reading texts. The main theme of this book is that the new technological revolution centering on AI has arrived. It recounts the evolution of AI in more than half a century. In the future, when you read books, you will not only be able to read books, you will also be able to ask them questions. Who's the author of this book? The main author of this book is Li Yanhong. Of course. Right? From this video clip, we can see that the combination of semantics and 3D vision, that is, the

combination of semantics and 3D information, will bring some new experiences.

Now we still have some more time. I would like to talk about some work highly relevant to our team, namely, autonomous driving. What Baidu has been doing recently is the project we call Apollo Project. This is our Open-Source Platform for Autonomous Driving. Just like Android, our autonomous driving is open source. In this way, everyone can download our software and convert a normal car to an autonomously driven car.

What I'm showing you here is the views that our autonomous cars see. What it can see is laser and radar. Our autonomous driving uses mainly Laser and radar. Here is the 3D scene reconstructed using laser and radar. There are many semantic elements here. We must analyze from these laser and radar point clouds and identify which are roads, which are pedestrians, and which are road obstacles, and which are traffic lights, etc.

Also related to autonomous driving is robotics, which we started recently at Baidu. Here are some business slides. Actually in China, robotics has plenty of niches. We can see that we have an estimation of how large the robotics market will be in 2020. As you can see, the most prevalent use of robotics is the use of vacuum robots, which you can buy nowadays.

3D vision plays an important part in robotics too. First is navigation, or how to enable a robot to walk automatically in a scene.

Then we have mapping, or the reconstruction of the scene, which informs me how to get from A to B. Also, we have obstacle avoidance, or how to avoid obstacles. If you are interested in robotics, we have an open platform of robotics at Baidu, including open source hardware and software. For example, let me show you a demo video clip here. Here we have many technologies. One is SLAM, the other is OCR—Optical Character Recognition. So in a large mall, with our sensors, we have a good idea where it is. We also get to know which shop it is facing now. We have done multi-source data integration.

Under some circumstances SLAM is really quite difficult. For example, when it is seeing a white wall, how can it know which white wall this is? In this situation, we can only OCR or use other sensors of IMU to accurately identify the location.

Now actually, a lot of work on AI needs to be moved from the cloud to edges of the network, that is, from cloud computing to edge computing. For many applications, especially robotics and autonomous driving, this is very important. All of these are necessary. AR/VR is especially important. In terms of AR/VR, interpretation of semantics must be executed at the edges, i.e. on mobile phones.

Otherwise, say I have a picture and I would like to identify whether it is an object, a person, or a car in this picture. If the picture is uploaded to the cloud and then sent back, it

will take up hundreds of milliseconds for the round trip. The interactive experience will be unsatisfactory. Therefore, personally, I believe, at Baidu, much of our capability for production should be placed not only on the cloud, but also on hardware to achieve improvement of speed and to improve edge computing capability.

Here is an example. How can we, through FPGA and ARM, improve the performance speed of stereo-vision to achieve real time performance? Here I'm going to show you. Using stereo cameras here on the top right corner of the screen, you can see, maybe not very clearly, the reconstruction by 3D technology and then a simple binary classification of the objects in the scene.

Basically, it can classify the areas into two categories, through and no through. Blue areas are areas that are no through for the robot, white areas represent floor areas. The robot can walk through these areas. Now, this assessment is better. Finally, I would like to tell you about our two platforms, apollo.auto and ai.baidu.com. Many of the capabilities I talked about can be found here. You can download software here, including api and SDK. You are welcome to give it a try, especially software relevant to AR/VR, and semantics SLAM that we talked about earlier; and as to reconstruction and tracking of objects, ai.baidu.com is now open to the public.

That's my talk today. Thank you.

Future Design

◎ Ludger Pfanz

I will discuss our new project: "Future Design."

We are based at the Center of Art and Media Technology, in Karlsruhe Germany, and eight years ago, Gulsel Ozkan, my partner, and I opened the first research laboratory with the main objective to get a completely new alliance between technology, art and science; and the other idea was—because technology is going so fast—we want to concentrate on making sure technology does not take over our own ideas, so the first concept was Content Driven Technology. We always wanted to first prepare really great ideas and then create the technology around those ideas.

So to showcase all of our works and to invite people who were working in different fields, we founded the Beyond Festival, eight years ago, and we also have a Beyond Symposium—which is where we started to work on "Future Design," an idea not only to make design for the future, but start to design the future itself. And now we have a European program under the same title, and for the last year there has been a "Future Design" Institute.

So what is this idea all about?

We have now more than 30 partners at Universities, and also some commercial partners like 3IT, Fraunhofer, and Disney Research.

Over the coming decades, new technology will change our lives in a way beyond our imagination. "Future Design" is a creative and critical cooperation of science, technology and art, an experimental laboratory for new art forms and perspectives on the social, political, and environmental impact of these new technologies in a global context.

Ludger Pfanz on ICEVE

Future Design

Much of what will happen in the next thirty years is more or less inevitable, driven by technological trends that are already in motion. From virtual reality in the home, to on-demand economy, to artificial intelligence embedded in everything we manufacture: it all can be understood as the result of a few long-term, accelerating forces, and these accelerating forces, are based on digital technologies interacting, cognition, flowing, screening, accessing, sharing, filtering, remixing, tracking, and what is the last refuge for humans, intelligence and questioning. These large forces will revolutionize the way we learn, we work, we buy, and we communicate with each other.

"Future Design," therefore, is concerned with the art of thinking about and the way of shaping the future actively and consciousness based. We have to blend art, science, history, philosophy, and every discipline in between, to offer a vision for tomorrow that seems incomprehensible.

The main objectives are to attract wide attention to these technologies and generate debate and interest in order to stimulate their use by independent artists and unrepresented groups in the community.

We have to bring these emerging new artistic practices into visibility inside the framework of a critical global cultural dialogue, and to recognize the potential these technologies offer in shaping and strengthening cultural identity.

"Future Design" contributes to people's assessment of their local identity and appropriation, and works on local solutions for global problems, respecting the local environment. Every place has to identify its specific knowledge, specific problems, and solutions, and those solutions may later become global. At the same time it encourages cultures and helps to bridge different sensibilities.

"Future Design" is an interdisciplinary and highly intercultural project based on mobility-led research, artistic and cultural creation. It focuses on the encouragement of peoples' creativity and free expression. Availing itself of the latest and upcoming technologies leads to

higher participation of the audience, changing their role from consumer to producer/creator.

New technologies and emerging markets will change not only the environment, but also could lead to sustainable economic development, new forms of social life and exclusion, housing, leisure and consumption. People will have to adapt to societal changes, and changing relationships between humans, as well as interrelations of humans with machines, with animals, and with digital and natural networks and people will have to come to terms with artificial intelligence, and probably in the far future, artificial consciousness or sub-consciousness.

Virtual realities and network-worlds might become part of human life similar to our dreams, which are a nightly routine, somehow separated from our daily lives, obeying different

"Future Design" is a creative and critical cooperation of science, technology and art

physical rules. There's a lot of people asking "In how many realities can we live?" On our daily basis, we live in at least three realities. We have a day world, we have a dream world, and we have a deep sleep world, where we still have some cognitive actions. And we are also in Art-worlds: literature, in books, in theater, music and films. So I think humans can adapt to as many realities as there are possibilities.

But when we work with all those new media, we have to invent a new international visual language. I always call it something between Eisenstein and Einstein.

So we have to invent "space-time narratives." I spoke about this last year, here, but I want to focus on a couple of aspects again, because this is still not researched at any university, and I call it the "Four Space-Time Tensions."

What we have learned from 3D film is: We have to start thinking in space in the beginning, in the script. If not, we get 2D films with 3D effects. We have to stop thinking in

frames, but when we go to 3D, we have to think in stages, and when we go to VR, we have to think in spheres.

The space needs emotional, intellectual, and aesthetic meaning. We need depth dramaturgy. I will talk about this later, and, this is very important. We have to do more common research on that. We need stories with not only tension in time, but have vertical parallax and horizontal tension.

So the whole history of dramaturgy since Aristotle, is how we organize time; and Hitchcock said, "Film and theater is life without the boring parts." We organize time. Actually we are quite knowledgeable in that. In our daily experience and in every important drama, mankind has three levels of conflict, or three levels of stress. We have outer plot conflict, relationship conflict, and an inner character conflict; and we can reflect those different levels of story, or these different levels of conflict, in different layers of space time.

So, for example, the horizontal tension. The horizontal tension is the attraction and repulsion through places, objects, and people. The horizontal tension is dominant in the emotional network and that should be very clear, because in our day to day life when we talk about relationships, we always use special metaphors. We say, "We are coming closer, or a distance is building up in our relationship. So in our day to day language, we use horizontal metaphors for expressing relationship.

"Future Design" contributes to people's assessment of their local identity and appropriation, and works on local solutions for global problems

Another aspect is all those emotional network things, our desires, which are erotic desires in the old Greek sense that they are want-to-have things. Whenever I want to have something, I have a horizontal movement to it, but there is another tension, this is the vertical tension.

The vertical tension is the constant striving to improve to higher and further development, and growth beyond the status quo, which is based in the inner character conflict. I will give you an example: in the old times, in Greek dramaturgy, they said, "There is an erotic, a want-to-have driven tension, and there is a want-to-become-tension," they call the latter a Thymotic tension.

I'd like to explain it using the case of Achilles. When Achilles was asked by Menelaus to join him in the Trojan War, he despised this king. He didn't want to fight for his king. So he went back to his mother, she was a seer, so he asked his mother: "Mother, what should I do, should I go to Troy? To the war?" and his mother said, "If you stay here, you will have hundreds of women and a lot of children, wine, gold, whatever. You will have a beautiful kingdom. If you go to Troy, you die. But in thousands of years, people will still sing songs about you." He went to Troy. What kind of erotic motivation is this? He prefers to become immortal in stories, in songs. This is a Thymotic motivation, and you as artists, you know definitely this kind of inner power, which looks for greatness.

The fourth dimension, is the Z axis and this normally defines the relationship between your story and your characters towards the audiences. So when we come to the parallax tension of the Z axis, we have to think in five different depth spaces: which creates different feedback for the audiences.

The first is the intimate space. The intimate space is very close around you. It is where you can be touched, and where you smell intensively. Normally you do not like anybody, except your lover, or your parents, or your children, to get into your intimate space. Whenever something enters this space uninvited your nervous system says, "You are too close." You have to be very careful when entering someone's intimate space. When we meet outside, if I would go into your intimate space without your allowing me that, you will feel very uncomfortable. So as artists, we should be very, very careful to stick some spears and fingers towards our audiences.

The next space is the personal space. This guy takes his personal space very, very serious. Once in a while when you drive through the subway here, you have to give up your personal space.

And then we have an interactive or social space. The interactive space is, for example, a speaker to an audience. Social space is a direct feedback space. It's not really complicated for me, it's not dangerous at the moment, but I still get feedback towards my actions. This

is normally a space where we can work quite nicely in VR and in 3D, because we react immediately to the space, but it is still comfortable.

Then we have a public space. The public space is where I can see the people all over, but normally I don't react or get any feedback. They will not react to me too much and I will not react to them. But there is still enough reading that, if say, somebody sprung up with a sword, I could immediately react and have feedback. So it's a space which is far more ahead than the normal social space, but we still have a direct feedback.

Then we have the fifth space, which is the surrounding space. The surrounding space normally creates no feedback, but it creates atmosphere. It would be a completely different scene if we would now have the surrounding space, for example, in Beijing, or now in the mountains. You react, you have a direct feedback to the surrounding space only, for example, only if one of those mountains would be a volcano and explodes. If not, they would just kind of create, in the layers of depth, an atmosphere towards your story.

So this is a way you can kind of think about structuring a VR piece, and you want to keep all those things in mind so you can construct a meaningful space.

We always have to relearn our craft and this is, I think, one of the most important things for us as professors. That we know we have to learn every year our profession anew. We should not tell the old war stories, we should research with our students. And one of the researches that we are doing now is participatory storytelling.

It is how you can create interactive stories, and we've created a model, which I call the "Story Functions/Bottlenecks and Vegetables." To keep a story logical, so that your audience can understand the logic even when the story is interactive, you have to make sure that they know the necessary information.

So whenever you are on a level in your game, or in your film, or in your VR, you cannot pass to the next level if you don't have the necessary story functions; but it doesn't matter in what sequence, if you go one, three, five, four, or in another rhythm, but you need it to enter the next level so that the whole thing makes sense. If I do not know your conflict, then I would not understand the next level. So only when you have the necessary story functions in the story, when your audience has watched them, then you can go through a "bottleneck" towards the next level. If you do not have them, then the next level is closed. But of course, gamers will immediately understand this idea. So we throw in on every level a lot of vegetables, and vegetables are story elements which are really interesting, but they are not necessary, they lead to nothing. So you have a wide range and you can still make a plan, you can still know how many scenes you have to shoot to make this really immersive experience, and you can plan on that. A lot of people always ask me why I call those story parts vegetables, and I have to confess

New business models in all industries and especially in the cultural and creative sphere

I am a meat-eater, and I'd like to have some vegetables on my plate but I don't need them. So with this strategy you can create complex stories and you still have to control your budget.

Now stereoscopic and auto-stereoscopic technologies, mobile devices with 3D capabilities, 3D laser scanners, 3D printers, virtual and augmented reality and new interfaces co-developed by engineers and artists, are finally fully presenting the third dimension in a way that can be creatively used in representation and expression, creating new business models in all industries and especially in the cultural and creative sphere.

A lot of people don't know, now in Germany the cultural and creative industry is the third biggest industry. It's not engineering anymore, it's not automobiles anymore. With all those new digital technologies, cultural and creative industry will become one of the main forces of economy for any country.

So in addition to current productions and trends of VR, AR, stereoscopic, multi-scopic and auto-stereoscopic films in cinema and television, "Future Design" focuses on new narrative forms of "space-time narration" and it is concerned with a new dimension of moving pictures to space-time stories and a quantum theory of digital dreams. Supported by higher frame rates, higher resolutions, micro-and macro-scopic insights, super slow motion and super accelerations, new displays will bring immersive communication not only in your homes, but will transform any surface into a screen. Digital distribution, and video on demand, 3D landscapes will change the atmosphere of your living room like a window to the world, and portable 3D devices will enlarge the home-screen to wherever you go. Traditional televisions

will be reduced to live events, for example, in sports, politics, and news.

New ways of creative thinking can resolve the antagonism between nature and technology. There is no need that our technologies be antagonistic to nature anymore. If you look at other beings like ants, they kind of reproduce all the time, tons of material, they never leave garbage. So we are not over-populated on this planet, we are just too stupid. Most of the tools of the future will, and have to, be supplied by new kinds of energy harvesters as every house and every cottage could potentially provide more energy than it consumes.

A formula for all future start-ups: you take whatever you want, you add artificial intelligence, and then you have a new product. If it's your tooth brush, if it's your car, you can add artificial intelligence to whatever you know, and create something new. And in the bigger relationships, it will be inter-networks which are combined with smart objects and renewable energy.

Artificial intelligence is already here and it will increase daily to an extent that AI will make its own decisions and could help to integrate individual behavior into the overall ecosystem of the planet and on climate control.

When you research something new, everybody on this planet has more or less the same information at more or less the same time. So the next obvious step, which is more or less obvious to everybody, is that when you start to research something, which is very obvious, you know that you are probably a day in front of Germany, or to the U.S, but when you start to look into the shadow, where the new disruptive forces come from, it's always starts in markets with low quality, high risk, low margins, small market and unproven concept. Those disruptive explosions which we saw, for example, with Baidu, and with Facebook, will in a couple of years become multi billionaires.

We made a research with the University of Oxford and, more or less, by 2030, 67% of the jobs in Britain will be gone by automatization and algorithms. In Germany, what we have it a little bit better, it is 43% by 2030, which is still, almost, half of the population, half the jobs, we know.

Super intelligence, that is whenever an AI can create an intelligence which is more intelligent than itself, is already looming around the corner, and it might not only serve the desires of individual humans or humanity in total. A couple of scientists like Stephen Hawking and Max Tegmark believe that super intelligent machines are quite feasible and the consequences of creating them could be either the best of the worst thing ever to happen to humanity.

"Future Design" explores the future of digital distribution from atoms to bits, and from bits back to atoms. The emerging Internet of things could speed us into an era of nearly free

goods and services, precipitating the meteoric rise of a global collaborative of commons and, might be the eclipse of capitalism.

Supercomputers can simulate various outcomes of future crises. "Future Design" though takes a new approach to problem solving. "Future Design" will not simply extrapolate probabilities. "Future Design" will imagine and simulate a possible and desirable future as starting point and then regress from this point backwards in time to the present in order to find paths we can follow to arrive at that future.

"Future Design" will create new narratives of possible and desirable improbabilities and thus create the chance to make them realities, like the narrative of Post-capitalism and the age of abundance.

With the nuclear threat, climate change, inequality, and the possibility of super intelligence, we can no longer afford to fly blind or on autopilot. Considering the risks and possible collateral damage connected to these new technologies, scientists and artists have to take a stand for their values, openly discussing the potential and the risks to formulate a vision for our PLANET and BEYOND.

— Change the lens you use for seeing the unknown;

— Consciously engage uncertainty;

— Allow the process to be messy;

— Actively leave the familiar;

— Use multi-dimensional creative approaches;

— Be the beginner;

— Accept the human paradox.

And one last thing: in the "Future Design" R & D Think Tanks, which are collaborating all over the world, and with Charles Wang at AICFVE, we are preparing a "Future Design" Think Tank here in China. "Future Design" designs students and artists, creates not only a new design, but a new narrative, and a new vision for the future. Create probabilities and desirable improbabilities beyond the lmitation of life as we know it.

未来设计

▶▶ Ludger Pfanz

我要讲一下我们的新项目"未来设计"。

我们的总部在德国卡尔斯鲁厄的艺术媒体技术中心。八年前,我和合作伙伴 Gulsel Ozkan 开设了第一个研究实验室,主要目的在于实现技术、艺术和科学的全新结合。此外,还有一个考虑是,现在技术发展太快,我们想要确保自己的想法不会被技术所掌控,所以我们提出了第一个概念,叫作内容驱动技术。我们希望是想法先行,然后围绕这个想法开发技术。

为了向大家展示我们的工作成果,并邀请到不同领域的人们来参与我们,我们创办了 Beyond 科技节。八年前,我们还举办过 Beyond 研讨会。"未来设计"项目就是在这个研讨会上开启的,它不仅是要设想未来的发展,更是要设计未来。如今在欧洲,我们也有这样一个项目。从去年一整年的工作来看,我们可以说我们所在的机构就是一个未来设计机构。

那么这个想法具体到底是什么呢?

现在我们有 30 多所合作院校,还有一些商业合作伙伴,比如 3IT、Fraunhofer 和迪士尼研究院。

未来几十年里,新技术对我们生活的影响将超乎我们的想象。"未来设计"使科技和艺术之间达成一种创意满满又至关重要的合作关系。我们实验室对新艺术形式以及这些新技术将在全球内对社会、政治和自然环境产生什么样的影响展开研究。

未来 30 年,新兴技术的发展如火如荼,在其推动下很多事情不可避免。从家庭里的虚拟现实设备,到按需经济,再到我们生产的所有人工智能的东西,都可以被理解为一种长期加速发展的结果,这些加速发展的动力都以数字技术为基础,包括它的互动、认知、流动、筛选、存取、分享、过滤、融合和追踪,还包括人类的终极归宿、智能与质疑。这些强大的动力将变革我们学习、工作、购物和交流的方式。

所以说,"未来设计"关注的是思考的艺术和塑造未来的方式。我们需要融合艺术、科学、历史、哲学种种学科,才能展望未来。

我们主要的目标在于引起大家对这些技术的广泛关注、讨论和兴趣,从而推

动独立艺术家，抑或是各个不知名团体去使用这些技术。

我们要把这些新兴的艺术实践带到全球文化对话的框架中，发挥这些技术在塑造、强化文化身份中的潜能。

"未来设计"可以帮助人们对自己的当地身份做出评估，在尊重当地环境的基础上为全球性问题提供本地化解决方案。每个地方都得发现自己特有的资源、问题和解决方案。这些解决方案在未来可能会变成全球性解决方案，同时还能推动文化发展，连接不同的情感。

"未来设计"基于流动研发、艺术创作和文化创造，是一个跨学科、跨文化的项目，它着重鼓励人们去创造和自由表达，充分利用最新的技术，提高观众的参与度，让他们从消费者变成生产者。

新兴技术和新兴市场不仅会改变整个环境，还能带来经济的可持续发展、全新的社会生活方式、住宿方式、休闲方式和消费方式。人们将不得不去适应社会的变化、人类彼此之间关系的变化，还有人类和机器、动物、数字化世界、自然世界关系的变化。人们将会面对人工智能，在遥远的未来，还可能要面对人工意识或潜意识。

虚拟现实和网络世界可能会像梦境一样成为人类生活的一部分，我们每晚都会做梦，但是梦境和我们日常生活是分离开来的，遵循的是另外一套规则。有很多人问："我们能在多少个现实世界里生活？"就每天的生活来说，我们生活在至少三个现实世界里：白天的世界、梦境的世界和深度睡眠的世界。在深度睡眠的世界里，我们还会有一些认知活动。另外，我们还有一个艺术的世界，它存在于文学、书籍、戏剧、音乐和电影里。我认为，人们可以适应无数个现实世界。

但是我们在面对这些新媒体时，必须发明一套全新的国际视觉语言，我称之为"介于爱森斯坦和爱因斯坦之间的语言"。

因此，我们得发明一种"时空叙述方式"。去年我在这里也讲到过这一点，但是今天我想要再次强调几个方面，因为还没有院校在做这个研究，我称之为"四种时空张力"。

从3D电影当中，我们知道，最初编写剧本的时候就要开始用空间思维去思考。如果不这么做，最终得到的只能是有3D效果的2D电影。我们不能再用帧率的思维去思考问题，3D得从舞台的角度去考虑问题，VR得用球体的角度去考虑问题。

我们需要赋予空间以情感、智力和美感，需要深度编剧，这一点我待会儿会谈到。这些都很重要，需要更加深入的研究。我们的故事不仅要有时间张力，还得有垂直视差和横向张力。

从亚里士多德时代开始，编剧学讲的就是怎么组织时间问题。著名导演希区柯克曾说过："电影和戏剧就是剔除了无聊部分的生活。"我们要对时间进行组织。

实际上，这方面我们很在行。在生活中，在每一部伟大的剧作中，人类都有三个层次的冲突，或者说压力——外部冲突、关系冲突和内在冲突。我们可以通过不同层次的时空展现故事不同的层次，或者说冲突的不同层次。

以横向张力为例。横向张力指的是地点、物体和人之间的互相吸引和排斥。横向张力在情感网络里占据支配地位，这一点很清楚，因为在日常生活中，当我们讲到关系时，总是会用空间打比方。我们会说，我们俩越来越近了，或者是我们的关系有了隔阂。也就是说，在日常用语中，我们会用横向关系的变化打比方，形容关系的变化。

另一个方面是情感网络层面，即我们的欲望。在古希腊语中，欲望就是我们想要某种东西。我想要某种东西的时候，就会在横向距离上去接近它。还有一种张力叫作垂直张力。

垂直张力指的是对发展的不懈追求，对现状的提升，以内在冲突为基础。给大家举个例子，在希腊编剧学里，他们是这么说的，"有两种张力：一种是欲望，想要某种东西的张力；另一种是想要变成什么样的张力"，后者他们称之为意志张力。

我要用阿喀琉斯的例子来说明。斯巴达国王墨涅拉俄斯要求阿喀琉斯参与特洛伊战争时，阿喀琉斯看不上这个国王，不想为他迎战。他的母亲是个先知，于是他回家问自己的母亲："母亲，我应该怎么做？我应该去特洛伊打仗吗？"他母亲说道："如果你留在这里，会有很多女人，生很多孩子，喝很多美酒，拥有很多黄金。你的生活会很精彩。如果你去特洛伊，命就没了。但是，在你死后上千年的时间里，你会得到人们的歌颂。"听了这句话，阿喀琉斯去了特洛伊。这难道是一种欲望吗？他更希望活在故事里、颂歌里，这是一种意志上的动力。作为艺术家，在座各位肯定知道这种内心的力量、对伟大成就的追求。

第四个维度是 Z 轴，它往往决定了你的故事和角色与观众之间的关系。说到 Z 轴的视差张力，有五个不同的深度空间，能引发观众不同的反应。

第一个是亲密空间。亲密空间离你很近，是可以触碰、可以清楚闻到味道的距离。通常，除了爱人、父母和孩子，你不希望别人进入这个亲密空间。一旦有人入侵这个空间，就会刺激到你的神经系统，你会和对方说"你太近了"。因此，在进入他人亲密空间时要格外注意。如果我们在外面偶遇，而我没有得到你的许可就进入你的亲密空间，你会很不舒服。因此，作为艺术家，我们得格外小心，和观众保持一定的距离。

第二个空间是个人空间，人们很看重自己的个人空间。不过偶尔在坐地铁的时候，我们不得不放弃个人空间。

然后还有交互空间，或者说社交空间。举个例子，演讲者和观众之间就是一

种交互空间。社交空间是一种直接的反馈，这对我来说并不复杂，目前也没有危险，但是我的一举一动还会得到反馈。通常，这个空间在 VR 和 3D 里能得到很好的体验，因为我们会做出即时的反应，同时也是舒服的。

接下来还有公共空间。在公共空间，我可以看到周围所有人，但是通常情况下，我不会做出反应，也得不到反馈。他们和我，我和他们，都不会有什么交流。但是，如果有个人拿把剑冲过来，我还是会立刻做出反应的。因此，这个空间离普通社交空间有点远，不过我们还是会做出直接的反馈。

最后第五个空间是周围空间。通常周围空间没有反馈，但是可以塑造氛围。比如北京的周围空间和群山里的周围空间就有完全不同的景象。此外，只有在某座山是座正在爆发的火山时，你才会对周围空间做出直接的反应。否则，这些景象只会以层层展开的方式为你的故事营造一种氛围。

以上就是构建 VR 作品的一些思路，记住这些就可以构建出一个有意义的空间。

我们总是要重新学习，我想这也是作为专家学者最重要的一个方面。大家知道，每年我们都得从头去了解自身这个行业。不能总是把过去的战争故事放在嘴边，我们得和自己的学生一起去研究发现。最近我们在做的一项研究就有关参与式故事叙述。

它讲的是如何创作互动故事。我们做了一个模型，我称之为"故事功能／瓶颈与蔬菜"。故事必须有逻辑，这样观众才能理解。即便是互动性的故事，也得确保观众了解必要的信息。

所以，不管你是在游戏、电影、VR 的哪个层次，如果没有必要的故事功能，就不能跳到下一个层次。顺序不重要，不管是 1、3、5、4 的顺序还是其他顺序，只要这些功能可以推动下一个层次的发展，就行得通。如果不了解其中的冲突，就无法理解下一个层次。因此只有在呈现了所有必要的故事功能后，只有在观众看到这些功能后，才能穿过"瓶颈"进入下一个层次。否则下一个层次就是关闭的。当然，游戏玩家上手会很快，我们会在每个层次设置很多蔬菜，蔬菜指的是各种有意思但是非必要的故事元素，不会触发任何情节。所以说，你有很多选择，你可以做一个规划，知道要拍摄多少场景才能完成一部沉浸式体验作品。这么一个策略的意思是说，你可以创作出复杂的故事，同时还能控制预算。

目前，不管是立体技术、裸眼立体技术、具备 3D 功能的移动设备、3D 激光扫描仪、3D 打印机、虚拟现实、扩大现实，还是工程师和艺术家共同开发的全新的人机界面，都充分展示了第三维空间，可以用于创意展示和表达，催生所有产业的新商业模式，尤其是在文创领域。

很多人不知道的是，现在德国的文创产业已经成了他们第三大产业，它不再

是工程产业,也不再是汽车产业。有了这么多新兴的数字技术,文创产业将成为各国经济主要动力之一。

所以,除了目前影院电视里的 VR 电影、AR 电影、立体电影、多视角立体电影、裸体立体电影的制作和发展趋势外,"未来设计"还致力于新的叙述形式,即"空间叙述",它关注的是一种将图片故事转变成时空故事的新形式和数字世界的量子理论。有了更高的帧率、分辨率以及微观和宏观上的认识,我们可以实现超级慢镜头和超级快镜头。新的显示技术不仅能让你足不出户就能拥有沉浸式体验,还能把各种物体表面变成屏幕。数字化发行、视频点播和 3D 景观模型将把你的客厅变成面向世界的窗户。可携带的 3D 设备将跟随你去任何地方,为你提供大屏体验。而传统电视机将只用于播放体育、政治、新闻等直播节目。

全新的思维方式将化解自然与技术之间的矛盾。从现在开始,技术不必站在自然的对立面。不妨观察一下其他生物,比如蚂蚁,它们不停地繁殖,数量上成千上万,但是它们没有给地球带来负担。同样,人类不是数量太多,而是太笨了。在未来,大多数工具将要,也必须使用新能源来驱动,每家每户生产的能源将超过其消耗的能源。

对未来创业公司的建议:在产品上加入人工智能就能生产出新的产品。不管是牙刷、汽车或其他什么东西,用上人工智能就能生产出新产品。从更大的层面来看,它还将融入智能产品、可再生资源组成为一个互联网络。

我们已经实现了人工智能,它每天都在发展,终有一天人工智能可以自己做出决策,推动将个人行为融入地球整个生态系统中,对全球气候进行管理。

我们每研究一个新东西的时候,地球上可能会有人在同一时刻掌握着相同的信息。显而易见,下一步要做的是开始研究某个东西的时候,必须确保自己比德国、比美国领先一步。但是,也就是在这种调查的时刻,才能够出现新的动力。新机会总是出现在低质量、高风险、低利润、小规模、未被验证的市场上。百度、Facebook 就是很好的例子,它们在短短几年的时间里就成长为亿万级别的公司。

我们和牛津大学做了一项研究。研究表明,到 2030 年,英国 67% 的工作都会因为自动化和算法而消失。德国稍微好一些,到 2030 年会有 43% 的工作消失,但这依然是将近一半的人口和工作。

超级智能,也就是人工智能可以创造出比自己更高级的智能,这个时代即将到来。它将满足个人和全人类的需求。诸如史蒂芬·霍金和泰格·马克这样的科学家相信,超级智能完全可以实现,对人类而言,它们可能是最好的事,也可能是最坏的事。

"未来设计"分析了数字化发行的未来,发现新兴的物联网将我们快速带入了一个几乎可以免费获得所有商品、服务的时代,加速了全球协作的迅速崛起和资

本主义的崩塌。

超级计算机可以模拟未来各种危机带来的结果，而"未来设计"另辟蹊径来解决问题。我们不只是简单地推断未来会发生什么，我们会对理想未来进行想象和模拟。从这里起步，回溯到现在，这样才能找到通往未来之路。

"未来设计"将用新的方式来叙述这些可能性，创造出令人期待的不可能性，从而使它们有机会美梦成真，比如说，后资本主义和富足时代的实现。

核威胁、气候变化、不公平和超级智能这些问题就在眼前，我们不能再盲目前行，也不能再坐以待毙。想到这些新技术带来的风险和潜在的危害，科学家和艺术家必须拿出自己的立场，公开讨论这些潜在的风险，展望地球和 Beyond 的未来。

—— 改变固有方式，探索未知世界；

—— 有意识地涉足不确定领域；

—— 接受混乱的现状；

—— 积极脱离熟悉领域；

—— 多维度使用创新性方法；

—— 成为领头羊；

—— 接受人的悖论性。

最后提一下我们的"未来设计"研发智囊团。我们的团队包括全球各地人才和未来影像高精尖创新中心的王春水先生。现在我们正在中国组建"未来设计"智囊团。"未来设计"由学生和艺术家组成，我们不仅用全新的视角设计未来，还用全新的视角叙述未来、展望未来。让我们打破生命的局限性，去创造各种可能和不可能。

近眼显示技术的现状和展望

◎ 宋维涛

大家好，我是宋维涛，来自未来影像高精尖创新中心。今天前面几个报告探讨了关于 VR 和 AR 显示内容相关的研究。我代表未来影像高精尖创新中心未来显示团队介绍一下关于 VR 和 AR 的硬件显示呈现平台以及近眼显示现在的发展和未来的展望。

近眼显示设备是虚拟现实和增强现实的一个重要呈现平台，被认为是继电影屏幕、平板显示之后显示领域的又一次革命，也引起了广泛的关注。近眼显示设备也被称为是头盔显示器。它主要是由显示屏幕和显示目镜组成的，主要工作原理是由显示目镜把显示屏幕成像放大在较远的地方，一些具体设计参数包括出瞳大小、出瞳距离、视场角、分辨率以及光学目镜的成像质量。大的出瞳直径可以让用户的眼球在更舒适的范围内进行运动，较大的出瞳距离可以让大家佩戴这个眼镜更便携、更舒适，视场角、分辨率，以及光学目镜的成像效果决定了它呈现给大家的效果。所以近眼显示系统追求做大的出瞳直径、长的出瞳距离、大的视场角以及良好的成像效果。

沉浸式的显示设备也就是应用于 VR 的眼镜，从结构上主要分为半沉浸式和全沉浸式。目前大部分眼镜，像 Oculus, Samsung, 还有 HTC, 都是采用全沉浸式的这种显示方案。大部分市场上的眼镜都是由单片式的镜片构成目镜系统。刚才晶怡老师说去年 VR 创业公司死了一批，其实不仅仅是内容没有做好，设备也没有做好。

我们在十年前，用了六片全球面的镜片，目的是获得一个更好的目镜成像效果。该系统在圆明园重建工作的虚拟显示方面进行了一些应用，效果良好。团队在去年使用了两片非球面镜片并进行了一个优化设计，获得了一个大视场、高分辨率的 VR 呈现平台。该设备也被应用到航天领域，"神舟十一号"的宇航员通过该设备与家人进行了隔空交流。

关于 AR 系统，由于其光学系统需要光学穿透显示，结构就显得复杂一些，所以它的结构形式就较多一些。最早受到大家关注的 AR 眼镜是谷歌眼镜，其结构是一个潜望式的光学结构。图像从图像源出来经过三次反射，然后进入人眼。同

高品质 VR 近眼显示

时人眼透过半透半反的玻璃观看真实世界，虽然它比较小巧，但是它的视场角比较小，而且由于只有一个表面有光焦度，所以其解析度和视场角都略显不足。

第二种结构是利用自由空间耦合面结构。目前结合一些手机的屏幕可以实现一个较大的视场角，而且近眼呈现的成本较低。著名的 Meta 公司推出的产品就是采用这种结构。目前这个结构的缺点是比较笨重。

自由曲面棱镜是有 3 个自由曲面的表面，自由曲面就是一个各个方向都不对称的结构，它引入了很多自由度，可以实现更大视场角、更便携的一种近眼的呈现。

我们团队其实也在这个领域做了大概近十年的工作，目前也获得了很多国家和国际的专利。实际上的设计效果也优于学术期刊中显示的优秀成果的效果。而且我们这个设计由北京耐德佳显示技术有限公司产品化，目前相关光学性能优于竞品，显示模组也在多家 AR 的近眼显示产品中得到了一些应用，比如联想和悉见科技公司。

自由曲面棱镜的结构虽然小巧，而且进行了一些优化，但是用户可能对这个小巧程度还不够满意，目前自由曲面的厚度在 10 mm 左右。所以为了进一步让系统更加小巧、更薄，光波导也被引入了近眼显示的设计当中。光波导技术是通过光线在内部进行全反射来增加光学长度，从而减小光学厚度。这种光波导的近眼显示结构，需要光进入光波导内，然后由光线在光波导内传输，从光波导耦出进入人眼。

根据耦出端的不同，结构又分为四种。比如 EPSON BT-300 的产品，它就采用曲面的反射进行耦出；Optinvent ORA 这个公司，实际上对自主提出的棱镜表面进行了耦出，使得出瞳更大；Lumus 提出了多反射镜的方案，对于产业化和杂散

AR NED with Freeform TIR Prism

Model	Eye-Trek FMD 220	Z800 3dvisor	i-Visor	ProView SL40	BIT
Full FOV (°)	37	39.5	42	40	53.5
EPD (mm)	4	4	3	5	8
F number	5.25	5.5	8.9	4.1	1.875

Moto HC1　　　Kopin SOLO　　　NED+

D. Cheng, Y. Wang, H. Hua, and M. Talha, Applied optics 48.14 (2009): 2655-2668.

自由曲面棱镜的 AR 近眼显示

辐射进行了一些优化，获得了良好效果；衍射光学表面也被很多产品引入近眼显示的设计当中，比如 Hololens 和 Sony 的 AR 产品。

刚才对目前的近眼显示设备进行了分类总结，主要是阐述一些现状。关于未来近眼显示设备将会向哪个方向发展，我想学术上的一些热点研究可能可以代表它的一些方向，所以接下来我将对学术上比较热点的小型化、大视场的高分辨率化以及真实化进行解述。

关于小型化，其实大家就希望它无感化，希望戴着它跟完全没有一样，这是

AR NED with Light Guide

1. Curve reflector combiner
2. Micro-prisms combiner
3. Cascaded half-mirrors
4. Diffractive surface combiner

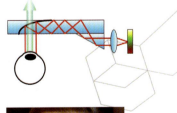

Epson bt-300

光波导技术的 AR 近眼显示

大家理想的目标。在这方面,很多学者进行了一些努力。我们团队在自由曲面研发基础上结合光波导的技术,使镜片的厚度进一步降低,通过自由曲面棱镜增加它的优化参数,使光学性能更好,从而达到最优的效果。我们搭建了基于这个原理的样机,并对系统的杂散辐射进行了一部分优化,最后获得了一个比较良好的成像效果。

另外,在研究过程中我们发现,近视或者是远视的用户在使用近眼显示设备的时候,需要同时佩戴自己的矫正眼镜,这样的话近眼显示设备就比较厚,而且佩戴起来比较复杂。基于这种想法,我们提出了一个结合了自由曲面的光学目镜以及矫正的近眼显示设备,使两镜片一体化,所以设备变得更小巧、更方便。

Innovega 公司同时提出了一个更好的想法,它想把近眼显示和隐形眼镜结合在一起,通过隐形眼镜增加一个微透镜,将显示屏上一个物体呈现到较远的一个位置,同时对这个透镜之外的地方进行镀膜处理,使屏幕上的一些显示并不能进入人眼当中,而且这块外界的物体通过其他部分呈现到人眼。结果是,这样的系统更加小型化,但是目前它的量产性评估和生理性评估还正在进行,希望这个产品能够成功。

第二个研究热点:如何实现一个大视场,同时能够保持一个较高的分辨率。由于现在一些 VR 和 AR 设备的屏幕分辨率是一定的,随着视场角的增加,角分辨率也会降低,这个关系在学术上称为分辨率/视场角不变量。

为了解决这种不变量,除了增加屏幕的分辨率,学者们还想到了一些其他方案。但是目前很多方案比较复杂,所以没有将它们引入工业化。我们也研究了光学拼接的方案,通过多通道光学系统,通过通道拼接来实现高分辨率,这样可以

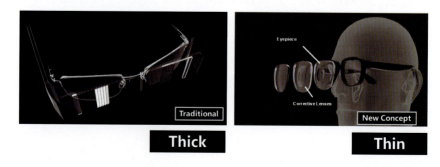

结合矫正镜片的近眼显示(1)

在保证每个通道内分辨率的基础上形成更大的视场角。

我们分析了传统光学拼接的一些问题，发现存在这些问题：拼缝比较明显，系统比较笨重，很难进行穿透式显示。为了解决这些问题，我们提出了一个新型的自由曲面的拼接方案，通过光学整体注塑成型，以及自由曲面多参数的特性，可以解决刚才说的那些问题，并且获得了一个较好的拼接效果。同时，我们也探讨了自由曲面拼接的不同方案，目的是获得更大的分辨率，获得更好的沉浸感。

另外，在学术界和产业界一个比较重要的研究方面是构建真实感的近眼呈现。就是大家在观察真实空间当中，除了双目视差，包括刚才晶怡老师也提到，每个单眼也会有一个聚焦的效果。比如人在观察真实世界当中，人看到这个物体其实单目是起到调节聚焦到这个平面上的，同时通过双目视差感，它的辐辏也是感觉形成到这个平面上。但是对于目前商用化的近眼显示，在空间当中，只有一个呈现平面，这样的话，我们单眼的聚焦是在这个平面上的；但是为了产生3D感，我们通过视差的方式，使我们辐辏的感觉是离开这个平面的，这种聚焦和辐辏的不一致，就是导致我们佩戴VR眼镜和AR眼镜感觉不舒适，无法长期佩戴的一个主因。

针对这个问题，也有很多解决和缓解的方案，在这里就挑几个比较典型的方案进行简述。由于传统的近眼显示设备在人眼前只构建一个平面，所以这里有很简单的一个想法，就是说我可以在前面构建多一些的平面，亚利桑那大学Hua教授团队在近眼显示设备中插入了液体透镜结构，通过改变液体透镜的电压，改变液体透镜的焦距，从而使得成像平面在空间中形成多个，通过这种方案来缓解辐辏和聚焦的不一致。

我们团队也使用了两片胶合光学目镜，通过胶合位置使用半透半反膜使用户可以同时看到两个屏幕，控制结构位置使之呈现在不同的深度上，实现多深度重建方案并且获得较好的成像效果。

另外，重要的解决方案是光场近眼显示技术，光场是一个表述物体各个方向光线的重要手段，如果可以将要呈现物体的光场稠密地输入眼睛，我们就可以获得它的深度信息。斯坦福大学Wetzstein团队提出多层显示屏的近眼显示方案，通过计算机一些优化方案充分利用多层显示屏上的像素，来构建进入人眼的稠密光场，但是算法较为复杂，暂时无法进行实时渲染。

英伟达公司Lanman博士通过传统方法——集成成像方法，构建稠密的光场进入人眼当中，它的光场每一条光线都严格地跟像素一一对应，并且他们使用GPU技术实现了实时的光场渲染。我们团队也是国际上最早提出使用光场手段来解决聚焦和辐辏不一致问题的团队之一。我们团队利用微孔阵列结构和光学目镜的放大作用实现了大视场角可穿透式光场呈现，我们完成了基于该原理的样机，并通过用相机在出瞳的位置模拟人眼进行了拍摄，获得了前后聚焦的景深效果。

结合矫正镜片的近眼显示（2）

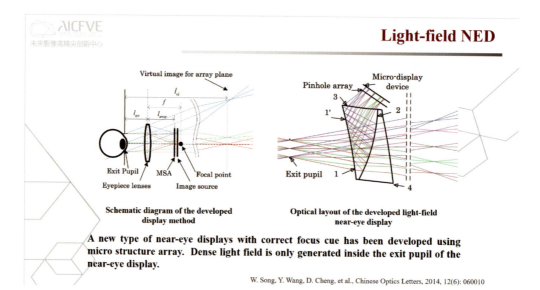

结合矫正镜片的近眼显示（3）

最后作一下本次演讲的结论：近眼显示目前发展的三个方向——小型化、大视场高清化以及真实化，在学术上大家都在探讨研究，但是目前还没有一个让产业界或是用户更满意的方案，所以还有很长的路要走。总之，希望便携化、适人的、高沉浸感、真实性的显示技术可以更快应用到大众生活之中。

谢谢！

Present State and Perspectives of Near-eye Displays

▶▶ Song Weitao

Hello, everyone. My name is Song Weitao. I'm from the Advanced Innovation Center. Following the many great reports that talked about the content of VR and AR, and as a representative of our future display team, I'd like to introduce the display platforms for VR and AR, as well as the present state and perspectives of Near-eye Displays.

Near-eye Display (NED) is an important platform for virtual reality and augmented reality, which has been considered another evolution in the field of display, after film screens and panel displays, and it has attracted a lot of attention. VR display is also called "head-mounted display." The display is mainly made up by the display screen and lenses. The main principle of its operation is that the lenses magnify the image on the screen to a further place and its design parameters include the exit pupil and the eye relief. A larger exit pupil would allow the pupil to move within a more comfortable range, and a longer eye relief would make it more portable and easy for people to wear. A good visual effect also relies on the FOV, the definition, and the imaging performance, therefore, what the NED seeks is long eye relief, large FOV, and high imaging performance.

The structure of occlusive display devices, that is, of VR NED, could be mainly divided into partial occlusion and full occlusion. At present, most displays are applying the full occlusion, such as Oculus, Samsung and HTC; and most displays have their lens systems made up by single-piece lenses at present. The reason why a few VR companies have shut down during the last year, as Professor Yu said earlier, was that they hadn't made good enough display products, it's not just the content.

To reach a better imaging result, 10 years ago, we applied the technology of 6PN lens to the reconstruction of the Old Summer Palace and achieved a great result. Last year, we optimized two pieces of aspheric lenses, and obtained a VR display platform with a large FOV and high definition. The application of it allowed the astronauts of the Shenzhou 11 to communicate with their families across space.

The structure of AR's optical system is more complicated because the optical penetration rule must be obeyed, and accordingly, there are more types of AR NED. Google Glass was the earliest AR NED that had attracted the public's attention. This is a periscopic optical structure. The image gets to people's eyes after three reflections from the imaging source, and people will see the world through half-mirror glasses. Although it has a small volume, it has a relatively small FOV with single-piece lens as optical structure, which leads to drawback to both its definition and FOV.

The second structure is the free-space combiner, which at present, can achieve a relatively large FOV and an NED of low cost when combined with cell phone screens. The famous Meta has applied this type of structure to its product. However, this structure has a weakness: the large volume makes it heavy.

The Freeform TIR Prism has three freeform surfaces that are not in symmetry from all directions; with the introduction of degrees of freedom, it would contribute to a more portable NED with a larger FOV.

In fact, our team has done research in this field for nearly ten years, and has obtained many national and international patents. The last picture might look dark, but its practical effect has been superior to the effects that some academic articles had publicized. And our design has achieved production from Beijing NED+ Display Technology CO., Ltd, and some of our optical performance tests have been superior to competing products. The display module of our design also has been applied to many AR NED products, such as the products of Lenovo, Seengene, and more.

Although the freeform TIR Prism has a small volume and optimization applied, people might still not be satisfied with its volume, while the thickness of the freeform surface is about 10mm. To further reduce the volume and thickness of the system, the light guide has also been introduced into NED designs. Through the totaling of internal reflections of light, the light guide technique increases the optical length and reduces the optical thickness. For the kind of AR NED with light guide, light travels into the light guide and transmits it inside.

According to the coupling-out ends, this structure could be divided into 4 types. Products such as EPSON BT-300, uses the reflection of the freeform surfaces for the coupling-out; and the products of the Optinvent ORA, use their initiative prism surfaces for the coupling-out, which makes a larger exit pupil. The Lumus, which has done a relatively good job in this field, initiated the multi-reflection method, and achieved great results when optimized on industrial and stray light emission. Diffractive optical surfaces have also been introduced to the design of

many NED products, and different techniques have been used. Products like the Hololens and Sony, have adopted the holographic exposure to conduct diffraction.

Above said is the classification of the NED, through which I'd like to introduce their present state. As for what the future development of the NED will be like, from my perspective, some hot topics of academic research might represent its future direction. Therefore, for the rest of my speech, I'd like to talk about three hot topics of academic research, which are compact NED; NED with large FOV; and natural view NED systems.

When it comes to the compact NED, they are expected to be as light as if they were not being worn. The expectation is indeed our ideal goal. To reach it, a lot of scholars have made great efforts, and our team has adopted the light guide techniques on the basis of developments of the freeform surface, all in the hope of lowering the thickness of NED lenses. This is done by using the light guide techniques with increased optimized parameters through the freeform prism in order to have the FOV enlarged and the weight reduced. We've set up a model machine under this theory with the stray light emission of its system optimized, and have achieved a favorable imaging effect.

During our research, we've also noticed that those who have nearsightedness or farsightedness have to wear their corrective lenses before applying NED eyepieces. This makes the NED thick and difficult to wear. To solve this problem, we've brought up an NED combining optical eyepiece for freeform surfaces and corrective lens. With the integration of two kinds of lenses, the NED has been more compact and portable.

A better idea that combines NED with contact lenses has been initiated by the Innovega Company, which would add the micro lens to the contact lens, imaging the object on the screen to a farther place. Additionally, coating would be applied to the lens except the area that the micro lens occupies, so that some screen displays would not enter the eyes while objects from the outside world could enter from this area. This kind of NED system would be more compact, but its productivity possibilities and physiological applications are still under evaluation. And I sincerely wish this product's success in the future.

The second hot topic is how to achieve a large FOV with a high definition. The resolution of VR and AR NED screens is fixed, so the angular resolution would reduce with an increase of FOV, which is academically called the Resolution/FOV invariant.

Besides increasing the screen resolution, scholars have come up with other solutions to solve this invariant, although most of them are too heavy to be introduced to industrialization. And we have done our research on some optical tiling methods, through which two pieces

of optical structure have their optical channels tiled together to achieve a higher resolution. A larger FOV would form with the resolution of each channel assured, while the angular resolution would be kept relatively high in the same channel.

During our research on this topic, we'd also analyzed some shortcomings of traditional optical tiling methods, and found there existed visible seams, bulky structures, and the incapability of optical see-through. To solve these problems, we've initiated a new freeform optical tiling method, which would apply optical integrated injection molding and can make the most of the flexibility of freeform surfaces. Through the optical injection molding process, this prism has been made with good potential tiling effect. We have also done our research on some freeform optical tiling methods, by which we hope to pursue a larger FOV and a better occlusive experience.

Natural viewing NED systems are another important research orientation in both the academic and industrial community. Let me put it this way. When we observe the natural space, you would have binocular parallax, and as what Professor Yu mentioned earlier, there would also have a monocular focalizing result for each eye, which is to say that when you are observing the true world, each eye of yours would make accommodation to focalize the objects that you're looking at, and at the same time its convergence is focalized onto this same surface owing to the binocular parallax. However, the present commercial NED only has one display surface, where monocular accommodation is focalized, but convergence is made separately from this surface in a special way that uses binocular parallax to create a 3D visual experience. The mismatch between accommodation and convergence is the main reason for visual fatigue that we feel when we are uncomfortable wearing VR or AR NEDs for a long time.

Many methods have been designed to resolve or relieve this mismatch, and here I'd like to introduce some typical ones. As we already know, there is only one surface set up in the traditional NED. It's easy to think that we should set up more surfaces in front of the eyes, to solve this mismatch. Like Professor Hua of Alexander University and his team, they've inserted liquid lenses into NEDs, and the focus distance of liquid lenses could be changed by adjusting their voltage. In this way, NED would have multiple imaging layers and the mismatch between accommodation and convergence would be reduced.

The method of our team is to use two pieces of optical lenses; the gluing process is applied, and a half-mirror optical coating is used on the gluing area. Through this kind of NED, the viewer could see two screens in different depths, but at one time. A multi-depth reconstruction is achieved and a favorable image is obtained. The display technique of light

field is involved here.

Light field is an important means to describe the light of objects from every direction. We could know its depth if we input the light field of the object that we're trying to present. According to this concept, the Stanford Wetzstein Team have brought up a multi-layer NED method, which builds a dense light field into one's eye by computer optimization and the usage of pixels on multi-layer screens. Owing to its complex algorithm, the real-time rendering cannot be conducted.

While, Dr. Lanman from NVIDIA has used a traditional method, which is integral imaging, to build a dense light field into each eye. He therefore made sure that every light of the light field is in correspondence, one-to-one, with the pixels. What's more, the GPU technology that they have applied to help realize real-time rendering of the light field is sufficient. As one of the teams who brought up light field methods at one of the earliest times as a way to resolve the mismatch between accommodation and convergence, we have applied the micro structure array and the magnifying function of optical lenses to achieve a see-through light field display with a large FOV. Here, this is our experimental system. From the shooting, at the position of exit pupil, we can see fields of depth on the near field and the far field.

Well, I'd like to make my conclusion here. I talked about three orientations—compact NED, high definition NED with large FOV, and natural viewing NED, which are being researched and discussed in academic fields. But at present, there is still no method to meet the higher pursuit of the industrial field or the higher requirements of potential customers. A long road lies ahead. I hope that, soon, a compact, adaptable NED can be introduced to the public, offering high immersion and natural viewing.

Thanks!

Dip Transform for 3D Shape Reconstruction

◎ Kfir Aberman and Oren Katzir

I am Kfir, and this is Oren. We are both Israeli researchers who represent the Advanced Innovation Center for Future Visual Entertainment. I will talk about the relationship between scanning of 3D objects and water via what we call the "dip transform." But before I start, I want to give you some introduction about our team. Our aim is to bring new technologies into the Chinese film industry. This team is led by Chen Baoquan, the Chief Scientist of the center; and we have some full time researchers like us, such as the talented Wang Bin, and also some part-time researchers, international collaborators, some visiting professors and intern students.

Our main goal is to make research on shape acquisition, scene acquisition, and processing or everything that is related to the capturing of the reality. Our story begins a year ago in XISHUANBANNA, a very beautiful place in south China. We were in a Chinese-Israeli conference and on our way back to the hotel we saw this nice sculpture of three standing elephants, and we wonder how a regular optical scanner would be able to reconstruct this shape. As you can imagine, this shape has many hidden parts, which means that we have no line-of-sight between the optical scanner and the surface of the object. And this is one of the requirement of conventional optical scanners.

This is an example for how conventional optical 3D scanners are used today. We can use an array of cameras, however, as I said, the reconstruction points of the point cloud should be all accessible to the sensor. For example, in the reconstruction of the fertility statue we have many, many missing parts due to the fact that there is no line-of-sight between the sensor and the object itself. Let's take it one

Kfir Aberman and Oren Katzir on ICEVE

(a) (b)

Regular optical scanner cannot reconstruct these models

step further, and talk about optical scanners. If we scan a transparent object, we know that there is a limited scanning ability because of the glossy and transparent materials. In addition, we can move out of the optical scanning and make use of techniques like computed tomography, or CT. But actually, these machines are huge, very expansive, and produce radiation. So, it doesn't work for daily usage, especially in the film industry. So let's be inspired by a famous Chinese movie scene and speak about water.

> *"So empty your mind. Be formless, shapeless, like water. Now you put water in a cup, it becomes the cup, you put water in a bottle it becomes the bottle, you put water in a tea cup, it becomes the tea cup. Now water can flow or it can crash. Be water my friend."*
>
> —Bruce Lee

So be water my friends, and as Bruce Lee said, water can adapt its shape into the device that holds it. So it might be kind of a good idea to use water in order to scan and to reach the inaccessible parts. But, as a sensor? What actually can we measure with water and how can we do it in practice?

So I want to take you back two thousand years ago, when Archimedes shouted in his bath "Eureka!" which means that he discovered that the volume of his submerged body is equal to the volume of the overflowed water. This discovery means that we can partially dip an object in water, and measure the volume of slices along a specific direction, and this is the main postulation of our work. Can we reconstruct 3D geometry, using volumetric measurements? So let's try to achieve some intuition regarding this interesting problem and let's imagine that we have this two-dimensional elephant and we rotated it, and dip it, in a specific direction into a bath. We can measure the volume of the water as a function of time, right? Because if we dip the elephant at a specific direction in the water it will be elevated. But what can we say about this signal? So if we look at the derivative of the signal, which means that we look at small changes between consecutive samples, we can get something. In our first trial we could see a shape form, the 4 legs of the elephant. We can see some evidence for his four legs and maybe if we do something more sophisticated, we can extract the geometry, using the collection of these dipping signals.

Fig. 1. 3D scanning using a dip scanner. The object is dipped using a robot arm in a bath of water (left), acquiring a dip transform. The quality of the reconstruction is improving as the number of dipping orientations is increased (from left to right).

Using dipping signals to see a shape

I think maybe it is pretty clear and intuitive that using just one signal, we cannot reconstruct the object, because many objects will share the same dipping profile. However, if we multi-dip it, we opt that we will be able to construct an object. We wish to express this one dimensional signal, as a collection, in a 2D heat map, where the horizontal axis represents the angular axis, meaning the dipping

2D heat map of objects

orientation; and the vertical one represents the time. So the point on the heat map represents the dipping amplitude in a specific dipping orientation and a specific time.

So here is an example for 3 objects and their 2D sinogram. So we see the collation between them is pretty clear. So basically our goal is to go from the second row to the first row. We are giving the dipping measurements, and we want to reconstruct the object. How can we do it? We need to first have some kind of a model for a dipping process.

So a simple method model for a dipping process can be something like this: you take an object, you rotate it in a specific orientation, and then you measure the volumes of slices in the object. So now we have a mathematical model that represents the object, it has established a connection between an object and the dipping measurement; but we said we are going to do multi dipping, right? So now we look for an object, which is the most consistent with all of the dipping measurements. We have a lot of dipping measurements and we want the object that is most consistent with them. This leads to the following energy minimization problem.

But wait a second, we have a huge challenge. Practically, we cannot dip too much. We are limited by the amount of dipping measurements that we have, therefore we need to find some harder solution. This limitation on the number of dipping measurements will lead to ambiguity. Many solutions will have the same dipping measurements and we need to select one of them. For this, we need an algorithm that will assist to select one of these objects.

Another challenge that we might face is that if we try to directly solve the previous problem, we see that the solution becomes computationally very, very heavy. Therefore, we need to do something better. Which is to utilize the structure of our matrices, which are sparse.

I think it's interesting to take a look at the error of reconstruction as the number of dipping increases. As we increase the number of dipping, the reconstruction errors become lower and lower, but we see even for a relatively low amount of dipping measurements, we get pretty much a low error. We can also visualize it as the number of dipping increases, the object will be reconstructed.

So now, after we have an algorithm, we want to validate the algorithm. What we do, we build a dipping simulator, meaning that with the given object, we visually dipped it, so we have a visual measurement and now we try to reconstruct the object. So we took an object whose resolution was 240 cubed, and with only 10% of the required angels, meaning a very low amount of angels, and then we try to reconstruct the object.

The more dipping, the more details

So notice, on the left, we have the original object, on the middle we have the reconstructed one, and on the right you see the error. There are no missing parts in the reconstructed object, and after we found that object, it was voxelized, and has some noise in them, so we meshed them and smoothed them; and again, we see the effect is the number of dipping increases, more and more details in the object are reconstructed.

We then built a robot that was constructed from a simple water tank and an existing robot arm. The goal of this robot was to dip the same object in various orientations as we say it. Let's think about some practical issues. I will not take you into all the details of this work, but I guess that you can imagine, that if we try to build a real system that will perform, that imitates the simulated process, we might encounter many practical problems. And I think that the main problem was the noise. Noise can exist due to many reasons, but in this water case the main noise source is the small ripples that exists on the water's surface. So actually, when we dip the object, and we want to measure the water, after every step, we have to wait for a while. Actually, for something as short as two seconds, we are required to wait for the water to be stable. Even after we waited it is very noisy, so we had to smooth this signal using some Gaussian kernel, and some other techniques, so in fact the resolution was degraded when we used this in practice.

But despite the noise, I want to present you some of our results. So as you can see the right column represents the result of our dipping robot, in the middle column we see the results of a conventional optical scanner, and in the left column you see the printed object that we actually dipped in the water. There are many occluded parts which exists, as I mentioned before, due to the lack of the line-of-sight. However, we have the entire object. We can claim that the resolution is not as good, but the object is more complete, more than the scanning of conventional optical scanners.

So I will say, in short, some of our current limitations. As I said, we have the problem of the noise with the water. In addition, there is something that is called caps. Caps are defined as small cavities that lay on the object's surface. You can imagine it as a cap, and if we dip a cup in a specific direction in the water, we will have an air pocket there . This air-pocket will not fit the real object, and this dipping orientation will be considered as an outlier. So currently we don't support complex objects that have these caps. In addition, as I said, due to the fact that we have to wait between consecutive dippings, the entire system is pretty slow, and the acquisition time can even take a few hours for a single object.

I will summarize this talk with the key idea of this work. We used liquid as a sensor. We reconstructed hidden and occluded parts, and even overcome optical scanning limitation. But I think that the main contribution of this work is that it paves the way to a new world of non-optical scanning and I guess that you can be inspired and imagine what we can do with other kinds of materials or liquids and even gas, in order to overcome the existing limitations of scanners. Thank you all very much.

Robot arm used to dip

Our results and optical scanner results

基于浸入变换的三维重建

▶ Kfir Aberman and Oren Katzir

我是 Kfir，这位是 Oren，我们来自以色列，是未来影像高精尖创新中心的研究员。今天我演讲的主题是通过"浸入转换"的方法研究 3D 物体表面重建和水的关系。正式开始之前，我想给大家介绍一下我们的团队。我们团队的目标在于将最先进的技术带进中国电影产业。团队负责人是我们创新中心的首席科学家陈宝权，团队里既有和我们一样的全职研究员，比如研究员王滨，也有兼职研究员、国际合作伙伴、访问教授和实习生等。

我们的主要研究领域包括表面形状获取、场景获取、加工处理等任何与现实捕捉相关的研究。故事开始于中国南方一个美丽的地方——西双版纳。当时，我们在西双版纳参加一个中以会议。在回酒店的路上，我们看到了一个精致的雕塑，雕刻的是三只站着的大象。我们很好奇，常用的光学扫描仪是怎么才能把这样一个三维物体重建出来的呢？大家可以想象得到，这种三位物体表面有很多隐藏的部位，也就是说有光学扫描仪检测不到的地方。这也就是说传统光学扫描设备无法完成扫描任务。

如今我们是如何使用传统光学 3D 扫描仪的呢？举个例子，我们可以用好几台相机，但是，正如我之前说过的，要确保传感器能够感应到点云数据的所有重建点。比如在对这座雕塑进行重建的时候，我们丢失了部分数据，因为传感器在检测物体的时候视线受到了阻挡。另外，我们知道扫描一个透明物体时，由于物体的光泽性和透明性，其扫描能力是有限的。我们也可以不用光学扫描，而是使用其他方法，比如说计算机断层扫描，简称 CT。但是，这些设备体形大，费用高，还会产生辐射，不适合每天使用，尤其是在电影产业。接下来让我们把目光转向一部知名中国影片，来讲讲以水为媒介的 3D 重建。

"清空思想，无态无形，像水一般。水入杯中，水便成杯。水入瓶中，水便成瓶。水入壶中，水便成壶。水能奔流，亦能冲击。成为水吧，我的朋友。"

——李小龙

成为水吧，我的朋友。正如李小龙所说，水可以改变形状，适应承载它的容器。这也就是说，我们用水来扫描物体，扫描那些难以到达的部分。问题是如何把水变成我们的传感器？用水到底可以测量出哪些方面，实际操作中又该怎么做呢？

让我们回顾一下2 000年之前发生的事吧。那天，阿基米德在他的浴缸中欢呼道："我找到了！"他发现自己水下的身体体积相当于溢出来的水的体积。这一发现表明，我们可以把一个物体部分浸入水中，测量它特定方向部位的体积，这就是我们的主要假设。是否可以用这种体积测量法重建3D几何？我们来想象一下这个有趣的问题。假设有一头二维的大象，使之旋转，以特定方位将其浸入浴缸，这样就可以通过一个时间函数得到水的体积了。没错吧？因为如果我们以特定方位将大象浸入水中，水面就会上升。那么它给了我们什么信息呢？如果利用这些信息，也就是以各种方位将大象浸入水中之后出现的细微变化，我们就能得到一些有用的数据。第一次尝试，我们可以看到一个形状，4只象腿的形状。我们可以根据一些证据描绘出4只象腿的形状，如果再复杂一点，就能通过搜集各种信息勾勒出整个几何形状。

很明显，一条信息不足以重建整个物体的形状，因为很多物体浸到水中会有相同的数据。但是用大量的浸入数据能够构建出准确的物体形状。我们将这一条单维度的信息呈现在2D热图上，横轴代表角轴，也就是沉浸的方位，纵轴代表时间，即热图上的某一点代表在某个特定时间以某个特定方位将物体浸入水中时的水面变化幅度。

我们以三个物体和它们的2D正弦图为例，可以看到它们的排序规则很清楚。基本上我们的目标是将第二行拖到第一行。我们要用浸水式测量法来重建物体。具体怎么做呢？首先我们得建立一个浸水过程的模型。

一个简单的浸水过程模型是这样的：拿起某个物体，朝不同的方位旋转，对其体积进行测量。这样我们就有了一个数学模型，建立起物体和浸水式测量数据之间的联系。但是我们说过，物体要入好几次水。所以我们要找的是和浸水式测量数据最匹配的物体。得到很多浸水式测量数据后，我们想要找到与之最匹配的物体，就会遇到能量最小化问题。

我们还面临着一个巨大的挑战。在实际操作中，我们不能让物体入水太多次。在浸水式测量数据的数量上会有一定的限制，我们需要找到一些含更多钙和镁盐的溶液。浸水式测量数据数量受限，会导致不明确的结果。也就是说，这么多溶液会产生相同的浸水式测量数据，我们得选取其中一个。因此我们需要算法来帮助做出选择。

还有一个可能会面临的挑战是，如果我们试图直接解决前面提到的问题，就

会发现从计算的角度来看计算量太大了。因此我们得想出更理想的方式,这个方法就是利用稀疏的矩阵结构。

观察重建误差随着入水次数增加所发生的变化是一件很有意思的事情。入水次数越多,重建误差也越来越小。可以想象得到,随着入水次数增加,物体就能实现重建。

建立好算法后,就需要验证一下。我们做一个浸水模拟装置,也就是说在视觉上把特定的物体浸到水中,得到视觉数据,然后开始试图重建物体。这个物体体积测量的结果是240,我们只用了10%的角度方位,也就是很少量的角度数据,在此基础上我们试图对其进行重建。

请大家注意,左边是初始物体,中间是重建结果,右边是误差。从中可以看到,重建结果中没有缺失的部位。我们将其网格化之后,这里有一些噪声。将其进行网格处理和平滑处理后,可以得出这么一个结论:入水次数越多,重建出的物体会有更多细节。

之后我们简单构建出了一个机器人、一只机械臂以及用于重建的水池。机器人的作用是从不同的方位将同一个物体沉浸到水中。举几个实例,我不会展开所有细节。但是我想大家应该想象得到,建立真正可以运行的、可以模拟的系统时,可能会遇到很多操作问题。我认为最主要的问题是干扰。基于种种原因,干扰会存在。但是在这种情况下,干扰的主要来源便是水面的波纹。所以在实际操作中,将物体浸到水里之后,如果想要测量水的体积,则需要等待一段时间,一般是2秒钟左右,等到水面平静下来。就算等了一段时间,还是会有很多干扰,所以我们得用高斯核函数以及其他一些方法对这些信息做平滑处理。在实际操作中如果这样做的话,清晰度会受损。

虽说有干扰,我还是想给大家看看我们的一些研究成果。大家可以看到右栏呈现的是我们通过机器人得到的结果,中间栏是通过传统光学扫描仪得到的结果,左栏看到的是我们浸到水里的那个物体。正如我之前提到的,由于光线无法到达,这个物体有很多闭塞部位。在我们的方法中,我们扫描出了整个物体。尽管清晰度不是很高,但是它的完整性已经超过了传统光学扫描仪所能达到的程度。

接下来简单说一下我们目前的局限性。比如,我提到过用水进行扫描带来的干扰问题。另外,还有一种叫作帽儿(cap)的东西。帽儿指的是物体表面的小孔,他们就是帽儿。比如说,我们以某个特定方位将杯子浸到水里时,就会看到一个气窝。气窝无法和真实物体实现匹配,这个入水方位就不会被计算在内。所以说,目前,我们无法扫描这种有帽儿的东西。还有,我说过,由于物体每次入水我们都得等一会儿,这就使整个系统操作起来速度很慢,获取一个物体的形状可能会

需要好几个小时。

简而言之，我们研究工作的主要贡献就是，将液体作为传感器，对物体隐藏部位和闭塞部位进行重建，打破传统光学扫描的限制。但是我认为，这项工作最大的贡献在于为全新的非光学扫描技术铺平了道路。我相信你们会受到一定的启发，说不定我们可以利用其他材料、液体甚至气体，来打破目前扫描仪的限制。

谢谢大家！

Attempts for Life and Visual Expression Devices

◎ Toyomi Hoshina

I'm going to talk about the expression of art and science. I won't talk much about technique. I'm going to introduce a very experimental story about art and science from the Tokyo University of the Arts where we held four types of experiments.

First of all, our main concern is the extension of the art of light: both art expression and energy expression, and the works that use this as their theme. Second is the biophoton, and its fusion with art. The third one is a negative one, the artworks about fusion energy; and the very important one is local places: using local places to create media art which combines science and art. These forms of art and science are what I'm going to explain.

Humans always used light as a theme. We can see from it the thoughts that people express in art and science throughout history. In a work of Rembrandts, we can see the light is invisible. Humans think it belongs to a supreme world, and adopt this idea to art expression. Even in an invisible world, there is light. Actually it's hidden.

In the field of art, people think of light as a very supreme existence, like god. It can represent our soul. People even express it as something beyond human. Take the work of Friedrich, a romanticist artist, as an example, it shows something that people are eager for, the longing of a mysterious world.

Or the work of Turner. Turner also deals with light. He travels between the ambivalent world of reality and image, and he immerses himself into it to seize the light.

Before modern science began, Monet had been called the painter of light. At that period, technology represented modernization. It

Toyomi Hoshina on ICEVE

developed as the world advanced into modernization.

To be an artist, one had to present the world of dark and light. Also, he needed to find the light in the dark. This gave birth to a scientific way of painting, thus, the light plays a very important role in the development of science and art. As for now, technology has developed, visible and invisible, therefore we need to figure out how to make the invisible visible like in the painting where that was achieved. But in the reality, in the film, how can we do this? How to present it? We now have these questions.Let's review the evolution of humans.

Modern science gave birth to technology. The technology of art and science concerns how to capture light. Talking about capturing the light, we may think of the shining sun. Why does the sun shine? Because it has fusion energy. Fusion energy is a kind of energy that we recently obtained. After we got this energy, we faced a question of how to present, in another word, how to use it. Some use it peacefully, while some made mistakes and used it in an awful way. While using this technology, the power of art plays a very important role. In the art experiment,technology can be a way of expression, a way of artistic expression. It can lead science and art advancement towards a good goal.

I'm going to introduce an experiment about how technology serves humans. In this experiment, location or placement are an important factor. In this case, the experiment doesn't use an art space, instead, it uses a farm. This experiment takes place in a greenhouse on a real farm. It's a media art work, so this greenhouse is for growing vegetables and in the middle of it, there are some points, these are experimental marks, where normally, there would be farming, but now it becomes an art place, a stage of media art.

Why choose this place? Because there are indispensable parts in it. They are vegetables and plants. Seedlings were used in this experiment. The seedling have roots and though they are small, they contain biophotons, a kind of luminous energy that humans can't see. Actually, every living thing has this luminous energy, but it's too small to be detected by our eyes.

Turning this energy to something visible is a piece of art. Therefore, this place is necessary because there are plants. In a tent, at night (this work was done at night) we can see some small lights in the tent. These

The experiment takes place in a greenhouse

are invisible lights from the roots of plants. This work marks them visible while in the tent. Right here, in a tent, the living plants produce luminous energy and we present it and by doing so we can know if the plants are healthy; if they have energy, or maybe they are so sad that they can't produce energy, they have become weaker.

Living things produce invisible, tiny biophotons. This work was done by using the super kamiokande. This is invented by a Japanese doctor who since earned a Nobel Science Prize. There are light particles falling towards Earth and this device can make them visible.

Light particles plunge into water at an extremely fast speed. The device can detect the light when the light particles crush together with water particles. Our experiment also used this device to make light particles visible. Talking about light particles, the light we see actually is a wave, and light particles are actually round grains. Because they are round grains, when they crush, they can be detected.

It comes as a kind of pulse. Pulse particles can be detected, but this must be done with another device. We installed one such device in a dark room because it's

Our experiment work（1）

Our experiment work（2）

Our experiment work（3）

an amplification device. Though particles are not visible, we installed this device to make them visible, and that way we can detect light. We can see the life light of living plants. When people come close, and touch it with their hand, it will make some change to it. We have made a device like this.

We also made a dome like the starry sky. This is very beautiful. We used a reflecting board, and amplified it with a lens to do so.

What is biophoton really? Plants can produce very weak light. It is so weak that we can't see it.

This work uses the same technique as the super Kamiokande, it captures light at the level of a particle and then we have a signal, and we can see it. This is the world of particle. There are flowers, and other kinds of lovely plants. They shine with their own light. They produce light and we amplified that light. In order to make such invisible light visible, in a way that is an artistic expression, this place is necessary and this indicates a technique that can form the image of a vivid reality.

Nuclear explosion

Nowadays, the artificial intelligence, AI, is developing very quickly. This is dangerous, or in other words, people hold questions about this. The point is our physical sensation. AI makes the space and our feelings about the real place fade away. That means our creative ability can be weakened because of it. So how to find a balance in the artistic expression, and revive our creative ability? That's what we need to consider.

The movie *Black Rain*

Here is another case, a negative one. This light is produced by the fusion energy which we talked about. It also makes a shadow. Where there is light, there is shadow. We have light here, so there is shadow beneath me. The focus here is at the shadow. It developed towards a direction that people don't want to see, because this is a shadow caused by a nuclear explosion.

This explosion is the first nuclear explosion released in human history. Its radiation ascended 2,000m and the image of this explosion is terrifying, as we can see in the movie *Black Rain*, made by a Japanese director.

Another artist also did a similar experiment. Ando, who is a lecturer at our university, has worked with JAXA and accomplished an amazing experiment. From the 2nd of Februarty till the 10th, EPO (Education Payload Observation) was operational. The theme of which is "admire the earth." Ando played a leading role in developing many kinds of experiments with ISS, not only science, but also art.

Japan is the only country who does artistic experiments in ISS. This is the 18th experiment to be carried out by the EPO. The experiment was operated by a Canadian astronaut and the ground operation room was in the Tsukuba center. The Japanese experiment module (KIBO) operated the experiment as the ground demanded it. This entailed spraying water and taking photos where all kinds of movements occurred.

Artistic experiments in ISS

The experiment took pictures of Earth that can only be seen in micro-gravity circumstances. This could be very usual here, and it is for sure very beautiful. This kind of experiment is only done by Japan, where expressing scientific technology by using artistic methods is encouraged, and this is an experiment that studies how to combine art with science, and how to use them in the development of space.

In another example done in space, out of a spacecraft where many lenses are installed, we amplify the lenses and then we fix them to prevent them from dispersing, and we use them to reflect light. Although artists want to try this, it's hard to say if it's art, but that should be justified by later generations. The combination of artists and ISS, can be an example for humanity. It is a fun and a happy example. This also concerns place. Here, the place is not

Our experiment work（4）

Our experiment work（5）

on Earth. We have to think about what we can express in the universe. I think it will become a kind of site-specific art that concerns the universe a lot.

At last, one more case, this is a biophoton experiment. It was done during the same period as the others, but on the side. There is a device, a simple one, because we made it portable. This time, we are going to change the biophoton to wind energy, not to luminous energy. It can detect the energy that plants produce and it produces wind. When the energy is strong, it will make noise like papapapa. When the energy is weak, let's say at dusk, the wind becomes weak too; but in the daytime, in the morning, it acts fierce, and the wind is strong. This device can show the activity of wind on the screen. By placing this light in the amplification device, the light becomes the wind.

This is a simple device, as an art expression, it's still a test. If we apply it on a bigger scale, and use a bigger device, I think later we can create a nice work. We are doing many experiments like this. It's done by Tokyo University of the Arts, and Tokyo Institute of Technology with the support of the State.

Besides this work, there are films made by using advanced computer and technology. One example is a video project we are making. Imagine in the sky, there is an island that looks like a spacecraft. It's made up by many materials, and it can revolve. How? What makes it

revolve? There is a village, and in the village there are all kinds of things that will be thrown away. All are the remains of the past. With the development of technology and urbanization, old things will be abandoned, but they contain our memories. Among them is the history of my father, my grand-father, and grand-grand-father, the memories of them. These will disappear when high buildings are built up.

Our experiment work（6）

This is the theme of this work. The artist tries to keep these memories. He puts them into a media art work like this. Society, art, media: these three combine, and the art expression, film expression, in human history and how that film should play its role, how it can contribute to our society, these will be the main subject.

In the front, there is a shadow of a kid. A sensor can move the image on the screen as the kid looks away. If he gets closer, it will amplify. If he sits, all the memories will come close to him. This is how it works by using this new technology, and it's an 8K film.

We can join many technologies into the works which use place as one of its parts. We also welcome the usage of old machines in the art expression. We have used machines as motivating power. This is where the idea for a current installation art piece comes from. It is like a toy, maybe we can't say it's a technology. It's a toy made from a sort of motive machine. Like these, Tokyo University of the Arts is doing various experiments.

对生命与视觉表现装置的尝试

▶▶ Toyomi Hoshina

今天要说的是从艺术角度来考虑艺术和科学的表现，不太涉及技术方面。下面我讲一下我们东京艺术大学进行的、十分具有实验性的艺术和科学的故事吧。我将给大家介绍四方面的例子。

第一，最中心的话题是视界艺术和能量艺术在艺术层面的扩张和以此为主题的作品；第二，生物光子和艺术融合的艺术表现；第三，比较负面，是以聚变能和艺术的关系为主题的作品；第四，是十分重要的一点，即地域，是指直接使用场所创造出的科学与艺术结合的新媒体艺术。我想就这几个方面展开演讲。

人类经常以光为主题，我们可以从中看出从古至今人们在艺术表现或科学表现中融入的思想。这是伦勃朗的作品，像这里展示的一样，光是看不见的东西。人类认为这是属于崇高世界的东西，所以在艺术表现中融入了这一思想。在看不见的世界里有光，它实际上是隐藏的。

在艺术表现中人们认为光像神一般十分崇高，尤其是可以代表人的灵魂。人们甚至把它当作存在于人类之上的崇高之物来表现。这是浪漫派画家弗雷德里希的作品，这里画是人们十分向往、憧憬的东西，或者说神秘世界。他一直在画这样的东西。

这是特纳的作品，特纳也在画光。他在暧昧的现实世界和印象世界的来回运动中，投身其空间中去捕捉光。

近代科学兴起之前，莫奈被称为光之画家，在这个时代，科技最能代表近代化，在近代化不断前进的同时，科技也在发展。

作为艺术家，他们不仅要捕捉光明和黑暗的世界，还要捕捉黑暗中的光明，这就催生了科学的绘画法。因此光在科学和艺术进化的过程中有着重要的意义。那么到了现代，科技发展了，无论是看得见的还是看不见的，我们要考虑的是如何将看不见的东西变成可见的。虽然在绘画中实现了这一点，但在现实中，在影像中如何去实现？如何来表现？我们会面临这些问题。在这里，我想介绍几个现在进行的实验。在介绍之前，我们先来回顾一下人类的进化。

近代科学催生了科技，艺术和科学的科技。它触及的是捕捉光的问题。说起捕捉光，大家可能会想到太阳是发光的。太阳为什么发光？因为它有聚变能，近代人们获得了聚变能这种能量。人们在获得聚变能后的问题就是如何表现，其实

也就是说怎么用的问题。有人以和平的方式使用，也有人走上歧途，用不好的方法使用。那么我想说的是，在如何使用科技这个问题上，艺术的力量是很必要的。在实验层面上，科技作为一种表现手段，作为艺术的创造性表现手段，可以引导科学和艺术往一个美好的方向发展。

接下来要给大家介绍的就是一个科技为人服务的实验例子。这个实验中场所是非常重要的一个因素。这个实验使用的场所不是什么艺术场所，而是一个农场。这是在一个真实的农场大棚中进行的实验作品，是新媒体艺术。这是一个种各种蔬菜的大棚，中间有一些点，那是我们安放的实验标记，这个场所一般是用来种菜的。而现在成了艺术，新媒体艺术的表现场所。

为什么要使用这个场所呢？这是因为这里有该实验不可或缺的东西，就是蔬菜、植物。蔬菜的小苗，实际上我们要用的是这个，小菜苗有根。虽然是很小的菜苗，但它含有生物光子，这是一种能发光的能量。这种东西人是看不见的，所有生命体其实都有这种发光的能量。只不过这些能量都非常小，所以人眼看不见。

把这种能量变成人眼可见的东西，并且变成艺术作品，这就是一个例子。因此这个场所是必要的，这里有植物。在这个大棚里，这个作品是在晚上完成的。大棚里可以看见一点一点的光，这是从植物的根部发出的微小的不可见光，该作品把这些能量在大棚里标记了出来。这就是——在这里，在这个场所，活着的植物的光能，它们散发出来的光能。我们把这些光相应地表现了出来，这样一来我们就会知道这些植物健不健康，是否具有能量，或者是悲伤到发不出能量，渐渐衰弱。

生命体在散发的是肉眼不可识别的极其细微的生物光子。这个作品使用了神冈宇宙射线检测装置，这是日本获得了诺贝尔科学奖的博士研发的。能够使落向地球的光粒子变得肉眼可见的装置实际上是存在的。

光粒子以一种猛烈的速度冲进水中，该装置就在这一瞬间捕捉光粒子和水粒子冲撞时发出的光。我们的这个实验就使用了这样一种能使光粒子变得可见的装置。说起光粒子，我们看见的光其实是波。但是光粒子其实是圆形的颗粒，正因为是圆形颗粒，所以碰撞时能被观测到。

光粒子以一种脉冲形式出现，脉冲粒子可被检测到。但必须用另一种装置来做。我们在黑暗的房间里装一个这样的装置——放大装置。粒子虽然不可见，但我们装的这个放大装置让它变得可见，这样我们就可以探测到光。我们可以看到活着的植物的生命之光。人一走近，用手一碰，它就会发生变化，我们做的就是这样一个装置。

做成这样一个像星空一样的穹顶是非常美的，我们使用了反射板，然后用镜头把它放大了。

到底什么是生物光子呢？所谓生物光子就是植物发出来的微弱的光，因为特别特别微弱，所以肉眼是看不见的。

这使用了和神冈宇宙射线检测装置一样的方法，从粒子层面去捕捉这些光，然后就有了信号，就可以看到在屏幕上显示的这样，那粒子的世界就是这样。在这个装置里我们刚才看了里面有花之类的，各种可爱的植物，它们散发着光。我们把这个放大了，把这种不可见光用艺术的表现形式让它变得可见。这必须使用这个场所，这说明了我们有把非常真实的现实影像化的方法。

现在人工智能 AI 发展势头迅猛，但其实很危险，也许不能说危险，但是大家都对它抱有疑问，疑问的点就在于我们的知觉。AI 会让现实的场景、我们对于场所的感觉渐渐消失，也就是说我们的创造能力有因此而被削弱的可能。那么如何在艺术表现中找到平衡，让我们恢复创造能力，这是我们应该考虑的。

还有一个例子，是反面的例子。这个光就是我们刚才说的核聚变产生的，它也产生了阴影。有光就有影，这里有光，所以我的脚下就有影子，影子这里就是焦点。事情往一个人类不希望看到的方向发展了下去，因为这是核爆炸造成的阴影。

这是人类历史上的首次核爆炸，它的辐射向上冲了两千米。这次爆炸的危害，这个电影里反映了。这是一部影视作品，名叫《黑雨》，是一个日本导演的作品。

另一个艺术家也做了同样的实验。安藤是我们东京艺术大学的讲师，他和 JAXA 合作成功完成了一次精彩的实验。在 2 月 2—10 日，EPO（文化人文社会科学用飞船计划）实施，主题是"望地球"。安藤在与国际空间站开发各种各样的实验时起了主导作用，不仅在科学方面，还在艺术方面，都开发了一些实验。

国际空间站中进行艺术领域实验的只有日本，此次是 EPO 的第 18 次实验。实验是由加拿大的航天员操作的，实验在筑波宇宙中心设立了控制室。实验进行得非常顺利，日本空间实验舱"希望"在地面人员的要求下进行了实验。在喷射水的这个实验里边，拍下了这些图像，其中展示了各种各样的运动。

实验拍下了只有在微重力下才能看到的地球的样子，这个可能是这边一般的状况，特别漂亮。宇宙之中非常漂亮，回到这种漂亮的世界之中去，这是只有日本在做的实验。用艺术表现科学技术，这是一个探讨如何将科学和艺术结合，并且跟宇宙开发结合的实验。

另一个实验是在太空的宇宙飞船上做的，这个宇宙飞船外置了许多镜头，我们把那里的镜头再放大，然后把它们固定住，不让它们散开，用它们来反射光。艺术家想要做这样一件艺术品，这是不是艺术精品得让后人来判断，艺术家和科学宇宙空间站相结合，对于人类来说，是快乐的、好玩的艺术表现。这里也关系到场所。不在地球，而是在宇宙中能表现些什么，我认为这会成为一种与宇宙有很大关系的场所特定艺术。

最后再给大家介绍一个例子，这也是使用生物光子的一个实验，是同时进行的，边上有这样一个装置。这个是简单的装置，因为我们把它做成了便携式的，这次不是要把生物光子变成光能，而是变成风能。这个装置能探测到植物释放的能量，能量强的时候它会发出啪啪啪啪的声音；能量弱的时候，比如说到了傍晚，能量就变得很小，风也变小了。到了白天，到了早上，它的活动变得很猛烈，风也很强。这个装置把吹风的影像放到屏幕上来表现。把这个光放到刚才的放大设备里，在里面光能就会变成风能。

这是一个简单的装置。作为艺术表现它还处于试验阶段。如果把它放到更大的一个层面上，用更大的新装置来创作，我认为下一个阶段就能做出非常好的艺术作品，我们在做这样的实验。这是东京艺术大学和东京工业大学在国家支持下共同完成的。我们现在正在进行各种实验，在此过程中就产生了这些作品。

除此之外，当然还有用改进过的电脑和极高的技术做成的3D影像。这个也是一个纯粹的影像作品，这里在空中做了一个像宇宙飞船一样的岛，是用各种素材做成的岛，它会转。这个是地方上的小村庄，村里有各种各样即将被扔掉的东西，都是过去的遗物。随着现代科技和城市化的发展，过去的东西都将被扔掉。而它们其实包含了我们的回忆。其中有我爸爸、我爷爷、我曾爷爷这样好几代积累下来的历史，它们是留在这片土地上的记忆。这些都会随着高楼的崛起而被扔掉，我们的回忆会消失。

这个作品就是以此为主题的，艺术家想方设法把记忆留下来，于是他把它们放进了这样一个新媒体艺术作品中。社会、艺术、媒体这三者为一体，人类历史中的艺术表现、影像表现，以及映像该如何发挥作用、如何给社会做贡献，这些将会成为主题。

它前面有一个影子，是一个孩子。探测器会使影像随着孩子的目光而转动，走近一些就会放大。孩子坐下的话，所有带有回忆的东西都会聚集到他身边，这是使用了这样一种科技的8K影像。

就是这样一个作品，我们可以在这些使用场所而制作的作品中加入很多科技元素，同时它们也欢迎我们把曾经用作动力的机械加到艺术表现中来。像这个有趣的，像玩具一样可以玩的，也算不上是科技吧，就是一种使用动力器械的玩具、这样一个空间艺术作品。诸如此类，东京艺术大学在进行各种各样的实验。

Cutting Edge VR Content in Hollywood

◎ Jake Black

I'm going to talk about my day to day. I live and work in Los Angeles with, you know, the Hollywood Studios, and I create VR experiences based on their films and usually it's in service of promoting them or marketing them, but we are growing fast beyond it.

Some of the work that we are best known for are at Create Advertising. We released an experience for *Spider Man Homecoming* over the summer, and I know that had a Chinese and Mandarin version. I spent many days listening to it, even though I understood none. So we have that on PlayStation and Vive and Rift. Our first experience, that we're best known for, was for the Robert Zemeckis film, *The Walk*, though that was based on the true story of a French acrobat named Philippe Petit, who in 1974 walked on a tight rope between the two towers of the World Trade Center buildings. So in our experience we recreate that in a small way.

Earlier this year we released an experience for *Ghostbusters* called "*Now Hiring*", that was a chapter 1, and Chapter 2 of that should be released in the next month or so.

What I'm going to talk about is just sort of the history of VR content in Hollywood. Where it's at today, and where it's at in the near future. What's being worked on right now, if it's going to be released soon, and where we want it to go. We're going to talk about some ways to get there but also what some of the risks and problems are. And then I'm going to also talk about what we've learned in our experiences. How to design a VR experience to maximize the sense of presence and really try to make it into something that takes advantage of VR as a medium, and is not just a film that is in 360° suddenly.

Hollywood has actually been using VR for a couple of decades. Disney used it with Aladdin at Disney World and some people might remember the old 90's movie *Lawnmower Man*, their perceptions are

Jake Black on ICEVE

Early representations of VR

colored by this still. There were stories that at *Aladdin* they would have to put trashcans next to the headsets because so many people would throw up right away. Whether or not that's true it doesn't really matter. The fact is I know that story and a lot of people do. So when you talk about doing VR today, people still say, "Well, It sounds nice. Aren't I going to get sick?" And that's a pretty big hurdle to come up against. So it's really important to keep that in mind.

 The rebirth of VR in Hollywood is tied to the release of the Oculus Rift headset. That's really the new wave of VR. We really owe a lot to them for doing this, and that's the reason I'm doing what I'm doing right now for a living. Hollywood jumped on it pretty quickly. Paramount did a short experience for Christopher Nolan's movie *Interstellar* where you sit down on a chair and it kind of simulates zero gravity floating through a spaceship.

 Fox has done a bunch, they are actually very active. *The Martian* was the first large experience that was up for sale. So that was about a 7 chapter, 20-30 minute experience that sold for, I believe, 20 dollars, at the beginning.

 Sony, they did the project for the walk with us and *Goosebumps*, which was sort of like you're on a motion chair and you're sitting next to Jack Black and you go through a scene in the movie, sort of like an amusement ride.

 Lion's Gate has also been pretty active, they have been doing work for *The Hunger Games*. I think a lot of what they are doing right now, the current work that's being released, is a little more interactive than the last group, but there's still a lot of 360° video.

 So you'll see Sony Pictures is still very active with an on-site, with a location based experience for *Ghostbusters*, with a company called the Void, and then the *PlayStation* game that we made, and then the *Spiderman* game we made. And that was a free download, that was in service of getting people excited about the movie and jumping into the world with the hope that they'll get people to come see the movie. They're creating an experience for the new *Jumanji* movie coming out, and that will be distributed in fifty different locations via VR X, which is another location based entertainment company.

 Warner Brothers is releasing a lot of 360° video content. They recently released one for *Annabelle and It*, that was a horror movie, and at the end of it, they promised more is coming.

It seems like they are building a larger, more interactive experience than just the 360° video. They've also promised larger experience for *Justice League* and *Aquaman*, and they have a deal with I-Max theaters to put that into location base.

Fox is a very similar situation where they released a 360° video for *Alien Covenant*, called "*In Utero*", where you're inside a person and

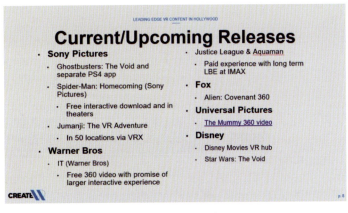

Current/upcoming releases

you're becoming an alien and bursting out of their chest, all from the POV. And then again, they tease, "We are doing more, down the road, just wait."

Universal Pictures has released many 360° videos, including for the Tom Cruise movie *The Mummy*. Usually it's purely a 360° video, again, in service of marketing with that. They haven't really done too many interactive pieces.

Disney is definitely trying a lot of different things. They have an App called the Disney Movies VR Hub, so when you log into it, you'll see the big magic castle, and to the right is the *Star Wars Land*, and to the left is the *Marvel and Avengers Land* and it is sort of a shell for individual pieces of content. And they're also coming out with a location based experience from the Void, for *Star Wars*, and so that is released in the U.S. in January, so that is the same company that put out the *Ghostbuster's*, which is in New York and Dubai right now.

What we can see from that is those are all studio based, but filmmakers are also very interested in VR as a medium. I think it really gives them a new tool that they can use a lot of what they know, but the rules are so different that they have to start from scratch in a lot of ways.

So outside of studio IP, two of the better pieces of content out there right now, are Alejandro Inarritu's *Carne y Arena*, and that's only viewable right now in a museum in Los Angeles. It's a pretty large space, and you walk around it, and it tells the story of something that happens on the border of the United States and Mexico and it's very hard to get tickets for, but it was recently awarded an Academy Award, a special Oscar, that was the first one that the Academy gave out since *Toy Story* came out, more than 20 years ago. They recognized it as a leap in creativity and technology that only this medium can provide. And then, Jon Favraeu, the director of the upcoming *Lion King*, and *The Jungle Book*, for Disney, has a small interactive piece of content called "*Gnomes and Goblins*," which again, is promising to be a part of a larger piece of content when it's ready down the line. And it's really, really well done,

it's about a 5 or 10 minute thing, and it's a room scale experience and it's free, on Steam, if you have a Vive and it's really worth checking out. So these are pieces of content that are really, highly regarded in the VR community, and that are done by traditional filmmakers.

So one of the things that we see across all of these, as trends, is location based entertainment is still hugely important. Pretty much everything I've done has had a component that is location based. There are a lot of promotional 360° videos. They are definitely the easiest to make, and they are also the most disposable and they have the least amount of impact, but it's more of a world that they know, it's more of a YouTube video plus. Most of these are free, there are very few that cost anything. At the location base, they are often paid, but at least for home it's a free kind of thing because most of time these are paid for from marketing money, as a way to get people to see the movie or whatever it might be. That's how they can justify it, because right now nobody is really making a profit. Maybe one or two companies that have the mega hits, but right now, the market isn't big enough to make a profit. So they say, "Here's our content. We know you want it, it's really cool. Here's this free thing, more is coming in the future, you'll have to pay for it though, but we're not going to do it until, you know, we're going to make our money back."

It really is a kind of marketing thing for right now, but all the studios do recognize that it's coming and they want it to be a part of their business. So most of them have a department or vertical to handle immersive technologies. Not just a VR department, but one that can handle VR or AR and whatever else might come. So all of the studios are looking at it very, very seriously, but for the most part they're focusing on larger franchises and I think that's just a sign that again, since you have a pretty small market, you want to attract as many eyeballs as possible, because the difference between a small hit and a big hit can really make all the difference. So if you're trying to get somebody to watch a piece of content, you want to say something like, "Oh, well, here's Spiderman in VR." Not, "Here's this new character you may or may not like and you've never heard of. You know. Go check it out."

Some of the biggest issues: the market size is still pretty small. I don't really deal with mobile VR, but I understand why everybody wants it, it's a lower barrier to entry. But for me, as we're trying to make high quality experience, the best quality experience, we are already at a disadvantage with the hardware we use, so to go to mobile makes it even more difficult. As for the market size for tethered headsets right now, there are no real official numbers, but from what we can tell and guess, we think there are two, to two and a half million, tethered headsets in the wild. So that's your total market size for something like this, at least in the home. And of that, the markets fragmented. You have the 3 major headsets: you have PlayStation, Oculus Rift, and HTC Vive. So when you're creating a piece of content that goes to a small market,

you have to keep your budget relatively tight. But then, when you have 3 different platforms you have to deliver for, and even more stores, your dollars don't go nearly as far. It makes development a little more difficult to reach as many people as you can. So I'm really looking forward to open standards becoming the norm. I know they already exist, multi-platform development isn't too terrible, but I still have to spend a decent amount of my time and attention on switching between platforms.

As I'm sure you've heard, the media hype is gone and it's completely flipped 180 degrees and now people are saying, "Well, is VR dead? What's the point? Was it just a fad?" And I think that's just because a lot of people made a lot of really big predictions about, "The size of the market is going to be a hundred billion dollars by 2020," or something ridiculous like that. And if you ever hear something that sounds too good to be true, it definitely is. So I try to ignore all of that and I try to look at what are the real numbers today. So if we are at two, two and half, million headsets versus 6 months ago, then what will it be in the future? Headsets sales are rising as they get cheaper and content gets better. So those are all signs of health for me, but for tech writers that just want attention on headlines, it's really easy to say, you know, "Oh, VR is done and now AR is the hot new thing." And now all the easy money in venture capitalism is moving to that and you can expect the exact same reaction within a couple of years to what it is now. Where, "Yeah it's cool but it's not really what we want it to be," so it's only going to lead to disappointment.

There's also a big problem where content is not cheap to make. It costs hundreds of thousands of dollars, if not millions, and you know we have some weird competition. I bet every single person in here has a game on their phone that was free or cost one U.S. dollar or the equivalent, very cheap, and they can give you a lot of entertainment through that. Your money goes a long way. But with VR you have to spend a lot more time and attention to make a piece of content that is good, so if you want to then sell a game or whatever you might make and say it's a 10 minute thing, or 20 minute thing, or 30 minute thing, and say you charge twenty dollars, people's expectation of what 20 dollars gets them for a game, is very, very, very high. So there can be a backlash if you put out a piece of content for VR that is a little on the shorter side or might not have good replayability and they have to spend money for it. That's a difficult cultural perception to work against. As more and more headsets come out, the return will become greater and that will be a little easier, but today that's still a problem.

The hardware is still an issue. I know they've done a lot of work, on making things more comfortable, and smaller, and looking cooler, but it's not enough. I have a personal kind of thing in the back of my head, always, whether it's the content I create or the hardware I test, it's called the "parent test." Would my parents be able to use this hardware, would they want it,

would they be able to figure it out? And with the case of VR right now, absolutely not. If I gave my parents an HTC Vive, and told them to "Have fun," they wouldn't know where to start. Whether it's, "How do I figure out if I have a good enough video card, where do I set up the base stations. I have to move my living room all over the place?" It just is not there. And people also still feel kind of dumb with the big headset on them, even though they are getting smaller. So it's really not going to take off and become the big mainstream thing, until it gets as close as it's going to get anyway, to put on a pair of sunglasses and have a lot of automated setups. That's still a way down the road.

And realistically, there are still technical problems like motion sickness, like what I said, that's a cultural perception issue we have to fight, but it is also very real. As Jim Chabin and I went to the VR Center in Tokyo the other day, all their experiences were very short, they were about 4 or 5 minutes each, and at the end of them, we were like, "Okay, I can feel a twinge of motion sickness there." If it were a 10 minute thing, it probably would have actually made us sick. So that's a very complicated challenge, because higher frame right, higher resolution, wider field of view—none of those are going to solve that. So right now, we are still pretty limited with what we can do in terms of motion.

In a video game, if you push up on the controller, your player moves forward, that's a pretty standard thing, and right now we don't have that for VR, the best we can do is a teleport. You hold the button, a little icon appears, and then it takes you there. And it works, but it's not immersive, it's against the point of VR, so until those issues are solved, it's really not going to become what we want it to be.

There's going to be a lot of bad content out there. Remember the Nintendo Wii, very, very, very popular hardware, people loved it, and it was great. But, you know what? There was not really a lot of content outside of Nintendo that was triple A quality. There was a lot of casual, small games, a lot of, what we call waggle, where you kind of shake the controller and something happens, and so even though that console made a ton of money and was very popular, it was just, sort of, a bit of fad and even in Nintendo's future consoles, the elements that made the Wii successful are less and less prominent. The way I see that relating to VR, if you only have a bunch of simple or boring, kind of casual games that are kind of silly and not deep, big that you might get from a triple A title, it's not going to be what we want it to be, and people will say, "Oh, that's just a little toy," rather than something I can have a really great experience with.

There's still a lot of backlash between visual fidelity and what's realistic. On a normal video game that you might play on a 1080p TV, you could get away with rendering it at 30 frames a second, maybe 70% resolution, and it could still look great. With VR, we have to render at 60 frames per second or 90 frames per second and we have to render at 130 percent

resolution, and we can never drop our frame rate unless we make people sick. Using the exact same hardware, people expect like, "Oh, I have a PlayStation 4 and this game looks amazing, why doesn't the VR game look like that?" Our hardware requirements are so much greater and they are only going to get greater, especially if we have a 2k per eye display, or 120 frames a second, or whatever that might be. It's really going to take a long time until we get optimized rendering that works and give people the quality that they expect.

And one of the things I see all the time, like I said, we do a lot of location based things and a lot of it goes to China. A lot of times the question is, "Alright, well here's this piece of content that we need to make. Alright, we are going to release it for this, this, this and this and what about the Chinese arcade version?" And for us, right now, it's a positive because there is a strong sense of arcade culture here, or cafe culture, so there's a lot of installations and it provides us with a lot of income that we wouldn't have otherwise. The arcade culture kind of died in the United States. It was popular when I was a kid, in the 90s, and then it just went away and I think that's really emblematic of both video games with arcades, but also with movies and theaters.

So you'll see, there's a quote from the CEO of I-Max, they're looking at VR as potentially a savior for movie theaters or Hollywood, and the key quote is, "The quality of in-home is so good today, the challenge is to offer something that they will never have at home." So that could apply to movies, that could apply to games or VR experiences, because, again, if I've got a 4K, HDR TV at home, that is 65 inches, I could have an amazing visual experience with that. So do I really need to go to the theater, or what is the benefit of that? So people are rethinking, "What is the benefit of these institutions?" And so, they know though that VR is not ready, he says, "Well, although VR may not be entirely ready for prime time at this moment, we are excited about the opportunity." I mean he knows there are issues right now, but the potential of it is so gigantic.

And what does Hollywood have to offer? I mean, why are we talking about Hollywood and VR in the first place? Shouldn't it be more of a game-centric kind of medium? Hollywood really latched onto it for a few reasons: one, like I said with Jon Favraeu and Inarritu, they are storytellers and they are hungry for challenges. Directors haven't had a new technical challenge like this for a long time, where you really have to think differently about how a story is built and told. So they like the challenge of it, and they like that they have a leg up, and they know some things that work for it but they still have to learn other things. Hollywood has, at least with the larger budget movies, there's a lot of high-end visuals and world building, so they are really good at creating a well thought out environment or world that you can live in, which is really well suited for VR, with a lot of details. And movie stars, let's not forget that, I think

Designing for presence

something that will be really exciting for people will be to be in the same room as a movie star, right? We are not technically capable of that yet, but as a goal, if I can give you an experience and you can walk up to Chris Hemsworth as Thor, that'll be really powerful for people. And that whole industry is based on wish fulfillment.

Designing that presence is, or the sense of presence, is really important for VR experiences and users want to feel like they are a part of a Hollywood movie. I think what we are really looking for is high-end volumetric capture, rather than CG game engines. We're looking for higher fidelity but still interactive experiences, so right now we are limited to either game engines or videos and there's not a good thing in between that gives you the benefits of both. We're getting there, the Lytro Emerge camera and that kind of volumetric capture is very exciting for Hollywood.

Using this language of personal space can be really great for making people feel like they are in a virtual space. Making eye contact is very powerful, especially when you can move your head and the eyes of a ghost or a monster follow you. Setting the right pose, for example in *The Walk*, people held out their arms to keep balance, and they just automatically do that. It tells the back of their head, "Oh, I'm in this world. I'm doing this thing." Even though they don't really need to hold out their arms to keep balance, to be successful.

The size of an object can be really powerful too, or the size of the world. So if you're a mouse and your eyes are only one centimeter apart, it's going to look very different than what you're used to in the day to day world, and you get really overwhelmed by that. Phobias and fears are also a little cheap, but they are a powerful thing to experience as well, and that's why *The Walk* was so successful.

To sum it up, what we really need is a higher level of visual realism, whether that is volumetric capture, higher resolution, that's a sort of catch all. Make sure it's easy for non-gamers to use. The parent test. Make sure that the hardware is small and the form factor is okay to get over the social stigma of it. Social experience, the isolation of it, is something that people really need to get past. And when we get all of these, they are going to create a really healthy market, both for home downloads and location based entertainment, and for Hollywood that's success and for the rest of the industry that is success.

好莱坞 VR 内容的前沿探索

▶▶ Jake Black

首先跟大家分享一下我的日常。我生活和工作的地方都在洛杉矶,和好莱坞影城有合作。我的工作内容是根据他们的电影创作 VR 体验产品,一般都是为了宣传或营销,不过我们发展得很快。

在 Create Advertising 集团,我们有几部知名的作品。今年夏天,我们为《蜘蛛侠:英雄归来》发布了一部作品,还有中文版。我听了好多天,尽管一个字也没听懂。这个作品在 PlayStation、Vive 和 Rift 上都可以找到。我们第一部作品是我们最知名的作品,是为 Robert Zemeckis 执导的《空中行走》创作的。这部电影以法国杂技演员 Philippe Petit 的真人真事为背景,1974 年,他在世贸大楼双子塔之间搭建钢索并完成了行走。在作品中,我们小规模地重现了这样一种体验。

今年早些时候,我们发布了《捉鬼敢死队:新人招聘》。这是第一部,第二部的发布时间应该会在下个月。

我今天要讲的是好莱坞 VR 内容的过去、现状及未来,包括我们在作品发布之前都会致力于哪些工作,以及希望它有怎样的发展。我们会讲到实现目标的方法以及其中的风险和问题。接下来我还会分享我们从过去中学习到的经验,怎么去设计一款 VR 体验产品才能让人最大程度体验到身临其境的感觉,才能让这款产品不仅仅是 360°全景电影那么简单,而是充分利用 VR 这个媒介的优势。

VR 在好莱坞的应用已经有好几十年历史了。迪士尼乐园里的阿拉丁飞毯游艺项目就用到了这个技术。有些人可能还记得 20 世纪 90 年代的老电影《异度空间》,里面的一些概念也是受到这个技术的影响。据说在阿拉丁飞毯游艺项目旁边,他们还在头戴式设备旁边放上一个垃圾桶,因为项目一结束很多人就把头戴式设备扔到一边了。这是不是真的不重要,重要的是我是这么听说的,好多人也是这么听说的。所以即便是现在,一提到 VR,人们还是会说:"听起来不错,不会晕是吗?"这是很大的一个障碍,我们必须时刻牢记这一点。

VR 的重生和 Oculus Rift 头戴式设备的发布紧密相关。这是新浪潮下的 VR。现在很多成就都归功于这款设备的发布,这也是为什么我做了这一行。好莱坞在这方面的反应堪称迅速。派拉蒙影业公司为 Christopher Nolan 执导的《星际穿越》

做了一款小型体验产品，玩家坐在一把椅子上就能模拟出在宇宙飞船里飘浮的零重力状态。

福克斯公司做出了很多成绩，他们在这方面很积极。《火星救援》是第一款在售的大型体验产品。大约有七个章节，二三十分钟，我没记错的话，刚开卖的时候，售价是 20 美元。

索尼公司发布的《鸡皮疙瘩》这款产品，玩家只要坐到一张会动的椅子上，就会感觉自己坐在 Jack Black 身边，亲身经历电影里的某个场景，有点像游乐场里的游乐设施。

狮门电影公司也很积极，他们一直在为《饥饿游戏》创作作品。在我看来，他们现在做的这些工作，马上就会发布的这部作品，和上部作品比起来，互动性强了一些，但还是有很多 360° 全景视频。

索尼影业有线下体验产品《捉鬼敢死队》的制作经验，有 the Void 公司的帮助，有我们制作的 PlayStation 游戏和《蜘蛛侠》这款游戏，可见它还是很活跃的。《蜘蛛侠》这款游戏提供免费下载，为的是引起人们对电影的兴趣，希望以此引导观众走进影院观看这部影片。他们现在在为即将上映的《勇敢者的游戏》制作一款体验产品，将由另一家叫 VR X 的线下娱乐公司在五十个不同的实体店发售。

华纳兄弟发布了很多 360° 全景视频内容。最近他们发布了恐怖片《安娜贝尔》和它的衍生产品。在这款产品的结尾处，他们承诺会有更多东西呈现给大家，他们似乎是在制作一个比 360° 全景视频交互性更强的作品。他们还承诺要为《正义联盟》和《海王》制作更大型的体验作品，通过与巨幕影院合作使其在各个地方发行。

福克斯公司的情况也差不多，发布了一段《异形：契约》的 360° 全景视频，叫作《在子宫中》。在这段视频中，你会发现自己身处在某人体内，然后慢慢变成异形，冲出宿主的胸口，这一切都是通过主观镜头实现的。同样，福克斯也宣称"我们在未来还会有大动作，请大家拭目以待"。

环球影业发布了很多 360° 全景视频，包括 Tom Cruise 执导的《木乃伊》。他们制作的往往是纯粹的 360° 全景视频，同样也是作为一种营销手段。他们还没有很多交互性作品。

迪士尼公司在做很多独特的尝试。他们有一个 APP 叫作"迪士尼电影 VR 中心"，你登录进去的时候，会看到一座巨大的魔法城堡，右边是《星球大战》，左边是漫威的《复仇者联盟》，继续点进去还有各自独立的内容。下一步他们将与 the Void 合作推出一款《星球大战》的线下体验产品，于 1 月份在美国发布。与他们合作的这家公司曾经在纽约和迪拜推出过《捉鬼敢死队》的衍生产品。

从这些例子可以看出，这些都是公司的作品。其实电影制作人对 VR 这个媒介也很感兴趣，我认为他们可以大量地运用这个新的工具，但是规则截然不同，在很多方面，电影制作人都得从头开始。

除了各家公司的作品外，现在还有两部优秀的个人作品。其中一部是 Alejandro Inarritu 的《肉与沙》，目前只在洛杉矶艺术博物馆上映。这部短片刻画了一个巨大的空间供你漫步，里面讲述了发生在美国和墨西哥边境的故事。这部短片一票难求。最近它斩获了奥斯卡特殊成就奖。上一次颁发这个奖项，还是二十多年前《玩具总动员》面世的时候。他们都认为这部短片体现了创意与技术的一大飞跃，只有 VR 才能实现这种飞跃。另外一部作品的创作者是 Jon Favraeu，是即将上映的迪士尼影片《狮子王》和《奇幻森林》的导演，他有一部交互性短片叫作《地精与哥布林》，它将成为一部长片中的一段内容。这部作品非常优秀，时长大约 5 分钟或 10 分钟。它是一款房间规模体验产品，在 Steam 上可以免费获取。如果你有 Vive，很值得一试。这就是由传统电影制作人生产的在 VR 领域备受推崇的作品。

从以上种种迹象我们可以得出一个结论、一个趋势——线下娱乐依然占据重要的地位。几乎我的每个作品都有线下产品。我们有很多 360°全景宣传片，它们绝对是最好做的片子，也是寿命最短的，影响力也是最小的。但它们也是超乎我们想象的世界，不仅仅是升级版的 YouTube 视频。这些宣传片大多数是免费的，很少有收费的。在特定地点，它们是收费的，但是至少在国内是免费的，因为通过吸引观众去影院看电影或其他方式，实际上已经有人为它们买单了。这就是为什么宣传片不收费，目前还没有谁真正因此赚到了钱。或许有那么一两家公司有很好的业绩，但是就目前来看，市场不够大，还无利可图。所以这些公司都是这么说的："这是我们生产的内容。我们知道这是大家想要的东西，它很酷。目前免费提供，未来还会有更多的内容。虽然以后可能需要大家掏腰包，但是不到我们想要收回成本的时候我们都不会收费。"

目前它确实是一种营销手段，但是所有公司都承认收费的日子指日可待，他们希望这个技术能给他们创收。因此，大多数公司都专门成立了一个部门来处理沉浸式技术相关的工作。它不仅仅是一个 VR 部门，还是一个掌握了 VR、AR 等技术的部门。所有公司都很严肃地看待这个问题，但总的来说他们还是更看中市场更大的特许经营权。我认为这透露了这样一个信号，由于市场狭小，就会想吸引尽可能多的眼球，影响力小还是大会产生很大的不同。所以在说服别人去看某段内容时，你会说"这是 VR 版的《蜘蛛侠》"，而不是说"这个新的东西你可能喜欢也可能不喜欢，你之前也没有听说过这么一个东西。让我们来一探究竟"。

其中最大的问题：市场规模太小。我没有真正接触过移动 VR，但我也能理解为什么人人都想做这个，它的进入门槛很低。但是对我来说，我们想做的是优质的体验产品、最好的体验产品。我们使用的硬件已经把我们放在了一个不利的位置上，转而去做移动产品会更困难。与游戏主机捆绑的头戴式设备，目前有多大的市场规模还没有准确的官方数据，但是根据推算我们认为市面上有 200 万～ 250 万台这样的头戴式设备，这就是完整的市场规模，至少从国内来看就是如此。这么小的市场规模还得细分，主要分为三类：PlayStation、Oculus Rift 和 HTC Vive。这意味着生产一个市场规模如此之小的内容时，预算会非常紧张。另外，由于要推送到三大不同的平台上，甚至更多的软件商店里，有限的资金支撑不了太久，因此开发产品、扩大用户群体变得愈加困难，我迫切希望开放的标准能变成一种常态。我知道这些是存在的，多平台开发的现状没有那么糟糕，但是我还是得花时间、花精力去处理不同平台的转换问题。

我相信大家都听过这样的说法，媒体炒作的时代已经过去，世界发生了 180° 的改变。现在人们挂在嘴边的是："VR 是死了吗？它有什么意义呢？会不会是昙花一现？"我认为这仅仅是因为有很多人把前景想得太美好了。他们预测到 2020 年，市场规模能达到一千亿美元，以及还有其他一些荒谬的想法。当你听到这种好到令人难以置信的话时，它确实是不会发生的。所以我会试图不去理睬这些说法，只看当前真实的数字。如果 6 个月以前，市面上有 200 万～ 250 万台头戴式设备，未来会是多少呢？随着头戴式设备价格越来越低，内容越来越好，头戴式设备的销量一直在上涨，对我来说这都是很好的信号。但是对于那些只对新闻标题能吸引多少眼球感兴趣的科技写手来说，随手写这么一句话真是太容易了："VR 到头了，现在 AR 才是香饽饽。"现在风投的钱都轻易流到了 AR 这个领域，可以预见，再过几年还是会发生这样的事情。人们会说"确实挺酷的，但它不是我们想要的"，所以只会带来失望。

还有一个大问题，制作内容的成本可不低，就算不需要上百万美元，也得几十万美元，而且这个行业里还有各种奇怪的竞争。我敢打赌，每个人手机上都会有一款免费游戏，或者是价值一美元或等值的游戏。不贵，但是可以给你带来巨大的乐趣。你的钱可经花了。但是如果是 VR，制作一条优秀的 VR 内容需要耗费大量时间和精力。如果你想要售卖你自己制作的一款游戏或其他什么产品，假设是一款 10 分钟、20 分钟、30 分钟的产品，而且你要收取 20 美元，那么用户会认为用 20 美元去买个游戏简直是天价。所以说，如果你出售的这个 VR 内容，时间又短，可玩性又低，人们还得花钱去买，那肯定会有人抵制这款产品。这种文化理念是很难推翻的。随着以后头戴式设备越来越多，收益会增加，事情会变得简

单一些，但是就目前来看这还是个问题。

硬件也是个问题。我知道为了让设备戴起来更舒服、体积更小巧、外观更时髦，大家付出了很大的努力，但做得还不够。不管我是在创作内容还是测试硬件的时候，我脑子里都会问这么几个问题，我称之为"父母测试法"：我的父母可以学会使用这个硬件吗？他们会想要这么一个东西吗？他们能搞明白吗？如果针对的是目前的 VR，这几个问题的答案绝对是否定的。如果我把一台 HTC Vive 交到我的父母手中，告诉他们"好好玩吧"，他们都不知道怎么开始。不管是"怎么知道我的显卡够不够好"，还是"定位基站要放在哪里"，还是"我是不是得在客厅里走来走去"，这些他们都不知道。而且，虽然头戴式设备一天比一天小巧，但是人们戴上这么一个庞然大物看上去还是呆呆的，所以这个市场是不会真正蓬勃起来的，也不会成为主流，除非它能变得很小巧，就像戴一副太阳眼镜似的，并且能够自动完成很多设置。我们离这么一天还有很长的路要走。

实事求是地讲，我们还有一些技术问题没有解决，比如说晕动症。正如我之前说过的，这也是我们必须解决的文化理念问题，它是真实存在的。前几天我和 Jim Chabin 去了东京的 VR 中心，他们所有的体验产品时间都很短，大约四五分钟的样子。体验结束的时候，我们俩的感觉是"哎呀，好晕啊"。如果是 10 分钟的话，很可能真会让我们吐出来。这是个复杂的挑战，因为不管是提高帧率、分辨率还是拓宽视野，都无法解决这个问题。所以，目前我们在这方面还是没有很大的作为。

在电子游戏中，你往前推动控制摇杆，控制的玩家就会往前走，这是例行的方式。但是现在 VR 里没有这种东西，我们最多只能提供一个远距离传送设备。你手持按钮，然后出现一个小小的图标，再然后就可带动玩家走动。这是可行的，但是没有沉浸感，它与 VR 的初衷是相违背的。这些问题不解决，就达不到我们想要的效果。

市场上会出现很多不好的内容。还记得任天堂 Wii 吗？它一度非常流行，人们都很喜欢这个伟大的发明。但是你们知道嘛？任天堂，它没有多少 3A 级内容资源，上面有很多随意的小游戏，很多我们称之为简单的动作游戏，玩家只要晃动控制摇杆，就会触发动作。这样的游戏曾广受玩家欢迎，赚得盆满钵盈，但这种狂热只是昙花一现。即便在任天堂后来开发的游戏中，那些曾帮助 Wii 大获成功的元素也越来越不奏效了。这个教训可以应用到 VR 里。如果你有的只是一堆简单、无聊、随意、愚蠢的小游戏，既没深度，也不宏大，够不上 3A 级标准，那么这不是我们想要的。人们会说："那不过是个小玩具罢了，而不是能让我有非凡体验的东西。"

关于视觉保真和真实体验，还有很多反对的声音。在传统的电子游戏中，玩家可以在 1 080p 的电视机上玩游戏，只需要 30 帧每秒的帧率、70% 的分辨率，看起来就很不错了。但是在 VR 中，我们必须达到 60 帧每秒甚至 70 帧每秒的帧率、130% 的分辨率。我们不可以降低帧率，除非是在玩家发晕的情况下。如果硬件条件完全相同，人们会想"我有一台 PlayStation 4，在那上面游戏看起来可清晰了，为什么 VR 游戏看起来就是这副鬼样子"？我们对硬件的要求高得不是一点点，尤其当我们用的是 2K 单眼分辨率，或 120 帧每秒的帧率，或其他什么的时候，要求就更高了。让画面得到优化，向用户呈现他们所期待的画质，还需要很长的时间。

正如我说过的，一直以来我们做了很多线下的东西都是面向中国市场推出的。很多时候，问题是："好吧，这是我们需要生产的内容，我们要发布这个、这个和这个。那么中国的游戏厅版本呢？"目前，对我们来说形式很乐观，因为在中国有根深蒂固的游戏厅文化，或者说网咖文化，所以就会有很多设备，这样就能为我们带来大量的本来不会有的收入。这种游戏厅文化在美国几乎不复存在，20 世纪 90 年代我小的时候一度很流行，之后就销声匿迹了，我想这标示了电子游戏在游戏厅的命运，也标示了电影在影院的命运。

I-Max 的 CEO 说过这么一句话，他们认为 VR 或许能拯救电影院和好莱坞。他说："今天，家庭影音设备已经很先进了，我们的挑战在于提供一些在家里体验不到的东西。"这句话适用于电影，也适用于游戏和 VR 体验。因为如果我家里就有 65 英寸[①]、4K 的 HDR 电视机，我在家就可以有极致的视觉体验了。那我还需要去影院吗？对我有什么好处呢？所以，人们在重新思考这些机构存在的意义是什么。虽然知道 VR 发展得还不够成熟，他还是说了这么一句话："虽然目前 VR 还没有发展到占据娱乐的黄金时段，但是我们都很期待看到这一天。"这表示他知道目前还有很多问题要解决，前景是巨大的。

那么好莱坞可以做些什么呢？我是说，为什么我们刚开始就讲到了好莱坞和 VR 的关系？难道 VR 的核心不是游戏吗？好莱坞之所以感兴趣，里面有几点原因。首先，正如我说过的，Jon Favraeu 和 Inarritu 都很会讲故事，都渴望挑战。很长一段时间以来，导演们都没有遇到过像这样的新技术挑战，他们得重新思考怎么去编造并讲述一个故事，他们喜欢这个挑战。令他们高兴的是，他们已经有优势了，知道什么行得通，但是还得学点新的东西。在好莱坞，至少在那些大制作电影里，有很多高端的视觉画面和布景，他们在精心构建居住环境、勾勒细节方面

① 1 英寸 = 2.54 厘米。

可是一把好手，这对于 VR 来说再合适不过。另外，还有电影明星的魅力，我想对人们来说，和电影明星共处一室会是一件激动人心的事吧？从技术的角度来看，我们现在还做不到，但是作为一个目标，如果我能给你这么一种能够走近 Chris Hemsworth 扮演的雷神的体验，是不是很有吸引力？而好莱坞这个行业就是在"梦想成真"的基础上建立起来的。

让用户出现在画面里，或者让他们产生身临其境的感觉，对 VR 体验来说至关重要，用户希望成为好莱坞影片中的一部分。我认为我们真正追求的不是 CG 游戏引擎，而是高端的容积捕捉。我们既追求更高的保真度，也追求互动体验。所以现在我们不是受限于游戏引擎，就是受限于视频，两者之间没有一个折中的东西让我们同时享受到它们所有的优势。不过很快就要实现了，它就是 Lytro Emerge 相机，这种容积捕捉让好莱坞大受鼓舞。

个人空间语言的应用能够有效地让人们感觉自己确实是在那个虚拟空间里。眼神接触的威力是巨大的，尤其是在幽灵或怪物的眼睛跟着你的头部运动一起移动时，摆出正确的姿势也是同理。以《云中行走》为例，人们会自然而然地伸出手臂保持身体平衡，因为在他们的大脑里有这么一种声音——"我就在这个世界里，我在走钢丝"，虽然其实他们不需要伸出手臂保持身体平衡来走过这根钢丝。

物体的大小也很关键，包括世界的大小。如果你是只老鼠，眼间距只有一厘米，你眼中的世界将和你平日看到的世界截然不同，你会非常不知所措。恐惧和害怕都不是什么好的感受，但也是很强烈的情感体验，这也是为什么《云中行走》会如此成功。

一句话，我们真正需要的是更逼真的视觉体验，不管是通过容积捕捉还是更高的分辨率，我们要的就是逼真。确保非游戏玩家也能轻易上手，也就是父母测试法。确保硬件足够小巧，外观不会引起别人异样的眼光。社会经验和社会经验的孤立是人们需要忘却的东西。完成了这些目标之后，就能创造出一个健康的市场，不管是供家庭下载，还是供线下实体店娱乐。对好莱坞而言，这是一种成功；对这个行业里的其他人而言，这也是一种成功。